PIMLICO

732

MICHELANGELO

James Hall writes, lectures and broadcasts widely on art history and contemporary art. He has been the chief art critic of two newspapers, and was awarded the first Bernard Denvir Memorial Award in 1995 for an outstanding young critic. He is the author of many catalogue essays, and of the critically acclaimed book *The World as Sculpture: the Changing Status of Sculpture from the Renaissance to the Present Day.*

MICHELANGELO

and the Reinvention of the Human Body

JAMES HALL

PIMLICO

Published by Pimlico 2006

2 4 6 8 10 9 7 5 3 1

Copyright © James Hall 2005

James Hall has asserted his right under the Copyright, Designs
and Patents Act 1988 to be identified as the author of this work

First published in the Great Britain by Chatto & Windus in 2005

Pimlico edition 2005

Pimlico
Random House, 20 Vauxhall Bridge Road,
London SW1V 2SA

Random House Australia (Pty) Limited
20 Alfred Street, Milsons Point, Sydney,
New South Wales 2061, Australia

Random House New Zealand Limited
18 Poland Road, Glenfield,
Auckland 10, New Zealand

Random House South Africa (Pty) Limited
Isle of Houghton, Corner Boundary Road & Carse O'Gowrie,
Houghton, 2198, South Africa

Random House UK Limited Reg. No. 954009

A CIP catalogue record for this book
is available from the British Library

ISBN 0-7126-6789-X

Papers used by Random House UK Ltd are natural, recyclable products
made from wood grown in sustainable forests. The manufacturing processes
conform to the environmental regulations of the country of origin

Printed and bound in Great Britain by Clays Ltd, St Ives PLC

To Emma, Benjamin and Joshua

Contents

List of Illustrations

Figures in the Text

Plates

Acknowledgements

I AM EXTREMELY GRATEFUL TO all those who have offered assistance. Hugo Chapman, David Ekserdjian, David Landau, Martin Mc-Cloughlin, Alexander Nagel, Tom Nichols, Thomas Puttfarken, Pat Rubin and Luke Syson read and commented on one or more chapters. Martin Clayton, Virginia Cox, Michael Hirst, Geraldine A. Johnson, Jonathan Nelson, Paul Taylor, William E. Wallace and Marina Warner answered questions or made suggestions. I am especially grateful to Hugh Honour who looked at almost the whole book. All other intellectual debts are, I hope, fully acknowledged in the notes.

The librarians of the Warburg Institute, British Library, National Art Library, London Library, and the staff of the print rooms at the Ashmolean Museum, British Museum, and Royal Library, made my research considerably easier.

At Chatto and Windus, I would like to thank my editor Jenny Uglow, my copy-editor Beth Humphries; and at Farrar, Straus and Giroux, Jonathan Galassi, Annie Wedekind. My agent Caroline Dawnay smoothed the path to publication. The Society of Authors gave me a grant at a crucial moment.

My biggest debt, as always, is to my family, who have offered support and inspiration throughout. I would like to thank in particular my aunt and late uncle Joyce and Michael Mountain, and my father Philip Hall; my mother Françoise Carter, who commented on the whole text; and above all my wife Emma Clery, who makes so many good things happen and who read more drafts than I care to remember. The recent arrival of our two sons intensified my interest in Michelangelo's images of the *Madonna Lactans*.

Introduction

Unique master Michelangelo and my most singular friend. I have received your letter and seen the Crucifixion which has certainly crucified in my memory every other picture I have ever seen . . .

Vittoria Colonna, *Letter to Michelangelo, c.*1540[1]

MICHELANGELO'S ART TENDS TO obliterate everything in its vicinity. When we visit the ground floor of the Bargello in Florence, the Italian Sculpture Galleries at the Louvre in Paris, or even the cast courts at the Victoria and Albert Museum in London, almost every other statue looks effete and inert compared to Michelangelo's giants.

And who can devote more than a few moments to the fifteenth-century frescos that line the longest walls of the Sistine Chapel, even though three of the panels were painted by the otherwise immensely popular Botticelli? Our eyes are irresistibly drawn upwards, like sunflowers seeking the sun

Yet the overwhelming quality of Michelangelo's art often stops us seeing it in anything more than splendid isolation, and its aura of exclusivity is underpinned by the artist's own considerable efforts at self-mythologisation. The purpose of this book is to see Michelangelo afresh, connected in surprising ways with his own culture – and in different ways with our own. The best way to do this, I believe, is to attend closely to the body language of his figures, and to explore his lifelong pre-occupation with the male nude.

Too often we take these aspects for granted, in large part because Michelangelo's work is so much a part of our cultural furniture. We are, as it were, blinded both by its brilliance and by its ubiquity. There is a tendency to assume that his expressive distortions of the human body are merely extreme manifestations of natural phenomena, or else to see them

as the product of his private passions and demons, and therefore not really open to rational inquiry. Thus, for example, it is frequently observed that Michelangelo gives exaggerated prominence to the male torso, but there has been no serious attempt to explain why. So too the extraordinary poses of some of his figures, which are all too often regarded as formal demonstrations of his command of human anatomy. It is no wonder, perhaps, if our initial excitement and exhilaration at Michelangelo's work sometimes gives way to bewilderment.

I discuss most of the major works, more or less in chronological order. I begin with three thematic chapters that explore some of Michelangelo's major preoccupations, and then devote individual chapters to the Sistine Chapel, the Medici tombs, the presentation drawings made for Tommaso de' Cavalieri, and the late images of the dead Christ. By asking simple but fundamental questions about Michelangelo and his times, I hope to shed new light on many of his most familiar sculptures, paintings and drawings. These questions address basic issues such as – Why are his Madonnas so unmaternal? Why are his figures of superhuman scale and size? And why did he spend so much time performing anatomical dissections? I also address specific problems of iconography and purpose. The book will function as a sort of primer that seeks to answer key questions about the meaning of Michelangelo's art and what it tells us about the human condition.

At the same time, I hope it will have a wider and more contemporary relevance. Our culture is currently fixated on what is rather abstractly termed 'the body'. Many of today's artists, film-makers, writers and scholars claim to be exploring the depths and surfaces of 'the body' in their work. In many respects, Michelangelo can be regarded as the first artist to put the unadorned human body centre stage. So if we really want to understand our own culture, we need to understand Michelangelo.

THERE IS NO DENYING Michelangelo's power and singularity. It is not simply a matter of the intrinsic quality of individual works, a quality that is pretty much sustained – in one medium or another – from his teenage years working for the Medici in Florence through to his final years working for the Popes in Rome (he was born in 1475 and died in 1564 at what was then the prodigiously old age of nearly eighty-nine); it is also due to his single-minded focus on a restricted range of concerns – above all, the heroic male nude.

Throughout his life, whether in the marble *David* (1501–4) or the late

images of the dead Christ, Michelangelo was largely concerned with making the male body the vehicle for the most significant actions and passions. The male nude is often placed in poignant counterpoint to a heavily draped figure, as in his Madonna and Child images, and his representations of the dead Christ. It remains his central concern despite some dramatic stylistic changes (the protagonists in the *Last Judgment* (1536–41) are much more bulky and ungainly than those in his youthful works, and then again, in one last creative spasm, the bodies in his late drawings reverberate, dissolve and bleed). It is scarcely an exaggeration to call him the 'most concentrated and undeviating of great artists'.[2]

It is thus a serious mistake to think of Michelangelo as the perfect example of the 'universal man' of the Renaissance. He is only really a 'universal' artist in the sense that he mastered a wide number of different media – sculpture, painting, architecture, drawing and even poetry (he started writing poems in about 1500 and knew the whole of Dante, his favourite author, by heart). This was how the Florentine intellectual Benedetto Varchi, who delivered Michelangelo's funeral oration, imagined him in a poem appended to his tomb:

> Who lies here? One. Who is this one? Buonarotti.
> Aye, truly one. You err: four in one.[3]

Here Michelangelo, the master of many media, has trumped the Trinity, the three-in-one.

In this respect Michelangelo stands far apart from his greatest contemporaries – Leonardo, Mantegna, Bellini, Botticelli, Dürer, Raphael and Titian. These artists could all more or less claim to be universal in terms of their range of subjects and genres. As such they were influenced by the *modus operandi* of fifteenth-century painters and printmakers from northern Europe such as van Eyck and Schongauer, whose work spanned several genres and teemed with all manner of intriguing naturalistic detail.

Michelangelo largely disdained landscape backgrounds, anecdotal details of setting and costume, and portraiture. He dismissed this kind of art as diffuse to the point of unintelligibility. In conversations recorded in Rome in around 1540, he called it a degenerate 'Flemish' art that appeals to women, 'especially to the very old and the very young, and also to monks and nuns and to certain noblemen who have no sense of true harmony'. Because 'Flemish' artists try to do everything well, he

insisted, they end up doing nothing well. For Michelangelo, the best kind of art – and the most Italian – is preeminently concerned with the human figure: 'a man may be an excellent painter who has never painted more than a single figure . . . There is no need of more.' This was to be one of Michelangelo's great and dangerous gifts to western culture: an ideal of a solitary artist heroically struggling to create a single great figure.

The fact that Michelangelo could be construed as a specialist – albeit of surpassing genius[4] – led to him being compared repeatedly with his younger contemporary, Raphael. While Raphael was hailed as the genial all-rounder who mastered a whole range of genres and figure-types, Michelangelo was increasingly regarded as brilliant but unbalanced, a fanatical devotee of the anatomically extrovert male nude. Michelangelo *v.* Raphael became the greatest of all art historical 'compare and con-trasts'. Hostile critics, who were especially numerous during the seventeenth and eighteenth centuries, often castigated Michelangelo for his perceived excesses, and praised Raphael for his equilibrium. But regardless of whether Michelangelo has been loved or hated, no one interested in art has ever been indifferent. The key point at issue has usually been whether he is the supreme fertilising genius in European art, or a magnificent cul-de-sac.

By virtue of being the first great tunnel-visionary, Michelangelo changed art from being a trade to a crusade. His avoidance of portraits, landscapes, genre, anecdotal detail and the 'feminine' was not through incompetence: scattered among his surviving drawings, for example, we can find distinguished if modest examples of all these facets, except for landscapes. Rather, it was a magisterial repudiation on moral as well as on aesthetic grounds. The male figure, shorn of the 'worldly' distractions of intricate landscape backgrounds and anecdotal detail, was always in some sense a surrogate for the ultimate human being, the dying and dead figure of Christ. It was He who would be the focus of Michelangelo's final sculptures and drawings. Thus when Michelangelo specialises in the male nude, he is also specialising in Christ's Passion.

More generally, one might say that in Michelangelo's art it is always Judgment Day, the time when bodies reclaim their flesh and in all their nakedness go before their God. His figures are always, as it were, in the process of beng reborn and judged. Hence the agitation, and the feeling of total exposure. Last but not least, his art represents one of the first examples of aesthetic 'nationalism', in so far as Michelangelo regarded his art as defiantly non-'Flemish'.

Michelangelo's emergence as a specialist of genius parallels a similar tendency in contemporary religious practice. Before and during the Reformation, there was widespread disquiet concerning the cult of the saints, which was compared by religious reformers such as Erasmus to pagan polytheism. Michelangelo may have tackled pagan as well as Christian subjects, but he is effectively monotheistic in his loyalty to the male nude. However, he was in some respects walking a tightrope with this strategy as his contemporaries were not always sure whether he was Christianising pagan culture, or paganising Christianity. For precisely these reasons, the St Peter's *Pietà* proved controversial, while the *Last Judgment* came close to being destroyed.

Michelangelo's single-minded idealism affected the way in which he conceived his own biography. He insisted he was largely self-taught – an aesthetic virgin birth, as it were, whose only debt was to God. When Vasari published the first edition of the *Lives of the Artists* (1550), in which Michelangelo was deified and placed at the summit of the Florentine – and therefore European – tradition in art, the artist was incensed by Vasari's insistence that he had been taught sculpture by Bertoldo di Giovanni, a pupil of Donatello, and that he had learned from Domenico Ghirlandaio, who taught him painting. Three years later, Michelangelo replied with an autobiography ghost-written by his pupil Ascanio Condivi, and probably revised by Annibale Caro, one of the leading literary lights in Italy. In Condivi's *Vita di Michelagnolo Buonarroti* (1553) there is no reference to Bertoldo at all, and we are reliably informed that Ghirlandaio 'gave him no help whatever', but was merely envious of his precocious pupil. A little later we are led to believe that he taught the brilliant architect Bramante, who had just won the commission to build the new St Peter's, how to construct scaffolding so that he could paint the Sistine Ceiling – which he then proceeded to paint all alone, 'without any help whatever, not even someone to grind his colours for him'.[5] We know that, especially for projects involving architecture, Michelangelo organised large teams of workers, many of whom served him over many years.[6] But in marked contrast to Raphael, he had few pupils and none of any note. He could not brook rivals, potential as well as actual.

At times, Michelangelo even feared that social interaction with friends might involve a profound violation and diminution of the self. The most celebrated expression of this occurs in a dialogue compiled by Michelangelo's Florentine friend Donato Giannotti, a republican who

left the city for Rome after the Medici's return to power in 1530 and for whom Michelangelo carved an unfinished bust of Brutus. It is based on conversations in Rome in 1546, during which Michelangelo rejects a proposal from three friends to go dancing. As he was then in his seventies, his refusal is understandable, but his reasons have nothing to do with age: 'Oh you make me laugh because you can think of dancing! The only thing to do in this world is to weep!' He goes on to explain the dangers of socialising. Although no one loves men blessed with outstanding virtue or skill more than he, 'I am constrained to love that person, and I give myself to him as it were in bounty, so that I am no longer myself, but belong completely to him. So if I went to dine with you – who are all endowed with virtue and accomplishments – I would not only have stolen from me what you three have taken, but everyone else who dined would take a part.' Rather than suffer this dismemberment, he concludes, he would rather think about death instead.[7] Giannotti's dialogues were first published in 1859, and this passage was frequently cited by psychoanalytical critics as proof of the artist's 'frail ego boundaries'.[8]

Michelangelo's elaborate excuse is partly a rhetorical conceit. The loss of self in the loved one was part and parcel of modish Neoplatonic philosophy, and melancholy was also much in vogue, being particularly associated with creative types. In addition, as a homosexual in a society where sodomy was potentially a capital crime, and as the High Priest of the male nude, Michelangelo's relatively solitary existence was a good way of avoiding scandal. But there can be little doubt that he did fear loss of identity and energy due to social interaction. Solitude was much more than a flag of convenience. It suited his generally ascetic lifestyle, for despite his great wealth, and despite his predilection for good shirts and horses, he lived in austere and sometimes squalid conditions.

If certain aspects of Michelangelo's lifestyle seem designed to bypass the contemporary world, then so too do certain aspects of his art. Because of Michelangelo's devotion to the naked and semi-naked body, it is quite natural to think of his art as in some sense timeless. Very recently it was claimed that Michelangelo's 'role', and his 'preference', was to make the grand statement, 'consciously abstracted from current preoccupations and undertaken with an eye fixed on eternity'.[9] There is clearly some truth in this, and Michelangelo himself appears to sanction this view. When asked to explain why the statues in the Medici tombs in Florence bore so little resemblance to Giuliano and Lorenzo de'

Medici, he famously said that in a thousand years no one would know what they had looked like anyway. What mattered was to give the statues 'a greatness, a proportion, a dignity . . . which it seemed to him would have brought them more praise'.[10]

But too firm a conviction that Michelangelo's art is essentially timeless can become an excuse for not looking closer or deeper. It merely adds yet another murky layer of myth to the many that already surround the artist. Overall, the purpose of this book is to bring us a little closer to the contemporary logic which underpins Michelangelo's art, and which helps account for his unparalleled financial and social as well as artistic success. I want to reveal the worldliness of his art's other-worldliness, the topicality of its timelessness. By so doing, I hope to intensify our sense of his art's urgency and of its continuing presence in our lives.

1. Mothers

I am no connoisseur: but that it is a disagreeable, a hateful picture, is an opinion which fire could not melt out of me . . . here is the Blessed Virgin, not the 'Vergine Santa d'ogni grazia piena' but a Virgin, whose brick-dust colour face, harsh, unfeminine features, and muscular, masculine arms, give me the idea of a washerwoman . . .'

Anna Brownell Jameson, the *Doni Tondo*,
in *The Diary of an Ennuyée* (1865)[1]

This is no maternal Mary (there is no such thing in Michelangelo).

Heinrich Wölfflin, the *Doni Tondo*, in *Classic Art* (1899)[2]

ONE OF THE MOST original and controversial features of Michelangelo's work is the way in which he represents women. No other great pre-twentieth-century artist has depicted them in such a consistently 'unfeminine' way. Ever since Lodovico Dolce argued in the mid-sixteenth century that Michelangelo interpreted every figure, regardless of gender, in terms of the heroic male nude, critics have argued furiously over the implications of this claim, often in relation to his so-called anatomical excesses which gave rise to exaggerated musculature.

Hostile critics tend to think that Michelangelo's women are muscle-men in drag, and that his blind spot in relation to gender difference is symptomatic of an artist who was obsessed with power to the exclusion of grace. Favourable critics might sometimes try to defend him against this accusation by picking out a few images of women that they find alluring: the women in the lunettes of the Sistine Ceiling, or the allegorical figure of *Dawn* in the New Sacristy at San Lorenzo in Florence.[3] But more often than not they do not dispute the matter very

1

urgently. Rather, they insist that in art the sublime – or the grand manner – is far more important than the 'merely' beautiful.

Perhaps the most productive way of addressing Michelangelo's women (at least initially) is to think less about their putative maleness, and more about their austerity. For if we only think of them as surrogate men, and explain them away by citing the frequent use of male models by Renaissance artists, or by bringing in Michelangelo's homosexuality and the inference that he 'only knew breasts that were made of stone',[4] then we run the risk of not taking this tendency seriously enough: we impute it to a mixture of laziness, incompetence and misogyny. Such explanations are also inaccurate, because the monumentality of his women is not always certifiably masculine.[5] By looking at the problem in terms of austerity, on the other hand, we can begin to see his treatment of women not as a sleight of hand, but as a crucial component of a deeply felt artistic strategy.

The austerity of his women can be seen as underpinning his pessimism both about the possibility of social relations, and of religious inter-cession. Furthermore, the heroic nudity, solitude and pathos of his male figures is predicated on his representation of women, for these women deny the possibility of the existence of a domestic realm with its enveloping and comforting intimacies. No wonder his males seem so exposed.

IF WE WANT TO begin to understand Michelangelo's representation of women, the best place to start is with the six early sculptures and paintings of the Madonna and Child, all made in Florence and Rome before 1506, when he reached the age of thirty-one. The first is the *Madonna of the Stairs*, a marble relief usually dated to the early 1490s; the last is the *Bruges Madonna* (1504–6), a freestanding marble statue made for the family chapel of Flemish cloth merchants in the church of Notre Dame, Bruges.[6] All six were separate commissions, made during a period of rapid stylistic development, but they have enough qualities in common to be looked at as a group.

A further reason for examining them is because the Madonna and Child was by far the most popular subject in the visual arts. Although there are only a few fleeting references to the Mother of God in the Bible, theologians enthusiastically filled the gaps in the biblical narrative, devising all manner of intimate and moving episodes. As a result, more than a third of all fourteenth- and fifteenth-century churches in Italy

were dedicated to the Madonna, and paintings, sculptures and prints of the Madonna and Child could be found all over Christendom – in private homes and chapels, as well as on street corners and over doorways.[7] Any deviation from conventional modes of representation is all the more striking.

For Michelangelo's Florentine contemporaries and precursors, such as Botticelli, Ghirlandaio and Verrocchio, the Madonna and Child was perhaps the most charming and tender of all subjects. The maternal and domestic aspects of the Virgin had become increasingly central to Christian iconography and teaching since the thirteenth century. The traditional matriarch enthroned in a starry heaven became a pretty young mother, sitting informally outdoors, perhaps in a meadow, billing and cooing and offering a plump breast to her chubby son.[8] In a manual on spiritual instruction written in 1403, the Florentine Fra Giovanni Dominici advocated the use of serene images of the Virgin and Child as moral exemplars for children:

> The first is to have paintings in your house, of holy little boys or young virgins, in which your child when still in swaddling clothes may delight, as being like himself, and may be seized upon by the like thing, with actions and signs attractive to infancy . . . The Virgin Mary is good to have, with the Child on her arm, with the little bird or the pomegranate in his fist. A good figure would be Jesus suckling, Jesus sleeping on his mother's lap, Jesus standing politely before her, Jesus making a hem and the mother sewing that hem.[9]

Florentine artists vied with each other to develop ever more delightful and sophisticated variations on the Madonna and Child. The requisite modesty of the Madonna did not preclude her being stylishly attired, manicured and coiffured. In Botticelli's paintings, the Madonna's idealised beauty is comparable to that of the quasi-divine ladies to whom courtly love poems were addressed. The Virgin's suave elegance was pretty much in keeping with the advice given by Leon Battista Alberti for the depiction of young women in secular compositions. In his treatise *On Painting*, published in Florence in 1435–6, he stipulates: 'The movements and poses of virgins are airy, full of simplicity with sweetness of quiet rather than strength; even though to Homer, whom Zeuxis followed, robust forms were pleasing even in women.'[10]

Towards the end of the century, however, some Florentine artists

reduced Mary's clothing allowance, cut down on decorative trim-
mings, and made her marginally more robust. For Leonardo da Vinci
(1452–1519), writing in his *Notebooks*, excessive finery was an unneces-
sary distraction: 'Do you not see that among the beauties of mankind it
is a very beautiful face which arrests passers-by and not their rich
adornments? Have you not seen the women who dwell among the
mountains wrapped in their poor rude draperies acquiring greater beauty
than women who are decked in ornament?'[11] Although Leonardo was
working in Milan from 1482 to 1500, this kind of belief also seems to
have been prevalent in Florence. There were strong religious arguments
in favour of less glamorous Madonnas. The charismatic Dominican
religious reformer Girolamo Savonarola, who became prior of San
Marco in Florence in 1491, believed that the Virgin had been given
special powers over the city. However, he delivered a sermon in 1496 in
which he complained that artists made the Madonna resemble
contemporary Florentine prostitutes: 'Do you imagine that the Virgin
Mary would go about dressed as you paint her? I say to you that she was
dressed like a poor girl, simply, and covered up so that you could hardly
see her face . . . You make the Virgin Mary seem dressed like a whore.'[12]
Nonetheless, even the great Dominican could not ignore the prevailing
fashion altogether. He claimed to have had a vision in which he spoke
to the Virgin as she was seated on a throne, wearing a crown studded
with many different kinds of precious stone, each cut into the shape of a
human heart. With an eagle eye worthy of an Italian merchant,
Savonarola was able to tell the exact number, type and quality of these
stones.[13]

While late quattrocento Madonnas were more plainly attired, and in
some cases more robust, they were no less serene. The increased
monumentality of the Virgin in Leonardo's *Virgin of the Rocks* (1482–3),
completed shortly after he left Florence for Milan, serves to yoke the
protagonists together more securely. She hovers over the Christ Child
and the infant St John, a cocooning canopy, and shepherds them with
calm authority. The architectonic scale merely underscores the solidarity
of the maternal bond and the closeness of their relationship. In 1501,
Isabella d'Este could still call Leonardo the creator of 'holy and sweet'
Madonnas.[14] Michelangelo's Madonnas could scarcely be described as
'sweet'.

Michelangelo Buonarroti (1475–1564) was born into a Florentine
family that had been quite distinguished during the fourteenth century,

but had been in more or less continuous decline ever since. His child-hood was divided between the family home in the Santa Croce district of Florence and the small family estate in Settignano, not far from the city. Michelangelo claimed that his father Lodovico, who came from a higher social class than most painters' fathers, initially opposed his wish to leave a grammar school, where Latin was on the curriculum, and enrol in a painter's studio. He received his first training in the highly successful studio of the Ghirlandaio family in Florence. His presence was recorded there in 1487, when he would have been twelve years old, and the following year his father arranged a three-year apprenticeship. One of Michelangelo's earliest tasks as an apprentice was to assist Domenico Ghirlandaio (*c.* 1448–94) on the fresco cycle of *The Life of the Virgin* (*c.* 1486–90) in the church of Santa Maria Novella. Here the female protagonists are quite solemn, but still thoroughly elegant and charming.

By around 1489–90, Michelangelo had been taken into the household of Lorenzo de' Medici (1449–92), the *de facto* ruler of Florence, and while there seems to have studied sculpture in the Medici sculpture garden on the Piazza di San Marco. This loggia-lined garden was filled with antiquities, and some modern paintings, and was visited by sightseers. It was an informal academy where young sculptors and painters learned their trade. The sculptors probably spent at least some of their time restoring antique sculptures, providing missing limbs and heads, and tidying up the surfaces.

Michelangelo may initially have been taught by Bertoldo di Giovanni, a pupil of Donatello, but Bertoldo died in 1491, and we have no clear idea who then took charge of Michelangelo's education. While there, Michelangelo probably carved the *Madonna of the Stairs* (early 1490s; Plate 1) which most critics believe to be his earliest surviving work (preceded only by a few drawings).[15] It remained in his own collection for reasons that are unclear, although the sketchiness of some sections suggests it may be incomplete.

This small but fiendishly complex relief, probably made for the purposes of private devotion, is astonishingly ambitious and original. Indeed, there is something slightly preposterous about its earnest striving after portentousness. The Virgin is shown full-length in profile, seated on a large stone cube. A muscular Christ Child lies at her breast, with his back towards the viewer. The left side of the relief is filled by a steep stone stairway, at the top of which a gesticulating scrum of well-built putti struggle to unfurl what could be a sheet, banner or garland. Mary

5

is so massive, with bloated hands and feet, that she barely fits into the remaining space: the top of her halo is shaved off by the raised edge of the relief. Her robes swathe her body like heavy layers of damp chamois leather. She comes close to Alberti's epitome of an ugly figure: 'If in a painting the head should be very large and the breast small, the hand ample and the foot swollen, and the body puffed up, this composition would certainly be ugly to see.'[16]

Fifteenth-century Florentine artists rarely showed the Virgin breast-feeding – the theme of the so-called *Madonna lactans* scarcely appears from the mid-1440s to the 1470s.[17] Here, almost perversely, the motif seems to have become an excuse for a withdrawal rather than an increase of maternal attention. The Madonna keeps eyes front, and seems barely aware of her stockily muscled son. He may be asleep, since his right arm hangs loose, but even this is not an entirely plausible explanation for her indifference because he lies in such a precarious position. His arm is twisted uncomfortably behind his back, and his heavy body is canti-levered far over to the right, so it looks as though he could easily fall out of the front of the relief. Despite all this, her left hand hangs free and fails to fully embrace him. This motif, and the steep stairway, must make it one of the first *Madonna lactans* images to induce vertigo.

Critics have been disconcerted by the Virgin's disengagement, but they usually conclude that Michelangelo was trying to make an image that had tragic overtones. If the Virgin seems rather insensible, they say, it is because she is lost in thought, meditating on her son's eventual fate.[18] To this end, the sheet being unfurled by the putti may be a portent of the winding sheet that will eventually envelop Christ's corpse, while the slack posture of the child's body portends the *Pietà*. Such prefigurations of the Passion were very popular in north Italian and north European art.

We too are strangely alienated from the child since we see him from the back, so that his face is completely concealed. Michelangelo scholars consider this motif to be his own invention, but it clearly recalls an episode in the life of the early Christian saint and martyr Catherine of Alexandria (Michelangelo would later depict her, holding one of the spiked wheels to which the Roman Emperor Maxentius bound her, in the *Last Judgment*). Catherine was of royal birth, renowned for her learning, wisdom and eloquence, and she aspired to Christianity. A hermit gave her a devotional image of the Madonna and Child and that same night she had a vision of them in which the Christ Child always had his back towards her, no matter how much she changed her own position. When

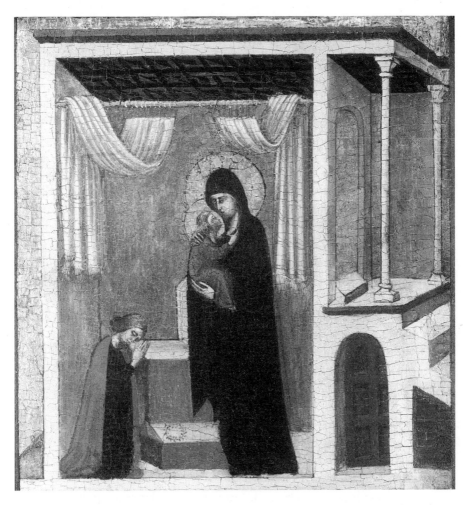

Fig. 1: Donato and Gregorio D'Arezzo, *St Catherine of Alexandria and Twelve Scenes from Her Life*, *c.* 1330 (tempera and gold leaf on panel, Los Angeles, the J. Paul Getty Museum). Detail showing Christ turning his back on Catherine

Catherine begged Christ to face her, she was told – either by Christ or by his mother – that she was still unworthy to see the splendour of his face.[19] Catherine was one of the most popular female saints, but only one depiction of this disconcerting episode has been identified, in a Tuscan panel painting from around 1330 (Fig. 1). By contrast, the more affirmative and intimate subject of Catherine's later 'mystical marriage' with the Christ Child, performed after Catherine has done some homework on the Christian mysteries, was frequently depicted.[20]

The episode is not even mentioned in the standard compilation of saints' lives, Jacopo da Voragine's *Golden Legend* (*c.* 1275), which devotes a long section to St Catherine, but her rejection by Christ does appear in other texts, especially in Tuscany. The first printed version of her life was published in Florence around 1487, *La Legienda di Sancta Caterina*, and here the Virgin Mary intercedes with Christ on behalf of Catherine by taking up her virtues, only to be contradicted by her son. However, a Tuscan religious drama of *c.* 1400 includes a slightly different version of the scene with a less friendly Madonna, and when Catherine expresses her dismay at the divine cold shoulder, she comes close to describing the feelings of any worshipper who tried to pray in front of Michelangelo's relief:

> I do not know why
> He turned his back to me and not His face.
> I was on my knees
> Saying, 'O sweet mother, open your arms.
> I pray you that it may please you
> To show me the shining face of your Son.'
> She gazed at me steadily
> And said, 'You have not yet deserved it.'[21]

Michelangelo's relief could have been made for a young woman who was a fervent devotee of St Catherine. But not necessarily. St Catherine was widely favoured, especially by the Dominicans, the most learned of the religious orders. The founder, St Dominic, believed learning and rational thought were necessary in order to refute heresies supported by sophisticated philosophical and theological arguments. The Dominicans regarded St Catherine as a perfect exemplar since she had defeated fifty pagan philosophers in debate, causing them to convert to Christianity; as a result, the Emperor burnt them at the stake.[22] Michelangelo's elder brother Lionardo (1473–*c.* 1516) had joined the Dominicans in 1491, so he may already have been well versed in the life of St Catherine. In addition, the Medici sculpture garden was next door to the Dominican church and monastery of San Marco. In later life, Michelangelo said he was a devotee of Savonarola, prior of San Marco, and had attended his sermons. Savonarola regarded St Catherine very highly. During the course of his famous vision of the Virgin Mary, she and her epony-mous Dominican follower, Saint Catherine of Siena, were his 'special

protectors'. However, it may just be that the relief remained in Michelangelo's possession because its patron found the novel imagery too troubling.

The relief borrows freely from the work of Donatello (*c.* 1386–1466), the Florentine sculptor who had produced some of the most moving images of the Madonna and Child. Vasari tells us that Michelangelo actually carved this relief because he wished to 'counterfeit the manner of Donatello'.[23] Donatello was regarded as the great genius of Italian sculpture, though long before his death in 1466 his emotional rawness had gone out of fashion in Florence, to be superseded by the more elegant sculptural solutions of, for example, Desiderio da Settignano and Antonio Rossellino. Michelangelo revived Donatello's method of carving in very low relief (the greatest depth of the *Madonna of the Stairs* is one inch), and his technique of varying the degrees of finish (the background figures left more sketchy than the Virgin in the foreground). Here, the use of low relief, allied to a lack of spatial recession, increases the feeling of highly charged claustrophobia. Bodies and architecture seem to have been squeezed into a narrow foreground strip. What is more, the wafer-thin carving means there is no way we can peer round the side and get a partial glimpse of Christ's face, as would be possible if it were carved in high relief. Our ostracisation is absolute.

Michelangelo has reconfigured a motif that was almost a trademark of Donatello. Its most extreme manifestation occurs in the *Pazzi Madonna* (1420s–30s), a marble relief of the Virgin and Child which is thought to be the first relief ever to have been widely reproduced in stucco.[24] The Virgin embraces her child so that they are virtually forehead to forehead, eyeball to eyeball, nose to nose. Their mighty clinch is filled with tragic foreboding, not least because the motif echoes numerous Pietàs and Entombments, when Mary or other female bystanders embrace Christ's corpse. In subsequent reliefs, Donatello depicted the Virgin gazing at Christ's head from close range. This *mise-en-scène*, which we might term the 'myopic Madonna', was too intense to be of much interest to Donatello's Florentine successors.

Michelangelo borrows the form of the 'myopic Madonna', but completely changes the content. For his Madonna does not eyeball her son, but the putto who leans over the stairs to unfurl the sheet: his head and the long straight line of her nose are only separated by the width of her halo. The halo's edge is abutted and even slightly squashed by the putto's head, as though the halo were a rubber ring. In actual fact, we

can't even be sure she is staring at the putto because perspective tells us that he, and the top of the stairs, should be much further back. Nonetheless, this inconsistency makes her appear even more substantial, by seeming to effortlessly encompass both the foreground and the background.

The net result is to sunder the Virgin from her human surroundings and to set her adrift in a physical and emotional no-man's-land. This is just about the first time in art that the bodies and the gazes of the Madonna and Child are not synchronised or linked in some way. Traditionally, they either look at each other (as Cardinal Dominici recommended); look to the side, or out of the picture, in a similar direction; or Mary gazes at the child while he occupies himself. If the Madonna does not look at the child, then it is usually because she has lowered her eyes deferentially, or is praying, or is looking towards the viewer, thus offering to intercede on their behalf. More rarely, she might look towards saints on her right hand side while the Christ Child blesses saints and donors on the left – in a sort of double intercession. This kind of eye language is well described in a poem addressed to the Venetian painter Giovanni Bellini, where his paintings are praised for their 'venustà col suo guardo benegno' (comeliness and generous glance).[25] The closest we get to the complex body language of Michelangelo's Madonna is in medieval allegorical figures of Charity, where the female figure sometimes looks upwards towards Heaven while suckling a child – the point being that charity involves love of God as well as love of one's neighbour.[26] But Michelangelo's Madonna is not looking up to Heaven, and she wouldn't need to anyway as God is by her side.[27] In the *Madonna of the Stairs*, Michelangelo forces us to consider whether and how the Madonna is fulfilling her maternal role. And if she is not fulfilling it, does this mean that she is in some way betraying it?

These anomalies have been explained away by saying that it is an 'experimental' and unfinished work by a young artist in his late teens. Yet although some of the minor details, particularly of the putti, are a bit confused and perhaps even unfinished, there is nothing accidental about the overall conception of the relief: it is densely packed with highly sophisticated theological and artistic allusions, and still manages to be utterly haunting. It attests to Michelangelo's own moral and intellectual ambitions and to those of the milieu in which he operated. What is more, the precise nature of the relationship between the Virgin and her son and the viewer continues to be a key issue in subsequent works.

★

IN 1492, LORENZO DE' MEDICI died and was succeeded as effective ruler of Florence by his twenty-one-year-old son Piero (1471–1503), for whom Michelangelo did some work. In 1494, however, Charles VIII of France invaded Italy to lay claim to the throne of Naples, and when his troops reached Tuscany, Piero panicked and made huge concessions. This was the catalyst for an uprising in Florence, and Piero was forced to flee, ending around sixty years of Medici rule. A republican government was immediately established, in which Savonarola played a leading part. Sensing the gravity of the situation, Michelangelo had fled a month before Piero's expulsion first to Venice, and then on to Bologna, where he carved three small figures for an incomplete shrine containing the relics of St Dominic, the founder of the Dominican Order. In 1496, after a brief return to Florence, he left for Rome, where he remained until 1501.

In Rome, Michelangelo began the unfinished panel painting the *Manchester Madonna* (mid-1490s). Here the Madonna's facial expression is more serene than in the *Madonna of the Stairs*, and her breast is fully bared to the viewer, but she still looks away dreamily and there is no direct contact between her and her child. Indeed, she is seated on a rocky outcrop and Christ perches precariously on the intricate folds of her dress that spill over its raised edge.[28]

The Madonna fails to look at the Christ Child in either of the two unfinished marble tondos (circular reliefs) of the *Madonna and Child with the Infant St John* (*c.* 1503–5), which were both made after Michelangelo's return to Florence in 1501. In the version known as the *Taddei Tondo*, the Christ Child scuttles headlong along the front of the relief, from left to right, having been frightened by a bird held by the infant St John. Christ's arms are outstretched to grab his mother, who sits on the far right and looks impassively towards St John on the left, and perhaps even touches his cheek with her right hand. But this hieratic Virgin seems more attentive to her child's persecutor. As she makes no attempt to raise her left arm so that she can embrace Christ, he may just overshoot her. In the second relief, the *Pitti Tondo*, the hefty Madonna does indeed hold the Christ Child as he leans nonchalantly on an open book that rests on her lap. But she still seems aloof, seated on a stone cube and looking over her shoulder into the distance. Indeed, even the book acts as a kind of barrier between her and the child: it juts out from her midriff, shielding her like a stray piece of plate armour, its harsh geometry picking up that of her stone seat.

The completed panel painting the *Holy Family* (probably 1504 or 1506; the *Doni Tondo*, Plate 7) rivals the *Madonna of the Stairs* in its intellectual ambition and complexity. It was commissioned by the Florentine merchant Agnolo Doni (1474–1539), probably on the occasion of his marriage to the fifteen-year-old Maddalena Strozzi. Here, the relationship between the Virgin and Christ Child is more synchronised, but no less disconcerting. Mary, Christ and Joseph are intricately and grandiosely linked together. Yet the cost in terms of comfort and joy is colossal. Mary sits on the ground in typical 'Madonna of Humility' fashion, with a closed book on her lap, yet she has to twist her powerful upper body right round and back in order to receive the Christ Child who is being passed to her over her shoulder by Joseph. Her husband squats behind her with splayed haunches, like an elderly samurai. For the only time in Michelangelo's work, the Madonna and Child make eye contact, yet how strained and precarious this meeting is. The *mise-en-scène* looks almost as contrived as a politician holding a baby, and the tondo has been called 'an exercise in gymnastics'.[29] Mary has to yank her head back and up: the whites of her eyes can never have been so prominent, and they seem all the more glaring because they are echoed in the marmoreal white highlights that bleach huge expanses of her rosy red dress. The background scene, with its athletic group of male nudes leaning louchely against a continuous band of jagged rock, and the child on the far right peering at the Holy Family from behind a stone parapet, contributes to the neurotic intricacy of the image. The whole composition is bathed in glaring, almost shadowless light.

Various antique and biblical sources have been suggested for the motif of the child on the Madonna's shoulder,[30] but these are only loosely analogous to Michelangelo's panel, and they do little to dispel the suspicion that the work is primarily a formal exercise, a brilliant showcase for artistic ingenuity. Yet there is a non-biblical religious source that is not only very similar formally, but which also infuses the tondo with profound meaning. Several aspects of the composition recall depictions of St Christopher,[31] a Christian saint and martyr (Fig 2). He was described in the *Golden Legend* as a Canaanite of huge stature who carried the poor and weak across a great river, and thus became the patron saint of travellers.[32] One night he carried a child who grew heavier with each step. This turned out to be Christ, who informed him he had been carrying the weight of the world on his shoulders. His cult was particularly strong along rivers like the Arno that were prone to floods.

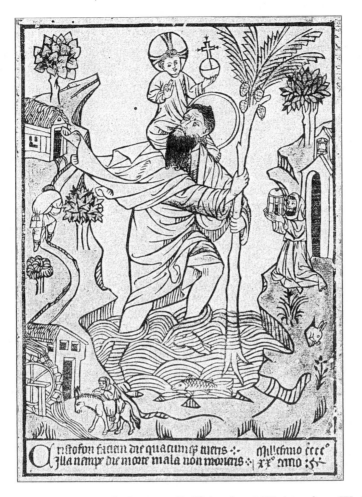

Fig. 2: Anonymous South German, *St Christopher*, 1423 (woodcut, Warburg Institute)

By looking at St Christopher, of whom colossal images were often placed on bridges and at the entrance to churches and houses, it was believed you would be preserved from sudden death or misfortune for that day. In many depictions, St Christopher twists his head round to look up at the heavy burden on his shoulder, and Christ sometimes holds or sits on a globe (here the rotundity of the tondo, with its elaborate frame, suggests Christ's global mission).[33] Michelangelo's Madonna has bare arms, and this unprecedented innovation, together with the gesture of the uplifted right arm, are common in depictions of St Christopher.[34] Often, the saint's arm is raised at an acute angle because he is holding his

13

staff. Michelangelo's Mary has the fingers on her raised hand half-clenched, and this gesture can only be understood if we think of her as holding an imaginary staff.

There are also suggestions of the presence of a river. The Virgin's blue cloak, with its Gothic-style angularity and bulk, swallows up and weighs down the bottom half of her body as if it were submerged in a mighty torrent, and the channel behind the parapet in which the child (undoubtedly St John the Baptist) stands up to his shoulders is probably meant to be a river. The nudes in the background would then be sinners waiting for purification in, and passage across it.[35] Because of his strength, St Christopher was also the patron saint of athletes, and this helps to explain why Michelangelo's nudes are exclusively male. The most telling feature, however, is the infant St John, who would one day baptise Christ. His role as an onlooker (he gazes up at Christ) and his position at the far right of the composition is almost identical to that of a hermit who converted and baptised Christopher, and who is found in numerous depictions.[36]

Michelangelo may have been encouraged to devise this unprecedented composition because his patron Agnolo Doni came from a family of dyers. Christopher was also the patron saint of dyers (dyers needed reliable and plentiful supplies of water, and so would have wanted to feel they had Christopher-like mastery of the river). The Doni family lived along the Corso dei Tintori, near Santa Croce, a marshy area filled with the slum dwellings of the dye workers. At the river's edge there was a wharf: perhaps the stone parapet in the *Doni Tondo* is an allusion to it.[37]

Michelangelo's incorporation of this symbolism – and sex change – would be purely academic if the story of St Christopher did not have a bearing on the meaning of the tondo. But it does have relevance. It makes the parenting of Christ seem more momentous and weighty than ever. In sacred terms, the Christopher motif underscores the heroism of the Holy Family in general, and of Mary in particular, by signalling the gravity of their responsibility as the earthly parents of Christ, and her giant-like strength. But in human terms, the awkwardness of her position, and the vertiginous height of Christ, suggests that motherhood must be a huge burden, even for a Madonna as virile as this. Once again, it confirms Michelangelo's resistance to the idea of intimacy and tenderness between the Madonna and Child: to this end, we should bear in mind that Christ and St Christopher were complete strangers before that brief encounter on the river, and that they never met again – in this

life, at any rate. By this visual metaphor, Michelangelo radically reduces our sense of the amount of time that the Virgin Mary spent nurturing Christ. Here Mary is a human bridge over which Christ speedily advances, rather than a provider of cocooning shelter. By remaining slightly above and beyond, this Christ Child insists on his independence and prepares for his eventual isolation on the cross.

THE REMOTENESS OF Michelangelo's Madonnas is of a different order from the Madonnas of his predecessors and contemporaries. While some were concerned to make their art more monumental, none was so resistant to maternal sentiment.

Michelangelo's radical complication of the Virgin's relationship with her son, with bystanders, and with us, the viewers, is crucial to his development as a Christian artist. Right from the start he questions the right of anyone to get a reply. Before Michelangelo, the Virgin functions as a glorified nurse, nanny, hostess, agony aunt, agent, marriage guidance counsellor, fairy godmother and switchboard operator all rolled into one. With many lavishly endowed shrines, the Virgin Mary is the one to whom most prayers are addressed; she is the one who intercedes with her son on the behalf of sinners; she is the least likely to forsake mankind. The Madonna of Impruneta, whose shrine was six miles outside Florence, was celebrated for her miraculous ability to fix anything – keep the rain away when required, bring the Florentines victory in battle, alleviate plagues, and give correct political counsel.[38] Her votive image, which was believed to have been painted by St Luke, was carried into the city at testing times. A list of books owned by the Florentine sculptor Benedetto da Maiano, recorded at his death in 1498 and one of only two artists' inventories to survive from the Renaissance, includes 'A book of the miracles of Our Lady, bound with a leather cover'.[39] Benedetto has been proposed as a candidate for having taught Michelangelo sculpture after the death of Bertoldo in 1491.

The affability of Michelangelo's Madonna cannot be taken for granted: she might not answer our prayers, and she might not get us on the list for Heaven.[40] Above all, she seems strangely disengaged from her son. Michelangelo's revamping of the Virgin's image was in fact part of a broader reappraisal of her role and character undertaken before and during the Reformation.

The best way of understanding this role change is by examining an image of the Virgin made by Leonardo da Vinci shortly after his return

15

to Florence from Milan in 1500. Here, uniquely, Leonardo showed an awareness of an alternative, more bracing convention, in which the Virgin does not automatically intercede. But he neatly side-stepped the issue. In 1501, Isabella d'Este, Marchesa of Mantua, made one of her many unsuccessful attempts to procure a painting from Leonardo, and she communicated with him through her agent, Fra Pietro da Novellara, the head of the Florentine Carmelites. In a letter, dated 8 April, Fra Pietro describes a small cartoon of the *Virgin and Child with St Anne* on which Leonardo was then working. St Anne, the mother of Mary, was an important figure in the art of the fifteenth and early sixteenth centuries, for as the Church was now asserting that the Virgin Mary had herself been immaculately conceived, it was all the more necessary to show that her own mother was a woman of unsullied character.[41] According to Fra Pietro, St Anne has an extremely exalted but severe role in the composition, which is far from that of the indulgent grandmother. The Christ Child is shown leaving the arm of the Virgin to seize a lamb, which he embraces:

> The mother, half rising from St Anne's lap, is taking the Child to draw it from the lamb, that sacrificial animal, which signifies the passion. While St Anne, rising slightly from her seat, seems as if she would hold back her daughter, so that she would not separate the Child from the lamb, which perhaps signifies that the Church did not wish to prevent the passion of Christ.[42]

Anne's restraining gesture recalls the uncompromising writings of the Dominican St Catherine of Siena (*c.* 1347–80), who was canonised in 1461, and who was partly inspired by her namesake, St Catherine of Alexandria. In her letters, she criticised excessive attachment to relatives, saying they must only be loved 'for the love of him who created them', and that mothers should prefer their children to die 'rather than offend their creator'. As a key exemplar, she praises the professionalism of 'our sweet mother Mary who, for God's honour and salvation, gave us her Son, who died on the wood of the most holy cross' – thus permitting the divine plan to take its course.[43]

These kinds of sentiment seem to have been particularly prevalent in the 1490s and 1500s. Savonarola insisted on the dignity of Mary's deportment during Christ's Passion, and in 1506, when Pope Julius II was considering a new feast to celebrate Mary's sufferings, he com-

missioned another Dominican, Cardinal Cajetan, to research the subject. Cajetan dissuaded the Pope by arguing that Mary was ruled by reason and would not have swooned with grief at the foot of the Cross.[44] Such attitudes may also have been influenced by a revival of interest in Stoic philosophy. The humanist Angelo Poliziano, who was attached to the Medici household, and who explained to Michelangelo the subject of an early relief, the *Battle of the Centaurs* (*c.* 1492), translated a treatise by the Stoic philosopher Epictetus in 1479 in which the bereaved were urged to be resigned rather than grief-stricken by the death of a wife or child.[45] However, Michelangelo's contemporaries were principally concerned with the Virgin's conduct at the time of Christ's death, rather than during his childhood.

In Leonardo's cartoon, Mary's mother Anne is the rationalist who keeps the show on the road. No comparable drawing or painting by Leonardo survives, though there are two paintings along these lines by one of his followers, Andrea del Brescianino (Fig 3).[46] As such,

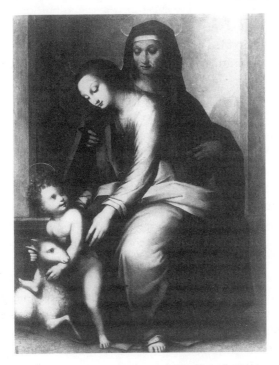

Fig. 3: Andrea del Brescianino, *Virgin and Child with St Anne*, after a lost cartoon by Leonardo da Vinci of 1501 (oil on canvas, formerly Berlin, Kaiser Friedrich Museum)

Leonardo's cartoon might appear to be a critique of his previous pictures in which the Madonna is a whole-hearted Madonna of Mercy, with few obstacles to maternal affection placed in her way. Yet the fact that this motif does not occur in Leonardo's own paintings suggests he could not bring himself to break with old habits. In a later altarpiece of this same subject, painted in around 1508, St Anne makes no attempt to restrain her daughter, and looks approvingly on. Leonardo couldn't bear to cut the Christ Child adrift.

After his return to Florence in 1501, Michelangelo became a keen student of Leonardo's work, and above all of his Anne compositions, which the younger artist assiduously and boldly reconfigured in several drawings. The St Anne in the Brescianino paintings appears to have had a direct influence on the hieratic severity of Michelangelo's *Bruges Madonna* (1504–6; Plate 9), a white marble sculpture which was probably conceived in the second half of 1501, soon after his return to Florence, though not executed until a few years later. It is the most hieratic work Michelangelo ever made. The Madonna is seated bolt upright, with the sturdy Christ Child perched between her knees, one foot gingerly dangling over the edge of an outcrop of rock. Both are orientated towards the front. The Madonna's eyelids droop slightly, as if she were praying. On the face of it, this composition comes within the bounds of convention – earlier Italian artists, including Donatello, depicted the Madonna and Child in a hieratic way. But what is particularly striking is the strong contrast between the two figures. The Madonna's body is stiffly impassive and her face mask-like – and she seems all the more so when contrasted with the mobility and alertness of the child.

Michelangelo must have looked closely at Leonardo's image. The gesture whereby the left hand of Leonardo's St Anne touches the Virgin Mary's hip is echoed by Michelangelo's Madonna in relation to the Christ Child. The way in which Leonardo's Virgin is situated between her mother's thighs is also echoed, with Michelangelo's Christ Child located between his mother's thighs. Yet Michelangelo's Madonna has the same mindset as Leonardo's St Anne, and does not attempt to restrain the Christ Child. She is merely helping him to climb down from the rocky pedestal, entirely naked, to embrace his fate. Indeed, the sharp downward motion even prophesies the moment of Christ's entombment, as though he were 'born astride the grave'.

★

WE HAVE NOW EXPLORED some of the religious ideas that may have sanctioned a less maternal image of the Madonna, but this still does not quite explain why Michelangelo should have been more receptive to these ideas than any of his contemporaries. The answer may lie in his highly personal mythology of stone.

Michelangelo's early Madonnas, with their 'stony' demeanour, are, I believe, the earliest and most decisive manifestation of this mythology. We know from his later poetry that he thought deeply about the metaphorical potential of stone, particularly as it pertained to romantic relations with women: in these poems, the female object of the poet's affections can be as obdurate as a block of marble, making it difficult and even impossible for him to get through to her.

Michelangelo may in part have developed this personal mythology of stone to bolster the moral and intellectual credibility of sculpture. During the late fifteenth century, the 'painter-designer' was in the ascendant through the whole of Italy.[47] Alberti had asserted that the two-dimensional art of painting was 'mistress' of all the arts, while from at least the 1490s Leonardo would claim that painting was both more versatile and universal than sculpture, and more noble because it required far less manual labour. If Michelangelo developed sophisticated ideas about stone, it could have been a defensive measure which made him better equipped to justify his work to himself and to others. His bold and even reckless assertion of the 'stoniness' of the Madonna would become the linchpin of his religious and artistic worldview. It is certainly central to his work's drama.

That's not to say there were no precedents for such ideas. It was customary in medieval hymns and devotional literature to compare the Madonna, largely because of her virginity, to various stony structures such as fortresses, towers or walled cities.[48] Since the tenth century, she had also been identified with Ecclesia, symbol of the Church, and was frequently referred to as a 'reliable column' or as the 'only column' of God's temple able to shelter and support the supplicant.[49] This was the analogy most frequently made in the visual arts, above all in images of the Annunciation, where the Virgin is often juxtaposed with a sup-porting column in a modern interior. Belief in her columnar qualities was encouraged by the fact that a vision of the Virgin Mary on a pillar had appeared to James the Greater, while the thirteenth-century writer 'Pseudo-Bonaventura' made the unlikely claim that she had given birth to Christ while leaning against a pillar in the stable (it is, however, a

feasible labour position). One of the most famous icons in Florence was a statue of the Virgin on a column near the oratory of Or San Michele, which was first reputed to have performed miracles in the thirteenth century.[50] But in the late fifteenth century, these figurative stone columns were understood as slender and elegant columns in the intricate Composite style, rather than primitive, chunky and isolated bulwarks.[51]

In the second half of the fifteenth century, coinciding with the fashion for placing the Madonna and Child in elaborate landscape settings, we also find an increasing tendency to juxtapose them emphatically with rocks and mountains, analogies that can be found in devotional literature. The most celebrated examples are Leonardo's two versions of the *Madonna of the Rocks* (1483–1503; *c.* 1508), large altarpieces both made in Milan for the Confraternity of the Immaculate Conception. The cocooning, canopy-like shape of the Madonna, kneeling on a flower-strewn verge in the foreground, both echoes and contrasts with that of the rocks which loom up behind her. The iconography seems to be based on an apocryphal narrative of the meeting of the Virgin and Child with St John and the Angel Uriel in the wilderness. But because of the friable, fissured and higgledy-piggledy agglomeration of rocks, this geological fantasy can only really give a ruined and savage echo of the serenely self-contained foreground group. This disconcerting rivalry between the Madonna and a rocky landscape can be found in the work of other artists – above all the Mantuan painter Andrea Mantegna (1431–1506), who was the most acclaimed artist in Italy during Michelangelo's formative years. (Lorenzo de' Medici believed him to be the greatest painter of all time.) The human protagonists of Mantegna's paintings are often juxtaposed with classical buildings and sculptures, both intact and ruined, and also with rocky outcrops and mountains. Because of Mantegna's love of antique sculpture, his former teacher accused him of depicting flesh as though it were made of marble, and Vasari endorsed the criticism.[52] But while Mantegna's Madonnas are somewhat austere, they are not especially aloof from the Christ Child or the viewer.

It is Michelangelo who creates the first authentically 'stony' Madonnas. Even if we ignore the fact that three of Michelangelo's four marble sculptures of the Madonna and Child are unfinished, which makes us peculiarly aware of the material from which they are made, we are constantly having our attention drawn to 'stony' aspects of his work – and this is just as true of his paintings as his sculptures. There are the stone cubes on which two of the Madonnas sit, and the curved rock which

cradles the back of the Madonna in the *Taddei Tondo*; the *Manchester Madonna* and the *Bruges Madonna* sit on rocky outcrops and our attention is especially drawn by the Christ Child clambering over them; there is also the stone staircase in the *Madonna of the Stairs*; and a stone wall and rocks in the background of the *Doni Tondo*.

A crucial catalyst for Michelangelo's poetics of stone was, I believe, the distinctly Florentine literary tradition deriving from Dante's *rime petrose* (stony poems), a celebrated sequence of four long poems which were probably written shortly before he embarked on the *Divine Comedy* (*c.* 1306–*c.* 1320). These poems are especially relevant to Michelangelo's Madonnas because they are addressed to a woman of quasi-divine beauty. It is her indifference to the poet that makes her a 'donna petrosa'. The poems were primarily circulated in the plentiful manuscript copies of Boccaccio's *Life of Dante* (1351), to which they were appended, along with eleven more of his longer poems. This selection formed the basis of the collection of great Tuscan poems sent by Lorenzo de' Medici to Federigo d'Aragona, the son of the King of Naples, in 1476.[53] In the same year, Lorenzo had begun his unsuccessful attempt to have Dante's remains repatriated from Ravenna. The *rime petrose* had a wide influence, above all on Petrarch, who often wrote about his beloved Laura as a *donna petrosa*. Michelangelo venerated Dante throughout his life, and addressed two of his own poems to him. When he stayed in Bologna for about a year after the fall of the Medici in 1494, he is said to have read every evening to his patron Giovan Francesco Aldovrandi passages from Dante, Petrarch and Boccaccio – only stopping when his employer fell asleep. By the end of his life, Michelangelo was regarded as an authority on Dante, and in 1519, when the Florentine Academy petitioned Pope Leo X for the remains of Dante to be returned to Florence from Ravenna, Michelangelo offered to erect a 'worthy monument' for the 'divine poet' in a prestigious location in Florence.[54]

Before writing the *rime petrose*, Dante had been a leading protagonist of what was known as the *dolce stil nuovo* (sweet new style), a Tuscan variant of courtly love poetry. In courtly love poetry the beloved is often a surrogate Madonna, a model of virtuous beauty.[55] Many of Dante's poems are addressed to his beloved Beatrice, and both before and after her early death, when she appears to him in dreams, she is for the most part the epitome of gentleness and grace, and the source of all salvation. At the end of the *Paradiso*, Dante is torn between looking at the Virgin Mary and Beatrice, who has been his guide through Heaven.

The *rime petrose* made a radical break with the *dolce stil nuovo*, because of the unusual ferocity of their form as well as their content. They were addressed to a woman who is as pitiless as she is beautiful, and were written in a style characterised by extremely harsh rhythms and sounds. The most anguished of these poems begins with the statement:

> Così nel mio parlar voglio esser aspro
> com'è ne li atti questa bella petra (Canto III, 1. 1–2)

[I want to be as harsh in my speech as this fair stone is in her behaviour.][56] This has always been compared to the moment in the thirty-second canto of the *Inferno* when Dante descends to the great lake of ice in which the shades of traitors are frozen, and he fears that words may fail him. He says he needs words that are 'aspre e chiocce' ('harsh and rough') in order to describe what he sees. It is 'no joke', he says, and certainly 'né da lingua che chiami mamma o babbo': 'no task for tongues that cry mummy or daddy'. Although Michelangelo would scarcely have considered the Madonna a traitor (consciously, at any rate), he did present her in his art as someone whom we cannot imagine indulging in, or responding to, baby talk.

The *rime petrose* each contain several verses of great formal complexity. They function through repetition (with slight variations) of a few stock similes, most of which revolve around the stoniness and coldness of the poet's beloved. She is always wintry even in summer, and her coldness petrifies the poet, turning him into a living statue. At times, the poet wishes he could fight back by being harsh (*aspro*) in his speech, but no arrow could ever penetrate her body, which is armed with jasper. It is a reversal of the Pygmalion myth, for here female flesh becomes stone, rather than vice versa. In the end the relationship – or non-relationship – seems almost masochistic:

> Ahi angosciosa e dispietata lima
> che sordamente la mia vita scemi,
> perché non ti ritemi
> sì di rodermi il core a scorza a scorza . . . (Canto III, 1. 22–5)

[Ah, agonising merciless file that hiddenly rasps my life away! Why do you not refrain from so gnawing my heart through layer by layer . . . ?] This imagery would be taken up by Petrarch, albeit in rather slicker

terms, and he even at one point quotes Dante's line where he wishes that his own speech may be as harsh as his beloved.[57]

When Lorenzo de' Medici sent his anthology of poems to Federigo d'Aragona, the poet Angelo Poliziano wrote an introduction outlining the history of Tuscan poetry. He explained that Federigo would notice a gradual process of refinement, a rejection of the 'ancient roughness' (*antico rozzore*) from which even the 'divine' Dante was not always immune.[58] Poliziano would later suggest the subject of Michelangelo's unfinished early relief, *Battle of the Centaurs* (*c.*1492), but Michelangelo was trying to reject elegance both of form and of content. In this, the *rime petrose* would have been an important precedent for him.

Not everyone in Medici circles was as cautious about poetic language as Poliziano. The philosopher Giovanni Pico della Mirandola, in a formal letter written in 1484 in praise of Lorenzo de' Medici's own poetry, said that it combined the elegance of Petrarch with the roughness of Dante – 'horridus, asper et strigosus, rudis et impolitus' (uncouth, rough, lean, raw and unpolished).[59] Lorenzo's poetry was a happy medium. Far more whole-hearted and widely known was the vindication of Dante by Cristoforo Landino, a highly influential Latin scholar and philosopher who championed the use by contemporary writers of vernacular Italian.[60] Landino saw the logic of Dante's 'rime aspre e ghioccie'. He gave a favourable gloss to the thirty-second canto of the *Inferno* in his extensive commentary to the first Florentine printed edition of the *Divine Comedy*, which was published in 1481 with woodcut illustrations based on drawings by Botticelli, and dedicated to Lorenzo de' Medici. Landino explains that the true poet adapts the form to the content: he must always 'paint' his subject-matter with vivid words so that it is present to the mind's eye. In the same way that harsh language is suited to a dreadful subject, so too there have to be rocks in the last circle of Hell as they are appropriate to this 'sad hole'.[61]

In the 1490s, there was a concerted effort in Florence to tailor the language of religious texts and sermons to the audience, the vast majority of whom were uneducated. The sermons of Savonarola were famously direct and confrontational, and eschewed the rhetorical flourishes and circumlocutions used by his humanist contemporaries. He reflected on his innovative practices in a Lenten sermon of 1496: 'I started out simply without philosophy, and [the learned] went complaining that I preached simply. Yet these sermons bore fruit among simple people, whom it was necessary to teach first.'[62] Such language was meant to have greater

authenticity and force, and to correspond to the language of the Old Testament patriarchs and the Church fathers.

These defences of raw language, both secular and Christian, were to help shape the poetry of Michelangelo. No poems by Michelangelo survive from the 1490s, but Condivi claims that Michelangelo had begun to write sonnets even before the death of Pope Alexander VI in 1503. Many of his poems were self-consciously unpolished – he claimed that his poetry was 'non professo, goffo e grosso' ('rough and clumsy, not that of a professional', no. 85). Some of them, written in the 1530s, were addressed to a 'beautiful and cruel lady', and he says that 'in its harsh hardness the very stone in which I model her resembles her' (no. 242). In his most famous poem, which begins with an assertion that 'the greatest artist does not have a concept which a single piece of marble does not itself contain', he compares the difficulty of carving a block of marble with the difficulty of getting mercy from his lady.

In another poem from around 1540 (no. 156), he complains about his lady's quasi-mountainous inaccessibility: it is impossible to ascend the 'long, steep road' which leads to her 'high shining crown', and so he insists she reach down to him 'with humility and kindness'. Although he delights in her exalted beauty, he also desires her to descend to his level. He concludes with a paradox: he hopes she will forgive herself for having been the cause of his 'loving [her] state as low and hating it as high'. His thoughts are iconoclastic for in wanting to make her descend to his level, he risks destroying the very thing he loves. Michelangelo's own Madonnas are the products of a similar conundrum. We can see them clearly, but they could hardly be said to be lowering themselves to our level, or to have the remotest intention of doing so. This is why we may feel slightly uneasy about them.

In his early years, Michelangelo was not only fascinated by 'ancient roughness' in literature; he was also fascinated by its manifestion in the visual arts. Thus even before carving the *Madonna of the Stairs*, when he was still serving his apprenticeship in the studio of Domenico Ghirlandaio, he made drawings of figures in frescos by Giotto (1267–1337) and Masaccio (1401–28) – painters who were, together with the sculptor Donatello, among the most robustly monumental of earlier Florentine artists.[63] The most eerily impressive is a recently discovered drawing of a woman which may be loosely based on a figure of a mourning woman by Giotto (Plate 3).[64] The woman stands up straight, facing left, with her head slightly bowed and her arms crossed on her chest with the left hand

swung up so that she can adjust her head-dress. She is cowled from head to foot with her face in almost complete shadow. Alberti, in his treatise *On Painting*, praised a picture by the Greek painter Timantes showing the *Immolation of Iphigenia*, in which various levels of grief were depicted in the bystanders. Timantes despaired of depicting the extreme grief of Iphigenia's father, and so 'he threw a drape over his head and let his most bitter grief be imagined, even though it was not seen'.[65] Michelangelo's woman is presumably meant to be covertly grieving too, and was perhaps drawn as a studio exercise using a classical subject. Yet the draperies of this awesome power-dresser have an impregnable cragginess that makes her seem like a praying mantis, or a giant crab lurking within its shell, protected by claw-like arms. She might almost be a member of the Inquisition praying for the soul of a heretic being burnt at the stake rather than a woman mourning a dead child.

This sinister sentinel is just as disconcerting as Michelangelo's early representations of the Madonna. One is reminded of a story related by Vasari about how the young Michelangelo reworked a drawing of some draped female figures by one of Ghirlandaio's apprentices: 'Michelangelo took that drawing and with a thicker pen outlined one of those women with new lineaments, in the manner that it should have been in order to be perfect.'[66] The thickness of the pen makes for a kind of impenetrability.

Those seeking a biographical explanation for the daunting women in his early work do not have far to go. In the biography written by his studio assistant Ascanio Condivi, which was published in 1553, we learn that as a baby Michelangelo was sent to a wet-nurse who was both the daughter and the wife of stonemasons, and that he used to say that breast-feeding from such a woman had given him his propensity for sculpture.[67] Vasari embroidered this in the second edition of the *Life of Michelangelo*, saying that the great man joked that he 'sucked in' with his nurse's milk the chisels and hammer with which he makes his figures.[68] Michelangelo may have both exaggerated and revelled in the harshness of his upbringing because of the early death of his mother, when he was only six years old. The slightly grotesque notion that he sucked in sculptor's tools with his nurse's breast milk not only evokes the pain he may have experienced in early childhood, but may also reflect an early determination to inure himself to pain – and a retrospective pride that he succeeded in doing so.

It was by no means uncommon for babies to be sent to wet-nurses,[69]

but Vasari showed disapproval for just this kind of practice in his *Life of Raphael*, Michelangelo's great rival and the paragon of the courtly artist:

> Since Giovanni [Raphael's father] knew how important it is to rear infants, not with the milk of nurses, but with that of their own mothers, no sooner was Raffaello born . . . than he insisted that this his only child . . . should be suckled by his own mother, and that in his tender years he should have his character formed in the house of his parents, rather than learn less gentle or even boorish ways and habits in the houses of peasants or common people.[70]

Michelangelo's contemporary, the historian Jacopo Nardi (1476–1563), subsequently wrote in his *History of the City of Florence* (1553) about the genteel upbringing of Florentine children in his youth: 'As an adolescent I saw fathers and mothers confiscating anything like a weapon from their sons' rooms in the interest of good discipline and of checking their wildness.'[71]

The fact that Michelangelo showed such pride in his ungenteel nurture, which furnished him (both metaphorically and literally) with a sculptor's 'weapons', suggests that the idea of the *donna petrosa* was central to his own sense of self as well as to his art. It also highlights how the tradition of the *donna petrosa* could blur class distinctions, in so far as the intransigent woman cannot always be distinguished from the uncouth and unrefined woman – and vice versa. Indeed, Michelangelo's wet-nurse is a more successful version of the allegorical figure of Statuary who appears in an autobiographical satire, the *Vision*, written by Lucian (born AD 120), one of the most popular classical authors during the Renaissance.[72] Lucian recounts a dream he had as a boy when he was wondering whether to follow in his ancestors' footsteps by becoming a sculptor. Two women approach him, grab him by the arms, and try to take him with them by pulling him in opposite directions. One woman is the beautiful and elegantly dressed Culture, and the other is the Art of Statuary – 'a working woman, masculine looking, with untidy hair, horny hands, and dress kilted up'. They each try to persuade him to come and live with them. Statuary promises him 'wholesome food and good strong muscles', but speaks in a strange, stumbling way. Young Lucian is easily persuaded by the greater eloquence of Culture, and the promise of a softer life. He goes off with Culture, and her beaten rival 'stiffened, like another Niobe, into marble'.[73] Michelangelo, however, was proud to have been fed by a living equivalent of Statuary.

Another aspect of the *donna petrosa* that seems to have been relevant to Michelangelo in his early years is the idea that she can be as cold and white as snow. Dante writes:

> Similemente questa nova donna
> si sta gelata come neve a l'ombra;
> ché non la move, se non come petra,
> il dolce tempo che riscalda I colli,
> e che li fa tornar di bianco in verde
> perché li copre di fioretti d'erba. (Canto I, 1. 7–12)

[This young woman stays frozen like snow in shadow; for the sweet season moves her no more than stone, the season that warms the hills and turns them from white to green, covering them with flowers and grass.]

The young Michelangelo was commissioned to make a snow sculpture by Piero de' Medici. A rather bewildered Condivi tells us that 'a great quantity of snow fell in Florence, and Piero de' Medici, Lorenzo's eldest son, who had taken his father's place but lacked the grace of his father, being young, wanted a statue of snow made in the middle of the courtyard. He remembered Michelangelo, sent for him, and had him make the statue.'[74] It rarely snows in Florence but snowfall lasting a whole day is recorded on 20 January 1494, so this is when the incident must have occurred. The snow was about two feet deep, and in some places where the wind had driven it, anything up to six feet, and lasted for about a week.[75] Condivi thought the snow sculpture demonstrated the patron's philistinism. But in a note recording Michelangelo's corrections and objections to Condivi's text, Michelangelo is said to have denied this. Vasari, in his revised edition of his life of Michelangelo, incorporates the incident, and may have taken Michelangelo's revisions on board, for he does not criticise Piero and says that the statue was very beautiful.[76] It is quite likely that the making of a snow sculpture would be taken seriously by all concerned especially if they were steeped in the tradition of the *donna petrosa*. Poliziano had, after all, written a Latin epigram addressed to a snow maiden: 'You yourself, virgin girl, are made of snow, and you play with snow. Carry on playing, but before your dazzling whiteness perishes, make sure that your hard frigidity perishes.'[77] We are not told the snow statue's subject, but it may well have been an ice queen Madonna seated on a rocky 'plinth'.[78] Indeed, in Florence there was even a lay confraternity of Santa Maria Della Neve,

a reference to a miraculous snowfall in Rome that had marked out the ground plan of Santa Maria Maggiore.

THE GREATEST OF ALL Michelangelo's stony Madonnas is the St Peter's *Pietà* (1498–9; Plate 5). This sculpture was commissioned by a French cardinal, Jean Villier de la Grolaie, probably for his tomb in the Chapel of St Petronella, the patron saint of the French in Rome.[79] Flanking St Peter's, it was a late classical circular mausoleum which Condivi claimed was built on the site of a Roman Temple of Mars (the chapel was demolished when work began on the new St Peter's, and the *Pietà* was eventually transferred to a chapel there).

Michelangelo's first major commission for a religious sculpture was his first great public success. The scene of the *Pietà*, in which Christ's corpse is placed across his distraught mother's knees, is not mentioned in the Bible, and was a medieval invention.[80] Part of its attraction was that it was a sad counterpart to images of Mary holding the Christ Child, and the dead Christ was often reduced to child-like proportions to emphasise this analogy. Although Florentine painters in the 1490s – above all, Botticelli – had tackled the subject, no large marble *Pietà* had been carved in Italy in the whole of the fifteenth century.[81] Yet it was a popular subject for sculptors as well as painters in France and Germany, and the patron may well have been reflecting French taste in his commission.

Michelangelo, however, introduced a novel feature by reducing the age of the Madonna to that of a young woman. The sculpture won great acclaim when it was installed in the Jubilee year of 1500, which brought pilgrims flocking to Rome in huge numbers, each staying for the fifteen days which Pope Alexander VI decreed it would take to have their sins absolved. But there were complaints about Mary's age, and the issue remained so controversial that sixteenth-century copies of the sculpture made her look less alluring by furnishing her with a fuller and more tired face. Even these revised versions were sometimes regarded as obscene, presumably because of the languid beauty of Christ's body, and the way in which he is enveloped by the over-life-size Virgin.[82] Some may also have felt that the knees of the Virgin were raised too high, the legs too far apart, and that the deep gorge in the draperies between them was a little too suggestive. Leonardo probably gave the consensus view when he observed in a different context that in women and girls 'there must be no actions where the legs are raised or too far apart, because that

would indicate boldness and a general lack of shame, while legs closed together indicate the fear of disgrace'.[83]

The Virgin had been extolled as the 'bride' of Christ since the twelfth century, and identified with the 'beloved' of the Song of Songs. Vasari quotes a poem written in praise of the marble copy of Michelangelo's sculpture made for the cathedral in Florence which concludes 'Unica Sposa sua, Figliuola, e Madre' (His only wife, daughter and mother). This announces the universal nature of Mary and Christ's relationship. But it was unprecedented for anything more than the maternal role to be expressed in a *Pietà*, and evidently many were shocked by this intimate depiction of two beautiful young people, one of whom was naked but for a slinky loincloth and, although a corpse, remarkably intact. Indeed, the veins on Christ's lithe body still seem to course with blood – ostensibly signs of Christ's imminent resurrection.[84] When Condivi asked Michelangelo to explain his innovation several decades later, he gave the following elaborate reason: 'Don't you know that women who are chaste remain much fresher than those who are not? How much more so a virgin who was never touched by even the slightest lascivious desire which might alter her body?'[85]

The similarity in age of the Virgin and Christ makes much more sense, however, if we take into account Michelangelo's characteristic way of depicting the Madonna and Child. All of Michelangelo's Christ children are physically as well as psychologically precocious, endowed with athletic physiques. The implication is that these Christ children leapfrog childhood 'innocence' and expand vertiginously towards manhood – and towards death on the Cross. It also serves to reduce slightly the apparent age difference between Christ and the Virgin. Michelangelo's desire to accelerate Christ's development appears to be carried over into the *Pietà*: here Mary may still be young not so much because virgins don't age, but because Christ has developed so fast. It would be understood as a kind of natural magic. Henry Cornelius Agrippa, in his book *The Vanity and Uncertainty of the Arts and Sciences* (1530), says that magicians

> very often bring out the things that are prepared by Nature before the time that She appointed for these effects to be produced. These are commonly taken to be miracles but for all that they are no more than natural works, nothing else coming into it than the speeding up of time, as if a man in the month of March should produce roses, ripe

grapes or beans or make parsley seed grow within a few hours into a perfect plant.[86]

Michelangelo's Christ lies on his mother's lap like a perfect plant that has bloomed, and been plucked, in the month of March. Hence the Virgin's thick, warm clothing.

But there is an undeniable sexual charge. The strongest artistic precedent for a beautiful young woman holding Christ's naked body occurs in a Botticelli *Pietà* (*c.* 1495), in which it is one of the three Marys who cradles Christ's head. What may have added fuel to the critics' fire when Michelangelo's *Pietà* was first unveiled in 1500 is its similarity to a salacious episode found in the second and final part of *Hypnerotomachia Poliphili*, a romance which was published in a luxurious illustrated edition in Venice in 1499, but possibly written as early as the 1460s and subsequently revised.[87] The author is generally thought to be Francesco Colonna, a Dominican friar from Treviso who gravitated to Padua and then Venice. The woodcuts are by an unknown artist who was probably in Mantegna's circle. The romance is a first-person account by a young lover called Poliphilo of a dream in which he searches for his lost love in a landscape which is strewn with astonishing ruins of antique buildings and sculptures. It has been described as unique in fifteenth-century Italian literature because of the proliferation of strong women characters – it represents the 'irresistible triumph of woman'.[88] At the climax of this racy dream narrative, we find a pseudo-*Pietà* in which the sacred and the profane are combined in a provocative way [Fig 4].

The two protagonists are the hero Poliphilo, and his beloved Polia who is so beautiful that she can't help looking at her own reflection in a mirror, which makes her fear she might suffer the fate of Narcissus.[89] Poliphilo's advances have been repeatedly rejected. He writes several passionate love letters to her but she has taken vows to serve Diana, the ultra-chilly goddess of chastity. Polia ignores him as any self-respecting *donna petrosa* would. The scorned lover complains: 'my writing and my words were as wasted as if I had addressed them to a marble statue'. She was 'unmoved and rough as stone . . . frozen more stiffly than the Arcadian Styx'.[90] After finding her in Diana's sanctuary, he becomes so distraught that he collapses senseless on the ground and appears to be dead. Even when he is lying at her feet, she does not relent. As Polia herself describes it: 'There was not the slightest vestige of pity in me, for my determined will was imprisoned in my cruel and stony breast as

Fig. 4: Francesco Colonna, *Hypnerotomachia Poliphili*, 1499 (woodcut illustrations, Warburg Institute)

surely as the stone in that sacred tomb.'[91] She merely drags the body into a corner of the temple and leaves quickly without getting help: '. . . as I took my solitary flight my heart remained hard and intractable, my mind unyielding . . . my icy breast frozen harder than the crystal of the northern Alps . . . or as though I had looked into the frightful mirror of Medusa'.[92]

But on her way home and during the night, Polia is assailed by dreadful visions and dreams, and wakes up the next morning in floods of tears. She regrets her cruelty and returns to the 'sacred basilica'. She goes to the place 'where, like a wicked undertaker, I had stowed Poliphilo', and tightly embraces his body, which is 'cold and frigid as hard marble'.[93] But as she hugs him 'closer and closer', he starts to revive, and their embraces become more impassioned − until finally, she exposes her breasts and 'we joined and wound ourselves in amorous embraces like the intricately convoluted serpents around Hermes's caduceus, or the entwined rod of the divine physician'.[94] However, they are rudely interrupted by the High Priestess.[95]

Two woodcut illustrations accompany this episode, and if they were combined, they would give a crude approximation of Michelangelo's *Pietà* (though Poliphilo is clothed). The first woodcut shows Polia kneeling over Poliphilo's 'corpse', with her arms opened wide; the second shows her sitting on a large stool, embracing Poliphilo as he lies stretched out across her widely spread thighs.[96] When Polia had first embraced him, she prayed for the return of his soul − which, as we subsequently learn, 'had been carried up and led into the divine presence, before the high throne of the divine Lady Mother'.[97] This refers to Venus, but it is Venus in a Virgin Mary role, as intercessor. So the mischievous hijacking of the *Pietà* imagery is quite deliberate.

It is unlikely that Francesco Colonna and Michelangelo were aware of each other's activities, though not impossible. Michelangelo did briefly visit Venice in 1494, when he fled Florence shortly before the fall of Piero de Medici.[98] Even if Michelangelo had known the author, and seen a manuscript, he is unlikely to have got very far with it, as it was written in a difficult prose that was full of neologisms. Analysis of annotations by early readers in the margins of several copies suggests that few finished the text.[99] But it was superbly produced (it is often called the most beautiful printed book of the Renaissance) and the woodcut illustrations were freely borrowed and adapted by numerous artists. Still, the important point is that the idea of both eroticising and classicising a *Pietà*-style scene was 'in the air'.

Michelangelo's *Pietà* makes most sense if we see the Virgin as a slowly defrosting *donna petrosa*. She sits on a rocky outcrop and her pyramidal body, bottom-heavy and draped in deeply furrowed robes, has a mountainous presence (Michelangelo would probably have told his patron that these rocky features alluded to the names of Petronilla and San Pietro). The strap that passes diagonally across the Virgin's chest, and on which Michelangelo inscribed a Latin signature, makes her even more formidable. It recalls the quiver strap worn by the goddess Diana.[100] It has been said that the folds of the Virgin's cloak 'flood down like a waterfall',[101] but this simile is too suggestive of rapid movement. Her cloak is more glacier-like, and the marble has been given a very high polish. Not everyone has appreciated her appearance. The neo-classical critic Francesco Milizia complained in 1781 that Michelangelo's Virgin had the build of a washerwoman, and that her draperies were a huge muddle.[102] Yet it is the tumultuous bulk of her body and draperies that heightens the sense of exposure to which Christ's body is subject. Not only do the Virgin's capacious clothes suggest that it is cold (much too cold to be naked), but Christ's wonderfully smooth skin is precariously placed on a promontory of rough and angular-looking fabric.

Milizia also complained that the Virgin's expression is 'a zero', and that she shows no pity. More recently it has been said that 'hardness and plainness work at the expense of feeling'.[103] The Virgin certainly sheds no tears and her face is a mask. Indeed, she even recalls certain fifteenth-century Italian images of Narcissus in which he is a beautiful boy sitting by a pool with parted knees, outstretched arms and a drooping head. Michelangelo's Virgin-Narcissus looks blankly at her own reflection in the shiny rock-pool of her lap. But here, the slight bow of the Virgin's diminutive head (it seems tiny in relation to her body) and the downward tilt of her outstretched hand, gesturing weakly to the onlooker, do suggest that an emotional subsidence of some significance is taking place. What Michelangelo offers us is a tantalising vision of a moment when an iceberg begins to melt.

THE DIFFICULTY WAS TWOFOLD – how to depict the Madonna as someone who puts duty before personal and maternal feelings without making her seem callous and unsympathetic; and how to give her a more withdrawn and reduced role in the life of Christ without appearing to discredit the cult of the Virgin.

Humanists had already questioned the idea that gods should be, so to

speak, on tap. Alberti wrote a satirical dialogue about religion in the style of Lucian which was included in his collection of *Dinner Pieces* (early 1440s). One of the protagonists observes that the gods have better things to do than listen to the entreaties of foolish mortals: 'Engaged in such great matters, the gods have little time to listen to the interminable, futile, and utterly ridiculous prayers of men. And if the gods paid attention to trivial matters, they would more gladly listen to the pure voices of cicadas and crickets than to the foolish entreaties of impure men.'[104] He makes the gods sound both flippant and utterly disdainful of the practice of prayer. An awareness of the absurdity of the intercession industry is implicit in a religious drama performed by a Paduan lay confraternity at around this time. The play climaxes with an argument between Christ and his mother in which he complains that she is interfering with his judgments, to which she responds that if she was not allowed to intervene, she would speedily lose her reputation as an intercessor. This was a real problem, for if sacred images or particular saints were believed to have underperformed, worshippers often transferred their allegiance – and in very extreme cases, attacked the image. In 1413, a man who was tried in Valdesa, Tuscany, for incest and for having slashed a painting of the Virgin after losing at gambling, was condemned to be decapitated.[105]

Later in the century the Florentine poet Luigi Pulci (1432–84), who was accused of heresy, made numerous invocations to the Holy Virgin in his scabrous romance *Morgante* (published 1478), about the knights of Charlemagne. It was commissioned by Lorenzo de' Medici's pious mother, Lucrezia Tornabuoni, in the expectation that Pulci would write a paean to the flower of Christian knighthood. At one point, when inspiration is running low, he implores the 'faithful column and gracious hope' to help him tell his story.[106] Near the end of his life, Pulci retracted his writings in a poem in which he appeals *ad nauseam* to the Virgin Mary, but so effusive is it that many have assumed it is satirical, and that Pulci is actually mocking the whole cult of the Virgin. It was published in 1495 as *La Confessione di Luigi Pulci*, with a woodcut frontispiece showing Pulci kneeling before a priest with a disconsolate Virgin in the clouds looking down on him.[107] The church was not convinced by these retractions. At his death in 1484, he was denied Christian burial in consecrated ground as an unrepentant heretic.

Even Leonardo da Vinci could be sceptical about the cult of the Virgin, as well as about many other aspects of the contemporary Church.

One of his so-called 'prophecies', which are really satirical riddles, illustrates the paradoxical or hypocritical nature of some Christians: 'Many, who hold the faith of the Son only build temples in the name of the Mother' (*c*.1497–1500).[108]

But the most flagrant attack came from the humanist scholar and religious reformer Desiderius Erasmus (*c*. 1466–1536). Indeed, thanks in part to Erasmus, the cult of the Virgin would be one of the biggest casualties of the Reformation. His new 'realist' conception of the Virgin, which is posited as a robust alternative to the compliant Mother of Mercy is, if anything, even more reprehensible, for she is envisaged as a grotesque manifestation of the *donna petrosa*.

In *A Pilgrimage for Religion's Sake* (1526), the two speakers, Menedemus and Ogydius, are discussing the recent rejection of the cult of relics and saints by Protestants. Times are hard, as the saints have far fewer visits from pilgrims bearing costly gifts. Ogydius knows of a letter of complaint written by the Virgin Mary on this very theme. When Menedemus asks him to identify which particular Virgin Mary he is referring to (because she has so many different shrines), he answers that it is Mary a Lapide (Mary of the Stones) at Basle. The letter written by this 'stony saint' sheds interesting light on Michelangelo's own approach to the Virgin. The letter begins:

> From Mary, Mother of Jesus, to Glaucoplutus: greetings. Know that I am deeply grateful to you, a follower of Luther, for busily persuading people that the invocation of saints is useless. Up to this time I was all but exhausted by the shameful entreaties of mortals. They demanded everything from me alone, as if my Son were always a baby (because he is carved and painted as such at my bosom), still needing his mother's consent and not daring to deny a person's prayer; fearful, that is, that if he did deny the petitioner something, I for my part would refuse him the breast when he was thirsty. And sometimes they ask of a virgin what a modest youth would hardly dare ask of a bawd – things I'm ashamed to put into words. Sometimes a merchant, off for Spain to make a fortune, commits to me the chastity of his mistress . . . A gambler cries, 'Help me, blessed saint; I'll share my winnings with you!' And if they lose at dice, they abuse me outrageously . . . If I refuse anything, they protest at once, 'Then you're no mother of mercy.'[109]

Now, however, thanks to Martin Luther's attacks on the cult of the saints, Mary of the Stones receives no honours from pilgrims, which is even worse than being badgered by them. She complains that they are now threatening to 'remove from the churches whatever belongs to the saints', but she warns that they are not defenceless – Paul has a sword; Bartholomew a knife; George a spear; and Anthony has sacred fire. And however defenceless she is, they will not be able to eject her 'unless at the same time you eject my Son whom I hold in my arms'. Either 'you expel him along with me, or you leave us both here, unless you prefer to have a church without Christ. I wanted you to know this. Think carefully what to answer, for my mind is absolutely made up.' The letter is signed the 'Virgin a Lapide', from 'our stony house'. Here, it does not seem to be love that makes her reluctant to leave her son, but self-interest. Erasmus' Virgin is the *donna petrosa* at her most Machiavellian.

Michelangelo had been trying to develop a Madonna who was not a glamorous Mother of Indiscriminate Mercy, but was made of sterner stuff. Yet it was difficult not to make the Madonna's stoniness seem either heartless or immoral. In 1549, an anonymous critic, having seen a copy of the *Pietà* in Santo Spirito, Florence, accused Michelangelo of obscenity and of making 'Lutheran caprices' which undermine faith and devotion.[110] The critic may have felt it was in the same vein as Erasmus' satire – a heretical reimagining of the Virgin's character and of her relationship with her son.

For Michelangelo, with his deeply pessimistic view of social relations, there had never been much possibility of running innocently to Mamma. When he later came to depict Mary in the *Last Judgment* (1536–41: Plate 26), instead of showing her grandly imploring her son (which he did in a preliminary drawing), he shoe-horned her unceremoniously into the narrow slot beneath Christ's right armpit. She is withdrawn and dis-engaged and, in a striking role reversal, her legs and arms are pulled up almost into a foetal position. Her face is impassive and unseeing, her head bowed and turned aside. Her body is cocooned from head to ankle in a thick chrysalis of clothes that are bleached with icy white highlights. The dutiful Vasari wrote that she was a beautiful Madonna of Mercy, but she is far too turned in on herself for that.

2. Giants

JOY: My body is huge and very strong.
REASON: Virtue, foremost among all things, does not need a massive body,
but dwells in the mind.

<div align="right">Petrarch, Remedies for Fortune Fair and Foul, completed c. 1366[1]</div>

It is better that one's stature be a bit smaller than the average, rather than
larger; because men with vast bodies are often of dull wit and unsuited to
those exercises of agility which are necessary for the courtier.

<div align="right">Castiglione, The Courtier, 1528[2]</div>

[With design] the artist will be able to make figures taller than any tower . . .
and he will find no wall or side of a building that will not prove narrow and
small for his great imaginings.

<div align="right">Michelangelo, quoted by Francisco da Holanda, c. 1540[3]</div>

MORE THAN ANY other great artist before or since, Michelangelo is
associated with figures of superhuman scale and size.[4] The marble statue
of *David*; the Prophets and Sybils on the Sistine Ceiling; the *Atlas* slave;
the New Sacristy 'Times of the Day'; the *Moses* from the *Tomb of Julius
II* and the Christ of the *Last Judgment* – all these and many more appear
to belong to a race of giants. As we have just seen, Michelangelo even
endows the Christ Child with a muscular physique, making him seem
impossibly precocious.

Michelangelo regarded the creation of large-scale figures as one of the
principal concerns of the artist. But in his own estimation, the most
prestige seems to have attached to the creation of large-scale statues.
Their successful completion was one of the sternest challenges, not only
aesthetically but practically, because of the huge investment of time,

money and materials. The largest statues of all were called colossi. Opinions vary as to precisely what constitutes a colossal statue, but in Michelangelo's time they tend to be a minimum of twice life size.[5] At around thirteen and a half feet high, Michelangelo's *David* (1501–4) is almost three times life size, if we consider that five foot was a good height for an adult male. It was the first freestanding colossal statue of a nude figure to be made since antiquity. A bronze statue of the seated Pope Julius II which was installed above the portal of San Petronio in Bologna in 1508, and which was later melted down, was also reputed to have been more than three times life size.[6] Most of Michelangelo's mature statues tend to be around one and a half times life size.

Statuettes, which were such a significant and delightful feature of sculpture from the mid-fifteenth century onwards, and which could easily fit on a table or shelf, are conspicuous by their absence from Michelangelo's *oeuvre* (though he did make a great many small wax and clay studies for larger works).[7] He also carved very few reliefs, a format that had been the basic currency of quattrocento sculpture. There are only four surviving reliefs, all unfinished, all from early in his career. After 1505 he planned several relief sculptures, mostly for larger projects, but never got round to executing them.

Due in part to Michelangelo's influence, more colossal statues were produced in sixteenth-century Italy than at any time since antiquity, and they were often made in emulation of antiquity. Fragments and remains of several antique colossal statues could be seen in Rome, and were described as 'marvels' in guidebooks.[8] Artists were also awestruck by Pliny the Elder's accounts of the numerous colossal statues made in antiquity, such as the Colossus of Rhodes, a 105-foot standing figure of Apollo who held a torch in one hand, and through whose parted legs ships were able to sail. Michelangelo expressed a wish to make a similar work when he spent many months in the quarries at Carrara securing marble for the *Tomb of Julius II* in 1505, which was itself going to be three storeys high and adorned with over forty statues, each at least one and a half times life size. Condivi tells us that Michelangelo toyed with the idea of trumping the Colossus of Rhodes by making a mountain-sized sculpture: 'One day . . . he was looking at the landscape, and he was seized with a wish to carve, out of a mountain overlooking the sea, a colossus which would be visible from afar to seafarers. He was attracted largely by the suitability of the rock, which could be carved conveniently, and by the wish to emulate the ancients.'[9] He may have

intended to carve an image of the Risen Christ, a Christian counterpart to Apollo and an inspiration to sailors who regularly diced with death. Not surprisingly, this proposal came to nothing, and later on Michelangelo said his idea was due to the madness of youth, and that even in four lifetimes he would have been unable to complete it.[10]

The belief that the ancients had created vast statues was also fuelled by the idea that in the past humankind was of greater stature, as well as being much longer lived. The most influential of the early Christian fathers, St Augustine, in *The City of God* (413–26), refers to the frequent discovery in his own day of 'bones of incredible size'. On one occasion he and some friends believed they had found a human molar on the seashore. It was

> so immense that if it had been cut up into pieces the size of our teeth it would, as it seemed to us, have made a hundred. But that tooth I should imagine, belonged to some giant. For not only were the bodies of men in general much larger at that time than ours are now, but the giants far exceeded all the rest . . . Pliny the Elder, a man of profound learning, testifies that as the centuries pass and the world gets older and older, the bodies produced by nature become smaller and smaller.[11]

This belief was still very much alive in the Renaissance. In Alberti's dedication to the architect Filippo Brunelleschi of the Italian version of his treatise *On Painting* (1436), he says he had always believed that nature was no longer producing great intellects – 'or giants which in her youthful and more glorious days she had produced so marvellously and abundantly'.[12] On the Sistine Ceiling (1508–12), the size of the figures in the central narratives tends to increase as the story goes back in time, and so does the size of the accompanying *ignudi*, Prophets and Sibyls, even though they are not placed in any kind of chronological order.[13] The *ignudi* grow from nine to eleven and a half feet high; the Prophets and Sybils from thirteen to fourteen and a half feet.

Yet while size clearly mattered to Michelangelo, there is not always a clear correlation in his work between size and power – or, to put it more precisely, between size and the ability to survive and prosper. Michelangelo was acutely aware of the paradoxical nature of colossal figures. They were certainly imposing, but in cultural and religious terms, they were acutely vulnerable – physically, morally and intellec-tually. Great size not only signified virtue and strength, it could also imply

hubris and incapacity – a body that has overreached and over-exposed itself. To this end, Michelangelo almost always gives his male figures a high centre of gravity, which makes them appear slightly top-heavy and unwieldy. Michelangelo's consciousness of the precariousness of such figures helped him to infuse his statues with psychological drama. The heightened exposure – moral as well as physical – to which large-scale figures are subject was central to their fascination.

The surviving large-scale statues of Michelangelo's early maturity (*Bacchus*, *David* and *St Matthew*) depict famously flawed and complex characters. Bacchus was an ancient god of fertility who could also symbolise mystical rapture as well as sensual intoxication; David was the boy who heroically killed Goliath, but who as a man became an adulterer and murderer; Matthew was a greedy tax inspector before answering the call of Christ. Michelangelo was perhaps the first artist to really explore that complexity. All three statues are visions of excess. Their bodies soar, and lurch, upwards and outwards. The German art historian Heinrich Wölfflin wrote of the *David* that 'the feeling of elasticity in the whole is a perpetual source of wonder'.[14] But the elasticity is not solely physical; it is moral as well. David took himself to the limit in the service of God, while also stretching God's capacity for forgiveness to breaking point. It is this feeling of plenitude – the feeling that these large figures have been infused with unprecedented quantities of moral and physical matter – that makes them at once exhilarating and disturbing.

IN THE VISUAL ARTS, there was a long-standing tradition whereby size was equated with virtue and power. The largest antique statues are of gods, or quasi-gods like Hercules, and emperors. The biggest statue of all, and one of the Seven Wonders of the World, was the Colossus of Rhodes, a statue of Apollo. Christian art took over the ancient sculptural tradition of the colossus but not (except in Byzantium) in order to make freestanding colossal statues, which were dismissed as 'pagan idols'. Rather, Christian artists inserted such figures into multi-figure groups and polyptyches. In medieval mosaics, painting and sculpture, the central figure of God, Christ or of a saint is usually depicted on a much larger scale than any of the other figures. Thus in the mosaic of the *Last Judgment* (*c.* 1270–1300) in the hexagonal dome of the Baptistery in Florence, the centrally seated Christ is at least four times bigger than the flanking angels and saints, and they in turn are far bigger than the sinners in Hell.[15] The actual size of figures in altarpieces, placed nearer the

ground, is always easier to gauge accurately than the size of figures in ceiling decorations. The massive enthroned Madonna in Giotto's *Madonna d'Ognissanti* (*c.* 1310), from the Florentine church of Ognissanti, is about six feet high, and she seems even bigger because the flanking angels are especially small.

In fifteenth-century Florence, the fashion for perspectival composition and naturalistic settings made such hierarchical distortions seem outmoded. Alberti is the only writer in the fifteenth century to discuss colossal statues in any depth, and he had decidedly mixed feelings about them. As a technocrat and an engineer who revered the ancients, the prospect of constructing a colossus was a fascinating one; and in an age that was obsessed with accurate measurement, gauging the size and proportions of large structures was an exciting challenge. But in his treatise, Alberti attacked colossal statues on intellectual grounds. He was suspicious of their singularity, which he regarded as uncommunicative and even anti-social. He much preferred the multi-figure *istoria* (historical narrative) depicted in perspective with a naturalistic setting and lighting: 'The greatest work of the [artist[16]] is not a colossus, but an *istoria*. *Istoria* gives greater renown to the intellect than any colossus.'[17] He would have been objecting to figures like the Christ in the Baptistery mosaic as much as to ancient colossal statues.[18] For Alberti, the *istoria* was the most adept and sophisticated way of expressing social relations, so long as all the figures 'harmonise in size and in function'.[19] Life-size figures were best.[20]

In what may seem like a proviso to his dismissal of colossi, Alberti does subsequently admit that solitary figures can serve a purpose. He writes that 'solitude' may be pleasing 'for one who greatly desires dignity in his *istoria*. The majesty of princes is said to be contained in the paucity of words with which they make their wishes known.' But on the whole he dislikes solitude.[21] In his later treatise on architecture, Alberti often appears sceptical when referring to ancient colossi, and belittles them by saying that he has included accounts of them purely for amusement.[22]

Alberti's suspicion of solitary colossi is borne out by his advice on how to make statues, in his treatise *De statua*. He thinks in terms of mass production by a team of sculptors collaborating together. He offers a precise template of ideal proportions for the making of a statue, and describes a gadget with which 'if you liked, you could hew out and make half the statue on the island of Paros, and the other half in the Lunigiana, in such a way that the joints and connecting points on all the parts will

fit together to make the complete figure and correspond to the models used'.[23]

A crucial point about all these procedures is that they ultimately facilitate the reproduction of statues, and once statues are reproduced, they can be integrated into a larger scheme. The technocrat Alberti particularly admires the way in which the ancients made symmetrical arrangements of identical statues:

> . . . with statues, especially for the pediments of their temples, they took care to ensure that those on one side differed not a whit, either in their lineaments or in their materials, from those opposite. We see two- and four-horse chariots, sculptures of the horses, the commanders, and their lieutenants, so similar to one another that we might claim here that Nature herself has been surpassed; since never in her works do we see so much as one nose identical to another.[24]

For Alberti, one-off colossi seem to have been disruptive elements with a rogue individuality. Their 'solitude' was even potentially seditious. He criticised the way in which wealthy Italian families built watch-towers beside their *palazzi*, and one suspects he believed watch-towers to be the architectural equivalent of colossi.[25] The highest were around 250 feet, but in Florence their tops were lopped off by communal ordinance in 1250. The statement by Michelangelo cited at the beginning of the chapter – '[With design] the artist will be able to make figures taller than any tower' – suggests he saw colossi as rivals to watch-towers.

Alberti's scepticism about size was shared by other Florentine writers. Giants came in for some brusque treatment in Florentine medieval literature. Dante has five giants chained up in the pit of Hell: they include Nimrod, who built the Tower of Babel and, as partial punishment, can now only speak gibberish. Dante is relieved that Nature no longer makes giants, for he believes that no man can resist their combination of malevolent intelligence and brute force. The tricephalous Lucifer, down whose shaggy body Dante and Virgil must clamber, is the biggest and most horrendous giant of all. The mathematician and scholar Antonio Manetti, who wrote a biography of Filippo Brunelleschi, contributed an introductory essay to Landino's 1481 edition of the *Divine Comedy* in which he estimated the heights of the giants (and the size of Hell) using the hints offered by Dante. Manetti concluded, after due consultation with other mathematicians, possibly including Alberti,

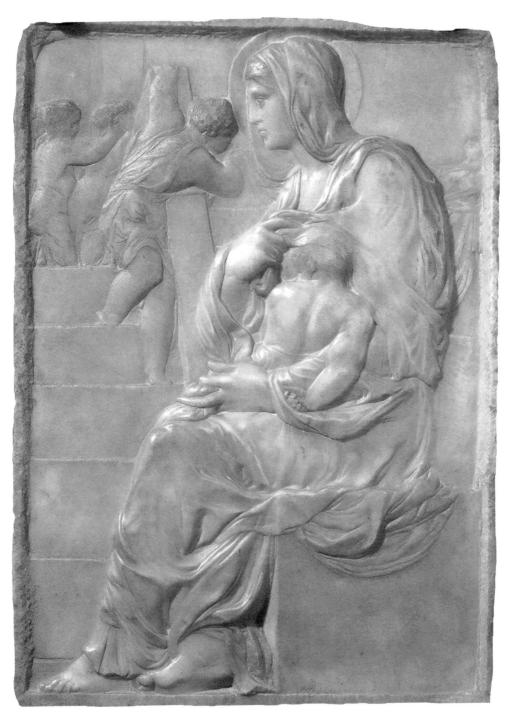

1. *Madonna of the Stairs, c.*1492

2. *Battle of the Centaurs, c.*1492

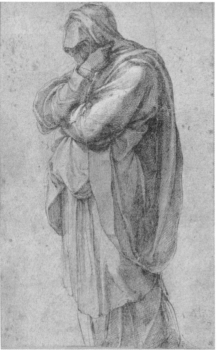

3. *Mourning Woman, c.*1495

4. *Bacchus*, 1496–7

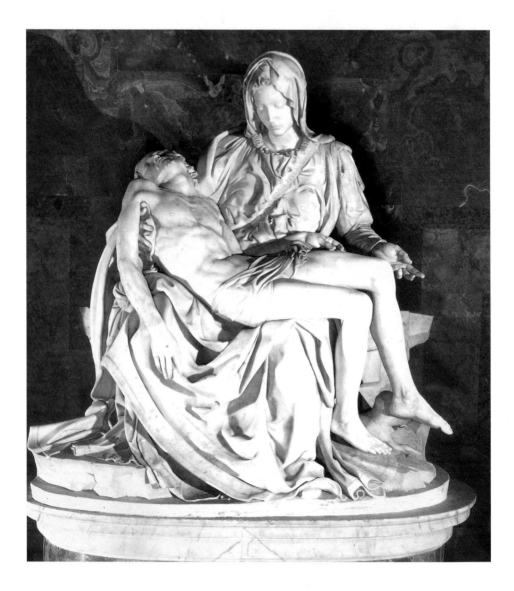

5. *Pietà*, 1498–9

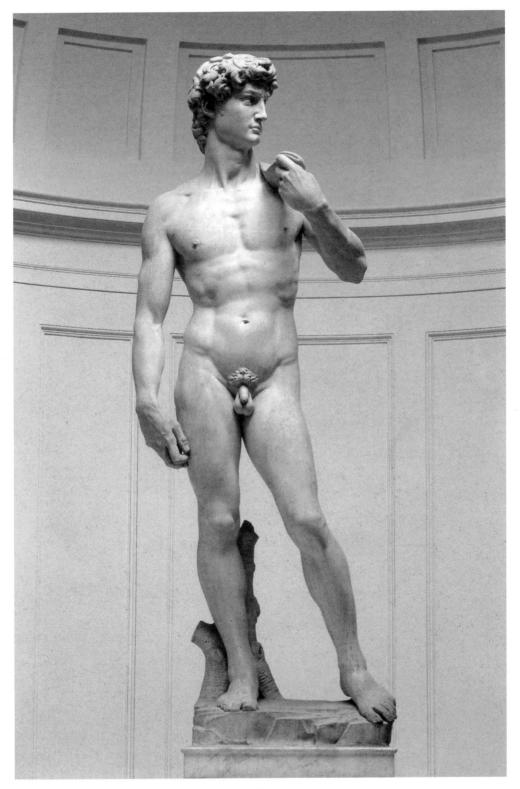

6. *David*, 1501–4

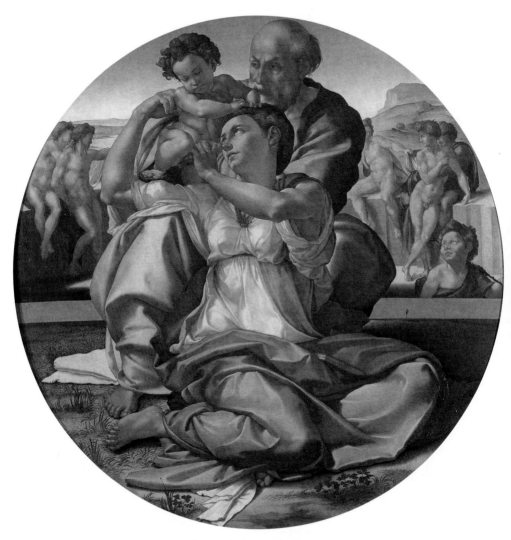

7. *Holy Family (Doni Tondo)*, c.1504–6

8. *Study for the Battle of Cascina, c.*1504

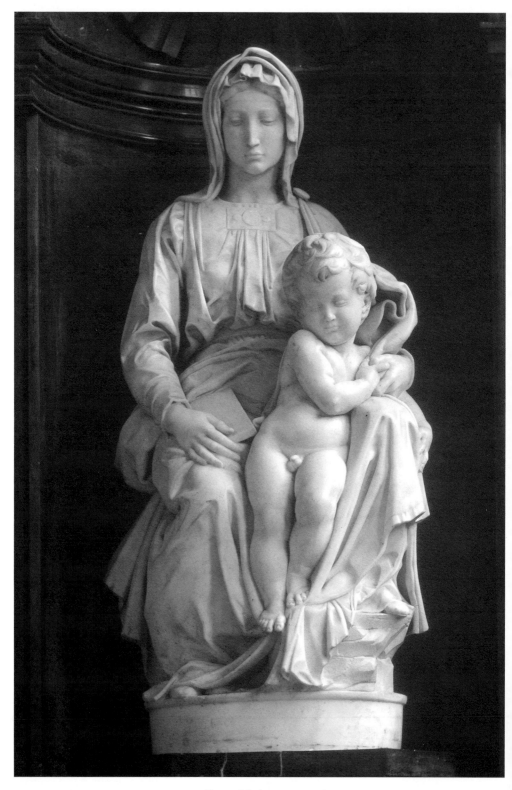

9. Bruges Madonna, 1504–6

that Nimrod must have been around 43 braccia tall (82 feet), and Lucifer a whopping 2,000 braccia (3,833 feet).[26] So much for the Colossus of Rhodes.

The most famous Florentine literary giants appear in Luigi Pulci's hugely popular *Morgante*, which was first published in 1478. This rumbustious epic, commissioned rather naïvely by Lorenzo de' Medici's extremely devout mother, was read by Leonardo and Rabelais, among many others, and partly translated by Byron.[27] Here, the numerous giants are ludicrous killing-machines, and all are pagans except for the jovial buffoon Morgante, who only converts on the basis that the Christian God backs winners. The heroic Christians are of normal stature, since no Christian has ever been 'of gigantic height'.[28]

A partial explanation for this last observation had been offered by St Augustine, who noted that the status and number of giants had declined catastrophically after the Flood. There were more giants before the Flood than in all succeeding periods because God wanted to demonstrate 'that the wise man should not attach much importance to physical beauty or to physical size and strength'. Augustine emphasises this point by quoting the prophet Baruch: 'There were those renowned giants, who from the beginning were men of great stature, experts in war. It was not those whom the Lord chose, nor did he give them the way of knowledge. In fact they perished because they had no wisdom; they disappeared through their lack of thought.'[29] Pulci's own giants rarely survive for more than a canto, and when the fatal blow comes the 'stupid beasts' collapse like towers, castles and mountains.[30] Lorenzo de' Medici was evidently undeterred, for after nearly being killed in the Pazzi conspiracy of 1478, he only ever went out in Florence with an armed escort, at least two of whom were nicknamed after Pulci's giants.[31]

Around 1487–90, Leonardo jotted down a proverb which neatly encapsulates the thorny relationship between size and virtue: 'If you had a body worthy of your virtue,' he wrote, 'you would be too big for this world.'[32] This is both a compliment, and (especially for an artist set on making colossal figures) a warning. In order to be of any practical and worldly use, virtue has to be housed in a body of normal size. A giant body, despite having immense power, would not necessarily be a precision instrument, or indeed at the heart of things. Rather, it would be lifted far above the throng, marginalised in splendid isolation. There would thus be less scope for the practice of public virtues. When the writer Pietro Aretino criticised the artistic licence of Michelangelo's

tallest painting, the 45-foot-high *Last Judgment* (1536–41), he sarcastically referred to him as someone 'who through being divine [does] not condescend to the company of men'.[33] This lofty arrogance contravened the whole spirit of the Christian faith, for its own God had been made flesh and had 'condescended' to the company of men. St Augustine had expressed this concept in the paradox 'exaltation abases and humility exalts'; commenting on a passage from the Psalms he said that 'they were thrown down in the very act of being exalted. The exaltation is in fact already an overthrow.'[34]

In the 1530s, while preoccupied with the *Last Judgment*, Michelangelo wrote a sardonic poem about an unfeeling and unseeing giant. It makes a distinct contribution to Florentine giant literature by combining the awestruck horror of Dante with the knockabout humour of Pulci. Michelangelo was evidently still in thrall to the literary fashions of his youth. The first half of the poem is worth quoting in full:

Un gigante v'è ancor, d'altezza tanta
che da' sua occhi noi qua giù non vede,
e molte volte ha ricoperta e franta
una città colla pianta del piede;
al sole aspira e l'alte torre pianta
per aggiunger al cielo, e non lo vede,
chè 'l corpo suo, così robusto e magno,
un occhio ha solo e quell'ha 'n un calcagno.

Vede per terra le cose passate,
e'l capo ha fermo e prossim'a le stelle;
di qua giù se ne vede dua giornate
delle gran gambe, e irsut' ha le pelle;
da indi in su non ha verno né state,
chè la stagion gli sono equali e belle;
e come 'l ciel fa pari alla suo fronte,
in terra al pian col piè fa ogni monte.

Com'a noi è 'l minuzzol dell'arena,
Sotto la pianta a lui son le montagne;
fra 'folti pel delle suo gambe mena
diverse forme mostruose e magne:
per mosca vi sarebbe una balena;

e sol si turba e sol s'attrista e piagne
quando in quell'occhio il vento seco tira
fummo o festuca o polvere che gira. (no. 68, ll. 1–24)

[Then there is a giant, so tall that his eyes cannot see down to us here below, and he has many times covered and smashed a whole city with the sole of his foot; he aspires to be as tall as the sun and sets up high towers to reach Heaven, but he does not see it, for his body, despite being so robust and large, has only one eye and that is set in one of his heels. He sees near to the ground only what lies behind, and he holds his head firm and close to the stars; from here below one can see that his legs are two days' journey in length, and their skin is hairy; from there on up he feels neither hot nor cold, for the seasons to him are all equally beautiful; and just as he has brought his forehead to the same height as Heaven, so on earth he makes every mountain level with his step. As tiny grains of sand are to us so to him are the mountains under his tread; in among the hairy skin of his legs he carries various large and monstrous forms; a whale there would be like a fly; he is only troubled, only saddened and tearful, when the wind carries into that eye smoke or bits of straw or dust blowing about.[35]]

The giant is accompanied by a revolting old crone who suckles him, and supports him in his 'arrogant' and 'blind' endeavours. Yet Michelangelo is not without tender feelings towards this brute. A paradoxical mixture of power and impotence, the giant is of extraordinary height yet cannot even see the marvellous things which his great height should permit him to see. Another pair of giants in an allegorical poem from the same period (no. 67) are so tall they have blinded themselves by gazing into the sun.

The Cyclopean eye that is inconveniently located in the giant's heel is the equivalent of an Achilles' heel. This also recalls Morgante who, after triumphing in innumerable battles, ends with a bathetic whimper rather than a bang: he strides ashore after killing a whale, only to be bitten on the heel by a tiny crab, and the wound proves fatal.[36] Michelangelo's own giant figures do not entirely escape what we might call their genetic inheritance. However heroic, they too often have an Achilles' heel which threatens to unbalance and even to topple them. While writing his poem, and while planning the *Last Judgment*, he may have been thinking of the fall of the giant Nimrod, builder of the Tower of Babel. Exaltation goes hand in hand with an overthrow.

★

MICHELANGELO's *Madonna of the Stairs* suggests he was fascinated by the idea of the colossal right from the beginning of his career. The Madonna, seated on her block of stone, looks enormous in relation to the architectural setting and to the putti. Both vigilant and aloof, she is what we might term a 'watch-tower' Madonna. Although her profile is classical, her outsize scale in relation to her immediate surroundings recalls medieval art. Similar disparities would be engineered by sixteenth-century artists when they drew antique colossi in Rome, for they routinely increased the disparity between statues and bystanders.[37] At the turn of the century an attempt was even made by the Paduan humanist Pomponius Gauricus to develop a systematic hierarchy of size for sculpture. In his treatise *De sculptura*, published in Florence in 1504, Gauricus recommends different sizes for different types of sculpture. Portrait busts should be life size; statues of kings and heads of state one and a half times life size; heroes, such as Hercules, twice life size; and gods should be three times life size.[38] Gauricus' concern to prescribe a clear hierarchy of scale is far more redolent of medieval art than of anything he might have found in antique art or literature. Thus the widespread interest in colossi at the end of the fifteenth century was not simply a rediscovery of a classical sculpture type. It was equally a revival of interest in medieval art. But Michelangelo alone treats superhuman scale as the basis for compelling moral drama.

The first large statue that Michelangelo is recorded as making is a lost marble *Hercules* (1493), which was just over life size.[39] It was made while he was in the service of Piero de' Medici, but it is not known for certain whether he was the patron. The statue could not be considered a colossus, but in comparison with most quattrocento representations of the hero, it must have seemed enormous. It was certainly a vast undertaking for an eighteen-year-old sculptor. Hercules was an important symbol of Florence, signifying virtue, fortitude and even reason. Since the late thirteenth century, his image had appeared on the great seal of the city, together with an admonitory inscription: 'The club of Hercules subdues the depravity of Florence'.[40] There had been two attempts to make large-scale statues of Hercules to be placed on the buttresses of Florence Cathedral, but the first had not been made, and the second (in terracotta) may not even have been installed and cannot have survived for long.[41] Otherwise, all the surviving sculptures of Hercules are statuettes and small reliefs. This is partly because artists often tended to

make cycles of images showing some of the Twelve Labours of Hercules, and this was obviously easier to do on a small scale. Michelangelo would later depict three 'labours' of Hercules side by side on the same piece of paper in a presentation drawing made not long after his statue of the hero had been exported to France in 1530. Unfortunately, we know nothing for certain about the appearance of the statue, because it disappeared in the eighteenth century and no clear visual record survives.

Michelangelo's earliest surviving statue represents the drunken wine god *Bacchus* (1496–7; Plate 4), made during his first stay in Rome. The height of the whole statue, including its 'rocky' base, is just under seven feet. In terms of height, the *Bacchus* is not an inordinately large statue for its period, but it feels far larger because of its wayward body language, which seems to claim a vast amount of ambient airspace.

Wine was a suitable subject for garden sculpture as it was associated with abundance and fertility, while drunkenness was often interpreted by pagan and Christian writers as being akin to mystical rapture.[42] Michelangelo's Roman patron Cardinal Raffaelo Riario, one of the most powerful men in Rome, must have hoped to receive a statue that emphasised the elevated nature of Bacchus' inebriation. But this god of wine represents the kind of depravity that we can imagine Hercules knocking on the head with his club.

Condivi, appreciating the lack of mysticism in the 'rapture' of Michelangelo's statue, later interpreted it as a public warning about the demon drink: 'Over the left arm he has the skin of a tiger, which animal is dedicated to him because of its great delight in the grape; and Michelangelo made the skin instead of the animal to signify that he who lets himself be lured to that extent by the senses and by the craving for that fruit and its liquor ends by giving up his life to it.'[43] This explanation may have been a retrospective justification, but it certainly helps explain the statue's brutality and coarseness. It evidently came in for some rough treatment early on. Before 1530 both its penis and the goblet had been broken off. Only the goblet was restored.

The statue was rejected by Cardinal Riario, and it ended up in the sculpture garden of the banker Jacopo Galli, who provided financial services to both Riario and Michelangelo. Cardinal Riario had probably intended to display the statue alongside his own important collection of antiquities, which included two antique colossi.[44] Galli also had a sculpture garden, so the setting was similar to the intended one. Yet Michelangelo's *Bacchus* is far more eerily sensuous and unbalanced than

any antiquity. Condivi said that the sculpture was inspired by antique literary descriptions of the god, and these would have undoubtedly left a great deal to Michelangelo's imagination. The figure rejects outright both the taut harmony of classical *contrapposto* and the lyrical sway of Gothic art.

Bacchus holds up a goblet in his right hand, and loosely grasps a tiger skin with his left. He is completely naked, reeling in a state of wine-fuelled inebriation, his eyes rolling blearily, vaguely focused on the goblet. His parted lips, which expose the teeth, give him a slightly sinister expression, and look forward to a similar motif on the severed head of Medusa in Cellini's *Perseus and Medusa* (1545–53). Bacchus wears a 'wig' made from grapes and ivy: wine has literally gone to his head. Diagonally behind his left leg huddles a young satyr, who steals some of the grapes which slip out of the god's left hand. The contrast between the diminutive satyr, coiled up into itself, and the plumply sprawling Bacchus increases our sense of the statue's scale still further.

The jagged rocky outcrop makes his stance seem all the more precarious. That Michelangelo got the sculpture to balance is a near-miracle since the undercutting of the marble is exceptionally daring, almost reckless. The slithering asymmetry of the deity's pose makes it hard to remember the lineaments of his body with any precision. He looms up before us, a fleshy apparition glimpsed in a distorting mirror. In Castiglione's *The Book of the Courtier* (1528), one of the speakers follows Plutarch in comparing great men who become corrupted to colossi which are 'badly counterbalanced inside, and placed on an uneven base, so that they fall over by their own weight'.[45] Michelangelo delights in making Bacchus teeter on the edge of collapse, in order to show the destabilising nature of excess.

It is not just the pose that points to his warped morality; his physique is inflated too. Bacchus was notoriously effeminate, but Vasari noted that Michelangelo gave him 'the youthful slenderness of the male and the fullness and roundness of the female'.[46] Bacchus' breasts and abdomen are strikingly swollen (as indeed are his testicles). Since the penis was broken off soon after its creation, one presumes this appendage was no shrinking violet either. The anatomical distortions suggest that alcohol is body as well as mind bending.

There is a predatory aspect to *Bacchus'* occupation of space, and his 'reach' appears to extend in every direction. The statue was designed to be circumnavigated, but the viewer's slightly dizzy and wary tour of

inspection becomes a counterpart to the deity's own drunkenness. Fearing it might topple on to us, we are unlikely to walk around the statue in a neat or tight circle. One of the principal attractions of larger-than-life freestanding statues must have been that they do seem to present a real danger to the viewer because of their height and weight: at some level, we are wondering whether Michelangelo's statues are properly stabilised.

THE MARBLE *David* (1501–4; Plate 6) is the tallest statue ever made by Michelangelo. It was commissioned by the Florentine Republic on the back of his success with the St Peter's *Pietà,* with most of the work being completed in around two years. In this work the moral drama of height and scale is expressed in the most striking way possible.

The vast block of marble from which Michelangelo carved the *David* had already been languishing for nearly forty years in the Office of Works of Florence Cathedral. It had been acquired by the cathedral authorities in 1466 for the sculptor Agostino di Duccio. Throughout the fifteenth century, intermittent and somewhat haphazard attempts had been made to place a series of twelve figures of Prophets, as well as of the virtuous pagan Hercules, on top of the buttresses, at roof level, at the east end of Florence Cathedral. It was at least as ambitious a project as Ghiberti's two sets of bronze doors for the Baptistery. But it had foundered because of the difficulty of making sufficiently large and stable statues out of durable but light materials.[47] The only statue that could be seen on the cathedral in Michelangelo's day was Donatello's *Joshua* (1410), the first colossus to be made in Florence. It was made from moulded bricks covered in stucco and painted white, but this technique had evidently proved unsatisfactory, for within three years Donatello and Brunelleschi were planning a never realised statue of Hercules made from different materials. Agostino di Duccio's *David* was initially going to be carved from four pieces of marble, but when a huge block was quarried in Carrara, he proposed to carve the statue from it alone. This he conspicuously failed to do, and the partially carved block was set aside.

According to Vasari, the twenty-six-year-old Michelangelo, who had just returned in triumph from Rome, offered to carve the mutilated block without adding extra pieces, a proposal which had been made by other artists: 'However difficult it might be to carve a complete figure out of it without adding pieces (for which work of finishing it without adding pieces none of the others, save Buonarotti alone, had courage

49

enough), Michelangelo had felt a desire for it for many years back; and, having come to Florence, he sought to obtain it.'[48] Antique sculptures, such as those in the Medici sculpture garden where Michelangelo had trained, were restored by adding pieces, and Michelangelo was in effect refusing to treat it as a restoration job. But equally importantly, multi-part stone statues were likely to be weaker because rain could seep into the joints and corrode the iron dowels.

Michelangelo's *David* was carved in the cathedral workshops, with the finishing touches being added after installation. At some unknown stage the decision was taken to site the statue at ground level. The cathedral authorities may have realised early on that the block was too big and brittle to be 'skied' on the cathedral, and the quality and detail of Michelangelo's carving must have confirmed them in the need for a lower-level site. On 25 January 1503, a committee of experts (mostly artists) convened to decide where to place it, and although most voted for the Loggia dei Lanzi, because the statue would be protected from the elements, it was decided to site it in front of the Palazzo della Signoria in place of Donatello's smaller-scaled *Judith and Holofernes*. The Palazzo della Signoria was the seat of the Republican government, and the resiting of the statue there is often seen to be a triumph of secular over religious values, but in Florence there was no major split between Church and state. Indeed, if anything, the new location marked an intensification of the statue's religious meaning, for it was placed at the corner of the *ringhiera*, a raised stone platform added to the front of the Palazzo della Signoria in the 1320s. This was the most important outdoor shrine in the city, and an altar was frequently set up on it and relics displayed (Fig 5). The man who had the final say in the siting of the statue was probably Piero Soderini. He had been elected Gonfaloniere for life (the equivalent of the Venetian Doge) in September 1502, and to aid the deliberations the Madonna of Impruneta had been brought to the city and placed on the *ringhiera* so that 'God would give the governors the grace to elect someone apt to lead the disturbed city in the path of God'.[49] In its new location, the statue came closer to sacred relics and altars than it ever would have done on a buttress of the cathedral.

It took four days and over thirty men to transport the statue, suspended upright inside a specially designed frame. On 18 May 1504 it was erected outside the Signoria, on a low, plain rectangular pedestal without an inscription. This ground-level location meant that the statue's scale and size impressed itself on the viewer far more than it

Fig. 5: Anonymous, *Burning at the Stake of Savonarola, c.*1500 (tempera on panel, Florence, Museo di San Marco). Detail showing an altar on the *ringhiera* and, on the far right, Donatello's *Judith and Holofernes*, soon to be replaced by Michelangelo's *David*

would have done on the cathedral buttress. It dwarfed the scale of every other Florentine sculpture placed at or near ground level.

The block from which Michelangelo carved his statue was always referred to as *Il Gigante* in cathedral records, and Florentines continued to call Michelangelo's statue by the same name. He was evidently fascinated by the paradox of having a 'giant' statue of a boy who was himself a giant-killer. This is clear from some verses he wrote on a sheet of paper on which he had sketched the arm of the marble *David*, and a study for a bronze statue of *David* commissioned in 1502, but which has not survived. It is the first occasion we know of in which an artist has attached to a drawing a written reflection on it. Michelangelo compared the task of carving the enormous marble block to David's battle with Goliath:

> Davicte cholla fromba
> e io chollarcho
> Michelangiolo

[David with the sling and I with the bow. Michelangelo.] The bow (*arco*) probably refers to the sculptor's drill, which was turned by a bow-like contraption, and which Michelangelo used to carve the deep cavities in *David*'s hair, and to mark the pupils in his eyes.[50] Just as David fought and triumphed over Goliath, so Michelangelo grapples with *Il Gigante*. Yet there is also a sense in which the young sculptor is struggling with the more unpleasant aspects of David's adult character, and that he felt a certain amount of hostility towards him. Other young men certainly felt real hostility towards *Il Gigante*. During the first night of its journey to the Piazza della Signoria stones were thrown at it by four youths.[51] It was customary during carnival for boys to throw stones, and one wonders if they imagined themselves as young Davids assailing a new Goliath.

Thanks to a breathtaking iconographic innovation, Michelangelo made the 'giant' size expressive of the whole man – of David's adult self as well as of his youthful self. In the Bible, David fights Goliath when he is a young shepherd boy. The subject was a particularly popular one in fifteenth-century Florence, for the Florentines liked to think of themselves as underdogs fighting against 'giant' super-states such as Milan. More generally, the boy David was a symbol of righteous resistance, and as such, he was a forerunner of Christ.[52] David's refusal to wear armour was often thought to prove that a person overloaded with armour or clothes (i.e. with material goods) would be impeded in his spiritual fight with the Devil. Christ, too, was said to have fought against the Devil unarmed.[53] The boy David proved conclusively that it was not the race of giants who had been chosen by the Lord. Florentine artists like Donatello, Verrocchio, Ghirlandaio and Castagno all showed David as a lithe boy, posing with the head of Goliath shortly after the fight. Donatello, in his bronze *David*, seems to stress that the story was a triumph of extreme youth over outsized age by placing a relief decoration on the side of Goliath's enormous helmet depicting a triumphal scene enacted by putti. The age of Donatello's *David* is, if anything, *reduced* even further by the presence of the putti.[54]

Michelangelo's *David* depicts an earlier stage in the proceedings, at the moment when he is sizing up his enemy and preparing to throw his sling. Yet he is much older than in any previous representation, a young man with an athletic physique that is pressed upon us unashamedly. While it is true that the narrowness of the marble block compelled Michelangelo to make a flatter and more relief-like image, he exploited this to the hilt, by making the torso as full-frontal as possible. His first act on getting hold

of the marble block had been to denude David. He cut off a knot of marble left by Agostino di Duccio on the chest: it was probably a knot from David's cloak. This naked man's body, with its huge hands, seems to dilate vertically and laterally before our eyes, maximising the amount of naked flesh that is available for inspection.

And what a torso! The full and exquisite depiction of David's nipples, navel and genitals is breathtaking. St Augustine singled out the male nipples as being created for aesthetic reasons alone since they perform no practical function,[55] and Michelangelo is the poet laureate of male nipples. David's nipples are erect, and stand to electro-charged attention. They contrast with the pin-sharp, drilled depths of the navel. In the biblical Song of Solomon, the Prophet's navel is compared by his female lover to 'a round goblet, which wanteth not liquor' (7:2). It would be more appropriate to compare David's navel to a round thimble of liquor.

The striking physiognomy of the genitals seems to mimic and upstage David's profiled nose, furrowed forehead and curly hair. His plump, 'nasal' genitals are surmounted by an elegantly coiffured patch of pubic hair. Even the two-pronged tree stump which supports his standing leg is erotically charged. It is like a hand – consisting of thumb and forefinger – grasping his lower leg (its position is echoed by David's own thumb and finger resting against the thigh of the standing leg). The frankness is almost embarrassing, and we don't even have the giant severed head of Goliath to distract our attention, or to shrink David's scale. The explicitness of Michelangelo's statue was too much for the authorities. It was soon decided to cover the statue's genitals with a garland of twenty-eight copper leaves.

But David is pulled in at least two different directions. The sideways twist of his head is so sharp, and the gaze so intent, that it almost feels as if he has left the rest of his body behind for us to dwell on unobserved. His body has scarcely even begun to turn to follow his eyes: only the left foot has started to twist round. Michelangelo is the first artist to routinely situate the viewer in one of his figures' blind spots. It has been said that the head must have been added 'at a moment when [Michelangelo] was under a totally different kind of inspiration', and that its 'passionate intensity . . . almost conflicts with the waiting substance of the body'.[56] As a result, we are invited as never before in Christian art to feast our eyes on a fully exposed live male torso.[57]

The iconographic innovation of David's physical maturity is as remarkable as the colossal size of the statue. On one level, it may be that

David's belief that he can kill Goliath (with God's assistance) has made him grow in stature. Positive, righteous thinking has given him superhuman powers; size is a state of mind and soul. To this end, the Florence-based philosopher Pico della Mirandola, who belonged to Lorenzo de' Medici's household, had claimed that man could rise up to the level of the gods if he dared to shape his own destiny: 'If man lifts himself to the full height [of mind and soul] he rises higher than the sky.'[58] St Augustine believed that David ushered in a new, more mature era in human history, one that culminated in Christ, the 'Son of David': 'David marks the beginning of an epoch, and with him there is what may be called the start of the manhood of God's people, since we may regard the period from Abraham to David as the adolescence of this race.'[59] Yet by turning him into a virile young man rather than a boy (Vasari thought he had represented David the King) Michelangelo greatly complicated the viewer's response. For David the man is a very different moral proposition. The 'tall', 'towering' David is not simply the brave shepherd; he is also the David who overreached himself on several occasions.

David's physical precociousness is even more radical than when Michelangelo endows the Christ Child with a mature physique. With Christ, it is as though Michelangelo were impatient to bypass childhood altogether, with its charming domesticity, and wanted to make his body ready for great actions and for the suffering of the Passion. In the last chapter I mentioned how magicians were believed to be able to speed up time, so that a seed could 'grow within a few hours into a perfect plant'.[60] But if with Christ Michelangelo attempts to produce the 'perfect plant' in spring, by speeding up the growth of David, he produces the 'imperfect plant'. By catapulting him out of boyhood, he takes him into far more complex and darker psychological territory.

After David's defeat of Goliath, his curriculum vitae gets more erratic. Up to this time he was a fearless harp-playing shepherd, chosen by the Prophet Samuel to be the next leader of the Israelites. But post-Goliath, despite being a brilliant soldier and the King of Israel, he blotted his copybook. Most infamously, he lusted after the beautiful Bathsheba, having spied on her while she was bathing. After discovering her identity, he invited her to his palace where he seduced and impregnated her. David then had Bathsheba's righteous husband Uriah killed so that he could marry her, despite already having several wives. As divine punishment, their first child died young. A second incident was when David danced virtually naked in front of the Ark of the Covenant. As a result, his first wife Michal

'despised him in her heart' and reproached him for uncovering himself in front of the maidservants, 'denuded as if he were a naked madman'.[61] David was furious, and claimed his behaviour was perfectly acceptable to the Lord, whereupon Michal, in one of those arbitrary instances of Old Testament rough justice, became barren. This incident caused a certain amount of embarrassment and defensive justification in the Middle Ages and Renaissance, not least because the modern equivalent – dancing in church – was disapproved of by most moralists.[62]

David's various crimes and his polygamy were roundly condemned by church leaders, and in 1503 the humanist reformer Erasmus attacked his contemporaries for using the example of biblical figures like David and Mary Magdalene to condone their own sins,[63] but his lax morals and flawed character had always made him an object of extraordinary fascination. Petrarch, in the *Trionfo dell'amore* section of his *Trionfi* (1350s–1374), lamented the way in which Love had led David astray:

> Poi vedi come Amore crudele e pravo
> vince Davit e sforzarlo a far l'opra
> onde poi pianga in loco oscuro e cavo (Canto III, ll. 40–2)

[Thus you see how cruel and depraved Love conquers David and makes him do the deed which later causes him to weep in a dark corner.] We know that Michelangelo was reading Petrarch's *Trionfi* in around 1501, because he jotted down a line from the *Trionfo della morte*: 'Death is the end of a dark prison'. At about the same time Michelangelo also wrote a line that describes David's predicament rather well: 'Desire engenders desire and then must suffer'.[64]

The orthodox religious view was that God's forgiveness of David showed that no one should despair of being pardoned.[65] Machiavelli, who hero-worshipped David, noted in a sermon 'Esortazione alla Penitenza' (1525–7) that although David had committed murder and adultery, God forgave him and honoured him 'among the first elect of heaven'.[66] Others thought his crimes proved that 'scandals never come singly', and demonstrated that men should steer clear of women.[67] Antonino Pierozzi (1389–1459), the first prior of San Marco and then Archbishop of Florence, was one of the most revered and widely read religious figures of fifteenth-century Italy. He believed that death (i.e. sin) enters through the eyes, and that if David had not seen Bathsheba, an infinite number of evils and deaths would not have occurred.[68]

Savonarola, who in 1498 was excommunicated and burnt as a heretic in the Piazza della Signoria, had been fascinated by David's mixed character. Condivi later said that Michelangelo had great affection for Savonarola, 'whose voice still lives in his memory', and he studied his published writings closely.[69] He may have heard a sermon on Psalm 73 given in Florence Cathedral at Advent 1493, in which Savonarola argued that David was the archetypal Christian, because Christians are divided into two types – the perfect, who are 'strong of hand and beautiful in appearance' because they strive energetically and have a clear conscience; and the imperfect who, although they have faith, 'still feel the fires of the flesh and of lust, and of other vices'.[70]

In another sermon on the Psalms given in Florence Cathedral on 13 January 1495, Savonarola said it was part of God's grand plan for David to sin, for it enabled him to cleanse the Temple: 'when God allows the head of the organisation to have all sorts of vices including ambition and lust, know that the scourge of the Lord is near . . . God allowed David to sin, in order to punish the people . . . thanks to David's pride, the plague was sent'. He then turned from David to present-day Rome: 'Look and see if Rome is full of pride, lust, greed and simony! Look and see if sins are always being multiplied there.' If this is the case, it means 'the scourge of the Lord, and the renewal of the Church is nigh'.[71]

Michelangelo's little poem – 'David with the sling and I with the bow . . .' – suggests a full awareness of David's chequered career. At first, it may seem surprising and even bathetic for Michelangelo to compare his bow-drill to David's sling, for this tool is not particularly flamboyant. It is far less spectacular than the hammer and chisel. Yet Michelangelo chose the term *arco* because the metaphorical resonance of the archer's weapon was so rich. In classical mythology the bow was an instrument of both love and war. That Michelangelo saw himself as somehow 'shooting' David into existence reminds us (as Petrarch had done) of David's vulnerability to Cupid, the most dangerous of all the antique archers.[72] Michelangelo had carved two marble Cupids in the 1490s, and he refers to Love's 'dannosi e preteriti strali' ('cursed and fatal arrows') in a sonnet of around 1504.

It is unlikely, however, that Michelangelo thought David had only been assailed, and thus shaped, by Cupid's arrows. The militant God of the Old Testament also fired arrows at David. In one of the most anguished Psalms of all, David begs God to stop firing at him in punishment for his terrible sins: 'O Lord rebuke me not in thy wrath;

neither chasten me in thy hot displeasure. For thine arrows stick fast in me, and thy hand presseth me sore' (38: 1–2). Michelangelo's identification with an archer was thus a good way of expressing a range of feelings about David.

Before Michelangelo, Donatello was the only Florentine artist to interpret David in a frankly sensual way, though here the eroticism is seen in relation to Goliath. There is a huge sexual charge to the louchely reflective way in which his *David* (*c.* 1440), clad only in boots and hat, looks down at Goliath's severed, helmeted head. The relationship is intensely tactile, for the wing attached to Goliath's helmet teasingly caresses the inside of David's thigh, while David's foot rests on the side of Goliath's head and is lapped by his bushy moustache. The relief of putti on the helmet suggests the triumph of Love as much as the triumph of Youth. So sensuous is the statue that it is said to reflect a revival of interest in Epicureanism in Florence at that time. It has even been claimed to mirror Donatello's supposed homosexuality and the flourishing sub-culture, in which boys were often idealised by older men.[73] All the same, as John Berger has astutely observed: 'In Donatello's *David* the young man's sex is discreetly in its proper place – like a thumb or a toe. In Michelangelo's *David* the sex is the body's centre and every other part of the body refers to it with a kind of deference, as if to a miracle.'[74]

No representation of David prior to Michelangelo made him appear so isolated, stripped, exposed and expanded. He is shown in a state of vigilant and potent readiness. His head faces sharply away, to stare at an invisible object. But what exactly is this naked man preparing for? Will glory or death enter through his eyes? If we observe *Il Gigante* as a whole, the body as well as the head, we cannot be certain if he is preparing himself for War or Love, for moral victory or disgrace.

THE EROTIC ASPECTS of the statue have been underestimated by most scholars (though not by the makers of tourist knick-knacks). This is because they almost always claim that *David* is inspired by antique and modern representations of Hercules, a symbol of virtue and fortitude (and therefore of the Florentine republic) who was usually depicted in the nude. There certainly are strong formal similarities, and Michelangelo was soon commissioned to make a statue of Hercules as a pendant to his statue of *David*, but this was never completed. Yet Hercules was a popular subject not for his psychological complexity, but for his wide range of daredevil exploits, the Twelve Labours of Hercules.

He is an action man, little more than the sum of the physical challenges which he faces. This had been recognised in antiquity by the Neo-platonic philosopher Plotinus (AD 204–70) in a treatise translated into Latin in 1492 by the Medici-sponsored philosopher Marsilio Ficino: 'Hercules was a hero of practical virtue. By his noble serviceableness he was worthy to be a God. On the other hand, his merit was action and not the Contemplation which would place him unreservedly in the higher realm.'[75] The Paduan humanist Pomponius Gauricus, in his treatise *De scultura* published in Florence in 1504, says that Hercules does not have the same characteristics when he fights Antaeus, holds the sky on his shoulders, and snatches Dejanira, and so different statues will have to be made representing each incident. The different characteristics are different *physical* characteristics. Only later, and largely in northern Europe, do we start to get depictions of Hercules at the Crossroads, torn between Virtue and Vice.[76]

The marble *David* is, I believe, an attempt to make a very different sort of image. It is a composite effigy of the kind that was admired by Pliny, and then (following Pliny) by Alberti and Gauricus. Pliny praises several portrait statues that depict various aspects of that person's character and various events in their lives in the one statue. Most pertinent to Michelangelo's marble *David* is Pliny's account of a statue of Paris, the son of Priam, King of Troy and the most famous lover in antiquity. This statue, made by Euphranor, 'is praised because it conveys all the characteristics of Paris in combination – the judge of the goddesses, the lover of Helen and the slayer of Achilles'.[77] Alberti adds another example of his own, a second portrait of Paris by the painter Demon in which you could see 'the wrathful, unjust and inconstant, as well as the exorable and clement, the merciful, the proud, the humble and the fierce'.[78] Gauricus cites yet another statue of Paris, described by the classical author Statius, in which he is simultaneously shown as a shepherd, judge and lover.[79]

In the *David*, Michelangelo does not represent a single action, as in all those images of Hercules. Instead, he creates a richly composite figure who is both boy and man, warrior and lover, hero and villain, athlete and giant, relaxed and tense. To this end he excludes props that might confine him to a single place and time (his sling is barely visible). The sculpture is thus a prophetic image of a prophet. Michelangelo was a firm believer in astrology and prophecy, and had left Florence in 1494 shortly before the fall of the Medici on the basis of a friend's admonitory dream.[80] In his figures, future motions of the mind and body are

prophesied. They are not so much Janus-faced, looking into the future and into the past, as Janus-bodied. Or rather, their face looks one way, and much of their body points another way – and perhaps more than one way. Literally portentous, their stretching and twisting and flexing catapults a part of the figure away from the present time and place. They thus rupture the surrounding space and their scale seems all the greater.

But whereas the double face of the Roman god Janus allowed him to survey both the future and the past, thus making him omniscient, Michelangelo's figures often seem divided against themselves. The expansion of their physical and mental horizons stretches them to breaking point. They are not quite fully in control. Their body language is, to a degree, wayward, dislocated and truant. St Augustine said that a consequence of the Fall was that man lost control of his genitals, so that they were liable to be aroused of their own accord: the flesh gave 'proof of man's disobedience by a disobedience of its own'.[81] Yet while Augustine locates the disobedience in the male genitals, Michelangelo finds sites of potential disobedience spread throughout the whole body. As such he seems to come closer to a view expressed by Montaigne in his essay 'On the Power of the Imagination' (*c.* 1592), where the penis is far from being the only truant member: 'The same causes that animate that member animate – without our knowledge – the heart, the lungs and the pulse: the sight of some pleasant object can imperceptibly spread through us the flame of a feverish desire. Is it only the veins and muscles of that particular member which rise or fall without the consent of our will or even our very thoughts?'[82]

Nonetheless, Michelangelo's image of David can be seen as truthful, rather than disrespectful. A powerful and sometimes rogue sexuality was an intrinsic part of David's character – and therefore of his meaning. In this respect, Michelangelo's attitude towards David would be similar to that of the religious reformer John Calvin (1509–64), who adored David, believing that the virtue that most singled him out was not his perfection (for he was far from perfect) but his honesty, because of his capacity for contrition: David begs for forgiveness in several of the Psalms.[83] The vast size, scale, solitude and nudity of Michelangelo's statue expressed the Old Testament prophet's penchant for absolute disclosure. It is a confession as well as a celebration in stone. After the turmoil of recent years – the expulsion of the Medici in 1494; the burning of Savonarola in 1498 – this was a highly appropriate symbol for Florence, and one that could 'lead the disturbed city in the path of God'.

★

IN 1503, WHEN MICHELANGELO was still engaged on the marble *David*, he received a commission to carve twelve marble apostles for Florence Cathedral, each almost twice life size. Because of huge pressure of work, he made little progress with the project, and then in 1505 was summoned to Rome by Pope Julius II to work on his vast tomb-cum-mausoleum. When in 1506 work on the tomb was suspended, Michelangelo fled in disgust back to Florence, and it was only then that he started to carve one of the apostles, *St Matthew* (*c.* 1506; Plate 10). However, at the end of the year Michelangelo was forced to go to Bologna to make peace with the Pope and the statue remained unfinished. Even so, it has become one of his most celebrated works, both because its incomplete state gives us an insight into his working methods, and because its twisting pose and massive musculature ushers in a more convulsive phase of Michelangelo's work. Here, the trauma of God's summons has all but dislocated Matthew's body.

Michelangelo started carving from the front, finishing off the raised portions first, before working his way backwards. Matthew's bare left knee and thigh are the most highly finished sections and project furthest forward. The left leg is tucked under, with the (uncarved) foot presumably meant to rest on a raised dais or step. The bare knee is thrust forward, as though testing the air, while the bearded head squirms upwards and backwards. The catalyst for this expressive pose is often said to be the discovery in Rome in January 1506 of the classical sculpture *Laocoön*, which Michelangelo was apparently one of the first to see. It showed the Trojan priest Laocoön, flanked by his two sons, being killed by sea-snakes as divine punishment for warning his countrymen about the Trojan horse. All three are naked.

It is surely no accident that of the twelve apostles, Michelangelo chose to begin with Matthew. For Matthew was another flawed biblical giant, twinned with David. Like David, Matthew had sinned grievously, but repented, and was forgiven. His great sin was to work as a tax collector. According to the standard compilation of saints' lives, the *Golden Legend*, Matthew was part of a triumvirate of great penitent (and literate) sinners that included Paul as well as David. He exemplified the sin of avarice, and they the sins of pride and lust. In Florence, Matthew was the patron saint of the Money Changers' and Bankers' Guild. Michelangelo's *Matthew* clasps a large book in his left hand and scholars are divided over whether Michelangelo has shown the moment when Christ first

summons Matthew (in which case he would be holding tax records), or when he receives divine inspiration for the writing of his Gospel. We shall never know – and it is quite possible that Michelangelo intended us not to know.

We must be cautious about interpreting an unfinished work, yet one can't help feeling that the moment of conversion is what interested Michelangelo most, and determined the form and content of the statue. This was the most controversial moment in Matthew's life. For many biblical commentators, the most remarkable thing about Matthew's call-up was the speed with which he obeyed Christ's summons. Although Matthew was doing his accounts, he got up immediately, 'not fearing his superiors though he left his accounts unfinished'.[84] Yet some commentators queried this version of events, finding it absurd that someone would immediately follow the Saviour, 'as if without rhyme or reason they followed anyone who called them'.[85]

Matthew's critics may have been comparing his reaction with the more measured response of the Virgin Mary to the news that she is carrying the Son of God in her womb. She passed through various mental stages when the Angel Gabriel suddenly flew into her home (St Luke 1: 26–38), which were neatly itemised in a sermon given by Fra Roberto Caracciolo da Lecce, and published in Venice in around 1495: Disquiet, Reflection, Inquiry, Submission, Merit.[86] Leonardo criticised those artists who overemphasised Disquiet. In such pictures (and he was probably thinking of Botticelli) the angel seemed to chase Mary out of the room, 'and Mary, as if desperate, seemed to be trying to throw herself out of the window'.[87] Michelangelo's Matthew is imbued with some of the characteristics of an annunciate Virgin – so much so that the position of the book and the step on which Matthew stands recall the lectern into which the Virgin backs in works such as Botticelli's *Annunciation* (1489–90), painted for a Florentine church. The way Matthew clings to his book, almost concealing it, and the way his massively muscular right arm forms an impassable, vertical barrier, suggest a continuing determination to keep hold of it. He is perhaps 60 per cent Disquiet, and 40 per cent Inquiry.

The most striking indicator of Matthew's confusion is his lack of feet. One critic has said that the feet stand 'as though in thick mire'.[88] In actual fact, Michelangelo has scarcely even begun to delineate his lower legs, and has barely left room for the feet. It is almost as though Matthew had been vanquished by the two Ethiopian sorcerers who in later life he

is said to have thwarted: their spells deprived their victim 'of the functioning of his limbs'.[89] The sudden presence of the divine has simultaneously electrified and paralysed him. Even his massive right shoulder and arm seems oddly inert and even detached from the torso, as though it were a flying buttress that has come adrift from the structure it is meant to support. Hanging down vertically, it is a repoussoir prosthetic limb that menaces Matthew as much as it protects him.

The painter Delacroix was probably thinking of a work like *St Matthew* when he observed: 'It seems that when [Michelangelo] makes an arm or a leg, he only thinks of this arm and of this leg.'[90] Michelangelo never made a multi-part statue, but this kind of traumatic autonomy of limbs means that his statues are pervaded by the idea – or threat – of dismembered multi-partness. Heads, too, often get displaced from the body by a violent twist.

Matthew stands at the crossroads, his legs buckling, his arm separating, his head lifting off in a cloud of beard. He could go in any direction. His body is a clumsy obstacle as much as a powerful enabler. The point of giving Matthew such a heroically scaled body is not simply to suggest that he is capable of performing great deeds; a giant body is also a body of which we can never be in full control. As Castiglione noted, men with vast bodies are 'often unsuited to those exercises of agility which are necessary for the courtier'. When Raphael, as an aspiring artist in Florence in around 1506, drew Michelangelo's *St Matthew,* he tried to give back to the apostle some of his self-possession. He stabilised him by straightening the left leg, and made him hold his right arm away from his body, so that it gestures rather than hangs there inertly. Overall, Raphael's Matthew appears to be more slightly built; he can thus possess more of the agility that Castiglione deemed necessary for the courtier.

3. Bodies

. . . [Michelangelo] was constantly flaying dead bodies, in order to study the secrets of anatomy, thus beginning to give perfection to the great knowledge of design that he afterwards acquired.

Giorgio Vasari, *Life of Michelangelo*, 1568[1]

. . . [Bernini said that Michelangelo] had more art than grace, and for that reason had not equalled the artists of antiquity: he had concerned himself chiefly with anatomy, like a surgeon.

Paul Freart de Chantelou, *Diary of Cavaliere Bernini's Visit to France*, 1665[2]

ONE OF THE MOST controversial features of Michelangelo's work has been his study and representation of anatomy.[3] If, for the most part, Michelangelo's contemporaries marvelled at his command of male anatomy, gained through the dissection of corpses, in subsequent eras increasing numbers found his anatomical expertise repellent. The Venetian writer Lodovico Dolce was the first to cast doubt in print on Michelangelo's treatment of anatomy. Provoked by the publication of Vasari's *Lives* in 1550, which culminates in the apotheosis of Michelangelo, Dolce's *Dialogo della pittura intitolato l'Aretino* (Venice, 1557) argued that anatomy was not only his chief strength as an artist, but also his biggest weakness. While Michelangelo was supreme in the depiction of muscular nudes in violent motion, he was incapable of depicting any other kind of figure, or indeed of distinguishing between age and gender. For Dolce, who preferred the more versatile and wholesome Raphael, it was 'more important to clothe the bones with plump soft flesh, than to flay them'.[4] He would have been thinking above all of the visceral clumps and chains of heaving bodies in the *Last Judgment* (1536–41).

Works like the *Last Judgment*, which was widely known due to the circulation of reproductive prints, could at the very least be admired for their realism. An English survivor of the brutal sack of Antwerp by the Spanish in 1576, in which 7,000 men, women and children lost their lives, said that the bodies offered 'as many sundry shapes and formes of man's motion at time of death as ever Michael Angelo dyd portray in his tables of Doomesday'.[5] But once attention turned to Michelangelo's psychology, there was speculation as to whether his creative juices flowed when – and perhaps *especially* when – confronted by the spectacle of mutilated human bodies. By the beginning of the eighteenth century, Michelangelo's image was being transformed from that of an unflinching prophet of doom into a sadistic monster. A story started to circulate that he had actually crucified a peasant in his studio, leaving him nailed up until he had died, so that he could study from life the agony of Christ.[6] There is no evidence to support this accusation, though Michelangelo may have 'crucified' and flayed a corpse for anatomical purposes. A drawing does survive of a crucified figure whose body looks partially flayed, and other Renaissance anatomists did occasionally depict a crucified man.[7]

The anecdote about the peasant is probably the invention of an age with a different sense of decorum. Hogarth did, after all, make a satirical print of a public dissection entitled *The Reward of Cruelty* (1751–2) in which a dog is 'rewarded' by being allowed to eat a jettisoned internal organ. The Romantics were more sympathetic to Michelangelo's anatomical expertise – on a visit to Italy in 1816 Géricault was hugely affected by Michelangelo's art, and he subsequently made studies of severed limbs in preparation for his macabre masterpiece, *The Raft of the Medusa* (1819). However, at the beginning of the twentieth century, the sculptor Brancusi would dismiss all the art that had been inspired by Michelangelo – especially that of his great contemporary Rodin – as 'beefsteak' art.

We would be unwise, however, in this age of ultra-raw beefsteak art and cinema, to dismiss any hostile reaction to Michelangelo's anatomical 'expertise' as merely squeamish or superficial. For once we start to look at the history of dissection for artistic purposes, and at its impact on Florentine art, we cannot fail to notice the existence of a very specific cult of violence. Violence was central to Michelangelo's conception of himself as an artist, with anatomy its main focus. As such, he is the first great example of a peculiarly modern type of artist, one for whom destruction is inextricably linked to creation.[8]

★

THE FIRST DISSECTIONS IN western Europe since antiquity are thought to have been undertaken in Salerno in the twelfth century. Pigs were used because of the supposed similarity of their internal organs to those of humans, particularly the female. Dissection of human corpses had begun by the end of the thirteenth century at universities such as Bologna. Initially, these were autopsies performed for legal reasons, but dissection of the bodies of executed criminals was soon introduced as part of medical and surgical training, with paying members of the public in attendance.[9] Medical dissections tended to be carried out on corpses simply to confirm what the ancient authorities had written rather than to correct them.[10] Machiavelli observed with approval at the beginning of his *Discourses on Livy* (1531) that contemporary medicine was nothing other than 'a record of experiments, performed by doctors of old, upon which the doctors of our day base their prescriptions'.[11]

The non-empirical nature of medicine in the Renaissance, together with the lack of anaesthetics and sterilisation, meant there were limited opportunities for using anatomical knowledge in healing. The hugely influential Greek physician Galen (AD 129–199) had said it was only necessary for the physician to understand external anatomy (which was vital for blood-letting), and the situation was little different in Michelangelo's time.[12] On the whole, surgeons confined their interventions on the living to the surface of the body, dealing with cataracts and infected wounds, and performing blood-letting by cutting veins or applying leeches. Some books insisted that even tooth extraction should only be performed as a last resort.[13] Dissection was of most relevance in autopsies: Leonardo famously diagnosed a narrowing of the arteries as the cause of death of a 100-year-old man, but there was very little that anyone could do to recognise or cure this ailment in a live patient. Michelangelo gave his opinion of physicians in a letter from Rome to his nephew Lionardo written in 1549, when he was recovering from a kidney stone: 'As regards my malady, I'm hopeful and very much better – to many people's amazement, because I was given up for dead, and so I thought myself. I've had a good doctor [Realdo Colombo], but I believe more in prayers than in medicines.'[14] Later in the century William Clowes, the most famous military doctor in England, could still complain that surgeons caused more deaths than the enemy.[15]

The early Church fathers – above all, Tertullian and St Augustine – had disapproved of human dissection, considering it sacrilegious. But in

the Middle Ages, the emergence of the Cathar heresy which posited two Gods, a 'good' God of spirit, and an 'evil' God of matter, prompted the Church to support study of the natural sciences as an effective way of proving that God's creation is good in every way.[16] Anatomy was central to this project, and so too were Galen's theocentric theories, for he considered anatomy to be the source of 'a perfect theology', which was 'far greater and far nobler than all of medicine . . . all men of whatever nation or degree who honour the gods should be initiated into this work'.[17] The human body, looked at in the right way, was thus a beautiful work of art, worthy of contemplation, inside as well as outside. Dissection was science at its purest. The English humanist Thomas More gave voice to such sentiments in *Utopia* (1516), again bowing to the ancients:

> The Utopians think very highly of [Hippocrates and Galen], for though nobody in the world needs medicine less than they do, nobody has more respect for it. They consider it one of the most interesting and important departments of science – and, as they see it, the scientific investigation of nature is not only a most enjoyable process, but also the best possible method of pleasing the Creator. For they assume that He has the normal reactions of an artist. Having put the marvellous system of the universe on show for human beings to look at – since no other species is capable of taking it in – He must prefer the type of person who examines it carefully, and really admires His work, to the type that just ignores it and like the lower animals remains quite unimpressed by the whole astonishing spectacle.[18]

Anatomical study could thus be considered almost a form of worship, and anatomists did usually get access to corpses through church authorities. When Michelangelo performed his first dissections in the winter of 1493–4 – or, more likely, as he was only nineteen, assisted and observed a skilled surgeon at work[19] – the corpses were provided by the Prior of the monastery of Santo Spirito in Florence, and probably came from the affiliated hospital. Leonardo relied on the co-operation of the Church in Florence and Milan for his own dissections, and would write: 'O investigator of this anatomy of ours, do not be saddened by the fact that your knowledge is bought by someone else's death, but rejoice that our Creator has concentrated your mind on such an excellent instrument.'[20]

Nonetheless, the practice of dissection never stopped being controversial. When Leonardo was in Rome from 1513 to 1516, he was prevented from carrying out dissections after a German artist complained to Pope Leo X and to the hospital authorities.[21] In the late 1520s, when Paolo Giovio was physician to Pope Clement VII, he observed in a biographical sketch of Leonardo that he had performed 'inhuman and repugnant' dissections on criminals.[22] One of the things that made dissection unrespectable, in addition to general concerns about 'violating' the human body, was the acute shortage of suitable corpses, which made many would-be anatomists resort to grave robbery. Vasari tells several stories about grave-robbing artists, none more grisly than that of Silvio Cosini, who carved grotesques and architectural details for Michelangelo in the New Sacristy in Florence in the 1520s. Cosini once stole a body from a grave, and, 'after having dissected it for the purposes of his art, being a whimsical fellow and perhaps a wizard, and ready to believe in enchantments and suchlike follies, he flayed it completely, and with the skin, prepared after a method that he had been taught, he made a jerkin, which he wore for some time over his shirt, believing that it had some great virtue, without anyone ever knowing of it'.[23]

The physical demands of dissection – and of medical practice generally – also laid it open to the charge that it was a mechanical rather than a liberal art. In numerous set-piece treatises and dialogues, medicine was compared unfavourably to other disciplines.[24] The most frequently drawn contrast was between medicine and law,[25] professions which came into contact through the use of dissection for autopsies. The debate centred on which profession contributed most to the well-being of society, and which was the most dignified. In 1399 the humanist Chancellor of Florence, Coluccio Salutati, contrasted the usefulness and dignity of law with that of medicine, complaining that it is 'repulsive' to inspect and show by hand viscera and intestines, and 'whatever diligent nature has no less curiously concealed than constructed'. The 'caverns of the human body' cannot be seen without 'a certain horror' and 'effusion of tears'.[26] In the aftermath of the Black Death of 1348 and the recurring outbreaks of plague in subsequent years, the impotence of the medical profession and the dangers for the practitioners of contracting the plague were all too obvious. In Florence, the sons of doctors from traditional medical families increasingly went into other professions. Those who followed family tradition tended to become physicians rather than surgeons, for surgeons were most in demand during plague epidemics.[27]

Salutati's diatribe was symptomatic of a real loss of prestige in the medical profession. Nonetheless, he did at least concede that the legal profession was more needlessly cruel than the medical, since judges use torture on suspects far more than strictly necessary.[28]

In the later fifteenth century, however, medicine became more fashionable. Humanists associated with the Medici such as Poliziano and Ficino collected texts of ancient medical treatises and began to study the natural sciences.[29] The Medici were better disposed towards doctors.[30] Two dialogues comparing medicine and law were dedicated to Lorenzo de' Medici and to Piero de' Medici, and here the arguments were presented in a more balanced way, not least because of the medical derivation of the Medici name, as one of the authors helpfully points out.[31] The patron saints of the Medici were the two early Christian doctors, Cosmas and Damian, who never charged their patients: Cosmas was the patron saint of surgeons. Michelangelo would make a pun on Medici/Medico in a poem of the 1530s (no. 85).

Dissections by visual artists first appear to have been undertaken in Florence at around the same time. Exactly why artists felt the need to perform dissections is not an easy question to answer, for there is no obvious reason why an awareness of the appearance of the interior of a dissected corpse should be relevant to the representation of living bodies, which was of course the principal task of the Renaissance artist. Ancient Greek artists did not study anatomy scientifically until the end of the fourth century BC (and then only the anatomy of animals), and this did not prevent them creating what are still regarded as among the most naturalistic nudes in the history of art.[32] In the Renaissance, the appearance of living bodies could be studied from live models,[33] and from plaster casts moulded directly from live models and from antique sculptures. A recent study of Michelangelo's anatomical competence concluded that he had an exceptionally sophisticated understanding of surface anatomy, and yet there is nothing in Michelangelo's art that could not have been learned from observing live models. His expressive distortions of body parts and of proportions were, of course, very much his own.[34]

The usefulness of dissection to Renaissance artists is further called into question by the fact that only a tiny handful of anatomical drawings can be related to finished paintings or sculptures.[35] Leonardo's anatomical studies were an end in themselves, with no obvious relationship to his paintings or sculptures, except perhaps his studies of horse anatomy. He

rarely depicted the nude figure. Most of Michelangelo's surviving anatomical studies show the muscles of limbs, presumably because it was easier to obtain isolated limbs than whole bodies.[36] These limbs bear little resemblance to those commonly found in his art. They are all straight, or nearly so, which may reflect the fact that it is hard to arrange a dead body into a wide variety of poses, and corpses were often suspended by the neck from the ceiling (Fig. 6).[37] Michelangelo seems to have gone to extraordinary lengths to compensate for the fact that the muscles of a dead body are flaccid.[38] Francisco da Holanda, the Portuguese illuminator who knew Michelangelo in Rome in around 1540, reports that Michelangelo made wax moulds of the muscles in one body, and then placed them in another.[39] Holanda does not explain the purpose of

Fig. 6: Michelangelo, *Anatomical Studies*, *c.*1520 (pen and brown ink, 28.3 × 19 cm/ 11 × 7 in, HM Queen Elizabeth II, Royal Library, Windsor Castle)

this practice, but it is possible that Michelangelo thought a pair of 'dead' muscles could substitute for a single 'live' muscle. It must have made the bodies look very lumpy.[40] When Michelangelo did draw 'flayed' bent limbs, the flayed parts are so schematically drawn as to call into question whether they were based on direct observation. We often seem to have a fantasy of a 'living' flayed body with 'living' muscles, tensed and relaxed according to use.[41]

Alberti, in *On Painting*, was the first to stress the importance of anatomical study for artists, but he made heavy weather when justifying it. Having urged artists to get the right proportions by first visualising the bones, then the tendons and muscles, and finally the flesh and skin, he adds:

> But at this point, I see, there will perhaps be some who will raise as an objection something that I said above, namely, that the painter is not concerned with things that are not visible. They would be right to do so, except that, just as for a clothed figure we first have to draw the naked body beneath and cover it with clothes, so in painting a nude the bones and muscles must be arranged first, and then covered with appropriate flesh and skin in such a way that it is not difficult to perceive the positions of the muscles.[42]

It is not a very convincing answer – it simply begs the question as to why, when depicting a clothed figure, the artist has to start with the nude body.

Alberti seems to have been aware of the weakness of the naturalistic argument. We get a better idea of his priorities when, later on, he tries to establish painting as a liberal art by showing that it is analogous to language: 'I would have those who begin to learn the art of painting do what I see practised by teachers of writing. They first teach all the signs of the alphabet separately, and then how to put syllables together, and then whole words. Our students should follow this method with painting.'[43] From this, we can understand why he is so keen on dissection. His fundamentalist approach to figure-drawing, starting with bones, and ending up with groups of figures in an *istoria*, is in keeping with this linguistic analogy: the bones would be individual letters, each figure would be a word, and a whole composition would be a sentence. The body is thus the key text of the visual arts. Alberti was also influenced by Galen. While Galen believed doctors only needed to

understand the exterior of the body, he thought that an understanding of the interior of the body was necessary for philosophers, 'either for simple theoretical interest or to communicate that the art of nature succeeded in every part'.[44] It therefore made sense for artists to do dissections if they wanted to be regarded as fully fledged philosophers.

Among artists, there was no consensus as to the purpose of dissection. Some said that it improved artists' sense of proportion, by making them aware of the composition of the bones, which were believed to provide the fixed basis of the body's proportions; others believed it helped in the making of lifelike figures by giving a full understanding of the muscles; still others thought it facilitated the depiction of corpses and skeletons.[45] This last claim is the least controversial. Accurate anatomical drawings would be crucial for the advancement of medical science, and artists played an important part in improving the clarity of such technical drawing.

Renaissance artists must primarily have seen the study of anatomy as a catalyst in the creation of an art that penetrated deep under the skin of human appearances. This art would, they hoped, reveal some of the most elusive secrets of the divinely constructed universe, while also enabling them to emulate the ancients. Such an art suggested that their acuity was more than merely visual. There is likely to have been more urgency among sculptors in this arduous pilgrimage to the nerve centre of the human body. Galen repeatedly makes the point that the skill of Nature far surpasses that of sculptors, for she has designed man perfectly not only on the outside (something which the sculptor Polyclitus was also able to do) but 'deep below the surface'.[46] Galen probably means to criticise painters as well as sculptors, but in the Renaissance this argument became a stick with which to beat sculptors in general and stone carvers in particular.

In Paolo Pino's *Dialogo di pittura* (1548), the Florentine interlocutor argues that sculpture is inferior to painting because sculptors start from the outside of the stone block and work in, whereas painters work from the inside out: 'The sculptor never forms what he makes by the direct method of forming, as we [painters] do; when a painter forms a figure, he begins from the centre, and this nature teaches in the order of her working, which begins from simple things and proceeds to more complex. A corpse is ordered first anatomically, then it is covered with flesh, distinguishing the veins, the ligatures and members, bringing them by true means to whole perfection.'[47] This kind of argument may well have been doing the

rounds of the artists' workshops in Michelangelo's formative years, and it could have contributed to the intensity with which he pursued his anatomical studies. Indeed, it was principally sculptors and sculptor-painters who pioneered the study of anatomy in the Renaissance.[48] It would have made Michelangelo all the more intent on showing that his stone figures had been experienced and created from the inside as well as the outside – not just on their surfaces, but in their depths.

PROVING THAT ONE FULLY understood the workings of human anatomy often drew Florentine artists towards violent subject-matter, preferably involving naked figures in vigorous motion. The ultimate expression of vitality – and of anatomy – occurred when men were threatened with the prospect of sudden death. A succession of major artworks were made in Florence with the novel subject, inspired by antique sarcophagi, of battles involving naked men. This theme was of 'compulsive'[49] interest for Florentine artists from the late fifteenth century onwards – and especially for Michelangelo. The Medici sculpture garden at San Lorenzo, where Michelangelo studied and trained in the early 1490s, epitomised the Florentine fascination with violent subject-matter (and with anatomy) for its entrance was flanked by two antique statues of the flaying of Marsyas, one of which, carved from porphyry, was extensively restored by Verrocchio.[50] Marsyas was flayed as punishment for challenging and losing to Apollo in a musical contest. Vasari admired the ingenious way in which the antique sculptor had exploited the delicate white veins in the red stone, making them appear 'to be little nerves, such as are seen in real bodies when they are flayed' (see Fig. 21).[51]

Michelangelo's first recorded act in the garden involved a comic brand of what we might term creative destruction. Condivi says that after Michelangelo had made a copy of an antique head of an elderly faun, Lorenzo de' Medici joked that old men always have a few teeth missing, whereupon the young sculptor performed some emergency dentistry. He 'removed an upper tooth from the old man, drilling the gum as if it had come out with the root'.[52] This rather heartless episode entailed a compelling, if minor demonstration of anatomical knowledge. The next work that Condivi records being made by Michelangelo in the garden is an unfinished relief, the *Battle of The Centaurs* (c. 1492), which is usually seen as a response to an earlier *Battle Relief* (c. 1475) made by Bertoldo di Giovanni. Both reliefs featured a spectacular display of naked warriors, with their bodies pushed *in extremis*.

According to Vasari, the first great artist-anatomist was the sculptor and painter Antonio del Pollaiuolo (1431/2–98): 'He had a more modern grasp of the nude than the masters before his day, and he dissected many bodies in order to grasp their anatomy. He was the first to demonstrate the method of searching out the muscles, in order that they might have their due form and place in his figures.'[53] Pollaiuolo demonstrated his command of the male nude in a succession of brutal yet elegant works – an altarpiece of the *Martyrdom of Saint Sebastian* (1475), and paintings and bronze statuettes showing the Labours of Hercules. But his most influential nude studies featured in a large engraving entitled the *Battle of Nude Men* (*c.* 1470; Fig. 7). The engraving is of exceptional size and seems to have been a demonstration piece, advertising the artist's skill. (Pollaiuolo signed the print with a flamboyant Latin signature.) Ten naked warriors set about each other with unbridled savagery, wielding sabres, axes, knives, bows and arrows. However, a harmonious choreographed rhythm is created by the re-use of the same figures, depicted from different angles.

Here it is the artist-anatomist who is the most formidable warrior of all. Only one of the battling nudes has been wounded, but even if their

Fig. 7: Antonio Pollaiuolo, *Battle of Nude Men*, *c.* 1470 (engraving, Warburg Institute)

bodies have not actually been pierced by an assailant's weapon, they have already been penetrated by the artist's own weapons, for Pollaiuolo, armed with the engraver's burin, has 'searched out' their muscles individually, and brought them to the surface. Each figure looks as if it has already been flayed, with the muscles being pushed out from within. The muscles are contracted in unrealistic ways. Some scholars deny they are based on anatomical study at all, but judging by their influence, Pollaiuolo's contemporaries (including Vasari) were struck more by their authenticity than their element of fantasy. The extroverted anatomy of Pollaiuolo's figures seems to prophesy the imminent fatal consequences of their actions. The scene showing a man leaning over the fallen body of his opponent, armed with a knife, would be adapted by Bronzino for a painting of Apollo and Marsyas in around 1530.

By seeming to have 'dissolved' clothing and skin to expose muscle and bone, the artist is also able to create visual rhymes between the struggling bodies and their surroundings. The warriors stand in a field that may have been recently ploughed as it is marked intermittently by horizontal furrows, against a backdrop of densely packed, head-high crops – ranks of what may be millet flanked by vines clambering up trees.[54] The millet and grapes are ripe so it must be autumn. The most obvious rhyme is between individual muscles and the lush, tongue-flap leaves of the millet. This affinity between leaves and muscles suggests that it is the autumn of all their lives. The grim reaper will cut down both crops and men indiscriminately. Pollaiuolo has thus understood a 'secret' of Nature. Or at least he thinks he has. Leonardo abhorred artists who made figures with prominent muscles, 'so that they seem to look like a sack of nuts rather than the surface of the human being, or, indeed, a bundle of radishes rather than muscular nudes'.[55] His reference to nuts and radishes suggests he was aware of a tendency to correlate anatomical parts with flora and fauna, and he himself drew analogies between rivers and arteries, rocks and bones.

Michelangelo carried out dissections on animals (especially horses) as well as on humans in Florence in the early 1490s and the early 1500s, and then again in Rome in the 1540s. Condivi says that when he first got the opportunity to dissect corpses, 'nothing could have given him greater pleasure'.[56] According to the sculptor Vincenzo Danti, Michelangelo devoted as much as twelve years in all to studying the subject.[57] His surviving anatomical drawings focus either on the skeleton or on the superficial muscles (a type of study known as an *écorché*). These were the

parts of the body that were of most interest to Renaissance artists. But he also planned to provide illustrations for a treatise on anatomy written by his physician friend Realdo Colombo, whose eminence was such that in 1556 he conducted an autopsy of Ignatius of Loyola, founder of the Jesuits. Colombo hoped their joint enterprise would 'contradict the ancients and moderns alike'. This would probably have involved more comprehensive dissections. Condivi observes that Colombo sent Michelangelo the corpse of a 'most handsome' Moor, and that the artist subsequently 'showed me many rare and recondite things', which suggests he did not only expose the superficial muscles.[58] But this joint venture was never brought to fruition.[59] Michelangelo also planned to write an illustrated treatise for artists focusing on the movements and gestures of the human body, which seems distinct from the collaboration with Colombo. But it too never materialised.[60]

These time-consuming and arduous operations can be usefully compared to the many years Michelangelo spent at the marble quarries in search of perfect blocks of stone. He was unique in the number of trips – or pilgrimages – he made to the quarries, and once there, he even selected the veins of marble to be mined. In 1505–6 he spent eight months in Carrara quarrying marble for the *Tomb of Julius II* (and while there, fantasised about carving out of a mountain a colossus that would rival those of the ancients).[61] There is a precise parallel with anatomy, for quarrying and mining were traditionally seen in anatomical terms. In Petrarch's *Remedies for Fortune Fair and Foul*, Reason observes: 'nothing in the whole world could equal Rome in the wonder and size of its structures. Thus you find also written that the entrails of the earth were pierced in search of marble.'[62] Piercing the body of the earth, and piercing the body of man, were equally central to Michelangelo's artistic endeavour, and helped establish its heroic – and profound – nature.

Although the *Battle of the Centaurs* (Plate 2) may precede the date at which Michelangelo is thought to have carried out his first dissections (1493–4), it is nonetheless a *tour de force* of anatomical demonstration, with struggling nude figures shown in a wide variety of postures. The relief is just under 3ft × 3ft, with the foreground figures carved in high relief and almost 2 feet tall. The large scale of the figures gives the relief a very chunky and pneumatic feel. Michelangelo valued it exceptionally highly, keeping it in his personal collection, and Condivi says that whenever Michelangelo saw it, 'he realises what a great wrong he committed against nature by not promptly pursuing the art of sculpture, judging by

that work how well he could succeed'. In a marginal note to Condivi's text, Michelangelo is quoted as saying that the work was 'perfect'.[63] Condivi says that Poliziano proposed the subject to him, 'the Rape of Deianira and the Battle of the Centaurs, telling the whole story one part at a time'.[64] Vasari gives a slightly different subject, the battle of Hercules with the centaurs. Neither title fits all the details, however, and it may just be a battle between humans and centaurs, a popular allegorical subject that was supposed to represent reason versus passion: centaurs were human above the waist, and horse below the waist, and thus signified bestiality.

Even so, there is no sense that the scene represents reason versus passion because Michelangelo downplays the 'animal' aspect of the centaurs. Only one bit of horse is visible, and it is consigned to the lowest portion, belonging to the central figure lying on the ground. The relief is very much a showcase for well-muscled male anatomy: a woman is having her hair pulled, but as she is seen from the back, the most obvious signs of femininity are hidden. It has been said that Michelangelo realised he could not finish the relief because the composition is fundamentally incoherent, yet it is exceptionally coherent if looked at in the correct way. The bottom right and the top left sections are filled with a tightly packed, heaving scrummage of bodies, but in between a diagonal slice of space opens up, like the parting of the Red Sea.

Here we find the two most isolated and heroic-looking figures in the composition, squaring up to each other in single combat. Theirs is a whole different order of conflict. The standing figure in the lower left twists mightily like a discus thrower, his left arm raised towards his target, and his right arm holding his lethal projectile, a large rock. (Appropriately enough, as he is fighting with a centaur, the pose of his upper body recalls that of one of the most famous antique nudes, the *Horse-Tamers* in Rome.) His adversary occupies the top half of the middle of the relief, and is thus in the dominant pivotal position of the composition. We only see his human upper body. His right arm is raised behind his head, poised to strike. It almost feels as though he is holding on to the top of the relief, and is suspended in space, like a human candelabra. As has often been pointed out, his pose makes him a precursor of Christ in Michelangelo's *Last Judgment.*

The two combatants are at arm's length from each other. Unlike the other fighters, they seem to have both time and space – time to compose themselves, and space to look each other over and to deliver a lethal

blow. But their torsos and shoulders are front on to the viewer and fully exposed, as though they had suddenly stopped for a last ever full-frontal photo-opportunity. In his treatise *On Painting*, Alberti said that it would be 'absurd for one who paints the Centaurs fighting after the banquet to leave a vase of wine still standing in such tumult'.[65] In comparison with their fellow combatants, they are indeed like undisturbed vases. Yet in a moment, they too will be sucked into the maelstrom, for a man who pulls his (female) opponent ignominiously by the hair is surging into the gap between them.

Unlike Pollaiuolo, Michelangelo's concern with the anatomy of men of action does not lead him to make visual rhymes with the organic world. Here, there is simply no room for a landscape background, and as we know from Michelangelo's subsequent work, he never depicted lush vegetation. Nonetheless, there is at least one unmistakable visual rhyme with the *inorganic* world, for there is a close similarity between the rocks which are used as weapons, and the heads of the protagonists. This must have been deliberate on Michelangelo's part, for in no source did men and centaurs battle each other with rocks (in Bertoldo's *Battle Relief* the protagonists are armed with swords and daggers). The 'rhyming' is at its most conspicuous in the bottom left-hand corner, where a seated figure holds his wounded head, while two figures standing near him prepare to throw head-sized rocks. The correspondence would have perhaps been less clear-cut if Michelangelo had finished carving the hair, but the heads would still have had a boulder-like rotundity. The feeling of roundness is further enhanced by the fact that the faces are virtually expressionless, rather than distorted by grimaces. His 'failure' to finish carving the relief may simply be because he liked the visual pun so much. It is a work of extreme artifice.

This rhyme has the effect not only of seeming to confine the violence to the head area (rocks being most effective when aimed at the skull)[66] but also paradoxically of making the head appear marginal to the torso, and less important. The seated figure on the left holds his wounded head, but he might just as well be a headless figure holding a rock. As for the figures standing by him, they are holding rocks, but they might just as well be holding heads. Another way in which the heads are loosened from their torsos is by the frequent placement of an arm, either their own or that of an assailant, across the neck. There is a comic element to all this. It is as though Michelangelo were suggesting that these brawlers are a bunch of blockheads who have lost their heads – which of course they

have. He milks these visual puns for all they are worth. Just as in his head of a faun, with its missing tooth, a damaged head becomes a source of black comedy.[67]

At the same time as he appears to loosen the head and to direct violence towards it, Michelangelo raises the status and profile of the rest of the body, especially the torso. He makes the torso seem unimpaired, preserving it almost miraculously – as if it is somehow autonomous and self-sufficient. Thus while the heads of the two 'heroic' fighters look across at each other, concentrating on the business of fighting, their torsos are orientated towards the viewer, and are fully exposed to us alone. They seem to be expanding and unfurling into the space around them, subject to a mysterious pressure from within that stretches their skin and brings their muscles to the surface. This privileging of the torso, and the focusing of violence on the head and neck, is in part informed by the consciousness of the anatomist, for the most suitable bodies for dissection were those of young male criminals who had just been hanged, or at worst decapitated. These forms of execution left intact the site of greatest concern to the artist-anatomist: the torso, together with the limbs.

There are thus two encounters taking place simultaneously. The first is between the two 'heroic' warriors, and the second between them and us, the viewers – connoisseurs of bodies who are potentially just as predatory as their current enemy. The double life led by the figures in Michelangelo's relief makes them seem doubly vulnerable and strangely isolated, heroic misfits, stretched across time and space.

At the same time, however, the insouciant and almost flirtatious way they offer their bodies up for our inspection – striking poses for our benefit – suggests they are anticipating and even consenting to their own deaths. It is as though they are making a target out of their own torsos. The mindset that seems to inform the peculiar body language of this relief is similar to that expressed in a witty – if macabre – poem composed by the seditious Lyons writer and publisher Etienne Dolet, which was published in 1539. It is written in the form of an epitaph for a hanged criminal whose body was immediately taken down and dissected in public and its anatomy explained by the physician and author François Rabelais. Dolet imagines the victim appreciating his grisly fate, for by virtue of being dissected, he is 'heaped in honours' and basks 'in glorious state', rather than suffering the ignominy of having his body pecked at by the crows:

Fig. 8: Anonymous anatomical illustration from Berengario da Carpi's *Commentaria super anatomia . . .* 1521 (woodcut, Wellcome Institute)

Anatomised, before the crowds I lie exposed to gaze
The while a learned doctor the Creator's art displays,
The beauty, order, workmanship by which He fashions man;
And great the throngs that gather round the human frame to scan
And wonder at the masterpiece of life's Great Artisan.[68]

Dolet was later burnt at the stake for heresy, so he did not even have the satisfaction of being dissected. But this 'willing victim' ethos is expressed in numerous anatomical illustrations where the body assists in the investigation. Berengario da Carpi, who made a fortune in Rome treating syphilis with mercury, included six such illustrations (about a third of the total) in his *Commentaria super anatomia mundini* (1521), dedicated to Cardinal Giulio de' Medici (a shorter version aimed at artists was published the following year). In those illustrations, a figure modelled on the Colossus of Rhodes stands heroically before us and uses his hands to hold back large flaps of his own belly skin, like a pedlar holding open his coat to offer his wares (Fig. 8).[69] The paramount importance for Michelangelo of 'presenting' the torso to the viewer may have influenced his famous aversion to deep perspective recession in his multi-figure compositions, whether it be the *Battle of the Centaurs* or the *Last Judgment*. His protagonists are mostly confined to a narrow foreground strip.

★

THIS LOOSENING OF THE relationship between the head and the body, and the emphatic, quasi-sacramental presentation of the torso to the viewer, occurs in many of Michelangelo's other works. In the *Bacchus*, the marble *David*, and in *Giuliano de' Medici* (Plate 15), the head and eyes point in one direction, away from the onlooker, while the naked torso points in another direction altogether, orientated powerfully and even heraldically towards the onlooker. A related motif, and one of Michelangelo's most celebrated innovations, is that of the figure's own arm crossing their body high on the torso. It is first found in the *Battle of the Centaurs*, and reappears in images such as the *Doni Tondo*, the Sistine Ceiling *ignudi*, and the statues of *Victory*, *Day* and *Apollo*.[70] This has the effect not just of creating a vigorous twisting movement, but also of separating the head from the bulk of the body, and making it appear to float or bob independently on top. Rarely in his drawings of the male nude does Michelangelo more than summarily sketch in the head (women's heads fare much better, and are almost never omitted).

His tendency to 'displace' the head also helps explain his dislike of portraiture. He was notoriously uninterested in a genre that puts the greatest emphasis on the face and eyes.[71] John Ruskin fulminated against what he saw as Michelangelo's contempt: 'Physical instead of mental interest. The body, and its anatomy, made the entire subject of interest: the face, shadowed . . . unfinished . . . or entirely foreshortened, back-shortened, and despised, among labyrinths of limbs, and mountains of sides and shoulders'.[72]

This displacement is particularly striking when we compare his sculpture and painting with that of his contemporaries and also when we look at his poems. Here, the eyes of the lover and beloved are almost always the centre of interest: the 'window onto the soul'. This was utterly conventional. The eyes had been fetishised by platonising love poets from at least the Middle Ages, and it was standard Petrarchan practice to exalt them. In Michelangelo's sculpture and painting, however, it is the torso, rather than the eyes, which acts as the window and door to the male soul. It is the torso that stares out at the viewer. Many of Michelangelo's torsos – whether seen from the front, back or side – have what we might term a 'wide-eyed' feel.[73] One of the most remarkable examples of this is the Sistine Ceiling *ignudo* who sits beside the Persian Sybil. The huge shoulders of this startled figure taper into tiny buttocks, while the spine is massively bent into a yawning, bow-like

curve. The torso is far more expressive and momentous than the figure's gaping mouth and eyes, which are cast in deep shadow, like anatomical marginalia.

As we saw with the *Madonna of the Stairs*, the withholding of the face can be extremely troubling, indicative of a loss of favour: the inability to see 'face to face' is central to the pathos of Michelangelo's work. But the necessary 'fall' of our eyes to the lower region of the torso can be seen, *pace* Augustine, as a humiliation that exalts and an exaltation that abases. We journey to the centre of our own humanity, and it expands in order to receive us.

One of Michelangelo's most characteristic techniques is to frame and highlight a central section of the torso by careful placement of drapery. In the *St Matthew*, an almost inexplicable, clean-edged slice has been taken out of the saint's robes to reveal and frame his abdomen and part of his chest. This neat aperture recalls the anatomical 'flaps' just mentioned. We are being offered a framed 'window' on to his torso. In the *Entombment* (*c.* 1500–1), the *Dying Slave* and the *Rebellious Slave* (1513–16) and the Florentine *Pietà* (*c.* 1547–55) the central torso is marked off above and/or below by clingy transverse thongs and rolled-up winding sheets.[74] These props function like displaced eyelids that both highlight and reveal the torso, giving it a startled quality.[75] Most remarkable of all, perhaps, is the statue of *Giuliano de' Medici* (1524–34) in the New Sacristy. The elaborate parade armour appears to stop just above his chest, so that the rest of his torso is left completely bare down to his waist.

Michelangelo would surely have agreed with a saying attributed by the Roman architectural theorist Vitruvius to Socrates. Vitruvius writes that the Athenian philosopher believed 'the human breast should have been furnished with open windows, so that men might not keep their feelings concealed, but have them open to view'. If this were the case, he continues, 'not merely the virtues and vices of the mind would be easily visible', but also its intellectual and creative faculties.[76] The satirist Lucian (AD *c.* 120–*c.* 180) adapted the motif in his dialogue *Hermotimos*: here, the god Momus criticises Hephaestus' statue of a human being because it lacks a window in its chest through which its thoughts can be viewed.[77] The motif was cited by Erasmus, among others, in the Renaissance.[78] In his poems, Michelangelo did occasionally experiment with moving the eye down from the head, thus changing the position of the 'windows of the soul'. The lumbering giant, as mentioned in the

previous chapter, has an eye in his heel and, more pertinently, in another poem addressed to a woman Michelangelo implores his beloved to make the whole of his body into an eye (no. 166), no doubt so that he could see her, and be seen by her, more completely.

In the sixteenth century the heart, the most important organ in the torso, was gaining prestige at the expense of the head. St Augustine's *Confessions* (397 AD), which had not been highly regarded before the Renaissance, was a key catalyst in persuading people that the affections and the will, both of which were thought to be located in the heart, should be given priority over reason.[79] Augustine frequently incorporates impassioned phrases from the Psalms into his narrative, such as 'O God of my heart'.[80] Ignatius of Loyola, founder of the Jesuits and author of the popular *Spiritual Exercises* (1548), believed that the penitent should engage in intimate conversation with God using the 'language of the heart'. Such expressions had been common in the fourteenth century – St Catherine of Siena, for example, offered her heart to Christ and received his own in return – but in the age of anatomy they were if anything intensified and particularised. In his anatomical treatise, Berengario da Carpi said that the heart has more dignity than any of the other body parts and is therefore called 'the sun of the microcosm because it illuminates the other members with its spirit'.[81]

Such beliefs crossed even the sharpest religious divides. The reformist theologian John Calvin took as his personal emblem a hand offering a heart, accompanied by the Latin words *Prompte et sincere* (readily and sincerely). Calvin was particularly struck by the visceral language of the Bible, especially the Psalms. He discussed the passage in Psalm 26 when David says: 'Examine me, O Lord, and prove me; try my reins [loins] and my heart'. Calvin explained that the Hebrews used the word 'reins' for 'that which is most secret in men', and so David was 'offering himself wholly for God's examination'.[82] In a commentary on another biblical passage, Calvin writes, 'The Latin text has viscera, bowels, for since the bowels are the seat of feeling, mercy, love and all godly affections are known by that name.'[83]

The marble *David*, with its 'open' chest, invites us to inspect its heart and loins, while in the *Last Judgment*, the torsos of the saved in particular are impossibly and even grotesquely exaggerated. It has been said that here Michelangelo could not resist 'that strange compulsion which made him thicken a torso till it is almost square'.[84] The squareness (and rectangularity) of his late torsos is that of windows. It is as if on the Day

of Judgment, the human torso is spread-eagled so that it can become more transparent, and every single virtue and every single vice laid out for God's inspection. Michelangelo strives to create what we might term a confessional torso. Human beings, he suggests, can only be properly understood by first focusing on the centre rather than on the periphery. He makes the torso the junction box and nerve centre for the entire body, the part that mediates between the head and feet, heaven and earth. In a sermon delivered on 10 December 1494, Savonarola proclaimed Florence as the 'navel' of Italy because it was the chosen and central city of the peninsular, and on other occasions he called it Italy's 'heart' because 'God's revealed truths spread out from Florence into the other regions'.[85] So Michelangelo's predilection may have been affected by his sense of Italian as well as of human geography.

It is not just the nudity, but also the expanded scale of Michelangelo's figures that is a declaration of the need for psychological transparency. A striking expression of this desire for transparency − and one which centres on the human heart − occurs in an early episode of Francesco Colonna's prose romance *Hypnerotomachia Poliphili* (1499), mentioned in the first chapter. In the course of his journey the hero Poliphilo hears a 'sickly human groan', and goes in search of its source. Having clambered over a field of ruins and marble fragments, he discovers 'a vast and extraordinary colossus, whose soleless feet opened into hollow and empty shins'. The colossus lay on its back, and 'it was of a middle-aged man, who held his head somewhat raised on a pillow'. Poliphilo climbs up on to its chest and then finds a stairway leading from its open mouth down its throat, and 'thence into his stomach, and so, by intricate passageways, and in some terror, to all the other parts of his internal viscera'. After this, everything suddenly becomes crystal clear:

> Then oh, what a marvellous idea! I could see all the parts of the inside, as if in a transparent body. Moreover, I could see that every part was inscribed with its proper name in three languages, Chaldaean, Greek and Latin. Everything was there that is found inside the natural body: nerves, bones, veins, muscles and flesh, together with every sort of disease, its cause, cure and remedy. All the closely-packed organs had little entrances giving easy access, and were illuminated by small tunnels distributed in suitable places around the body. No part was inferior to its natural model. And when I came to the heart, I could read about how sighs are generated

from love, and could see the place where love gravely hurts it . . .
What an object it was, surpassing the finest invention, as even a man
ignorant of anatomy could appreciate![86]

The sentient and accessible body is centred on a suffering heart, and the
head is reduced to the purely functional status of something that allows
access to the torso, like a tradesman's entrance. The giant scale is precisely
what makes it so accessible and transparent, and allows Poliphilo to gain
access to the heart. At the same time, to be transparent is to be vulnerable.
This giant is lying on the ground, groaning. It is an anatomical variation on
medieval mystical texts which urged worshippers to meditate on the
crucified Christ's wounds.[87] It was not enough for the worshipper to put
their fingers in the holes made by the nails, or to put their hand into the
wound in his side. Rather, as St Bonaventura urged, they must 'enter
entirely by the door in his side and go straight up to the very heart of
Jesus'.[88] Michelangelo's lugubrious reclining figure of Day (Plate 15) in the
New Sacristy, with his massively cantilevered musculature, is a fine example
of how a giant suffering body can almost be made transparent. At the same
time, his body literally eclipses his head.

The Christ of Michelangelo's *Last Judgment* has the broadest torso of
all. His chest has been called 'wide as an ape'.[89] In the *Confessions*,
Augustine begs God to increase the size of his soul: 'The house of my
soul is narrow, too narrow for you [God] to come into it; enter it, and
make it wider.'[90] In Michelangelo's universe, the torso is widened in
order to be God-like.

To put all this in perspective, and to underscore Michelangelo's
originality, we need only look at the way in which Alberti treats the
Momus myth. In his dialogue *Momus or On the Ruler* (c. 1452), Alberti uses
a completely different version of the story, which derives from Aesop's
Fables (no. 125). Here it is Prometheus who has made a man, and who is
criticised by Momus. This time, however, Momus complains that
Prometheus has thoughtlessly hidden the mind in the chest, 'in the middle
of the heartstrings, when it would have been better to put it high up on the
forehead, on the most exposed part of the face'.[91] Here Alberti seems to
represent the alternative and, until the advent of Michelangelo, dominant
artistic convention whereby the face is the centre of expressive interest.

AS WELL AS LEADING TO THE commission to carve twelve apostles
for Florence Cathedral, the success of the marble *David* resulted in

Michelangelo's first major commission for a fresco, a medium which he had not used since he had worked in the Ghirlandaio studio. Had it been finished, it would have been the largest work yet produced on the theme of the 'battle of nude men'. The painting was planned for a 19ft × 45ft section of wall in the new Great Council Hall in Florence to complement a fresco on the same wall which had been commissioned from Leonardo by the Republican government in 1503. Both pictures were battle scenes depicting famous victories by the Florentines. Leonardo's subject was the Battle of Anghiari, an important victory over the Milanese which had taken place in 1440. Michelangelo was given the Battle of Cascina, a victory over the Pisan army, in 1364. This subject was intensely topical, because Florence was once again at war with Pisa.

Such large-scale depictions of battles in a public building were unprecedented: the largest space in the council hall in Venice was filled with a depiction of Paradise. Michelangelo completed a full-scale cartoon in October 1504, but neither fresco was ever finished. Before he could begin painting Michelangelo was summoned to Rome in 1505 by Pope Julius II to begin work on his tomb, while Leonardo had technical problems with the execution of his fresco, and returned to Milan in

Fig. 9: Bastiano da Sangallo, copy of central section of Michelangelo's cartoon for the *Battle of Cascina*, *c.* 1542 (oil on panel, Norfolk, Holkham Hall, Earl of Leicester)

1508. The commissions have tended to be seen as an artistic battleground between the elder statesman Leonardo, who was fifty-two, and the young pretender Michelangelo, who was twenty-nine. But the two frescos would have complemented rather than upstaged each other.

The centrepiece of Leonardo's composition was a ferocious fight between mounted warriors in ornate armour. By way of contrast, the centrepiece of Michelangelo's composition was a scene before the battle when some Florentine soldiers were taken by surprise while bathing in the Arno near Cascina (Fig. 9). Their commander gave a false alarm in order to persuade them of the need always to be prepared, and their subsequent victory seemed to bear him out. Michelangelo focused on a group of soldiers who are desperately climbing out of the river, pulling on their clothes and armour. He thus transformed the commission into a 'battle of nude men' – even if their immediate battle was only to get dressed. It could almost illustrate a chapter on the subject of panic from Poliziano's *Miscellanea* (1489), in which 'panic terrors' are said to be tumultuous confusions and mad fears that turn limbs to water.[92] In the background, Michelangelo would probably have shown soldiers scrambling on to horses.

Many critics have been perplexed as to why Michelangelo chose such a seemingly undignified subject, something that verges on being a genre scene. From at least the time of Vasari, the principal explanation has been that he chose the subject for purely formal reasons, because it allowed him to demonstrate his knowledge of the most fashionable subject in art, the male nude. Vasari said that Michelangelo made all the nudes for the *Battle of Cascina* in different positions because he wanted to show what an accomplished artist he was.[93] Modern art historians have tended to agree. The subject of battling nudes 'had no social or iconographic justification; it was simply art for art's sake'.[94] An alternative account has been offered which takes the iconography more seriously, but is still rather vague: the scene demonstrates the need to be well prepared.

Although there is a certain amount of truth in both these explanations, the *Battle of Cascina* would have had much deeper *religious* resonances for at least some of Michelangelo's contemporaries. It closely resembles a scene of the resurrection of the dead, when skeletons and bodies emerge from fissures in the ground or, more rarely, rise out of the sea (representing those who drowned) and are then 'clothed' with flesh, in preparation for the Last Judgment.[95] Above all, the *Battle of Cascina* would have recalled a vision seen by the Old Testament prophet Ezekiel which

was regarded as a prefiguration of the resurrection of the dead. Ezekiel, who is one of the seven prophets depicted by Michelangelo on the Sistine Ceiling, sees a valley strewn with dry bones which are miraculously clothed in flesh and restored to life: '. . . and the breath came into them, and they lived, and stood up upon their feet, an exceeding great army' (Ezekiel, 37:10). The clothes that Michelangelo's bathers put on suggest that they are actually covering themselves in flesh, for they have a peculiar, skin-like transparency. There are other allusions to the resurrection. A pair of hands rises out of the water and further along the river bank a man reaches down towards someone who we can't see and who must therefore still be underwater; both these motifs suggest that drowned figures are resurfacing. The *Battle of Cascina* would thus say to Michelangelo's contemporaries: be prepared to be judged – and either saved or damned – at each and every moment of your lives. A statue of Christ the Saviour, by Andrea Sansovino, was intended to be placed between the two frescos, further underscoring the theme of resurrection.

Only a full-scale cartoon was completed, but this was put on display, and studied avidly by other artists. The main figures would have been about eight feet high.[96] Sadly, the souvenir hunters got to work and the cartoon was progressively 'torn in pieces, like Dionysus, by its admirers',[97] with no portion surviving beyond the seventeenth century.

All that remains of the planned fresco are a few figure studies by Michelangelo, drawings and engravings of details by other artists, and a painting of the main section by Bastiano da Sangallo which was commissioned by Vasari and executed in around 1542. Sangallo's painting was based on a drawing of the cartoon made when it was still intact. As far as one can judge, the original was an inventory of straining and twisting postures, with each figure strangely disconnected from the others. It has often been described as a 'forest of statues'. The independence of the individual figures was accentuated in the final cartoon. In the early drawings there is much more joint activity, and the figure groups often have a close-knit, triangular structure. One drawing shows two men lifting up a third so that he can see far into the distance – a motif that was quickly abandoned. The disconnection of the figures increases the sense that each warrior is about to be 'judged' individually, rather than as a group. By the same token, the intensified individuality diminishes our sense that this could ever be a unified army.

The most advanced drawing, and the one that is closest to the probable appearance of the lost cartoon, shows a man from the back,

holding what appears to be a spear (Plate 8). It is drawn in soft black chalk, with the white paper and touches of white body colour used for highlights. This is anatomy as seen in a waking dream. The muscles, particularly those strange clumps picked out with white highlights on the right shoulder and shoulder blade, float in and out of our consciousness. Leonardo proposed that a good way of inventing images would be to look at damp patches on walls, and there is an amorphous, meteor-ological feel to this back (as the soldier has just emerged from the water, he would indeed still be wet). The muscles clustered together on the right shoulder swell up like cloudy blisters. The pressure from within this body, inflating it to bursting point, is almost unbearable. The body is sheathed in Michelangelo's trademark rippling, unbroken contour lines. You feel that these lines do not delineate muscle and skin, but the meniscus of muscle and skin – the thin, seamless film of water that momentarily sheathes the head of swimmers when they come up for air. As a result, the tautness of the skin has a fragile perfection. One pinprick, one scratch, one prod anywhere and, you suspect, this torso will burst.

Few of Michelangelo's anatomical drawings survive, and most are fairly unremarkable representations of the superficial muscle between the bones and skin. But there is also a striking study of sections of nude bodies which has been assumed to be a study for the *Battle of Cascina*, but may be from even earlier.[98] The drawing shows straining bodies and twisting arms, and yet they bristle with what might almost be acupunc-ture needles. They are in fact lines marking particular muscles, and each is terminated by a specially designed abstract symbol. But the symbols resemble the fletching of an arrow that is embedded in the flesh, and where the lines meet the flesh there is a slight blob, as though it had only just pricked the skin.

This drawing, and other proportion studies (Plate 13), recall medieval astrological images in which a naked male body will be transfixed by rays emanating from the planets. The points where they touch the body indicated where blood-letting should be performed. In such images man was sometimes envisaged like St Sebastian, a 'victim or martyr, fettered, helpless, pierced as if with arrows by the rays of the twelve constellations, his body divided into segments each of which belongs to a given planet or star'.[99] The fate of Michelangelo's naked warriors hangs in the balance. We cannot tell if they are being 'needled' into action or inaction, fertilised or poisoned by their godlike creator and judge. Here Michelangelo seems to be imagining himself in a predatory relationship

with his own creations, and the result is an intensified dynamism: right from the very start of the creative process, he goads them simultaneously into life and into death. Small wonder if they appear to be on the brink.

IN FLORENCE IT APPEARS that artists began to study anatomy, and to depict battling nudes, almost simultaneously. It can hardly be an accident that both these phenomena also coincided with a revolutionary change in the image of the artist – and of warfare.

I have already argued that Pollaiuolo's engraving, *Battle of the Nude Men*, implicates the artist-anatomist as a key protagonist. He is not an 'objective' observer, but an active participant. Even before the naked combatants have been wounded, their bodies have been penetrated by the artist's own weapons, for Pollaiuolo has 'searched out' their muscles individually, and has brought them to the surface so that each figure looks as though he has already been flayed. Pollaiuolo, the first artist-anatomist, declares war on the human body at the very moment that he asserts its centrality and vitality, for it is only in the midst of naked combat, with sinews straining and blood pumping, and with violent death imminent, that the body can be displayed in all its anatomical glory. The violence inherent in the creative act is thematised in other ways. Cutting is central to the artistic process of engraving, as well as to the agricultural process of ploughing (there are furrows in the ground where the men fight).

In Pollaiuolo's print we find the germ of an idea that would find its richest articulation in the art of Michelangelo. The implication is that for an artist to prove he is at the forefront of anatomical research is the artistic equivalent of achieving military glory. Nowadays, we are accustomed to thinking that the highest praise for contemporary artists is to call them 'cutting edge': for Picasso, the archetypal 'avant-garde' artist, a picture was 'a sum of destructions'. But it was Michelangelo – armed with a surgeon's knife in one hand and a sculptor's chisel in the other – who gave real currency to the notion that the creation of art might involve violence.

An important measure of artistic achievement in the Renaissance was the level of 'difficulty' that had been overcome. Lorenzo de' Medici, in a commentary on his own sonnets, had argued that the fourteen-line verse form is the equal of all others because of its *difficultà*, and painting, sculpture and architecture were routinely praised in similar terms. Few things were more 'difficult' than dissecting a human body and then

trying to emulate the ancients by making sense of it. Vasari begins his final summation of Michelangelo's art by stressing that he was 'much inclined to the labours of art', and succeeded in whatever he did, no matter how difficult. Anatomy is the first of these great 'labours' to be mentioned: 'in order to be entirely perfect, innumerable times he made anatomical studies, dissecting men's bodies in order to see the principles of their construction and the concatenation of the bones, muscles, veins and nerves, the various movements and all the postures of the human body'.[100]

Vasari emphasises the intellectual 'difficulties' of this particular labour, but the physical challenges of anatomical study were probably even greater, and certainly better known. The lack of preservatives meant that corpses putrefied extremely fast, especially the abdomen. To slow down putrefaction and to reduce the smell, dissections were generally performed in winter and sometimes out of doors.[101] Every single body part had to be collected and placed in a basin, and at the end of the operation all the pieces were placed in a chest and returned to the relevant church authority for burial – that is, if the body had not been stolen.[102] A high proportion of Renaissance anatomical studies focus on the muscles because these were the slowest parts to decompose, apart from the bones.[103]

Leonardo had warned the aspiring anatomist of the hardships he could expect: 'if you should have a love for such things you might be prevented by loathing and if that did not prevent you, you might be deterred by the fear of living in the night hours in the company of those corpses quartered and flayed and horrible to see'.[104] Even though the physical demands were if anything greater than those placed on sculptors during the course of their work – which led Leonardo to condemn the art of sculpture as mere manual labour – he seems to have revelled in the insalubrious aspects of anatomical study. Even grave-robbing could be treated as a heroic caper. In Andreas Vesalius' pioneering anatomical treatise *De humani corporis fabrica* (1543), the author boasts about having to spend the whole night outside the gates of Louvain because he had gone out very late to rob the grave of a condemned man who had been buried that day; in the treatise itself the initial letter 'I' incorporates a scene of nocturnal grave-robbing. Later in the century, the Dutch painter and engraver Hendrick Goltzius showed incredible devotion to duty. When in Rome in 1591 during a famine, with corpses rotting away in the streets, Goltzius 'found himself drawing in places where the stench

of the dead bodies brought him near to fainting, such was the fervour with which he had thrown himself into his studies'.[105] The artist-anatomist often seems the equivalent of today's war photographer, a fearless witness to the unspeakably horrible. According to Condivi, Michelangelo eventually gave up dissecting corpses 'because his long handling of them had so affected his stomach that he could neither eat nor drink salutarily'.[106] He could almost be an old soldier, finally forced to give up active service.

Equally challenging, though for rather different reasons, was the dissection of animals. The smaller mammals – pigs, dogs and apes – were often cut open while they were very much alive. Michelangelo's anatomist friend Realdo Colombo specialised in vivisection and actively promoted the practice, favouring young dogs for the purpose. The engraved initial letters in Vesalius' *De humani corporis fabrica* show chubby putti dissecting a live pig and doing a Caesarean section on a pregnant dog, while the title page engraving of a public (human) dissection includes a live monkey and a dog among the bystanders. Vesalius admits to vivisecting pigs, dogs, cats and apes.[107] We are told by Vasari that Michelangelo wore dogskin boots, and it is perfectly possible they were made from the skins of animals he had personally flayed.

The practice of vivisection may have influenced the rather bewildering iconography of Michelangelo's unfinished statue, the *Dying Slave* (Plate 12), where the lineaments of a live ape can be discerned squatting behind the slave's thighs. He probably intended to carve an ape at the back of the unfinished *Rebellious Slave*, for a sizeable block of rough marble remains. Condivi said that these figures represented the liberal arts, painting and sculpture, and that the death of Julius II (for whose tomb the statues were destined) meant the death of the arts which he had patronised. The ape is often interpreted as a symbol of the visual arts, in so far as figurative art is said to be the 'ape' of Nature. An objection to this reading is that allegories of the visual arts were always clothed female figures – of the kind that would later appear on Michelangelo's own tomb constructed after his death in Santa Croce, Florence. But here he may have been trying to modernise such allegories. The ape's presence, together with a suffering male nude, may have reminded viewers of the importance of dissection to modern art, particularly to the art of Michelangelo. Apes were very widely used in dissection (by Galen as well as by his modern followers) due to their anatomical similarity to men.

Michelangelo could thus be making an analogy between the ape, doomed to be tied down to a table and effectively tortured to death in the cause of art, and the bound naked slave twisting in his own death throes. He thus alerts us to the meticulous study of Nature on which modern art is based, yet also suggests the complicity of the artist in cruelty. Similar thoughts may have prompted Leonardo to write a 'riddle' in around 1499 where we have to say what this statement refers to: 'Alas! I see our Saviour crucified once more.' The solution to this riddle is 'sculpture', by which he means crucifixes.[108] Leonardo implies that there is an intimate relationship between real and depicted violence in sculpture, and that the sculptor re-enacts the crucifixion as he carves or models Christ's wounds. If he is an artist-anatomist, he will have 'wounded' many corpses in the act of dissection.

That these ideas were countenanced is proved by a tale told by Vasari of the north Italian painter Francesco Bonsignori (c. 1460–1519), and his attempt to paint a 'realistic' picture of the martyrdom of St Sebastian. In order to do this, Francesco used as a model a handsome porter with a fine physique whom he tied up in his studio. But his patron, the Marquis of Mantua, Francesco II, a famous mercenary commander, thought the porter's body too relaxed, and with Francesco's permission, offered to help him make a perfect figure. So the next day, the Marquis rushed into the studio, ran up to the bound porter with a loaded crossbow, and cried out 'Traitor, prepare to die!' – whereupon the porter 'struggled in a frenzy of terror with the ropes wherewith he was bound, and made frantic efforts to break them'. Only then did he really look like someone who was about to be shot with arrows, and only then could Francesco paint a convincing picture.[109] This colourful anecdote has a strange plausibility as Mantegna (1430–1506) had been court painter to the Marquis in Mantua. His funerary chapel included a severe bronze self-portrait bust, its features furrowed by a bellicose scowl. A Latin inscription identifies him as 'Aeneas' Mantegna, thus allying him with the founder of Rome. His warlike demeanour alludes to the profession of his employer, while also suggesting that the artist's exploits can be just as aggressively heroic.[110] In Mantua, art making was not for the squeamish.

A few years after Michelangelo's Slaves, a satirical woodcut appeared, possibly designed by Titian, in which three apes mimic the doomed writhing protagonists of the Laocoön, the most revered antique representation of struggling figures. The purpose of this parody may have

been to show what the heroic bodies of antiquity would have looked like had they corresponded in every detail to anatomical knowledge derived, like Galen's, from the dissection of apes.[111] Once again, though, it also points to the real suffering, meted out by the artist, that may underpin depicted suffering. It might be argued that it is anachronistic to imagine that anyone at this time would care about the fate of animals, but St Francis of Assisi cared about them, and the wealthy sometimes made tombs for favourite pets. Leonardo continually bewailed man's cruelty to animals and is said to have bought caged birds so that he could release them. He only once practised vivisection – on a frog.[112]

THE PRACTICE OF DISSECTION does seem to have contributed to the pugnacious image of the artist, especially in the case of Michelangelo. An anonymous account of a controversial dissection undertaken by Michelangelo in the early 1500s casually mentions that he had just taken part in a fight, thereby implying that the two activities were of the same ilk:

> Michelangelo, when he was interdicted for the shedding of blood of one of the Lippi, entered into a crypt, where were many deposits of dead, and there he made anatomies of many bodies and cut and gutted them, among which happened to be one of the Corsini, because of which there was a great outcry made from the family . . . And there was made a call to Piero Soderini, then gonfaloniere of justice of about which he laughed, seeing that it was acquired for his art.[113]

Michelangelo was lucky that Soderini could laugh off this act of body-snatching.[114]

Other artists were more physically violent, and others also destroyed their own work when they were frustrated or angry, but no one else imagined their creative self in such a variety of aggressive ways.[115] We have already noted Michelangelo's early self-image as an archer, and his implicit rivalry with David. This suggests a deep-seated need to possess destructive as well as creative powers. It is something wholly new in the history of art, and it informs Michelangelo's study of anatomy. With anatomical study, the artist has to desecrate – or sacrifice – a body in order to create a convincing representation of one.

Some of Michelangelo's contemporaries understood violence to be central to his creativity. He was not only regarded as *terribile* (frightening,

awesome) in his dealings with other people (an adjective most commonly applied by his contemporaries to the warring Pope Julius II) but also seems to have been regarded as *terribile* in his dealings with his own artworks. A woodcut illustration in Sigismondo Fanti's *Triomfo di Fortuna* (Venice, 1517; Fig. 10), an astrological lottery book, shows Michelangelo at work. The sculptor is depicted as a naked wildman, clad only in a loincloth, astride a half-finished statue of a reclining female figure, with the marble block placed directly on the floor. His knee digs into her abdomen, and he holds his hammer behind his head, about to bring it down on a chisel placed between her breasts and throat. The marble woman seems to recoil from the impending blow, her head forlornly turned to the side. The figure is loosely based on the lugubrious figure of *Dawn* for the New Sacristy, on which Michelangelo was working at the time. But the illustrator has made her predicament seem even more desperate by not depicting any arms. Indeed, the 'hidden' arms, together with the facial expression and writhing body language, recalls the bound male nude the *Rebellious Slave* (1513–16).

The whole *mise-en-scène* of this woodcut ultimately derives from Roman images of the god Mithras killing a sacrificial bull with a sword.

Fig. 10: Anonymous illustration from Sigismondo Fanti's *Trionfo di Fortuna*, 1517 (woodcut)

In the Renaissance, the meaning of this image was unknown, and it was assumed to be a symbol of good conquering evil.[116] But this representation of Michelangelo is also a fundamental reworking of the Pygmalion myth, for here the female sculpture appears to be the unwilling victim of her predatory maker. Whereas Pygmalion merely fell in love with his statue, and his affection was reciprocated, Michelangelo seems to love *and* hate his creation. The angle of the chisel and the full swing of the hammer suggest he is not only perfecting the sculpture, but also putting a stake through its heart. As such he is making love and war with the human body. The form and movement of the sculpture is determined by its fear of its maker.[117]

Michelangelo himself appears to have seen the relationship between the artwork and the spectator in antagonistic terms. His only depiction of people interacting with a statue is one of mutual confrontation, involving attack and defence. In a drawing known as the *Archers* (*c.* 1530; Plate 19), a group of airborne naked archers (seven men, two women) shoot at a statue of a naked herm that defends itself by holding up a shield.[118] The herm (an armless human torso rising out of a stone pillar) is static and upright, but the twisting postures of so many of Michelangelo's figures – such as the Cascina bathers – can be understood as a form of evasive action taken by the unshielded.

Towards the end of his life Michelangelo repudiated the visual arts in his poems, saying that sculpture constitutes a 'grave danger to the soul' (no. 282), and that he had made of art 'an idol' (no. 285). These sentiments are usually said to be his response to the Counter-Reformation. But his muse was always an iconoclastic one; his particular genius was to harness this energy and make it central to his own creativity. He creates vast statues of male nudes, but because they are 'graven images', he has to chastise as well as make love to them.

Michelangelo's aggressive self-image was developed in his poetry. Around 1509, when he was working on the Sistine Ceiling, he wrote a scabrous and self-lacerating poem to his friend Giovanni de Pistoia complaining about the task. It is back-breaking work, made all the worse by his being a sculptor rather than a painter. At the end of the poem, he expresses his frustration by using bow and gun imagery:

> Dinanzi mi s'allunga la corteccia,
> e per piegarsi adietro si ragroppa,
> e tendomi com'arco soriano.

> Però fallace e strano
> Surge il iudizio che la mente porta,
> Ché mal si tra' per cerbottana torta.
> La mia pittura morta
> Difendi orma', Giovanni, e'l mio onore,
> Non sendo in loco bon, né io pittore (no. 5, ll. 12–20)

[In front my hide is stretched, and behind the curve makes it wrinkled, as I bend myself like a Syrian bow. However, the thoughts that arise in my mind are false and strange, for one shoots badly through a crooked barrel. Defend my dead painting from now on, Giovanni, and my honour, for I am not well placed, nor indeed a painter.]

Although Michelangelo is being self-deprecating, he does nonetheless seem sure of his *destructive* power. He is not a *broken* weapon, just an exotic, semicircular bow and an inaccurate gun. Indeed, the figure on the Sistine Ceiling whose physique most resembles a Syrian bow is far from being a crock: the *ignudo* beside the Persian Sybil, mentioned earlier, has an extraordinary semicircular back. As for guns, most were inaccurate anyway, and a projectile from a crooked barrel may still hit something, particularly when the target is as big as the Sistine Ceiling. Another poem of 1531 employs a topical military metaphor to express the strain Michelangelo feels in the presence of his beloved. He observes that if his beloved so much as smiles at him or greets him in the street:

> mi levo come polvere dal foco
> o di bombarda o d'altra artiglieria . . . (ll. 51–2, no. 54)

[I explode into the air like gunpowder touched by fire in a cannon or some other piece of artillery.] The simile suggests both power and impotence, aggression and humility. But once again, Michelangelo is confident of his destructive power. His exploding self will cause havoc.

Michelangelo had more than an amateur interest in military matters: he took far more pride in being a military architect than he did in being an artist. In 1529, when Florence was besieged by pro-Medici forces, the Republican government, which had come to power only two years earlier, put Michelangelo in charge of designing and repairing the fortifications of Florence. To this end, he made a special visit to Ferrara to examine their new, state-of-the-art fortifications, artillery and munitions. He was also a close friend of the architect Giuliano da

Sangallo, who with his brother Antonio belonged to the first and most important of a group of Italian 'fortification families'.[119] In 1545, during the course of an argument with Antonio, Michelangelo declared: 'I don't know much about painting and sculpture, but I have gained great experience of fortifications, and I have already proved that I know more about them than the whole tribe of the Sangallos.'[120] His own designs, which show artillery fire erupting from every angle, were much more suited to offensive than defensive action, due to the exposure and isolation of the corner bastions (see Fig. 12).

In some dialogues compiled at around the same time by Francisco da Holanda, Michelangelo boasts that he single-handedly kept the besieging army at bay, and he also expostulates on the usefulness of drawing in war, because it enables maps and plans to be made. He goes on to say that 'the great captain Pompey drew in excellent style, but was vanquished by Caesar as a better draftsman'. He concludes with a breathtaking assertion: 'And what country under the sun is there more warlike than our Italy, or where are there more continual wars and great routs and fiercely pressed sieges? And what country is there under the sun where painting is more esteemed and prized?'[121] Michelangelo is here pre-empting Harry Lime's famous remark in the film *The Third Man*, in which a spy observes that although Italy was continually at war, it produced the Renaissance, whereas the ever-peaceful Switzerland only came up with the cuckoo clock.[122] Michelangelo tried to get the best of both worlds, by constructing military fortifications *and* by metaphorically arming the artist.

Michelangelo's fervent interest in anatomical study and military matters would have made perfect sense to at least some of his Florentine contemporaries. In the spring of 1546 his great supporter, Benedetto Varchi, delivered a lecture to the Florentine Academy on the hierarchy of the arts according to their nobility, and in the highest position he placed warfare, medicine and architecture.[123] Michelangelo's skill in anatomy and in military architecture meant that he fitted the bill better than almost anyone. More generally, we can see Michelangelo wrestling with a conundrum that was frequently discussed in Italy at this time – whether skill in arms or literary pursuits was more admirable. It was a popular subject because of concerns that an excessive attention to learning and the arts had contributed to Italy's military humiliations.[124]

★

SO WHY, THEN, WAS aggression an integral part of the creative act for Michelangelo? I have already mentioned religious iconoclasm and qualms about 'graven images', but part of the answer also lies, I believe, in an assumption commonly held during the second half of the fifteenth and the early sixteenth century that the age of chivalry and heroism was dead. Of course, in most periods you can find someone lamenting the end of the age of chivalry (just as in the history books the middle classes are always rising). Even in antiquity there were complaints about the 'cowardly' use of weapons that kill from a distance, such as bows and arrows and the stone-throwing *ballista*. Pliny, in the same books of his *Natural History* that are devoted to the history of ancient art, denounces arrows as 'the most criminal artifice of man's genius, inasmuch as to enable death to reach human beings more quickly we have taught iron how to fly and have given wings to it'.[125]

But there really was a technological and tactical revolution in the late Middle Ages that brought about the demise of heavy cavalry and of single combat, and which had catastrophic results in Italy. With Michelangelo, aspects of this endangered chivalric code are honoured, and given a new lease of life in the visual arts. As early as the *Battle of the Centaurs* he is presenting rival forms of combat. The two 'heroic' figures in the middle who square up to each other suggest a chivalric ideal of single combat; and yet their 'heroic' duel is about to be interrupted and engulfed by the undignified scrum that surrounds them.

The centrepiece of a medieval battle was a clash of mounted and heavily armed nobles, each identified with his own heraldic device. They reached their operational peak around 1450, but by 1530 cavalry accounted for only one-eleventh of the French army and one-twelfth of the Spanish, while military theorists such as Machiavelli argued that the proportion should be one-twentieth. The decline of the heavy cavalry began after the deployment of the longbow by the English, initially at the Battle of Crécy in 1346. The next important development came in the second half of the fifteenth century when Swiss mercenaries organised themselves into tightly massed phalanxes of pikemen that could resist cavalry charges and mount offensives. They were as highly mobile as they were lightly armed. The last nail in the heavy cavalry's coffin was the development of portable cannon and firearms in the late fifteenth century. Unlike longbows, which required great strength and years of practice in order to master them, firearms could be used by almost anyone. They required about a day's training.

In the sixteenth century, heavy cavalry only had a ceremonial function, functioning as prestige guards and asserting a ruler's nobility. The potential of the new weaponry was most dramatically demonstrated in Italy. In 1494 the 18,000-strong army of Charles VIII, King of France, equipped with handguns and forty siege guns, blasted its way down the Italian peninsula, on the pretext that Charles was staking his dynastic claim to the Kingdom of Naples. For the next thirty-five years, Italy was Europe's principal theatre of war. Firearms caused far more casualties and changed the nature of wounds: they broke bones and caused burns that resulted in the loss of limbs due to gangrene. The Florentine historian Francesco Guicciardini believed that firearms had brought about a new kind of total war in which civilians as well as soldiers suffered dreadfully and continually.[126] The 'Italian Wars' were not continuous, but even so, significant parts of the peninsula were occupied by foreign powers, or became client states. Italians were appalled by the political and military humiliation of their country. And what made the humiliation even worse was the simultaneous arrival in Italy of syphilis. The disease was first observed in 1496, and was called – much to the invaders' annoyance – the *mal francese*, the French disease.[127]

The armour of mounted soldiers became increasingly elaborate to protect the wearer against these new weapons of war. But it was of little avail, not least because it became extremely heavy. Benedetto Ascolti, a Chancellor of the Florentine Republic, had complained in a dialogue written in 1459–64 that cavalrymen could not fight for an hour without collapsing under the weight of their armour.[128] Montaigne, writing in 1580, believed that modern armour was more of a hindrance than a help: 'Although we do see a man killed occasionally for want of armour, we hardly find fewer who were killed because they were encumbered by it, slowed down by its weight, rubbed sore or worn out by it, struck by a blow glancing off it, or in some other way.' It was so heavy that few soldiers wore armour on the march: it had become 'an intolerable burden to us'.[129]

Leonardo's *Battle of Anghiari* seems to have shown the last hurrah of mounted cavalry. The centrepiece is a swirling scrum of heavily armed and mounted nobles, absurdly dressed up to the nines in exotic armour and trimmings. From a copy by Rubens (admittedly made at second hand), it already looks slightly ridiculous, a Keystone Cops pile-up of men and horses. The horses appear to be collapsing into each other and join in the battle by biting the other horses. The warriors' legs are not

covered by armour, but this only serves to make them appear more top-heavy. In Michelangelo's own art, ordinary clothing is given the density and weight of modern armour, as we can see in the Sistine Ceiling Prophets and Sybils, and in *Moses*. When he does depict armour, it is carefully rationed and does not cover the entire body (*Giuliano de' Medici*), almost as if a complete suit of armour would be tantamount to live burial.

To many intellectuals and members of the ruling classes, the irresistible rise of the infantry meant that war was becoming less honourable, because it was more plebeian and anonymous. The numerous laments about the end of chivalry complained about the ability of untrained peasants to kill the bravest knight anonymously and/or from a distance. Petrarch was appalled by 'balls of iron which are ejected by fire with terrifying thunder', and thought the use of such weapons dishonourable: 'A valiant man-at-arms desires to encounter the enemy face to face, which those who shoot avoid.'[130] The complaints reached a crescendo after the mid-fifteenth century, when infantry increasingly prevailed. Matteo Maria Boiardo, in his chivalric romance *Orlando Innamorato* (1482/3), said it was better to speak of arms than to wear them 'because that worthy, honoured art / has been made common in our time'.[131]

The new style of warfare was showcased and perfected in Italy in the years after the French invasion of 1494–5. As the French army knocked out castle after castle with swift and concentrated deployment of siege-guns, the Italians were astonished by the superiority of their field artillery and also of their handguns. The French were forced out of Italy in 1495, defeated by the Marquis of Mantua, encouraging some to regard it as an ephemeral event, but when they returned in 1499, and the Spaniards conquered Naples in 1501, the campaign of 1494 began to be thought of as an epochal event.[132] Decadence, cowardice, sinfulness, and excessive indulgence in the arts and in sodomy were all blamed for the Italians' defeat, but the new weaponry was also held to have contributed significantly to the country's parlous state.[133]

The nostalgia for a largely mythical 'age of chivalry' was no doubt increased by the fact that forty years prior to the French invasion Italy had been the most peaceful area in western Europe (the Peace of Lodi, signed by Venice and Milan in 1453, had quietened things down considerably).[134] The Italian Wars spawned the first pacifist movement, with Erasmus and Castiglione among its adherents. Machiavelli thought the Italians were unsuited to the new kind of warfare precisely because

they were brilliant individualists, rather than team players: 'Look at the duels and the military skirmishes, how the Italians are superior in strength, in skill, in inventiveness; but when it is a matter of armies, they do not compare.'[135] His reference to duels is only appropriate, for such was the disdain of firearms that until the latter half of the seventeenth century personal duels were almost always fought with swords.[136] Castiglione, in *The Courtier*, tried to keep the chivalric ideal going. The courtier is urged to separate himself from the main action in a battle so that he can do something heroic on his own and in a highly conspicuous way – precisely what we observed in the *Battle of the Centaurs*.[137]

Michelangelo and his supporters did their best to present the artist as an all-conquering man of action who with 'boldness and courage' engages in single combat and 'duels' with huge blocks of marble and with colossal projects. He alone 'had courage enough' to carve the *David*, and while doing so, he compares himself favourably to David; he dissects corpses *ad nauseam*, in the face of appalling difficulties. He surpasses all other artists, ancient and modern; he thinks oil painting (as opposed to fresco) is a woman's art; he despises Flemish painting because it appeals to women, 'especially to the very old and the very young'.[138] Michelangelo was also obsessed with restoring his family to their 'former glory', and his professional distinction enabled him to do so.[139] Italy may have been weak militarily, but its most powerful artist was on hand to fill the breach.

In Holanda's dialogues Michelangelo laments the loss of an earlier age of chivalry, though he is resigned to its passing. He says that great artistic skill was needed to design traditional siege weapons and instruments of war, but 'since this evil iron age no longer uses these weapons but rejects them', artistry now has to be deployed in designing guns and cannon.[140] In some respects, Michelangelo seems to have been aware that he was operating in an anti-heroic or post-heroic age. Where his own artistic weaponry is concerned, its nobility is not always obvious. When he imagines himself as a gun with a crooked barrel, or exploding like gunpowder in a cannon, these are not especially dignified analogies, although they still, as I have said, suggest great destructive power.

The heroic, mounted warrior had been a key component of fifteenth-century Italian art. But while this chivalric tradition climaxes – ferociously – in Leonardo's *Battle of Anghiari*, in Michelangelo's work there is a conspicuous absence of people sitting authoritatively on horseback. When horses do appear they tend to be involved in something

disastrous and undignified, or else they are marginal figures. They do not increase a person's stature, or give them an obvious advantage. This is particularly remarkable as Vasari tells us that Michelangelo was not only especially fond of dissecting horses, but loved owning horses.[141]

The warriors in the *Battle of Cascina* would also have sent out mixed signals. At this stage in the proceedings they are on foot, a detail that would have suggested the conventions of modern warfare, as much as of antique warriors or the 'resurrection of the flesh'. For the viewer in 1504, their nakedness would recall an essential fact of modern life. In the field of battle, no amount of individual strength, or nobility, or armour would protect the warrior for long.

There is huge bathos in Michelangelo's naked warriors. We can see them as a bunch of muscular misfits floundering about on the river bank. It is as if the flower of medieval knighthood had been unexpectedly dumped down in the modern world. All that is left to them is their heroic physique and scale, their vast and exclusive occupation of space, and their singularity. We look on the protagonists with a certain amount of pity, as though they were martyrs going to a grisly fate. In 1504 they would be pike and cannon fodder – and ultimately, perhaps, if their bodies were not too mutilated, raw material for the artist-anatomist. The simultaneous topicality and antiquity of the subject of battling nudes helps explain why it was of such 'compulsive' interest to Florentine artists in general, and to Michelangelo in particular.

4. Crowds

I have no friends of any sort and want none.

> Michelangelo, letter to his brother Buonarroto, Rome, 1509[1]

MICHELANGELO WAS FAMOUSLY secretive and solitary. Even though he certainly had close friends and loyal studio assistants, he was a celebrated loner and the historian and papal physician Paolo Giovio, writing the first biographical sketch of the artist in the late 1520s, criticised him for discouraging studio visits, and for being less sociable than Raphael or Leonardo. For an extremely busy man, it is perhaps not surprising he did not want to be disturbed, but many of his contemporaries did regard his behaviour as eccentric.

Condivi tried to justify his master's conduct in the most exalted terms. He wrote that 'the love and continual practice of virtue made him solitary and afforded him such delight and fulfilment that the company of others not only failed to satisfy him but even distressed him, as if it distracted him from meditation, whereas he was never (as the great Scipio used to say of himself) less alone than when he was alone'. He added the proviso that Michelangelo has 'gladly retained the friendship of those from whose enlightened and learned conversation he could benefit and in whom there shone some ray of excellence'.[2] He gives an extremely impressive list of cardinals, aristocrats, 'honoured gentlemen' and even a Pope with whom Michelangelo was friendly – but probably not on a day-to-day basis. Solitude was thus a heroic lifestyle choice that could only be sacrificed on rare and important occasions.

It is worth bearing this cult of solitude in mind when we look at the Sistine Ceiling (1508–12) for it can enhance our understanding of some of its most original features. There is a marked tension in the ceiling caused by Michelangelo's attraction to lone figures, and his distrust of the

crowd and the group. This tension culminates in the breathtaking scene representing the *Creation of Adam*, for here the first man is depicted alone on a mountainside. At the moment of creation he is confronted not only by God, but by a seething entourage which envelops and clings to the deity. This entourage appears to be an alarming foretaste of the multitudes that will issue from the union of Adam and Eve.

The way in which Michelangelo pits individuals against crowds is in striking contrast to what we find in the fifteenth-century frescos that line the walls of the Sistine Chapel: before we can get the full measure of Michelangelo's achievement we must turn our gaze to these walls.

WHEN WE ENTER the Sistine Chapel, one of the first things we notice is the crowds. I am not simply referring to the hundreds of other sightseers with whom we must compete to get a good view and – if we're very lucky – a bench to sit on, but to the hundreds of figures who fill the frescos that run continuously around the walls and that extend over the whole ceiling (Plate 11). The real and the painted crowds in the Sistine

Fig. 11: G. Tognetti, *Conjectural Reconstruction of the Sistine Chapel before Michelangelo, looking towards the altar*

Chapel are not here in such numbers by accident. They are here because the chapel was specifically designed to accommodate as many people, and as much painting, as possible. It is a showcase and a forum for humanity – and the more the better. All in all, the presence of so many figures on the walls and on the ceiling makes a visit to the Sistine Chapel one of the most strenuous visual experiences in the world. Moreover, it is physically impossible to look up at Michelangelo's ceiling for long, and the initial exhilaration can quickly turn to frustration. The visitor, unless he is feeling penitential or masochistic, 'has no choice but to capitulate to the weight of numbers and renounce the exhausting sight'.[3]

This crowdedness is a basic but fundamental point. The Sistine Chapel was built and decorated during Michelangelo's childhood between around 1477 and 1484, on the orders of Francesco della Rovere, Pope Sixtus IV, and was dedicated to the Assumption of the Virgin Mary (Fig. 11). The structure incorporated the foundations of its medieval predecessor, the *cappella maior*. Ceremonial masses were held here, involving hundreds of officials and large lay congregations of distinguished visitors. It was also the place where the cardinals gathered in conclave to elect a new Pope. The high windows and thick walls meant that they could not be seen or overheard during their deliberations. The chapel was built to be secure and functional, rather than to look attractive or opulent: it was surmounted by projecting battlements, and the papal guard occupied the top floor, directly above the ceiling. The security of the papacy could not be taken for granted. For most of the fourteenth century the Popes had resided in Avignon because of fears for their safety in Italy, and from 1378 to 1415, following the return of Pope Gregory XI to Rome, there were two rival Popes (a period known as the Great Schism). Pope Sixtus was no pacifist. As work began on the chapel, he instigated the Pazzi conspiracy, a murderous *coup d'etat* against the Medici, and when this failed to get rid of Lorenzo de' Medici, he went to war with Florence (1478–80).

The chapel is built of brick, with internal cornices and window frames made of marble. A marble screen with bronze grilles separates the raised area near the altar, where the most important church dignitaries sat, from the rest of the chapel (originally, this screen was sixteen feet closer to the altar, but it was moved back behind the singers' balcony late in the sixteenth century). The screen, the pulpit, the altar and a marble bench running round all four walls are the only fixtures in what is otherwise a completely open space. The floor is unencumbered by columns, and the

walls, below the windows, are flat expanses divided only by two cornices.

The Sistine Chapel is a machine in which to do God's work. In its internal construction, there is a polemical primitivism – an attempt to return to the simple but effective piety of the early Church. Such austerity is unique in church architecture,[4] but this conscious revivalism is characteristic of the buildings erected by Sixtus IV.[5] The chapel's length is twice its height and three times its width. The proportions of the ground-plan are the same as those of the Temple of Solomon in Jerusalem, as given in I Kings 6. But whereas Solomon's temple had been lined with carved cedar, completely covered in gold, and decorated with gilded cherubim carved from olive wood also, the Sistine Chapel is filled with frescos enlivened with gold and silver leaf. Carving is confined to the cornices and the marble screen. The patterned floor, made from predominantly black and white marble slabs, is an adaptation of medieval Roman floors. The ceiling was a traditional arrangement of gold stars on a blue ground. If the decoration of the chapel prior to Michelangelo seems rather regimented, this is hardly surprising as it was complete in its entirety within about seven years.

The lowest section of the wall up to the first cornice is covered with painted *trompe-l'oeil* curtains of gold or silver brocade with, respectively, a white and red pattern, and decorated with the Rovere emblem, the oak tree. These hangings, separated by fictive painted pilasters, were probably meant to evoke an early Christian chapel.[6] Two continuous sequences of narrative frescos were painted in the zone above the curtains and below the windows by the leading painters in central Italy (Perugino, Ghirlandaio, Botticelli, Roselli, Signorelli). There are two cycles, depicting key episodes from the life of Moses (on the left wall, as we look towards the altar) and the life of Christ (on the right). The fresco cycles started and finished on the end walls, but the two frescos on the altar wall (and a frescoed altarpiece by Perugino) were later replaced by Michelangelo's *Last Judgment*. The two frescos on the entrance wall were restored in a different style in the 1570s. The cycles ran chronologically through the lives of Moses and Christ, with the earliest scenes shown on the altar wall. Altogether, there were six pictures on each wall, with two on each of the end walls, making a total of sixteen. They are as packed with people as the chapel was intended to be.

This may well be the most rigorously controlled and co-ordinated major fresco cycle ever carried out during the Renaissance, and the

consistency is all the more remarkable when we consider how many artists were involved.[7] Each fresco is organised more or less symmetrically around a central foreground scene. The principal figures are of similar size. Moses and Christ always look the same. Architectural features are approximately the same scale. Horizons are at the same height. Landscape backgrounds occupy roughly the same amount of space. The colour schemes and tonality are very similar. The light always falls from the direction of the altar wall, which originally had two windows. Perspective is the same. There is no foreshortening. The main distinguishing feature is that the six frescos on each of the long walls were divided into two triptychs, with the central picture given greater emphasis by being arranged around a prominent architectural feature.

There was little room for improvisation as each artist had to pack several scenes from the life into each fresco. Botticelli's contribution to the *Life of Christ* cycle featured four scenes, and on the opposite wall he had to squeeze in seven scenes from the early life of Moses. Altogether, the seven extant frescos of the life of Moses feature twenty-five episodes; those of Christ, twenty-three episodes. What we generally discern from the floor of the chapel are densely packed multitudes of anonymous standing figures (an average of about a hundred in each fresco) arranged around a more easily recognisable central scene. Even at the time, peripheral scenes would have been hard to read, especially those from the life of Moses, as the subject had not been thoroughly illustrated since early Christian times, and never so comprehensively. Explanatory Latin inscriptions above each fresco only indicate the general topic. Pope Sixtus, who was one of the leading theologians of his time, may have been the only viewer to recognise each scene.

Yet understanding every detail was surely not crucial, for the purpose of the frescos was to emphasise the institutional character and legitimacy of the Roman Church at a time when its authority was still shaky. They were selected to show the threefold authority of the Pope: as a priest, as a teacher and as a ruler. Inscriptions on the cornice explain that Moses is 'the bearer of the Old Law' (a reference to the Ten Commandments), while Jesus is 'the bearer of the New Law' (the tenets of Christianity). In keeping with this legalistic bent, no miracles were shown in the Christ cycle. Moses and Christ are shown as leaders of religious communities, with large numbers of participants. Early preachers in the Sistine Chapel frequently quoted Cicero's claim that 'we are not born for ourselves alone', and used it in a Christian context.[8] The community and the

greater good were paramount. Some of the ancillary figures do look out towards the viewer, and it is thought that they may be portraits of the Pope's friends. This glimmer of individualism does little to detract from the feeling that we are witnessing the pictorial equivalent of a stage-managed convention. They appear amiable rather than alienated. They are drawing us – and the figures in the frescos opposite – into the great family of believers.

The frescos directly above, flanking the windows, complement those below. Standing images of the early martyred Popes, larger than the figures below, are shown in chronological order, each standing in his own niche, like a coloured statue. This arrangement stresses the right of each elected Pope to be leader of the Church. They assume the role not so much of Moses and Christ, however, as of their right-hand men, Aaron and Peter, who perform a priestly function in the frescos. The lunettes (the areas flanking the high windows), which Michelangelo later filled with images of the Ancestors of Christ, may also have been painted. Over the frescos stretched the curved canopy of the ceiling, decorated with a repeating pattern of identical stars on a blue ground. Even the firmament, which spread out like a 'heavenly tent',[9] respected the institutionalised anonymity.

In around 1540, three decades after he had repainted the Sistine Ceiling, Michelangelo launched a sustained attack on Flemish painting during conversations recorded by Francisco da Holanda. But his criticisms apply just as well to the frescos on the walls of the Sistine Chapel, whose copiousness and realism were influenced by northern European art. Michelangelo knew this very well as he had copied northern prints while working in the studio of Domenico Ghirlandaio, who was responsible for two of the frescos in the Sistine Chapel. Michelangelo complains that Flemish painting

> will appeal to women, especially to the very old and the very young, and also to monks and nuns and to certain noblemen who have no sense of true harmony. In Flanders they paint with a view to external exactness or such things as may cheer you and of which you cannot speak ill, as for example saints and prophets. They paint stuffs and masonry, the green grass of the fields, the shadow of trees, and rivers and bridges, which they call landscapes, with many figures on this side and many figures on that. And all this, though it pleases some people, is done without reason or art . . . it attempts to do so many

things well (each one of which would suffice for greatness) that it does none well.

According to Michelangelo 'a man may be an excellent painter who has never painted more than a single figure', for this is the 'noblest object' of all: 'There is no need of more.'[10]

THIS IS THE RATHER indigestible cake for which Michelangelo had to provide some spectacular icing. The commission to paint the ceiling seems to have been mooted by Pope Julius II in 1506. Redecoration was necessary because major repairs had been carried out on the ceiling after a large diagonal crack appeared in May 1504, rendering the chapel unusable for the next six months. Initially, Michelangelo may have been disappointed by the commission, not simply because it confirmed the Pope's decision to suspend work on his tomb (Condivi would later refer to this saga as the 'tragedy of the tomb'), but also because it was a much less prestigious assignment. Prior to Michelangelo, painted ceilings tended to be made by artisan decorators following their own decorative scheme or one drawn up for them by artists and architects. The artist responsible for the first Sistine Ceiling, Pier Matteo d'Amelia, was a former assistant of Fra Filippo Lippi. It was also, of course, extremely arduous working on a large ceiling. The Sistine vault measures around 45 by 128 feet, has various kinds of curved surface, and is not entirely regular. It rises over 60 feet above the ground. In its way, it was to be as much of a logistical challenge as when Brunelleschi erected a dome over Florence Cathedral.

Nonetheless, in the last quarter of the fifteenth century, painted ceilings had become both more popular and more ambitious, and they must have made the existing Sistine Ceiling look very old-fashioned.[11] An exceptionally ambitious and innovative ceiling was commissioned in around 1479–80 by Cardinal Giuliano della Rovere – the future Pope Julius II – from Melozzo da Forlì, who was known for his skill at painting foreshortened figures and architectural backgrounds. The fresco cycle was painted in the apse of SS Apostoli, Rome, with which Giuliano was closely concerned.[12] In the vault, Melozzo depicted the *Ascension of Christ*, in which Christ stood on a cloud encircled by angels. Around the base of the vault stood the earthbound apostles. All the figures were steeply foreshortened, and the angels seemed to be circling upwards towards Heaven. The fresco does not survive, except for a few fragments, as the church was refurbished in the eighteenth century.

Pope Julius was obviously excited by the possibilities of ceiling paint-
ing, and his initial proposal to Michelangelo also featured apostles. In a
letter of 1523, Michelangelo explained that Pope Julius' first commission
had been for images of the seated apostles to be painted in the spandrels
(just below where the Prophets and Sybils now sit) and for the 'usual
decoration' to be applied to the rest of the vault. The 'usual decoration'
refers to another type of ceiling decoration that had recently become
popular, especially in Rome, since the discovery of the Golden House of
Nero – a coffered ceiling with compartments containing small narrative
scenes. A scheme with apostles would have complemented the images of
the Popes on the level below by stressing their apostolic preaching role.
It would also in some measure be a painted version of Michelangelo's
aborted sculpture project for the apostles for Florence Cathedral.

What were Michelangelo's qualifications for painting a ceiling? In a
letter of 10 May 1506, a Florentine master mason, Piero Rosselli, had
written to Michelangelo from Rome with news that the Pope had
received his drawings for the ceiling, but that the architect and painter
Donato Bramante, who was designing the new St Peter's, doubted
Michelangelo could succeed because 'he has not painted many figures,
and these figures especially are set high and foreshortened and it's quite
different from painting down below'.[13] Bramante, whose own archi-
tectural painting was influenced by Melozzo da Forlì's, was right to say
that Michelangelo had no experience in *painting* foreshortened figures.
Yet painted figures at the base of a vault were positioned no higher than
sculpted figures placed on the top of buildings, and in this respect
Michelangelo was admirably equipped.

The marble *David* was a full-length figure of a prophet initially
intended to be placed on top of the cathedral buttress, nearly 90 feet from
the ground. The highest statue in the earliest drawings for the *Tomb of
Julius II* (*c.* 1505) is almost 30 feet above the ground. In December 1506,
Michelangelo had started work on the bronze statue of *Julius II* to be
placed over the 60-foot-high portal of San Petronio in Bologna. In 1507,
the Pope visited the workshop in Bologna while Michelangelo worked
on the model, so he would have seen at first hand how the proportions
of his effigy had been adjusted to take into account the high location.
The statue was apparently three times life size, so it would have been
about the same size, and placed at a similar height, as the Prophets and
Sybils on the Sistine Ceiling. It is surely this experience that made
Michelangelo a suitable candidate to decorate the ceiling. When he

started painting, he had no difficulty with foreshortening; the principal problem was how to paint in fresco, which he had not used since his apprenticeship in the Ghirlandaio studio twenty years before.[14]

THE POPE'S INITIAL scheme for a series of apostles was quickly scrapped, however, and something even more ambitious was proposed. Many years after the event, Michelangelo claimed in a letter that he had warned the Pope the first scheme 'would turn out a poor thing', and when the Pope asked why, he replied that it was because the apostles themselves had been poor. The Pope immediately 'gave me a new commission to do what I wanted'.[15] It is unthinkable that in a chapel of this importance the Pope gave Michelangelo *carte blanche*, and did not vet his scheme. However, Lorenzo Ghiberti (1378–1455) said he was given a free hand to design the second door of the Florentine Baptistery, with its Old Testament scenes and flanking Prophets and Sybils, and there is little reason to doubt that the Pope gave Michelangelo a great deal of licence in devising and organising his material.[16] What he eventually created is a dynamic counterpoint between individual figures and narrative groups.

Michelangelo painted an imaginary architectural framework that seems to rise up far above the chapel, and he treated the areas of greatest curvature as continuations of the walls. This framework was influenced by Bramante's own monumental architecture and painted architectural decoration, and he may even have advised Michelangelo.[17] However, it is uniquely energised in a way that looks forward to Michelangelo's predatory architectural designs of the 1520s for military bastions (Fig. 12). The various sections abut each other like tectonic plates held momentarily in dynamic equilibrium. As the fictive stone is off-white, it seems both monumental and weightless, like a classical temple made from origami. Altogether Michelangelo created about 175 picture units, of ten different types. He stood on a gantry to paint, rather than lying on his back – a myth that was perpetuated in his own lifetime by Paolo Giovio, possibly to stress his squalid working conditions.

The ceiling's theological programme is for the most part conventional and complements the subject-matter of the walls. The areas beside and above the windows stress the universality of the Church. The curved lunettes and the concave triangular spandrels contain portraits of the Ancestors of Christ, and in between the spandrels seated on massive thrones we find various Old Testament prophets and pagan sibyls, who were all said to have foretold the coming of Christ. The bottom

Fig. 12: Michelangelo, *Project for Gate Fortifications*, 1528–30 (ink, 56.2 × 40.7 cm/22 × 16 in; Florence, Casa Buonarroti)

ledge of their thrones appears to cantilever out into the space of the chapel itself. In the four concave triangles spanning the corners of the vault are four Old Testament scenes of miraculous salvations: *David and Goliath, Judith and Holofernes*, the *Crucifixion of Haman* and the *Brazen Serpent* (Fig. 13).

The central narrative panels on the vault represent scenes from Genesis 1–3, and 6–9, the key historical period before the time of the Mosaic Law. There are nine large and small central narrative panels, framed like independent pictures, which are divided into three trilogies. The first trilogy, nearest the altar, represents episodes from the Creation; the second shows the history of Adam; and the third depicts the history of Noah, who was considered to be the 'second' Adam because he was the 'father' of the post-Flood world. The five panels in which God appears are situated over the presbytery, where the Pope and his entourage sat, and the scenes depicting fallen man appear over the part of the chapel reserved for less important visitors. Each of the five smaller narrative panels is framed by two pairs of naked men (*ignudi*, as

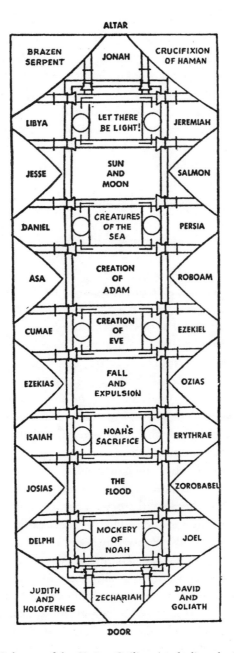

Fig. 13: Scheme of the Sistine Ceiling (excluding the lunettes)

Michelangelo called them), and each pair flanks a fictive bronze medallion adorned with various Old Testament scenes of divine punishment and redemption.[18]

Michelangelo started painting at the entrance end, with the scenes involving Noah, and worked his way towards the Creation scenes at the altar end. Condivi claimed his master painted the ceiling entirely on his own, without even an assistant to grind his colours, but it is inconceivable he had no technical back-up at all. Decorative and structural elements, as well as minor features such as the medallions, must surely have been painted by assistants.[19] Nonetheless, the claim that he worked alone shows his keenness to prove an almost superhuman energy and self-sufficiency.

There were considerable technical problems at the start, and a great deal of trial and error, which is hardly surprising as ceiling painting of this kind and scale was unprecedented. The first narrative scene Michelangelo tackled, the *Deluge*, was painted in two stages, using different techniques, and features numerous corrections. Michelangelo destroyed the first version of the fresco, with the exception of the island crowded with refugees. Condivi informs us that mildew then appeared on the surface of the fresco, so that 'the figures could barely be distinguished', whereupon Michelangelo was told he had been applying the plaster too wet.[20] It sounds a bit too neat to be true – a painting of the *Deluge* that is threatened by an excess of water. Vasari's account – that it was only after the first third had been painted that spots of mould appeared – sounds more plausible.

By the second half of the ceiling, Michelangelo was doing more of the work himself, both because he had got to grips with the technical challenges, and also because there were fewer figures in the central narrative scenes of the Creation. The surface area he painted each day increased dramatically. We know this because he painted directly into wet or 'fresh' plaster (hence the generic term *fresco*), and so a day's worth of plaster – a *giornata* – had to be applied each morning. As a result, the edges of each section can usually be distinguished. Whereas the large central panel of the *Deluge* required twenty-four *giornate*, the *Creation of the Sun, Moon and Plants* required seven, and the last panel – *God Separating Light from Darkness* – was executed in a single day. The letter Michelangelo wrote his brother on 17 November 1509 in which he boasts that he has 'no friends of any sort', and wants 'none', may well relate to his reduced complement of painter assistants.[21] As he embarks

on the Creation scenes, he gives the impression that his task is akin to the Creation itself, and is to be accomplished alone.

THE VAULT IS NOT CROWDED in the rather anonymous, serried way in which the wall frescos are crowded: the various classes of figure are much more distinctive. But crowding – and its corollary, claustrophobia – is an important theme. We are made far more aware of the space which Michelangelo's figures occupy, for they often seem to be constricted and pressurised by it. Indeed, the architectural framework, especially in the lower part of the vault, is quite aggressive and even punitive.

The forty Ancestors of Christ, arranged around the windows, are primarily shown in family groups, which was unprecedented.[22] (In the Bible, most of them only appear in a long list of their names at the beginning of Matthew's Gospel, the first book of the New Testament. The list starts with Abraham and ends forty generations later with Christ.) However, this grouping only seems to heighten the feeling of malaise, because of their lack of space. They have been provided with the Renaissance equivalent of economy class seats. They are squeezed into spartan lunettes (the curved sections wrapped around the arch of the windows) and gloomily lit severies (the tent-like concave triangles directly above the lunettes). Here, three is very much a crowd.

The families in the severies might almost be refugees, huddled together, and they recall images of the Holy Family resting on their flight into Egypt. Women dominate, possibly because the chapel is dedicated to the Virgin Mary, and this also intensifies the feeling of vulnerability. Directly above the ancestors, in darkened pairs of triangular niches wedged between the thrones of the Prophets and Sybils, we find small symmetrical pairs of bronze nudes, in various poses. Separated from each other by a ram's skull, they have been called benighted pagan figures who are totally unaware of the prophecy of Christ's coming.[23] They seem to bear down on the family groups from above, like nightmarish demons.

Other figures in the lower lunettes are sitting around waiting, and the fact that many have bundles or walking sticks suggests that they are displaced persons, or wandering Jews. Naason lounges around like a bored schoolboy, daydreaming rather than focusing upon the book resting on a bookstand before him; Aminadab languidly combs her long hair. Their bodies are not in the least heroic, and they often look attenuated and gauche. There is little acknowledgement of their

companions or neighbours. Michelangelo presumably wanted to suggest that those born before the birth of Christ are in a kind of limbo.

Some art historians argue that the Ancestors prove that Michelangelo could depict tender expressions of feeling, and genre scenes. Surviving sketches made for the Ancestors do seem to be taken from life. Their astonishingly brightly coloured costumes, revealed in the recent restoration, certainly give them a festive air. Yet when these images are not simply lugubrious, they are weirdly caricatural, like garishly coloured gargoyles on the ceiling of a Gothic church. The fancy dress makes it look as though they are all dressed up with nowhere to go. They are like guests for a wedding which has been cancelled at the last moment, or stranded travellers whose transport has been severely delayed. That said, we should not exaggerate the brightness of the costumes. They needed to be bright because if the ceiling is viewed in natural light, as was intended, the areas directly flanking the windows are the darkest.

JUST ABOVE AND TO THE side of Christ's Ancestors, we find seven Hebrew prophets and five pagan sybils, who were all believed to have foreseen the coming of Christ. They sit on massive white marble thrones, and although these may not be very comfortable, they are the closest we get on the Sistine Ceiling to business class seats. Many attempts have been made to link each prophet and sybil with the narrative scene from Genesis directly above their heads, but because prophetic writings were open to multiple readings, it is hard to prove that one prophet or sybil is more closely linked to a particular narrative than any other. The fact that male prophets alternate with female sybils suggests their arrangement is largely decorative. Michelangelo seems less concerned with evoking specific prophecies (only Jonah, at the far end of the chapel above the altar, is furnished with a trademark attribute, the 'great fish' which swallowed him) than with dramatising the actual processes of prophetic thought. Here, gaining access to divine truths appears to involve a struggle with the self – and with all manner of thoughts which literally crowd round them.

The Prophets and Sybils are by far the largest and bulkiest figures on the ceiling. They become progressively bigger (the earliest to be painted are just under 13 feet high; the latest, just over 14½ feet), until they are almost bursting out of their thrones, and in order to accommodate them, Michelangelo lowers the base of their thrones. Their vast size and almost planetary rotundity (echoed and reinforced by the circular medallions

directly above their heads) seems designed to evoke the way in which their prophecies extend back and forth across time and space. It also points to the way in which they universalise the Christian message. Whereas the cloistered Ancestors represent a single racial line that passes from Abraham to Christ, the Sybils, through prophesying Christ, show that pagans too (Libyans, Persians, etc.) had access to the Christian truths. They are given equal status with the major Old Testament prophets, and thus stress the cosmopolitan nature of the Church.

Although the Prophets and Sybils follow the tradition, stretching back to the ceiling mosaics of the Middle Ages, whereby the largest figures on a ceiling are placed close to the top of the supporting wall, they are far from being stable, finial-like conclusions of the wall. Their massive thrones are jammed in between the triangular severies, but the footrests jut out aggressively into the chapel, as though they are sitting in an unglazed glass lift attached to the side of a high building. They are not even allowed to sit back in their thrones, for this area is already occupied by pairs of smaller figures of children, who sometimes seem to force them forward until they are perching on the edge of their seats, on the verge of either sliding off or getting up. With the exception of Jonah, the Prophets and Sybils are swathed in tidal waves of boldly coloured robes that are both engulfing and billowing. Considering that they are seated figures, and all but two are shown holding books or scrolls, there is an extraordinary range of physical and mental operation – from the dour bookworm Zechariah, depicted in immovable profile, to the almost skittish Libica, swivelling round balletically to deposit her massive book behind her, its pages open like wings.

The attendant pairs of children that attend each figure are a flesh and blood echo of the fidgeting pairs of marble putti that adorn the flanking pilasters. They are usually assumed to represent inspirational *genii* or angels, who transmit prophecies to their human recipients and guide their thoughts. Dante referred to something very similar in his prose work the *Convivio*: at a moment of crisis, a particular *spiritello d'amore* perturbed his soul. By this he meant that he was perturbed by a thought that arose from the studies which he loved so much.[24] Dante's near contemporary, the Pisan sculptor Giovanni Pisano, depicted prophets and sybils on the pulpit in Sant' Andrea, Pistoia, and a particular sybil is always cited as a precursor to Michelangelo's. The Pistoia Sybil holds a scroll on her lap, and turns round startled to observe a *spiritello* at her shoulder who has just hailed her. The *spiritello* is thus a human thought

bubble, and they are a literal manifestation of Condivi's assertion about Michelangelo never being less alone than when he was alone. Michelangelo's *spiritelli* go further than simply aiding thought. Sometimes they help out, like devoted PAs, by lighting a reading lamp (Erithraea), or by supporting a heavy book (Daniel), and at other times they seem to guide a reading (Joel, Cumaea).

But the fact that there are always two *spiritelli* present, and that they are palely echoed by the flanking pairs of marble putti, who are shown frolicking and fighting, suggests that the minds of the Prophets and Sybils may actually be divided, distracted and even overcrowded. In illuminated manuscripts, flanking images of frolicking and fighting *spiritelli* can signify the random thoughts that arise in the reader's mind as his attention wanders from the elevated object of inquiry.[25] The difficulty of concentration, particularly during church services, was a pressing problem for preachers and theologians. Even St Thomas Aquinas (1224/5–74) had said it was impossible to say one Paternoster without thinking of something else.[26] At the very least, Michelangelo suggests that thought is a dialectical process, with a certain number of false trails. When other artists depicted major figures accompanied by more than one *spiritello* or angel, they usually held up legible texts, and were thus conduits of clarity.[27] On the Sistine Ceiling, this role is confined to the putti beneath the thrones who hold up inscribed name plaques of the Prophets and Sybils.

Michelangelo's treatment is a long way from the single, and single-minded, *spiritello* envisaged by Dante or Pisano. Pisano's Sybil and her *spiritello* look directly at each other with piercing gazes. The closest Michelangelo gets to direct eye contact is with the Prophet Ezekiel, who stops reading his scroll and turns to the *spiritello* standing behind his left shoulder. The *spiritello*'s index finger points upwards, presumably to Heaven. It is the only gesture of its kind to be made by a *spiritello*, though it is hard to discern from the chapel floor.[28] Yet Ezekiel is not obviously grateful at being informed about the divine plan. His movement is violent and he almost looks angry at his reading being interrupted. It might equally be a moment of confusion or astonishment, as of revelation.

There is a comic element in the *spiritelli*'s relations with the Prophets and Sybils – especially when they huddle together conspiratorially, or peer over a shoulder like an inquisitive parrot. The *spiritello* who stands between Daniel's legs in order to support his big book even looks down

towards the putto whose head supports the plaque on which the Prophet's name is inscribed. They can seem like pampered pets, who have the run of their owner's home and body and who sometimes push their masters and mistresses out of their favourite armchairs. One can understand from these tableaux why Joshua Reynolds, whose *Mrs Siddons as the Tragic Muse* (1784) is based on the Prophet Isaiah, could say: 'I think I have seen figures by [Michelangelo], of which it was very difficult to determine whether they were in the highest degree sublime or extremely ridiculous.'[29] In his portrait of Mrs Siddons, the *spiritelli* are shadowy apparitions who stand at a discreet distance behind the famous actress's throne; she gazes devoutly up to the heavens, and seems more focused than Isaiah.

There is little sense here of an instantaneous and unproblematic transmission of divine wisdom, which is what tends to happen in the Bible. The book of the Prophet Ezekiel opens: 'Now it came to pass in the thirtieth year, in the fourth month, in the fifth day of the month, as I was among the captives by the river of Chebar, that the heavens were opened, and I saw visions of God.' Ezekiel's visions are of a baroque complexity, but the visionary experience is transparent and amenable to precise documentation. It is like turning on a tap to fill a measuring jug with metred water.

Michelangelo's depiction of the Prophets and Sybils for the most part avoids representing the limpid simplicity with which divine revelation was received and publicised in the Bible. By having *spiritelli* crowding round he depicts a cacophonous, restless world where 'thought' has to be sifted, debated, monitored and perhaps even censored. We marvel at the astonishing variety of pose and attitude with which Michelangelo invests the Prophets and Sybils at the same time as we long for them to enjoy calm but authoritative solitude. There is an over-fertility of thought. Jeremiah is the closest we come on the ceiling to a solitary 'thinker'. He leans forward, plants his elbow on his thigh, and rests his bearded chin on his hand. He was believed to be the author of the Book of Lamentations, which mourns the destruction of Jerusalem. Here he looks thoughtful in a melancholy rather than distraught way. Yet popping up at his shoulders, and thus rendering him three-headed, like Cerberus, are two *spiritelli*. The one on the left does seem distraught, but because the other one looks across with a rather surprised expression, it makes us question whether this outpouring of sympathetic emotion is genuine or theatrical. It could almost be a parody of a half-length *Pietà*

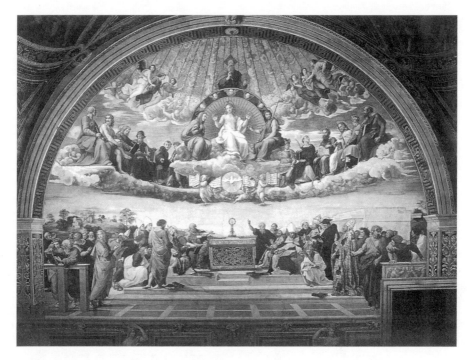

Fig. 14: Raphael, *Disputà*, *c.* 1509–10 (fresco, Rome, Vatican)

by Donatello or Bellini, in which the dead Christ is held up at the shoulders by a pair of grieving angels.

If it seems strange that Michelangelo would have given such a prominent role to argument and bewilderment, then we should turn to Raphael's *Disputà* (*c.* 1509–10), a fresco which was being painted nearby in the Stanza della Segnatura (Fig. 14).[30] Raphael's fresco is divided into two tiers, an earthly and a heavenly realm. In the earthly realm, a group of theologians is arranged around a central altar, surmounted by the Host set inside the golden ring of a monstrance. The Host was the consecrated wafer in which the body of Christ was believed to be 'really present'. The theologians are engaged in heated debate about the meaning of the Host, and some even explain its significance to pagan figures at the sides. Big books are piled on the floor, and others are being consulted.

In the heavenly realm, confusion and argument gives way to clarity. Directly above the Host, we find the Dove of the Holy Ghost, flanked by four winged putti holding four Gospel books open at relevant texts. Just above this, sitting on a cloud bank, is Christ, displaying his wounds,

in between the Virgin Mary and John the Baptist. Standing over Christ is God the Father. On a slightly lower level, spreading out in a horizontal arc on either side, are seated biblical figures, engaged in calm discussion. Raphael's fresco suggests that although on earth the ways of God may seem mysterious, for those with sufficient faith who look beyond worldly matters, they will become clear. Thus far, however, not many have seen the light – few of the theologians below are shown looking up to Heaven. This unusual subject was probably proposed by the constantly warring Pope Julius II, who was acutely aware of the need for theological disputes to be resolved without schism. We can perhaps imagine him praying before the fresco during 1511–12, when a Church Council was held in Pisa and Milan that attempted (unsuccessfully) to have him deposed.

Michelangelo's Prophets and Sybils are akin to argumentative theologians who are still finding their way towards the truth. Daniel has a massive book open across his thighs, and yet he turns away to write down something else on the lectern awkwardly placed to his right. The Cumaean Sybil reads one book while a *spiritello* holds another; Joel reads a scroll while a *spiritello* holds a book; the Libyan Sybil puts a book away while a *spiritello* holds a scroll. Adding to the feeling that we have entered a textual labyrinth is the fact that each of the containing architectural members – a wide, pincer-like 'V' – echoes the shape of an open book.[31] Unlike most previous and subsequent representations of Prophets and Sybils, where if a book or scroll appears it is usually inscribed with a text that is clearly shown to the viewer, we can never properly see what Michelangelo's Prophets and Sybils are reading or writing. He clearly wanted to universalise his representations of the Prophets and Sybils, by not tying them down to a specific text, while at the same time making their thoughts seem still provisional.[32]

The most spectacularly energised and unencumbered prophet is Jonah, placed directly above the altar at the culminating point of the ceiling. Only Jonah is privileged to look up at the world-creating God the Father directly above; and only Jonah is unencumbered by a book or scroll. He is the most single-minded of the Prophets – but he is single-minded in his *anger*. One modern critic called Michelangelo's Jonah 'a blaspheming urchin'.[33] Michelangelo depicts him leaning heavily on his right elbow, his upper body flung back at an oblique angle on his throne, thighs and knees thrust out into the chapel. With lips parted and head tilted up, he looks accusingly at the heavens. His left arm twists down

and across his torso, and both hands are joined together, the index fingers menacingly jabbing towards the ground.[34] Whereas the other Prophets and Sybils are swathed in tidal waves of heavy robes, Jonah is lightly clad in a loincloth and vest, which leave his arms and legs bare. This seems wholly in keeping with his unbuttoned nature. Both Condivi and Vasari singled him out as the finest figure on the ceiling, because of the way in which the thrust of his foreshortened body, convulsed by fury, contradicts the curve of the ceiling: 'A stupendous work and one which proclaims the magnitude of [Michelangelo's] knowledge, in his handling of lines, in foreshortening, and in perspective.'[35] Contradiction and paradox are also central to Jonah's character and meaning.

Jonah was regarded as a 'minor' Old Testament prophet because his book, at only four chapters, is one of the shortest in the Bible. But these four chapters are also some of the most distinctive. When God told Jonah to go to the pagan city of Nineveh and chastise the people for their wickedness, he took flight, and sailed away on a ship; whereupon God whipped up a terrible storm, and the sailors, in order to save themselves, threw Jonah overboard. He was immediately swallowed up by a giant fish and spent three days and nights inside its stomach. When Jonah prayed for forgiveness, God made the fish vomit him up on dry land. Chastened, he subsequently went to Nineveh, told the citizens their days were numbered, and they repented, wore sackcloth and fasted. But when God forgave them their sins, Jonah was furious, and said: 'I do well to be angry, even unto death' (Jonah 4:9). Because of his sins and penitence, Jonah belongs in Michelangelo's great sequence of flawed giants, along with *David* and *St Matthew*. Jonah's reluctance to take on a communal preaching role also means that he stands in marked contrast to the keen proselytisers on the wall frescos, and to the apostles who would originally have occupied his place on the ceiling. Jonah marks a temporary breakdown in communication, rather than its triumph.

Jonah was rarely chosen for pictorial cycles of prophets, and had never been depicted in the act of cursing God. Such unusual iconography is unlikely to have appeared in a chapel open to the general public: it presupposes some extremely sophisticated viewers. Jonah provides a double link between the lower human world of the chapel and of Christ (who was depicted on the altar wall),[36] and the upper world of God the Father depicted on the ceiling. The aspect of Jonah that was traditionally singled out and interpreted allegorically was his being swallowed by a fish, and then being vomited up on dry land. Christ referred to this

episode when making the only reference to Jonah in the New Testament: 'as Jonah was three days and three nights in the whale's belly; so shall the Son of man be three days and three nights in the heart of the earth' (Matthew 12: 40).

Yet Michelangelo relegates the fish to a position just behind Jonah, where it is dwarfed by him, and where two rather sheepish *spiritelli* appear to be shuffling it 'off stage'. By focusing on the moment when Jonah curses God for having pardoned the penitent pagans of the city of Nineveh, Michelangelo was able to ram home the message about the universality of the Church as this was the only occasion when the Old Testament God forgave a pagan civilisation. The ability of Jonah's God to forgive Jonah and the Ninevites prefigures Christ's own readiness to forgive. It demonstrates that anyone who is penitent can be spiritually reborn. As such, it has been said of the Book of Jonah that 'nowhere in pre-Christian literature can be found a broader, purer, loftier, tenderer conception of God'.[37]

Jonah's ability to see God 'face to face' is not unconnected with the fact that he, uniquely, has not been furnished with a book or scroll. St Augustine had emphasised Jonah's non-verbal nature, no doubt in part persuaded by the brevity of his book. He claimed that Jonah's experiences of being swallowed and vomited were far more eloquent about the nature of resurrection than any prophetic words could be: 'The prophet Jonah, for his part, prophesied of Christ not so much by his verbal message as by some of his experiences; in fact, he prophesied more plainly in this way than if he had proclaimed Christ's death and resurrection in words.'[38] Pope Julius may have sympathised with this aspect of Jonah, for despite being a very cultured man, he liked to stress his unbookish nature. When he saw Michelangelo's model for his statue in Bologna in 1507, and the sculptor asked him whether he would like to be depicted holding a book in his left hand, the Pope replied: 'What book . . . a sword: because I for my part know nothing of letters.'[39]

Michelangelo's Jonah is a man of action, a Prometheus Unbound, unencumbered by intellectual or physical baggage (he is clad only in a loincloth and a vest). As Jonah twists himself up and back, shaking himself free from the 'great fish' depicted behind him, and from the two *spiritelli*, he seems completely autonomous, a being who has momentarily broken free of social and verbal shackles. Here, disobedience is the making of Jonah because it is the making of God, in so far as it paves the way for Jonah to understand, and it gives God the opportunity to show he can forgive.

Michelangelo, who already in his brief life had twice fled (from Florence in 1494, and from Rome in 1506, when Julius suspended the tomb project), may have identified with aspects of Jonah's story when he was painting the ceiling. In 1509, he complained about the backbreaking task – his body bent and contorted, his face spattered with dripping paint – in a satirical sonnet. One thinks of Jonah inside the fish, and then again here, leaning backwards to look up at God on the ceiling. Michelangelo concludes his sonnet by saying he is not a painter, and that is why 'the thoughts that arise in my mind are false and strange'. It seems particularly fitting that Jonah, the reluctant prophet and rebellious loner, should be the artistic and moral climax of the great ceiling.

THE SCANTILY CLAD but athletic figure of Jonah does not simply provide a link to the world-creating God in the middle of the Sistine Ceiling. He also finds an echo in the ten pairs of elastic-limbed *ignudi* who frame the Genesis scenes. The *ignudi* perch on low pedestals rising from a fictive stone cornice which cordons off the lower section of the ceiling from the central narrative panels. If this lower part is a realm of frustration, constriction, confusion and dispute, the vast, even outsize presence of the *ignudi* turns the upper realm into something of a debating chamber too. Indeed, even more so than Jonah, the *ignudi* ask questions of God.

The *ignudi* go through many and varied motions, their bodies infused with a beguiling mixture of torpor and tension. Some sit on satin cushions. They are like male versions of Pygmalion's Galatea – beautiful statues who have come to life and have stepped down from their pedestals and are now sitting on them. Some look as though they are waking, stretching, getting to know their bodies; others look weary. In the first two narrative panels, dealing with the story of Noah, the paired *ignudi* are virtual mirror images, but from then onwards their poses become increasingly individuated, and they overlap the central narrative panels. Their ostensible function is to secure the bronze medallions situated between each pair. In order to do this they hold strips of satin cloth which are threaded through the border of the medallions. Yet they perform their allotted task with such insouciance that we cannot be certain of the medallions' stability. This also underscores the precariousness of their own position: if the medallions need to be secured, what is keeping the *ignudi*, hoisted to a vertiginous height on the ceiling, in place? But it is their potential for movement that keeps our eyes in motion, rolling from one narrative panel to another.

The *ignudi* are central to the originality – and pathos – of the Sistine Ceiling. More studies for the *ignudi* survive than for any other portion of the ceiling, and from the *Creation of Eve* onwards, Michelangelo painted them before he painted the central narratives.[40] Yet in two respects these solitary nude figures interfere with the telling of the Genesis stories. Firstly, because the need to accommodate them reduces the available space by about three-quarters; and secondly, because whereas the Genesis story is primarily about creation – and above all, about the creation of large family units that continue to expand over many generations – these male figures posit a different and more exclusive kind of social order.

There is little consensus as to the significance of the *ignudi*. Some scholars believe they are purely decorative, an excuse for Michelangelo to explore his favourite subject, the male nude; others think that they are wingless angels, because an early study for the ceiling showed winged angels in a similar position; still others think they are mediators between the human and divine realms. Yet their main significance is clear if we read Vasari carefully. Having praised the variety of expression and form in these 'beautiful nudes', he says that they hold festoons of oak leaves and acorns, 'placed there as the arms and device of Pope Julius, and signifying that at that time and under his government was the age of gold; for Italy was not then in the travail and misery that she has since suffered'.[41] The family name of Pope Julius, and of his uncle Pope Sixtus IV, who built the Sistine Chapel, was Rovere, meaning oak tree, and their crest featured a single scrub oak with spreading roots and two intertwined branches laden with acorns. It was an ancient symbol of strength, fertility and continuity. The oak was also the tree of choice in antique accounts of the golden age, when men were reputed to have lived off a diet of honey and acorns.[42]

Michelangelo used acorn symbolism in what may represent one of his first designs for the *Tomb of Julius II*, commissioned in 1505. The drawing features perhaps his most joyous compositions, and the only example in his work of communal ecstasy.[43] At the centre of the first storey of the tomb (just below a sarcophagus into which the Pope's corpse is being lowered by angels) is a large square relief in which an airborne oak tree, its roots supported by angels, showers acorns on to a group of naked men below. Some raise their arms to catch this 'manna from Heaven' while others gather acorns from the ground. Below, two male nudes recline on either side of a bowl piled high with acorns, and reach over to take the

fruit. The one on the left, with his left arm stretched forward and propped on his bent knee, is similar to the Adam of the Sistine Ceiling.

The Rovere oak tree was already prominent in the decoration of the Sistine Chapel, on the outside of the building as well as inside. But Michelangelo omits the tree altogether, and furnishes the *ignudi* with swollen sheafs of leaves and acorns. Lines of acorns also adorn the architectural framework. A whole oak tree has a more obviously Christian symbolism, with its suggestions of the 'Tree of Life' and of the oak from which the Cross was supposedly made. The connotations of acorns are exclusively pagan, however. In Ovid's *Metamorphoses*, acorns are a staple of the Arcadian diet, which is strictly vegetarian. Ovid followed a tradition, stemming from Hesiod, that only men existed at this early stage (Pandora arrived later, with her deadly box of tricks). They lived long lives and died painless deaths. Those classical writers who did countenance the presence of women in Arcadia tend to use them to underscore the brutality of primitive life. Lucretius says that mutual desire brought men and women together, 'or the male's mastering might and overriding lust, or a payment of acorns or arbutus berries or choice pears', while Juvenal, in his satire on women, says that Ur-woman 'was often more uncouth than her acorn-belching husband'.[44] Thus men-only Arcadias tend to be more harmonious. References to acorns became so prevalent that there was a saying, quoted approvingly by Cicero, dismissing the whole fad: 'Enough of the oak tree!'[45] But the metaphor persisted into the Renaissance to be used by Petrarch – 'those acorns which all praise and avoid'[46] – and by Michelangelo in a pastoral poem from around 1530 in which he waxes nostalgic about the days when people were satisfied with acorns and water.[47] The humanist Pietro Bembo called upon Pope Julius, the 'holy oak', to give back to the world its honour, the oak being the tree whose acorns had nourished heroes.[48]

The Sistine Ceiling *ignudi* would seem to represent an all-male pagan golden age. They are not entirely bereft of creature comforts, however: their poverty is gilded. Some sit directly on the cubic stone pedestals, but others have plump, brightly coloured silk cushions between their naked flesh and the harsh, sharp-edged stone. Some wrap the leafy festoons around their torsos like bloated boas, possibly an allusion to the golden age practice of using leaves as a blanket; others have skimpy silken cloaks.[49] The casualness with which they perform their task of holding the stays for the medallions also reinforces the idea of a golden age where

lounging around was the principal occupation. According to Hesiod, the 'golden race of mortal men' was 'untouched by work'.[50] There is also, perhaps, more to the acorns than immediately meets the eye. The Latin for acorn is *glans*, the same word that is used for the end of the penis, and this punning innuendo may account for the popularity of the acorn trope.[51] The *ignudi*'s big bunches of plump acorns are decidedly tumescent.

Pope Julius is unlikely to have been too perturbed by this trans-formation of his coat of arms into a phallic symbol. In the extremely cold winter of 1510–11 he was campaigning in the north of Italy against pro-French forces, leading from the front. As he set out from Bologna to besiege the city of Mirandola, he is reputed to have said: 'I'll see if I've balls as big as those of the King of France.'[52] He may also have had homosexual relations before he became Pope.[53]

Having established that the *ignudi* allude to some kind of golden age, which is brought into being by a Rovere Pope, we need to decide whether they have any other function in the frescos. Although they are apparently autonomous and self-contained, at least one *ignudo* does seem to interact in a meaningful way with the central narrative paintings. The *ignudo* seated below Adam in the *Creation of Adam* comes astonishingly close to his outstretched thigh. So much so that the back of his wrist, arched to hold a bulging sheaf of acorns in place, is actually closer to Adam than God's outstretched finger. This proximity underscores the physical similarity between Adam and the *ignudi*, all of whom have equally athletic bodies. They are also of comparable scale. The *ignudo* above Adam is perhaps closest in size and skin tone, though the out-stretched right leg of the *ignudo* below and the orientation of his torso and head echo Adam. Thus we are forcibly struck by Adam's apparent lack of uniqueness – indeed, his ubiquity – at the very moment when he is being created by God and is supposedly the first and finest human being. It feels as though the *ignudo* is a prophecy of Adam, rather than vice versa.

The *ignudi* are parallel presences who put an unmistakable pressure on the central narratives. The narrative panels beside which they sit are about a quarter of the size of the large panels, and they become even smaller as the *ignudi* become larger. It took Michelangelo some time before reaching this drastic solution,[54] which introduces variety and dynamism into the ceiling – but at a price. Less obviously, they put pressure on the biblical Creation myth by reminding us of an alternative

convention, of an all-male Arcadia. They celebrate the power of the penis, but not the *procreative* penis. Whereas the Sybils demonstrate in a straightforward manner the way in which paganism could be permeated by Christianity, the *ignudi* are not quite so amenable to co-option. In some respects, they are the classical cuckoos in the biblical nest.

A dramatic consequence of the presence of the *ignudi* is that in the Creation scenes God seems hemmed in. Rather than creating the world from and within an immeasurable void, *God Separating Light and Darkness* occurs in a small panel, and God, his purple robes swirling and spinning around him, fills much of the pictorial field. It feels as if his body has been choreographed in relation to this small panel. His legs are cropped by the edge of the panel, and his right knee seems to kneel on the frame. Indeed, through the liberal use of white highlights, applied in large patches to his robe, God's body seems to dissolve below the chest. He too is divided into a 'dark' upper section and a 'light' lower section. At this stage, it seems, God's own 'shape' is yet in flux. But it still feels like a miniaturised, made-for-TV version of the first day of Creation.

In the first large panel, the *Creation of the Sun and Moon* has been juxtaposed with the *Creation of the Plants*, and we see God twice, first from the front and then from the rear, which gives Michelangelo the opportunity to show us God's buttocks, revealingly clad in thin, skin-tight drapery, and bare heels. In the *Creation of the Sun and Moon*, the emphasis is still on God's upper body, with his massive outstretched arms slung like a massive hammock between the new planets. In the *Creation of the Plants*, God scoots past a tiny outcrop covered in grass and ferns. This is the first sighting of land, and it is only appropriate that we should now get our clearest sighting of God's feet and the only view of his posterior, for these parts are essential for the land-based activities of walking, standing and sitting.

Both these acts have been preceded by the creation of child-like, wingless angels, for the Creator of the Sun and Moon is shown sprouting pint-sized human bodies from his billowing robes. This motif was unprecedented, for no creatures, not even angels, were supposed to exist at this stage. But Michelangelo clearly wanted these prematurely born angels to give a sense of the urgency with which God wanted to *people* the universe. The *Creation of Animals* has been left out altogether and, in a sense, the creation of these very human, but pet-like creatures is a substitute for that scene. In the *Congregation of the Waters*, God hovers horizontally over a calm, grey sea. The upper part of his body protrudes

from the oval shell of his mantle, which also harbours three naked children. God is created anew by Michelangelo every time he creates something new. Here his massive, almost tentacular fingers are spread out as though he were kneading the oceans into their allotted shape. Seeing God emerging from his cavernous mantle, one thinks of the way in which Venus was born at sea and then carried to land in a scallop shell.

One of the most remarkable features of the Book of Genesis is the way the stories are punctuated by the bald enumeration of people's names.[55] Genesis 5, 10 and 11 consist solely of lists of names, and most of Genesis 36 and 46 are taken up by lists. They are the glorious manifestation of God's insistence that Adam and Eve transform themselves into a dominant people: they must be 'fruitful, and multiply, and replenish the earth, and subdue it' (Genesis 1: 28). In an era when life was often nasty, brutish and short, evidence of long lives – Adam lives 930 years, and has thirty sons and thirty daughters with Eve – and extensive family trees were causes for major celebration (today, conversely, we are just as awestruck by the lists of names on war memorials, mostly of young men cut down without offspring). The pressure to procreate is most dramatically demonstrated by the story of Lot and his daughters (Genesis 19: 30–38). Believing (erroneously) that only they remained alive on earth, Lot's daughters made their father drunk and made love with him in turn 'that we may preserve the seed of our father'. In the appropriately named Book of Numbers, when there is a census (26: 51), we are told: 'These were the numbered of the children of Israel, six hundred thousand and a thousand seven hundred and thirty.' It is an awesome number, and its precision makes it even more so because every single person has been enumerated, and valued equally. But Michelangelo has invested such procreativity not just with awe, but fear: he has populated the ceiling with many figures who lack space and/or who push against its limits.

The motif of the angels reaches a climax in the 'uterine mantle filled with attendants'[56] which confronts Adam as he reclines on the grassy mountainside. As God floats towards the first man, somewhat alarmingly, like a Zeppelin coming in to dock, he is accompanied by twelve naked attendants, mostly children but also a few adolescents – above all a young woman who emerges from God's flank and around whose shoulders God drapes his arm. It is widely assumed that they must be angels, and that the girl, who is staring towards Adam, is Eve. It has also been argued that the child on whom God lays the fingers of his left hand is Christ. As

such they would represent the 'idea' of these entities pre-existent in God's mind.

God was traditionally presented on his own, standing in front of Adam on level ground, perhaps pulling him up on to his feet. Here he is airborne, horizontal and surrounded by a mêlée of people and drapery, who push and pull and jostle for position, some supporting God from below, others leaning on him from above. The determined faces of his companions seem to express malevolence as well as anguish, and the faces of some are cast in a sinister darkness. It feels like a Pandora's box. Walter Pater, writing in 1871, described the scene as follows: 'What passionate weeping in that mysterious figure which . . . crouches below the image of the Almighty, as he comes with the forms of things to be, woman and her progeny, in the fold of his garment!'[57]

Never before had an entourage been shown so close to God. They are key protagonists in a multi-part epic that centres on the sense of touch – there is actual tactile interaction between God and his entourage; between the neighbouring *ignudo* and Adam; and there is imminent tactile interaction between God and Adam. But the physical intimacy of God with his entourage also serves to highlight the relative isolation of Adam. This is the God of innumerable women and children, and even of crowds and chaos.

The closest parallel to God's 'uterine mantle' motif is the conventional representation of the Madonna of Mercy, who is usually shown standing upright with her cloak open to envelop a group of penitent but orderly sinners. The Sistine Chapel was dedicated to the Virgin of the Assumption, so the parallel is perhaps appropriate. This is not the only allusion to the Virgin. The gesture of the outstretched fingers of God and Adam recalls certain paintings of the Annunciation in which the Virgin and the Angel Gabriel stretch their arms out towards each other.[58] Annunciations were often staged in churches with two separate statues or paintings of the Virgin and the angel placed high up near the walls of the nave, facing each other, with each protagonist placed at the same height. So this idea of 'reaching across' the central void of the nave is not entirely new.[59] But Michelangelo transforms any such precursors, intensifying them so that the gesture becomes overwhelming. The calendar year traditionally started on 25 March, the feast of the Annunciation: here, an 'Annunciation' signals the creation of Adam and the start of human history. Indeed, what seems to be announced here is not a single birth, but innumerable births.

The almost reckless fertility of Michelangelo's God recalls literary accounts of the Demogorgon, a hoary equivalent of the Demiurge who is first featured in Boccaccio's *Genealogy of the Gods*, a massive compendium of information about more than 700 pagan gods and mythical personages that was written in the late fourteenth century and remained a standard reference book in the Renaissance.[60] The Demogorgon is the founder of the whole race of the gods and lives in a cave in the bowels of the earth with nine children and two companions, Eternity and Chaos. Boccaccio thinks the first part of his name derives from 'demon', which means 'terrible god' (*deus terribilis*), a designation that also applies to the 'sacred and terrible' God of the Bible; the second part of his name refers to the fact that he could look at the Gorgon Medusa without being turned into stone, 'another sign of his pre-eminence'.[61]

The Demogorgon myth may help us to understand other aspects of the Creation scenes, though not in any systematic way. God was traditionally shown separating light from dark in 'perfect calm',[62] with the space behind him neatly divided. Michelangelo shows him immersed in and buffeted by primordial matter. He seems to be plunging his arms into it, struggling to split light and dark. This recalls the way in which the cave-dwelling Demogorgon is initially only accompanied by Chaos, and his first child is born when he plunges his arm into the belly of Chaos and pulls the child out. In the second Creation scene, the *Creation of the Sun and the Moon*, where four children are caught up in God's swirling robes, these robes are like the chaos from which Demogorgon's children emerge.

In the *Creation of Adam* scene, a woman peeps out from under God's bent left arm, and looks across at Adam. She is often identified as Eve, but her constricted position also has similarities with that of Demogorgon's first child, Discordia. After she had been snatched from the belly of Chaos, Discordia immediately flew upwards, whereupon Demogorgon threw her down.[63] If Eve is a counterpart to Discordia, then God's arm would be keeping her in place. Michelangelo certainly injects into the spare, bare bones of the biblical account of Creation some of the teeming, visceral quality we find in Boccaccio's account of the Demogorgon.[64]

Adam had never before been shown isolated on an empty grassy mountainside. The *mise-en-scène* makes one think of the opening to an unfinished sonnet written by Michelangelo in around 1550. It was based on a popular fable in which a solitary stone, situated high up on a verge,

decides to 'descend' into the crowded stream or thoroughfare of life, and ends up regretting its decision, for it is buffeted incessantly by other stones and by muddy cartwheels.[65] In his poem, Michelangelo vastly increased the scale and intensified the feeling of loss, for he imagines himself enclosed within a boulder that is dragged from a mountainside against its will:

> Dagli alti monti e d'una gran ruina,
> ascoso e circunscritto d'un gran sasso,
> discesi a discoprirmi in questo basso,
> contr'a mie voglia, in tal lapedicina. (no. 275)

[From a great ravine, high in the mountains, hidden and enclosed within a great boulder, I came down to find myself in this low place, against my will, among this heap of stones.]

With Adam reclining on his mountainside at the summit of the Sistine Ceiling, his torso pressed forward and flattened as though carved in low relief, Michelangelo seems to depict the moment before the animated boulder rolls into the muddy stream of life, here represented by the squirming shadowland inside God's mantle. A further implication is that as soon as Adam stands up and moves around, he will effectively 'fall', for he will have to come down from the mountain top.

Adam is already animate, if languid, at the moment of Creation. His left arm and right leg stretch out interminably like powerful but sodden wings.[66] His rather melancholy body language suggests that his creation does not simply mark the start of the biblical golden age in the Garden of Eden. It also signals the end of a pagan golden age which is defined by maleness and the self-sufficiency – if not exactly solitude – that this implies. In contrast to God's teeming entourage presided over by a woman, Adam is an echo of a dream world that is not defined by procreation. Adam is not so much being 'born' as being reborn – into a more troubling, more pressing world. He is the last *ignudo* as well as the first man. The *ignudo* below Adam is cast in deep shadow: it is as though he and his world are in eclipse.

WE NOW ARRIVE AT the *Creation of Eve*, which is positioned at the central point of the ceiling. Originally, the painting was above the gates separating the papal court from the less important worshippers. It is a small narrative panel, but the available space feels even smaller because of

the way in which Michelangelo has painted it – and because of the contrast between this representation of Adam and the one in the preceding scene. Adam is awkwardly wedged up against a dead tree stump and some enveloping rocks. Eve stumbles out from Adam's side, but because of the rocks, it might just as well be from a shadowy cave. She holds her hands up in prayer towards God, as though already engaged in an act of special pleading. God is an immovable bollard, anchored in place by an extraordinary elephantine foot that peeks out from below a hard-edged, oval mantle, vividly suggesting that the Creation story, which up until now has been largely airborne, has come down to earth with a thud.

God holds his right arm up to usher Eve forward, but its stiffness is such that the gesture seems as much threatening as welcoming. There is a strong sense in which Adam and Eve are trapped in a giant, near-symmetrical pincer formed by God's raised arm and the overhanging dead branch. This kind of brutal symmetry echoes that of the painted architectural framework, above all the trianglar severies which enclose the Ancestors of Christ. The *mise-en-scène* prophesies in an even more direct way Michelangelo's drawings of military fortifications of the late 1520s which have been compared to 'crustacean monsters eager to crush the enemy in their claws'.[67] The *Creation of Eve* is set on a featureless seashore, so it is perhaps not too far-fetched to suggest that God is here meant, at some level, to evoke a primordial crustacean.[68] Whereas in previous scenes, God's mantle resembles an open shell, here it is drawn tight around him until it is an impenetrable oval carapace. But even God is not exempt from the crushing weight of the composition. The crown of his stooping head is casually cropped by the frame of the panel, and he is further hemmed in by the *ignudi*. The elbow of an *ignudo* seems to dig into God's shoulder, while the hair of another *ignudo* rubs against his foot. It feels like pictorial punishment for the creation of Eve.

The next narrative panel juxtaposes the *Fall of Man* with the *Expulsion from the Garden of Eden*, placed either side of a central Tree of Knowledge. In the temptation scene, Adam stands over Eve, who crouches on a rock, twisting round to take the fruit of the Tree of Knowledge from the female serpent's outstretched arm. At the same time, Adam reaches up into the tree, a gesture that would seem to contradict the Bible where it is Eve who is the first to be tempted. It unmistakably points to the complicity of the first couple, and further suggests that sin is more likely to be a *collective* rather than an individual

act. Adam and Eve are not only more morally entwined than in any other depiction; they are also more physically entwined. Before turning to the serpent, Eve's face would have been opposite Adam's groin. Their poses have been compared to the classical type of 'Satyr and Nymph'.[69] Eve is one of Michelangelo's most voluptuous females, thereby suggesting that lust contributes to their downfall. The fruit handed over by the serpent bears an uncanny resemblance to figs, age-old symbol of the female sexual organs. But although Adam and Eve are physically close, and although they reach up simultaneously, there is no clear psychological connection. They each perform their tasks in a mechanical way.

In representing the Garden of Eden, Michelangelo has incorporated aspects of the classical vision of the golden age. It is an example of 'hard' rather than 'soft' primitivism. Instead of a stream- and flower-filled garden, we find a rocky enclave featuring a dead, blasted tree stump. The 'garden' is redeemed only by a single rather shapeless tree, anchored in place by a gnarled, boot-like base. Its lower branch appears to be weighed down by dense clusters of chunky leaves. This is the Tree of Knowledge, and according to legend, it blackened and withered away after the Fall. Here, however, its ungainly weightiness already suggests the burdensome and perverting nature of knowledge. The motif of Adam reaching up into the tree for fruit also echoes golden age iconography, for early pagan man reached up into the oak tree for acorns.[70] The allusion is strengthened by the fact that the hand of an acorn-clutching *ignudo* overhangs the top of the fresco, as if it is another branch of the Tree of Knowledge, and brushes the arm of the angel in the *Expulsion from the Garden of Eden*. This is the first *ignudo* that Michelangelo painted overlapping the central narrative scene.

Even the extraordinary iridescent colouring of the serpent's tail, made from orange, yellow, rose and green, and the way it slithers unctuously down the tree, recalls the honey found in those mythical oak trees, and which (according to Ovid) dripped down the trunk. The temptation scene thus becomes a negative mirror image of the life of early man.

The *Fall of Man* centres on the gesture of reaching out. The entire composition is structured by a remorseless symmetrical architecture composed of outstretched arms that interlink with the central Tree of Knowledge. The extended arms of Adam and Eve and the serpent in the *Fall of Man* are matched, in the *Expulsion*, by the outstretched arm of the banished Adam, with which he vainly tries to protect himself from

the sword-bearing arm of the angel. Together, they create two rudimentary 'arches' that pivot symmetrically around the tree trunk. Adam and Eve have clearly overreached themselves, and when they are expelled from the garden, both have aged and shrunk. But in the very act of overreaching, they have also entered a new phase of civilisation, for the double arch formed by their bodies and the Tree of Knowledge foreshadows the crude wooden frames of primitive dwellings, as depicted in Renaissance architectural treatises, and in the background of Piero di Cosimo's *Vulcan and Aeolus* (c. 1495–1500).[71] As in the previous scene, however, the structuring of a composition through architectonic means seems ominous – a prophecy of future imprisonment and of the perpetual need to find shelter.[72]

The three scenes dealing with episodes from the life of Noah were the earliest of the central narrative panels to be painted. The *Deluge* is flanked by the *Drunkenness of Noah*, and the *Sacrifice of Noah*. The *Deluge* and the *Sacrifice* are the most crowded of the ceiling narratives, and Michelangelo shows little sympathy for the protagonists. In the *Deluge*, the desperate refugees climb up, mostly naked, on to a grassy mountainside that is similar to the site where the newly created Adam is located further down the ceiling; even the group huddling under a tarpaulin on a rocky outcrop at the far right is comparable to the huddled attendants who fill God's 'uterine' mantle.

It feels like a violation of an exalted and remote place by an amorphous tide of humanity. From the chapel floor it is hard to distinguish individuals. When we do see close-up details of the composition, there are glimmers of pathos, but by and large, expressions of anguish are muted, as though Michelangelo felt these people were too debased to be capable of such feelings. No one prays, or looks up at the heavens. Some are clinging to their cooking utensils. They are stupefied bestial creatures, beyond redemption. Some try to clamber on to the Ark floating in the background, but it is a windowless fortress which was perhaps meant to evoke the impregnability and purity of the Sistine Chapel itself.

Even the *Sacrifice of Noah*, which is ostensibly a joyous and devout occasion, when Noah and his family show their gratitude to the Lord after their deliverance from the Deluge, is made to appear undignified, claustrophobic and alarming. The lack of dignity is due in part to the fact that this is a small panel, but Michelangelo could have avoided packing the protagonists in like sardines if he had so wished. Traditionally, Noah's sacrifice was represented as an act of devotion, with the family

kneeling in prayer around the altar, looking up to Heaven,[73] but Michelangelo shows Noah, his wife and a daughter-in-law standing cheek by jowl behind the altar. The sacrificial animals and their executioners (Noah's three naked sons and the wives of two of them, one clothed and one nude) jostle at the sides and in the front. Noah points upwards, but no one looks up.

The composition is designed like a relief sculpture, with those performing the sacrifice pressed into the foreground. The sacrificial animals are arranged in front and at the side, in a congested line. A horse raises its head and neighs, baring its teeth in terror. The centrepiece is a naked man astride a ram whose throat he has cut. The executioner helps put viscera into the furnace. The only time animals are depicted on the ceiling (with the exception of the serpent, and Jonah's beached fish) they are dead (the rams' skulls in between the pairs of bronze *ignudi*) or, as here, condemned to death. It has been suggested that Michelangelo demonstrated his disapproval of animal sacrifice by placing the Prophet Isaiah next to this scene. In the Book of Isaiah, the Lord dismisses animal sacrifice: 'To what purpose is the multitude of your sacrifices unto me? saith the Lord: I am full of the burnt offerings of rams, and the fat of fed beasts; and I delight not in the blood of bullocks, or of lambs, or of he-goats . . . Bring no more vain oblations' (Isaiah 1: 11–13). If this were so, then Michelangelo would be following his depiction of communal greed in the *Deluge* by an image of communal waste.

Such an overt criticism seems unlikely, but there is still an acute sense in this panel of humanity as insatiable consumers and despoilers. It is imbued with the contemporary unease about the spiritual value of making *material* offerings to God. Erasmus, in his influential *Handbook of the Militant Christian* (1503), had used God's apparent repudiation of animal sacrifice to attack the whole notion that conspicuous public displays of devotion proved one's spiritual worth. He claimed that while God 'despised the blood of goats and bulls, he will not despise a contrite and humble heart'.[74]

The *Drunkenness of Noah* is also constructed like a relief, with the reclining Noah stretched out naked in the foreground, the worse for wear after drinking wine from a vineyard he has recently planted. His three sons, led by the youngest, Ham, cover him up with a cloak. This humiliating episode was thought to foreshadow the mocking of Christ during his Passion. Michelangelo insists on having the three sons so scantily clad that they are effectively naked, which might appear to defeat

the object of the story. But it could be a way of showing their hypocrisy. Michelangelo certainly makes the most of it. Ham is in such a mad rush to cover his father up that his own penis and testicles swing wildly upwards (though the detail is hard to see from the chapel floor), as though he is demonstrating the endlessly unpredictable behaviour of this truant member. Yet this movement also underscores the scene's foreshadowing of the Passion, for Ham's genitals become a kind of flail that will swing down towards Noah. Noah's own seed is visibly turning against him. The drapery worn and held by Noah's sons is also a kind of flail, as the long, rib-like folds, which are boldly highlighted, resemble cords.

To the left of this ignominious scene, through an opening, we see a sober image of Noah, long before he succumbed to alcohol. He is clothed and alone, breaking the soil with a spade in order to plant his vine, a dignified image of dogged, solitary physical endeavour by a man with a 'contrite and humble heart'.

TWENTY-FOUR YEARS LATER, at the age of sixty-one, Michelangelo would return to the Sistine Chapel to paint the *Last Judgment* (1536–41) on the altar wall. Despite the passing of so many years, the continuities are striking. The bottom section of the composition is in many respects a reprise of the *Deluge*, but on a far larger scale. A body-strewn island rises at the bottom left, and on the right sinners are being forced off a boat (there's a similar boat in the middle distance of the *Deluge*). Here too, Michelangelo was quite happy to pack as many naked figures in as possible, without being unduly concerned as to whether the viewer could identify or distinguish them from their neighbours. He was just as fascinated by the chaotic, teeming and vermicular qualities of the crowd as in the *Deluge*. However, the body types are more bulky and muscle-bound, and thus slower in their movements. They seem far more ponderous naked than the Prophets and Sybils ever were, clothed.

Michelangelo's inability, or reluctance, to make a peaceful, orderly or serene crowd is given startling expression here. The subject of the company of the blessed ought to have given him the opportunity to depict a joyous crowd, but they are a writhing and largely anonymous scrum, their appearance and body language scarcely differentiated from the damned (the main difference is that the former rise, and the latter fall). Before Michelangelo, no artist had ever failed to clearly distinguish the damned from the saved.

The upper central portion of the painting is in part an aesthetic resurrection of the dead. It ultimately derives from Leonardo's unfinished altarpiece the *Adoration of the Magi* (*c.* 1481), and is the most spectacular example of Michelangelo's creative cannibalisation of his great predecessor's work. In Leonardo's altarpiece, a central pyramid consisting of the Madonna and Child and two kneeling Magi is surrounded by a tumultuous arc of onlookers. Michelangelo's composition is very similar: Christ and his mother, and two seated saints, form a central pyramid, surrounded by a tumultuous arc of onlookers. The almost grotesque physiognomy of some of Michelangelo's staring old men is very Leonardoesque. Even the lunettes at the top left and right of the *Last Judgment* echo the background of Leonardo's work. Whereas Leonardo portrayed two groups of fighting cavalrymen, Michelangelo's depicts two groups of angels desperately struggling under the weight of a cross and a column (the one to which Christ was bound for the flagellation). However, whereas Leonardo's central pyramid is a still, calm centre that contrasts with the maelstrom around it, Michelangelo's central pyramid features four twisting figures. In the unfinished sonnet mentioned earlier, a boulder-bound Michelangelo complains about being forced down 'against his will' into a 'low place' amidst a 'heap of stones'. In the *Last Judgment*, it appears as if the heavenly 'high place' has become just such a heap of stones, with each vast, rough-hewn figure rubbing abrasively against its neighbours. It seems entirely appropriate that the saint depicted on the right in the central foreground is St Catherine of Alexandria, brandishing a section of the spike-covered wheel to which the Emperor Maxentius tied her, for this epitomises our sense of the fresco as a series of clusters of twisting bodies, in friction with each other. Christ stands at the centre of a slowly turning 'wheel' of bodies, with curved lines of people pressing in on either side. The two curved tops of the fresco contain wheeling groups of angels, while below Christ there is a prickly circle of trumpet-blowing angels. If the triumph of the company of the blessed feels like a sombre Pyrrhic victory, it could well be because, for Michelangelo, it is too much like the victory of a crowd.

5. Benefactions

The man whose speech intoxicates and whose good deeds radiate may take as addressed to himself the words: 'Your breasts are better than wine, redolent of the best ointments.'

<div align="right">Bernard of Clairvaux, Sermons on the Song of Songs, c. 1136[1]</div>

It is characteristic of the poor ingrate that if you assist him in his time of need, he says you can well afford it, whatever you give him . . . And all the benefits he receives he attributes to his benefactor's need of him.

<div align="right">Michelangelo, letter to Piero Gondi, 1524[2]</div>

IN THE FIRST CHAPTER, we saw how the Madonna and Child in Michelangelo's *Madonna of the Stairs* refused to become the fulcrum for a fluent network of gazes and gestures that incorporate each other, the attendant putti, and the viewer. Rather, Michelangelo seemed to delight in confounding such expectations. The relief challenged the conventions of what is commonly called the *sacra conversazione* – a picture of the Madonna and Child with attendant saints, in which communication may seem to take place between the protagonists and the viewer.[3]

That Michelangelo was fascinated by the convention is evident from the New Sacristy at San Lorenzo (1519–34), a 'total work of art' involving architecture and sculpture. Although it remained unfinished at Michelangelo's final departure from Florence for Rome in 1534, it is still the most ambitious and elaborate *sacra conversazione* ever created (Plates 14–16). The project included the provision of tombs for four male members of the Medici family in a purpose-built chapel. For the first time, a polyphonic, three-dimensional dialogue was created between sculpted figures and human beings situated on all four sides of a chapel. As such, it had a huge influence on the development of the baroque

tomb, and in a more general way could be said to prophesy modern installation art. The protagonists are deceased members of the Medici family, saints, nude allegorical figures, a breast-feeding *Madonna lactans*, as well as 'live' officiating priests and visitors. Light, too, plays an important role. The sepulchre is generally gloomy, but different statues are illuminated at different times of the day. It is a wonderfully lugubrious dialogue of the dead and the living, marble and flesh, light and dark.

But even more so than the *Madonna of the Stairs*, the New Sacristy is a deeply paradoxical and mysterious work. Throughout the chapel, access and interaction are simultaneously offered and denied. The main protagonists gaze out into the chapel and their bodies project out into the viewer's space, yet at the same time they are blind, for their eyes have deliberately been left blank; the iconography features several symbols of charity, but these are counterbalanced by others which suggest the withholding of charity; and, last but not least, the architecture includes false doors and blind windows.

In Michelangelo's poems, and in those of his contemporaries, paradox is often used for its own sake, as part of a literary game. But the paradoxes in the New Sacristy have a deeper purpose and are motivated by new religious and political ideals. The whole effect was not systematically worked out from the start, as Michelangelo made constant revisions during the design process.[4] Nonetheless, in the New Sacristy sculptures he undoubtedly imbued the human body with an expressivity that is not just new and strange, but intensely topical. It is, I believe, his greatest and most probing work – more absorbing and intense even than the Sistine Ceiling.

THE LAYOUT OF THE New Sacristy owes much to the active involvement of its patron, Cardinal Giulio de' Medici, who would become Pope Clement VII in 1523. The church of San Lorenzo in Florence was the Medici family church, and the most important members of the family were buried there (Fig. 15). Cosimo de' Medici ('il Vecchio') had paid for its rebuilding by Filippo Brunelleschi (which began in 1421), and Cosimo himself was buried just in front of the high altar. Subsequently, members of the family were interred in the sacristy that flanked the south side of the nave, near the altar. Despite all this building activity, the main entrance to the church was never finished off with a stone façade, and the visitor was confronted by an ugly cliff of rough brick. When the first Medici Pope, Leo X, was elected in 1513, after the death of Pope Julius II, he decided to do something about it.

1 San Lorenzo
2 Old Sacristy
3 New Sacristy
 (Medici
 Chapel)
4 Cloister
5 *Ricetto* of
 Laurentian
 Library
6 Laurentian
 Library

Fig. 15: Plan of San Lorenzo

The Medici had been exiled from Florence after the collapse of Piero de' Medici's regime in 1494, and the subsequent establishment of a republic. They regained control of the city in 1512, with the support of Spanish troops, and the election of a Medici Pope in the following year cemented their political comeback in spectacular fashion. Leo X elevated Giulio to the rank of Cardinal in 1513, and also made him Archbishop of Florence, which meant he effectively became the city's ruler. Cardinal Giulio, who was three years younger than Michelangelo and probably first met him when he was an aspiring sculptor attached to the household of Lorenzo de' Medici, was instrumental in securing the façade commission for him in 1516. The façade, in which the architecture was a setting for numerous statues and reliefs, was intended to be a conspicuous statement of the Medici's resurgent power and wealth. It was Michelangelo's first major architectural work for the family, and he worked hard to secure the job. His work on Pope Julius' tomb had already given him some experience with architecture.

In 1519 the façade project was suddenly shelved, and the Medici decided instead to build a library at San Lorenzo to house their famous collection of manuscripts and books, and also a sacristy, next to the right transept of the church, thus balancing Brunelleschi's sacristy off the left transept. The façade project was partly cancelled due to spiralling costs,

for Michelangelo's plan had grown to vast and unmanageable proportions. But the need for a new sacristy had also become much more urgent because of the early deaths of Giuliano de' Medici, Duke of Nemours (1478–1516), and of Lorenzo de' Medici, Duke of Urbino (1492–1519). This had caused the extinction of the principal branch of the Medici, descended from Cosimo il Vecchio. On hearing the news of Lorenzo's death, Pope Leo reportedly said: 'Henceforth we belong no more to the House of Medici but to the House of God.'[5] The New Sacristy was a powerful − if slightly nostalgic − statement of the dynastic importance of the Medici, not least because no chapel with wall tombs had yet been built in Florence in the sixteenth century.[6] Michelangelo was once again given the commission.

The New Sacristy was also intended to house two other tombs for Medici with the same Christian names − one for Michelangelo's first patron, Lorenzo the Magnificent (Pope Leo's father) and the other for his brother Giuliano (the father of Cardinal Giulio) who had been killed in the Pazzi conspiracy of 1478. Referred to by Michelangelo as the *Magnifici*, both had been interred in what now came to be known as the Old Sacristy, but no monument had been erected to them there.

Michelangelo tried out several plans for the tombs, working on them more or less simultaneously.[7] Early on, he seems to have made three different proposals for a freestanding monument set in the middle of the chapel, with a sarcophagus placed on each of the four sides. Over half of the surviving studies for the tomb are concerned with this scheme, which would have echoed the sarcophagus placed in the centre of the Old Sacristy, though it was never intended to look anything like it. Not only was a freestanding tomb a highly original idea, but it also revived on a modest scale Michelangelo's aborted first plan for Pope Julius' tomb. Yet after asking Michelangelo to increase the size of the monument, Cardinal Giulio seems to have become concerned about circulation and sightlines in a chapel containing a centralised monument. It was even-tually decided that a freestanding monument was inappropriate for a relatively small chapel, and that wall tombs would better enable religious services to take place. Even so, Michelangelo was to make Cardinal Giulio's concern with circulation and sightlines central to the chapel's meaning. The whole ensemble revolves around the circulation of gazes and of gifts − specifically, of food and money.

Michelangelo had already been working on designs for wall tombs, and the final plan was for two single tombs on opposite walls for the

recently deceased Lorenzo and Giuliano (known as the *Capitani*), and a double tomb for their two ancestors (the *Magnifici*) on the wall adjoining the church. Two pairs of nude allegories, signifying the 'Times of the Day', were placed beneath the *Capitani* on freestanding sarcophagi with curved and scrolled tops. Standing allegorical figures were also planned for the lateral tabernacles of the ducal tombs, including for Giuliano's tomb, figures of *Earth* (mourning his loss) and *Sky* (celebrating his arrival in Heaven). But these were never executed.

In traditional fifteenth-century wall tombs, the architecture dominated the sculpture. The figures and the sarcophagus tended to be enclosed in an arched framework which formed a shallow niche. The deceased was usually stretched out horizontally on the lid of the sarcophagus, and very occasionally the head might be turned towards the spectator. The most significant exception to this rule was Antonio del Pollaiuolo's *Tomb of Pope Innocent VIII* (*c.* 1492–8) in St Peter's, Rome, which featured a 'live' seated statue of the Pope, his right hand raised in benediction, his left holding the relic of the Holy Lance. This was a topical reference, because the Pope had been presented with a fragment of the Holy Lance by the Sultan Bajazet two months before his death, and it subsequently became a focal point for propaganda for a new crusade.[8] The Pope's statue was placed on a plinth which projects well out of the niche, flanked by allegorical reliefs of *Fortitude*, *Justice*, *Temperance* and *Prudence*; overhead there was a lunette of *Charity* flanked by *Hope* and *Faith*. The radicalism of the seated statue was tempered, however, since it was surmounted by a conventional sarcophagus on which an effigy of the Pope's corpse lay. Michelangelo may well have seen the tomb being made during his first stay in Rome, and he envisaged a seated Pope in his first (1505) design for the tomb of Pope Julius II.

Michelangelo carved seated effigies of Giuliano and Lorenzo, and like the statue of Pope Innocent, each statue projects substantially out of its niche. However, their gazes are not directed out into the middle of the chapel, but towards the end wall, where the entrance door from the church, and the double tomb of their ancestors, surmounted by a Madonna and Child, are located. Giuliano looks as if he might spring up at any moment, and although Lorenzo is more sedentary, his massive legs are thrust out powerfully into the chapel. Both figures seem to project even further because of the shallow and cramped tabernacle niches in which they have been inserted. This aspect shocked some visitors. In the

eighteenth century the French man of letters Montesquieu was alerted by a Florentine sculptor to Michelangelo's 'skill' in putting 'such a great prince [Lorenzo] in such a small space: for he is in a mediocre niche and, if he rose, would touch the top of it'.[9] But Michelangelo clearly wanted the deceased to seem to extrude from the niche, so that they are half inside the sacristy and half out. Similarly, the bodies of the four 'Times of the Day', precariously balanced on their curved sarcophagi, seem to be about to slide down on to the chapel floor, and some of them gaze out into the chapel.

The double tomb of the *Magnifici* was to consist of two sarcophagi, surmounted by an architectural framework containing a statue of the Madonna and Child flanked by statues of the patron saints of the Medici, the doctors Cosmas and Damian. The architectural framework was never completed, and the only fully autograph statue, the *Madonna and Child*, is unfinished. The statues of the saints were carved by Giovanni Angelo Montorsoli and Raffaello da Montelupo after Michelangelo's models. They are orientated towards the Madonna: Cosmas puts his hand on his heart imploringly, and Damian holds an apothecary's mortar.[10]

It isn't only these statues, and those of Giuliano and Lorenzo de' Medici that are orientated towards her. The officiating priest in the New Sacristy stood facing the tomb of the *Magnifici*, behind the altar near the far wall. This was unusual. Normally the priest stood with his back to the chapel and the congregation, but the more open set-up in the New Sacristy followed the practice in the early Church and in medieval baptisteries.[11] Every hour, day and night, except at morning mass, two priests were expected to make intercession for ever for the living and the dead of the House of Medici, reciting the entire Psalter with alternating prayers. Three masses had to be said every day, a ritual requiring the appointment of four additional clergy. Such continuous intercession was unique in Italy during the fifteenth and sixteenth centuries.[12] It is likely to have been an early response to the Protestant Reformation, for until this time Italians had been relatively modest in their endowment of masses for the dead, but as soon as Martin Luther outlawed masses in the 1520s, Catholics rallied behind the practice.[13]

Michelangelo's work on the New Sacristy suffered severe inter-ruptions. The project ground to a virtual halt with the death of Pope Leo in 1521, and only recommenced with the election of Cardinal Giulio as Pope Clement VII, in 1523. A second, even longer interruption occurred from 1527 to 1530. Rome was sacked in 1527 by troops in the

pay of King Charles V of Spain, whereupon Pope Clement fled the city. This catastrophe provoked a rebellion against the Medici in Florence, and the establishment of a new republic, which was in turn overthrown after the Medici became allies of their former enemy, Charles V. The final interruption occurred when Michelangelo left Florence for good in 1534, and moved to Rome to paint the *Last Judgment* for Pope Clement. By then, only the statues of the *Capitani* had been put in place, with the rest lying on the floor of the chapel. The allegorical figures were erected in the mid-1540s, but it was not until 1559, thirty years after the initiation of the project, that the statues of the Madonna and the flanking saints were finally installed.

Despite being incomplete, there is enough *in situ* in the sacristy to allow us to discern the most important themes, for all the statues that Michelangelo proposed to execute himself are here. The *Madonna and Child* (*c.* 1524–34) on the double tomb is one of Michelangelo's most arresting works. The *Madonna lactans*, as we have seen, was rarely depicted in the period, and never on such a monumental scale. Michelangelo may have been partly influenced by the presence of a venerated painted image of a *Madonna lactans* in San Lorenzo.[14] And yet his Madonna, with her blank facial expression and agitated body language, is still not someone

Fig. 16: Tino da Camaino, *Charity*, *c.* 1321 (marble, Florence, Museo Bardini)

from whom one would expect too many favours. Her head sways to one side, and her body lurches forward; her legs are crossed, perhaps protectively, with one knee resting on top of the other. The massively muscular Christ Child sits astride her raised left thigh, and twists himself round violently to feed from her breast, which is still covered. This is far from a serene image. The Madonna and Child seem to be tightly knotted together in a crisscrossing tangle of drapery and limbs. The agitation is accentuated by the numerous unfinished sections, where rough tool marks are clearly visible.

The sculpture invokes basic instincts relating to touching, holding and feeding. Indeed, rarely has the desire to breast-feed seemed so savage. It is generally assumed that Michelangelo invented the motif of the child astride the thigh, twisting round to feed, but it is probably derived from a marble statue of *Charity* (*c.* 1321; Fig. 16) by Tino da Camaino, in which a voraciously hungry child hangs from each exposed breast. The statue is one of a group of three theological virtues commissioned for the east portal of the Baptistery in Florence.[15] For Christians, the virtue of charity was preeminent: its essence was love, not just for one's fellow men, but also for God. The statues were taken down in 1502 because they were damaged and also because they were thought to be 'clumsy'.[16] Shortly after, the motif of the twisting child appears in two of Michelangelo's drawings of a *Madonna lactans*.[17] As he was carving the marble *David* at the time for the cathedral authorities, Michelangelo must have seen this remarkable sculpture at close quarters soon after its removal.

In the New Sacristy the Christ Child presents his back to those coming in through the original entrance, a door in the wall to the left of the sculpture, connecting the sacristy with the church. As we enter the chapel we are being reminded – *pace* Catherine of Alexandria – that we are still sinners who must repent before being granted access to the 'shining face' of Christ which is partially visible from the far side of the sacristy. We take our emotional cue from St Cosmas, whose anguished state must in part derive from the fact that he too is confronted by the Christ Child's back. Once we reach the far side of the chapel, and are permitted to glimpse Christ's face, we should become more like St Damian, whose tranquillity must be due to the fact that he is permitted to see the face of Christ and the Madonna. This is the first time that the meaning of a statue placed against a wall unfolds as one moves round it – a principle that would be spectacularly exploited a hundred years later by Bernini.[18]

It has been argued that the 'violent movement' of Michelangelo's *Madonna and Child* 'seems a little irreverent in the still complex of the tombs', and the most likely explanation is that it was made for a different purpose and was 'later diverted' to the chapel.[19] Irreverent it may be, but it is scarcely inappropriate. The point of the 'violence' is partly to underscore the completeness with which Mary gave of herself in order to be the mother of God. It recalls the contemporary belief that breast milk was processed menstrual blood, which meant that the mother effectively gave her own lifeblood to her child.[20] In Michelangelo's work, the dramatic relationship between the Madonna and Child is most nearly approximated in an eerie presentation drawing of the dying Cleopatra with the asp biting her breast, usually dated to the early 1530s. Both Cleopatra and the Madonna have a resigned, almost drowsy expression.[21]

A comparable idea of the exhausted, self-sacrificial mother was depicted elsewhere in the chapel. One of the two large marble candelabra on the altar, designed by Michelangelo, has images of a pelican piercing its breast to feed its young with its own blood. This was a traditional symbol of Christ's sacrifice on the Cross, as well as being an attribute of allegorical figures of Charity (the other candelabra is decorated with a phoenix, symbol of the resurrection). Michelangelo emphasises the ravenous hunger of the muscular Christ Child, and the vast reserves of energy and strength that the Madonna needs to satisfy him, even if it means putting her own well-being at risk. Her blank expression and awkward pose suggest she may be swooning with exhaustion. Her own suffering would thus also be a premonition of Christ's Passion. Whereas Michelangelo's 'stony' Madonnas seem emotionally withdrawn through unbending determination, this Madonna seems withdrawn through enervation.

Thematically, this highly charged representation of the *Madonna lactans*, which makes us acutely aware of the personal sacrifice involved in giving sustenance to another person, is in keeping with the iconography of the statues in the rest of the chapel. The saints who flank the Madonna, Cosmas and Damian, were early Christian martyrs, physicians who never charged their patients. In a more general sense, the nude reclining allegories are also offering up their own bodies. But the meaning and the cost of charity are most compellingly expressed in the statues of Giuliano and Lorenzo de' Medici.

<div align="center">★</div>

BOTH GIULIANO AND LORENZO had been Captains of the Roman Church, which is why Michelangelo always referred to them as the *Capitani*. Six months after his coronation as Pope, Leo X had conferred this title on Giuliano, and made both him and Lorenzo Roman citizens in an elaborate ceremony on the Capitoline Hill in Rome amidst Roman triumphal trophies and Medici symbols.[22] Lorenzo succeeded his uncle as Captain of the Church in 1516. They had also been put in charge of the papal forces. This helps explain why Michelangelo has attired these Medici in elaborate and fantastical parade armour, with a classicising decoration of grotesque heads. The armour also alludes to the idea of the 'Christian soldier'. In Erasmus' *Handbook of the Militant Christian* (1503), Christians were warned that 'since our enemy [the Devil] is incessant in his attacks, we must be constantly on the battle line, constantly in a state of preparedness'.[23] Hence the *Capitani* remain armed while seated.

A more common motif, found especially in north Italian art, was to depict a princely warrior kneeling in full armour before the Virgin, usually to ask for her protection in battle. Something comparable could be seen in the Florentine church of Santissima Annunziata, the mother church of the Servite Order, the Servants of Mary. Its main claim to fame was a sacred painting of the Virgin at the time of the Annunciation. It was the most venerated shrine in Florence, and high-ranking visitors to the city made it their first port of call. The picture, which was believed to have been started by a monk in 1252, but completed by an angel, would be specially unveiled for these visitors. As a mark of respect they often left behind life-size effigies of themselves in wax, dressed in authentic clothing, which were sometimes suspended from the rafters. Among these were several effigies of armed and mounted *condottieri*. High-ranking Florentines, including several members of the Medici family, also had effigies made.[24]

Yet even if we assume that the *Capitani*'s armour signifies the 'Church militant', the classicism of its decoration is rather surprising. One wonders why it wasn't made to look more clearly Christian by the inclusion, for example, of a phoenix or a pelican in its decoration. The answer may be that the *Capitani* are clearly identified as 'Christian soldiers' by a striking detail of their appearance which has always fascinated and sometimes perplexed viewers. This is particularly conspicuous in the statue of Giuliano, not least because it is finished. In the place where Giuliano's breastplate should be, Michelangelo appears to

have carved naked flesh. Instead of steel, we find an anatomically detailed chest and abdomen, with every asymmetrical ripple of the muscles and crease of the skin made visible. At the midriff, the skin merges imperceptibly with the leather tunic.

Roman-style armour made from moulded leather did follow closely the shape of the chest and abdomen, with *trompe-l'oeil* anatomical detail – but in a very schematic and symmetrical way. This is what we tend to find in representations of Roman armour by painters such as Mantegna and Ghirlandaio, and in classicising Renaissance parade armour – often referred to as the *cuirasse esthétique*.[25] But with these sedentary figures, Michelangelo was evidently doing something deliberately ambiguous, by making the armour and leather appear to give way to real flesh.

Michelangelo is emphasising, in a radically new way, the dual role of a Captain of the Church. What we are seeing here is the Church in both its militant and benevolent aspects. The standard way of showing this can be seen in Pollaiuolo's seated statue of Pope Innocent VIII, where one hand is raised in benediction, and the other holds a replica of the head of the Holy Lance.[26] In the statue of Giuliano, the armour suggests the Church militant. And so, to an extent, does the muscular lower torso. But Giuliano's torso is strikingly swollen. The breasts are tumescent, and the nipples distended.[27] Thus the torso goes far beyond being simply virile. It is also maternal and vulnerable. In the New Sacristy, a *Madonna lactans* is confronted by a *Medici lactans*. Giuliano's torso is not just 'confessional'; it is charitable too.

This expressive distortion seems to be an allusion to the trope of the 'maternal' God, and the 'maternal' servant of God.[28] In the Old Testament, God often speaks of himself as a mother, conceiving the Israelites in his womb and comforting and suckling them on his bosom. But the most celebrated and extended exploration of this theme was by the twelfth-century Cistercian mystic St Bernard of Clairvaux. Bernard had promoted devotion to the Virgin Mary and the Infant Jesus, and was said to have been visited by the Virgin and breast-fed by her. Bernard uses the word 'mother' to describe Jesus, Moses, Peter, Paul, prelates and abbots, in order to underline their nurturing role. For Bernard, breasts are a symbol of the pouring out to others of affection and instruction. When discussing the role of abbots, Bernard contrasts the maternal with the 'headmasterly' aspects, and he firmly believed that the ideal abbot will embody both qualities; he also advocated a combination of the active and contemplative life. Thus his devotion to the Virgin Mary was

counterbalanced by enthusiastic support for crusades (he promoted the disastrous Second Crusade) and for new crusading orders like the Knights Templar. Michelangelo would certainly have known about Bernard, since he guided Dante through Paradise in the last three cantos of the *Divine Comedy*, and interceded between the poet and the Virgin Mary. At the beginning of the sixteenth century Bernard's writings were exceptionally popular. His vision of the Virgin, sometimes shown proffering her breast to him, was frequently depicted in art.

In his letters, Bernard urges faint-hearted novices who are struggling with the strictures of monastic life to seek out the maternal aspects of God: 'If you feel the stings of temptation . . . suck not so much the wounds as the breasts of the Crucified. He will be your mother, and you will be his son.'[29] This sort of imagery was taken up by Catherine of Siena (1347–80), who was canonised in 1461. For her, God was Charity, and through Christ God nourishes the faithful.[30] The theme was very occasionally depicted. A sixteenth-century hagiographer reports that Alda of Siena commissioned a painting in which Mary drinks from the breast of Christ while holding him in her arms. Images of the Virgin presenting her breast often accompanied the figure of Christ exposing his wounds, and in one case, the wound of a feminine-looking Christ is relocated to where his nipple should be. It was actually thought to be physiologically possible for some men to lactate. Berengario da Carpi, writing at the beginning of the 1520s in his anatomical treatise dedicated to Cardinal Giulio de' Medici, claimed that 'sometimes milk is made in the male because of the abundance of nutriment, especially a man who has large strong breasts'.[31]

The most elaborate use of maternal imagery occurs in Bernard's *Sermons on the Song of Songs*, where he uses erotic references to breasts in the biblical text as a springboard for discussions of the need for prelates to 'mother' the souls in their charge. At one point, he implores them: 'Show affection as a mother would, correct like a father. Be gentle, avoid harshness, do not resort to blows, expose your breasts: let your bosoms expand with milk not swell with passion' (Sermon 23).[32] Giuliano has exposed his expanded breasts in the most dramatic way possible, and Michelangelo hints at the possibility of suckling from them by carving Lilliputian heads with open mouths on the ends of his shoulder straps just above his nipples: the heads seem to be sliding down hungrily towards them (Benvenuto Cellini, in a bronze bust of *Duke Cosimo I de' Medici* (*c.* 1545–8), devised a *cuirasse esthétique* with an eagle suckling at each of

the Duke's hugely erect nipples). Giuliano exemplifies a further aspect of
the St Bernard story: not only is he depicted in maternal form, but he too
is having a vision of a lactating Virgin Mary. The Virgin was sub-
sequently said to have posed specially for Michelangelo when he made
his statue of the Madonna.[33]

Two pairs of river gods, reclining and kneeling, had been planned for
the spaces flanking the bottom of the sarcophagi below Giuliano and
Lorenzo, thus forming the base of a pyramid. They were never executed,
but would probably have had a geographical significance, with two of
them signifying the Tiber and the Arno.[34] These would have related to
the theme of beneficence, for St Bernard says that Christ's health-giving
properties are akin to those of a river, fountain or well: 'from him as from
a well-head comes the power to be pure in body, diligent in affection
and upright in will . . . Let the rivers of grace circle back to their
Fountain-Head that they may run their course anew. Let the torrent that
springs in heaven be channelled back to its starting point, and be poured
on the earth again with fertilising power.'[35] The sliding cascade of
allegorical statues seems to emanate from Giuliano like a torrent of water
from a sluice. Thanks to the Medici, the pure fertilising power of rivers
has been harnessed and unleashed.

The feminine aspects of the statue of *Giuliano de' Medici* do not end
with his exposed and expanded breasts. The diminutive and dainty oval
head, balanced on its stalk-like neck; the luxuriant foam of tousled hair;
the delicate, elongated fingers which scarcely grip the large baton resting
unused on his thighs, all these make him appear refined and even a little
girlish. Small wonder, then, if Michelangelo should adapt the
composition for a drawing of a full-breasted *Madonna lactans*,[36] or that the
statue influenced Parmigianino's stylishly attenuated *Madonna with the
Long Neck* (1534–40).[37]

DIRECTLY BELOW GIULIANO, reclining on the curved lids of the sarcoph-
agus, are the two allegorical figures *Night* and *Day*, which together
with the figures of *Morning* and *Evening* make up the 'Times of the Day'.
They are complementary figures, though not quite symmetrical. *Night* is
the only one of the 'Times of the Day' to be supplied with attributes. An
owl is ensconced beneath her left thigh; a grotesque mask lies below her
left shoulder, suggestive of nightmarish chimeras; a bunch of poppies,
symbols of death, rest beneath her foot. Michelangelo may have felt it
was enough to identify *Night*, and leave the viewer to work out the rest

of the allegorical statues. But if the Sistine Ceiling is anything to go by, where Jonah, the most important Prophet, is the only one to be given attributes, then it may also indicate that *Night* is the most significant allegorical figure. The pre-eminence of night would make perfect sense in a funerary chapel, especially one where nocturnal ceremonies were held, but Michelangelo also seems to have had a special affinity for night because he devoted two poems to the subject. In one (no. 103), night is said to be more important than day because human beings are conceived during the night; in the other (no. 247), a reply to a poem written during the 1540s about his sculpture, *Night* says she does not want to be woken up 'while harm and shame last' – probably a reference to the autocratic rule of Duke Cosimo I de' Medici and/or the parlous state of Christendom.

Night's bell-like breasts resemble allegorical props too, so loosely are they appended to her chest. Baudelaire thought that they had been 'formed in the mouths of Titans!' and were thus indestructible, but modern critics have stressed the signs of debilitation, her body showing 'signs of decline', her breasts 'so distended as to suggest actual distress' and resembling 'flabby bags'.[38] Recently, it has even been suggested that her strangely formed left breast shows signs of advanced breast cancer.[39] However, it seems probable that Michelangelo merely intended to represent a mother who has suckled several children, and whose stomach is lined and creased.

Night is also damaged in a more unnatural way. Her left arm is missing, and the grotesque mask occupies the space where it should logically be. It is said that Michelangelo misjudged the size of the marble block, and failed to leave room for the arm. But it was a happy accident, for the presence of the left arm would have made her more conventionally human. The missing limb makes her seem more self-contained, and more pelican-like. She curls into herself, with her head bent forward and down, facing her exposed breast and abdomen. A thick plait of hair seems to project directly from her right cheek, plunging vertically down as if pushing her right breast further to the edge of her chest. Indeed, it relates to the breast like a clapper to a bell. Her right arm is bent forward and across her thigh, with the elbow digging beakily into it. But *Night*, in plumbing the depths of her own self, is like someone digging for water in a dry well. *Night*'s three attributes are akin to monstrous offspring, who continually demand and feed off their mother's supplies of darkness. The 'visual noise' created by these props, and by the 'hammering' that

Night inflicts on herself, attests to an unending nightmare. Their presence here is thus thoroughly appropriate.

The potentially destructive aspects of feeding relate to another central theme of the chapel – that of time. According to Condivi, the allegories symbolise 'Time which consumes all', and 'to signify Time, [Michelangelo] meant to carve a mouse, for which he left a little bit of marble on the work, but then he was prevented and did not do it; because this little creature is forever gnawing and consuming just as time devours all things'.[40] The remorseless appetite of time is instead epitomised by the grotesque frieze of masks which runs along the wall behind the allegories. They are like an infestation of hungry mouths.

Whereas the main focus of interest of *Night* is the front of her torso, *Day* offers up his astonishingly muscular upper back, which is most fully viewed from the direction of the altar. This is the only figure in the New Sacristy, apart from the Christ Child, who is not shown primarily from the front. The treatment of the back, with the left arm twisted round in a self-inflicted half-nelson, and of the right shoulder, is breathtaking. The musculature is so pneumatic that his back seems to be about to split open along the upper spine, like bread baked with too much yeast.

Day recalls a fable jotted down by Leonardo in his *Notebooks* about an over-ambitious peach tree: 'The peach tree, being envious of the large quantity of fruit which she saw borne on the nut tree, her neighbour, determined to do the same, and loaded herself with her own in such a way that the weight of the fruit pulled her up by the roots and broke her down to the ground.'[41] This in turn relates to Leonardo's criticism of muscular bodies that look like sacks of nuts or bundles of radishes: for peaches, we can substitute 'muscles'. One might say that in general Michelangelo treats muscles, especially those of the torso, as a kind of fruit – the ultimate symbol of human fertility and even pregnancy. But this grandiose recumbent giant seems to have reached his peak and may be on the verge of being gnawed by the teeth of Time's retainers.

One would hardly guess that such a convoluted and lugubrious elderly bearded figure signified anything so bright and limpid as day. His principal day-like property lies in the exposure of so much of his body 'to the light of day'. Perhaps, too, we are meant to think of it as a body that has fully ripened in the sun. Yet as in the Leonardo fable, there is a pathos to this ripeness, for the sheer weight of it has immobilised him, and even hidden his face. Michelangelo has created a primordial landscape out of *Day*'s body. The face, which glances over to the other

side of the chapel, is like a sun which is partially occluded (a sensation that is increased by the unfinished state of the head). As such, it is either setting, or being eclipsed: day itself is sinking and disappearing in sympathy with Giuliano's death. This is *Day*'s Judgment Day.

ON THE OTHER SIDE of the New Sacristy we find the reclining figures of *Dusk* and *Dawn*, set on the tomb of Lorenzo de' Medici. Their poses are less convoluted and more full-frontal than their opposite numbers. *Dawn* is a nubile version of *Night*, sexually available but not yet pregnant. These two are Michelangelo's first and only statues of the female nude, and their presence here confirms the centrality of the theme of charity. They represent different phases of giving. Whereas *Night* has allowed herself to be impregnated, and has given suck, on numerous occasions, *Dawn* is offering herself up for the first time. She is either awakening or dozing in a kind of drugged daze. Even if she is not fully conscious, her parted lips, plump, firm breasts, attenuated belly, parting thighs, and her whole body tipping towards the viewer (and, provocatively, pointing towards the officiating priest), are an obvious enticement. Here, the notional blindness of her eyes increases the erotic charge as well as the pathos because it makes her seem more vulnerable. *Dawn* and *Night* were both objects of desire for Michelangelo's contemporaries and if posters had been invented, they would have become Florence's favourite pin-ups.

Day's partially occluded face is echoed in the statue of Lorenzo de' Medici, who is far more introverted than Giuliano. He leans his head on his left hand, which holds a handkerchief or a pouch, and his mouth and chin are concealed by his fingers. A fantastically ornate helmet, whose decoration features a lion's head, covers the top of Lorenzo's head and casts a shadow over his forehead and eyes. The elbow of his left arm rests on what is usually assumed to be a money-box. Money-boxes of approximately this size are known, and since Lorenzo is leaning his elbow on it, it could hardly contain objects of religious or sentimental value.[42] The money-box complements a similar motif in the statue of Giuliano, for he holds some coins in his left hand.

Lorenzo's closure and Giuliano's openness are more or less in keeping with what we know of their characters. This is an element of 'realism' about their portrayals, notwithstanding Michelangelo's famous claim (recorded in 1544) that he had not made accurate portraits of them because in a thousand years no one would know what they looked like anyway. When Giuliano returned to Florence after the fall of the

10. *St Matthew, c.*1506

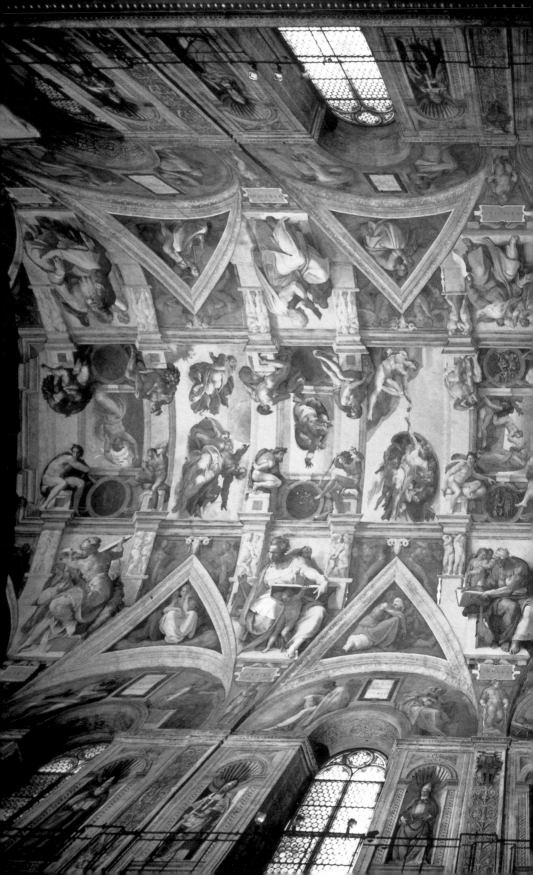

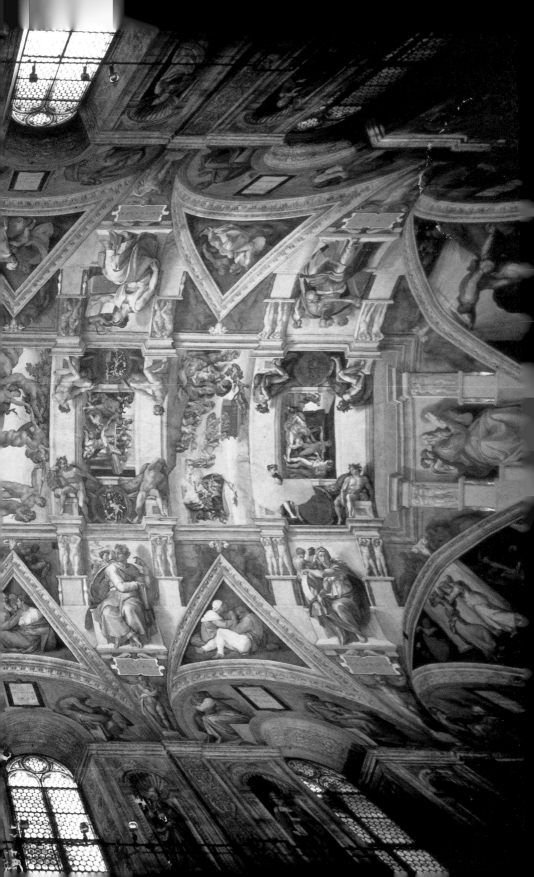

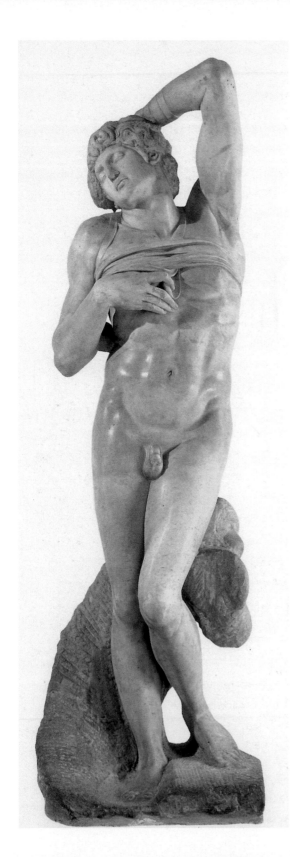

PREVIOUS PAGE
11. *Sistine Ceiling*, 1508–12

12. *Dying Slave*, 1513–16

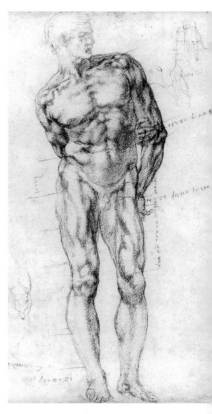

13. *Anatomical and Proportion
Studies*, c.1516

14. *Madonna and Child with Sts Cosmas and Damien, c.*1524–34

(*Left*)
15. *Tomb of Giuliano de' Medici,* 1521–34

(*Below left*)
16. *Tomb of Lorenzo de' Medici,* 1521–34

17. Staircase of Library at San Lorenzo, 1524–34, completed by Bartolomeo Ammanati in 1559

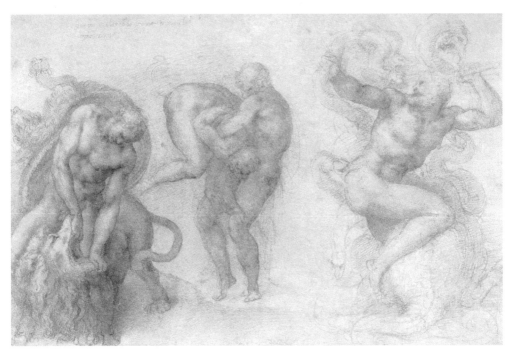

18. *Labours of Hercules*, c.1530

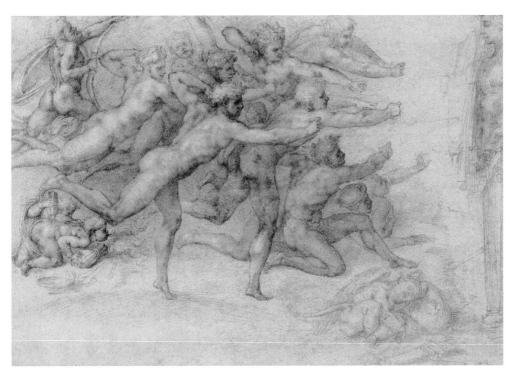

19. *Archers*, c.1530

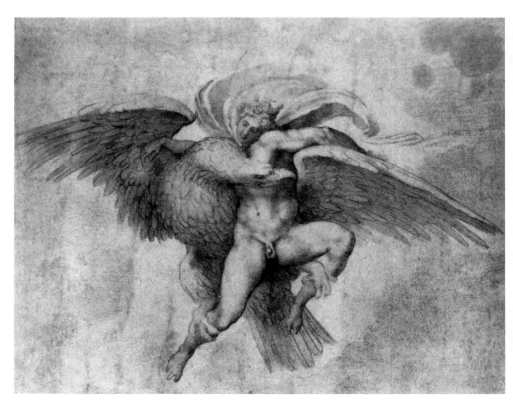

20. *Rape of Ganymede, c.*1533
(detail showing the top half of the picture)

21. *Tityus, c.*1532

Republic in 1512, he shaved off his Spanish beard (a sign of aristocratic distinction) and tried to have some contact with the people. A post-humous description by a contemporary reads: 'Tall, pale, long-necked, stooping, with long arms and blue eyes, serious both in gait and speech, kindly, humane, affable, courteous, witty, mild, amiable, of a weak con-stitution, compassionate, and most liberal.'[43] Pope Leo X soon had replaced him with his more autocratic nephew Lorenzo, who wore black Spanish dress, and kept his Spanish beard to show his superior rank. He only appeared in public accompanied by an armed guard, and people had to address him with their hats off.[44] Even in front of the Virgin in the New Sacristy, Lorenzo keeps his helmet on.

Yet it is almost inconceivable that Michelangelo would have depicted Lorenzo as an arrogant, brooding monster, which many critics have assumed. Vasari correctly described him as 'pensive . . . the very presenti-ment of wisdom',[45] and even if he keeps his helmet on, his body is orientated towards the Virgin, a clear sign of reverence. He would be even more physically exposed to her if the carving had been completed, for the indications are that he too would have been furnished with a quasi-naked torso. The statue of *Lorenzo* – like that of *Giuliano* – is far more likely to be a celebration of the magnanimity, piety and grandeur of the Medici family. Indeed, when Michelangelo said that no one would recognise them in a thousand years' time, this was because he wanted to give the statues 'a greatness, a proportion, a dignity . . . which [it] seemed to him would have brought them more praise'.[46] He was doing his best by his employers.

The statues of Giuliano and of Lorenzo were begun in the mid-1520s. Work had slowed almost to a standstill after the death of Pope Leo in 1521, and only picked up momentum at the end of 1523, when Cardinal Giulio was elected Pope Clement VII. In November 1523 Michelangelo again ordered marble blocks for the statues, larger than the ones he had ordered in 1521. The final appearance of the statues – especially the unique iconography of the money-box held by Lorenzo, and the coins held by Giuliano – may well have been determined by events that took place in the early 1520s.

During this period, as we have seen, Michelangelo had been giving a great deal of thought to the relationship between money and morality. In February 1521 his father Lodovico had stormed out of Florence to the farm at Settignano, complaining to anyone who would listen that Michelangelo had evicted him from the family home.[47] The root of the

problem seems to have been a misunderstanding over money. In order to make sure that loans and gifts to Lodovico and his brothers were repaid, Michelangelo had arranged for the outstanding amount to be subtracted from his father's estate after his death. Only then would the inheritance be shared out equally among all Lodovico's sons. Lodovico assumed Michelangelo was preventing him drawing on his own money. Despite Michelangelo's assurances to the contrary, he was intransigent, and stayed at Settignano. Siding with their father, Michelangelo's brothers Giansimone and Buonarroto moved out of the family home in Florence which was paid for by the now extremely wealthy Michelangelo (he had been purchasing property in and around the city since the time of his commissions for the *Battle of Cascina* and the *Tomb of Julius II*).[48] Buonarroto was the only brother to whom Michelangelo had been close. Although some of their differences were resolved, the family did not return. In June 1523, Michelangelo wrote sarcastically – to 'Lodovico' rather than to his 'Most reverend father', his usual form of address: 'all Florence knows that you were a rich man and that I have always robbed you, and have deserved punishment: you will be much praised! Shout and say about me what you wish, but do not write to me any more, because you do not let me work as I still must to make good what you have had from me for the last twenty-five years.'[49]

At the same time, Michelangelo was becoming increasingly embarrassed by his failure to complete commissions. In December 1518, he had lamented his inability to complete a statue of the Risen Christ for the church of Santa Maria sopra Minerva in Rome. It had been commissioned in 1514 and the patron was still waiting. Michelangelo wrote that he had become 'an impostor' against his will. But this was a relatively minor issue compared to his failure to complete – or even work on – the Julius tomb. The dead Pope's family, the Rovere, were losing patience. In December 1523, after one of the executors called him a cheat for failing to put 3,000 ducats into the account for the project, Michelangelo wrote a protracted justification to Giovan Francesco Fattucci, a priest who oversaw the tomb project for him in Rome, claiming that after all the unpaid work he had done for Pope Julius, the family owed *him* money. But Michelangelo was already gaining a reputation for meanness: in the first biography to be written about him, composed by Paolo Giovio in the late 1520s, we are informed that he has 'a character so uncouth and savage' that his domestic life is marked by 'an incredible meanness', and by his refusal to take on pupils, or to let

people visit his studio.[50] It has recently been shown that Michelangelo lied about the amount of money he had received for the tomb, and ended up spending only a third of the vast sums he had received for it from the Rovere family.[51]

However, the crucial catalyst for the imagery of the New Sacristy was, I believe, a less personal event: the canonisation in 1523 of St Antonino, a fifteenth-century Archbishop of Florence who founded the Dominican convent and library of San Marco, with considerable financial support from Cosimo il Vecchio.[52] A prolific theologian, Antonino was celebrated for his learning, asceticism and charitable works. It was said that he was made Archbishop of Florence on the recommendation of the Dominican painter Fra Angelico, whose frescos adorn San Marco.[53] Antonino was the most revered Florentine of the fifteenth century, and his books were certainly the most widely read – not least, by Savonarola.[54] Lorenzo de' Medici made an unsuccessful attempt to have Antonino canonised in 1488–9, and during a triumphal visit to Florence in January 1516, Pope Leo X again proposed it.[55] Pope Leo's initiative was partly a sop to the Florentines, and to the friars of San Marco, who were unhappy about being under Medici rule. The impetus is likely to have come from Cardinal Giulio, Archbishop of Florence, who was pursuing a policy of appeasement. After protracted negotiations with the papal consistory, the canonisation was agreed in December 1520. However, as Pope Leo died the following year, the formal announcement was made by his successor Pope Adrian VI in May 1523,[56] but because of Adrian's own death, the bull was published by Clement VII (the erstwhile Cardinal Giulio) in November 1523, on the day of his own coronation as Pope.[57]

Antonino's most important charitable work was the founding in 1442 of the Società dei Buonomini di S. Martino, which gave help, often secretly, to the so-called *poveri vergognosi* – respectable people in reduced circumstances who were too ashamed to beg. St Martin, their patron saint, was the archetypal Christian soldier. While serving as a Roman soldier, he had given half of his cloak to a beggar, whereupon Christ appeared to him, and he immediately converted.[58] The Buonomini based themselves in the oratory of San Martino, near the Bargello, and the oratory was also dedicated to the Medici saints, Cosmas and Damian.[59] Half of all their donations came from Cosimo de' Medici during his lifetime,[60] and Savonarola earmarked the gold coins placed by Lorenzo de' Medici in the collection box at San Marco for the Buonomini.[61]

Antonino emphasised that charity should not be distributed indiscriminately, but 'cum intellectu et ratione' – with intelligence and reason.[62] He drew up a list of nine different levels of misfortune so that the merit of each case could be determined, with the least deserving being heretics. The most deserving were the *poveri vergognosi*, because they suffered twice over – from poverty, and from not being accustomed to poverty. Antonino argued that it was actually sinful to help the unworthy poor. The idea of 'targeted benefits' was a significant change from the idealisation of poverty by the medieval Church, which regarded the poor man as akin to Christ, and poverty as a condition to which one might aspire.[63] Other Florentine contemporaries, such as Leon Battista Alberti and Fra Dominici, also saw poverty as a shameful condition, and distinguished between the worthy and the unworthy poor.[64]

Antonino's canonisation came at a time when begging, vagrancy and unemployment were regarded with increasing alarm and hostility. The appearance of syphilis in the 1490s – a disease which was thought to have been brought by the invading French and was therefore known as the *mal francese* (French disease) – contributed to an already growing intolerance of the poor and disabled. In the paintings and drawings of Hieronymus Bosch (*c.* 1450–1516), beggars and the poor are castigated as sinful knaves and fools.[65] In August 1515, six months before setting in motion the canonisation of Antonino, Leo X published a papal bull to set up a hospital in Rome to house 'incurabili' (Fig. 17). It was evident that the main concern was to get syphilitic invalids off the streets and stop them begging, for they dragged themselves along 'on little trolleys and vehicles, both giving offence to themselves and blocking the way of those they encounter'.[66] In 1520, Cardinal Giulio gave his backing to a similar hospital in Florence, and four 'custodians' were appointed to 'search diligently' through the city and bring the 'sick poor people' to the hospital.[67]

In the 1520s, concern with begging reached a peak. Erasmus published a satirical dialogue, *The Godly Feast* (1522), in which the host and his guests agree that Christ did not mean that the rich should give to everyone who asks ('If I did that, I'd have to beg myself within a month'); rather, they should support those who 'really need it'.[68] In 1524, Erasmus followed this up with two more satirical dialogues, *The Well-to-do-Beggars* and *Beggar-Talk*. The year 1526 saw the publication of Juan Luis Vivès' influential *De subventione pauperum* ('On Aid for the Poor'), which advocated centralised municipal distribution of alms, the

Fig. 17: Incised marble plaque over a collecting box outside the Church of Santa Maria in Porta Paradisi, at the Hospital of San Giacomo, Rome. Probably dating from the first half of the sixteenth century, it shows a beggar with syphilis seated on a cart. A turban covers his bald head, baldness being a symptom of an advanced form of syphilis

setting up of workhouses, and the expulsion of foreign beggars (after they had been given money for the journey home).[69] Then in 1532 Machiavelli's *The Prince* was published. It was probably written in around 1513, and was initially dedicated to Giuliano de' Medici, and subsequently to Lorenzo de' Medici – the two *Capitani* of the New Sacristy. In the chapter on 'generosity and parsimony', the Prince is advised that there is 'nothing so self-defeating as generosity: in the act of practising it, you lose the ability to do so, and you become either poor and despised or, seeking to escape poverty, rapacious and hated' – by those the Prince is then forced to rob.[70]

Michelangelo's famous letter of December 1523, in which he claims that the heirs of Pope Julius rightfully owe him money, expresses sentiments with which Antonino would have sympathised. While listing the huge – and mostly unrewarded – efforts he put into Julius' projects,

159

Michelangelo explains the gestation of the scheme for the Sistine Ceiling: 'After the work was begun it seemed to me that it would turn out a poor affair, and I told the Pope that if the Apostles alone were put there it seemed to me a poor affair. He asked me why. I said, "because they themselves were poor".'[71] Here there is an implied criticism of the poverty of the apostles, and it can be understood in the light of Antonino's own condemnation of the apostles' repudiation of private property. He objected to it because those who had no assets had to beg, as did the mendicant orders of friars. He believed that begging was a drain on the wealth of the rest of society, and produced even more poverty. It is likely that Michelangelo reworked his conversation with Pope Julius to reflect recent debates about Antonino. In the letter of 1524, quoted at the beginning of this chapter, Michelangelo castigates the sophistry of 'poor ingrates' who assume that a benefactor only operates out of self-interest.[72] Yet Michelangelo seems to have believed this too. Vasari informs us that he himself would never accept gifts 'because it appeared to him that if anyone gave him something, he would be bound to him for ever'.[73]

There is also direct evidence to suggest that Michelangelo was an admirer of Antonino. Writing threateningly to his nephew Lionardo in 1552, he urges him to take a wife: 'if you remain without legitimate issue, San Martino will inherit everything – that is to say, the income will be given for the love of God to those ashamed to beg, that is to poor nobles'.[74] Having heard that there is 'great poverty in Florence, especially among the nobility', he recommends that Lionardo perform the 'charitable' act of marrying a poor but noble woman.[75] In the event, Lionardo did marry a woman from a noble family in 1533, Cassandra di Donato Ridolfi, and produced eleven children (of which seven died). So the Buonomini got nothing.

Politically, Michelangelo seems to have had republican sympathies: in addition to working for the two Florentine Republics that came to power during his lifetime, he carved an unfinished bust of the tyrant-slayer *Brutus* in the 1540s for the exiled republican Donato Giannoti. But these Republican governments were far from being democratic or liberal. With only a tiny percentage of the population being eligible to vote, they were oligarchies largely dominated by members or clients of the leading families, and their social policies were often more draconian than those of the Medici. We should not, therefore, be in the least surprised if Michelangelo's 'republicanism' went hand in hand with reverence for rank and social class, and contempt for the (non-voting) masses.

★

THE MOST CELEBRATED work made in response to Antonino's canon-
isation sheds interesting light on the New Sacristy. In 1525/6 Lorenzo
Lotto was commissioned by the friars of Santi Giovanni e Paolo in
Venice to paint an altarpiece to St Antonino. The execution of the
altarpiece was greatly delayed, and took place from 1540 to 1542, but
Lotto had probably planned the composition shortly after the initial
commission.[76] He showed Antonino enthroned, flanked by angels, and
below him two of his deacons receiving petitions from the poor and
giving alms to them. But the deacon responsible for giving alms has put
his hand in his purse and has hesitated to withdraw it. This suggests that
Antonino's charity is not going to be handed out indiscriminately, but
only to those who deserve it.[77] Although enthroned bishops had been
depicted before, the altarpiece was unprecedented in its prominent and
detailed references to his exemplary acts.[78]

Critics frequently argue that Lorenzo represents the melancholy
temperament and/or the contemplative life, while Giuliano represents
the sanguine temperament and/or the active life.[79] There is an element
of truth in both, and Michelangelo may initially have set out to incor-
porate such antitheses into the figures. But such explanations cannot give
a positive account of Lorenzo's money-box. Critics end up saying
that his closed money-box signifies parsimony, because this was a
characteristic of the melancholy temperament.[80] It has even been
suggested that it alludes to the poor state of the Medici finances.[81] But
these interpretations are hardly flattering, and they do not accord with
Michelangelo's own statements about the chapel, which suggest he was
pulling out all the stops to glorify the Medici.

The cult of Antonino offers a more plausible explanation, and the
iconography of the statues would have been finalised around the time of
his canonisation. Michelangelo may well have conceived the references
to alms-giving shortly before he re-ordered his marble blocks late in 1523.
The affable Giuliano, with his coins at the ready (a motif that partly recalls
images of Roman emperors on coins),[82] is the counterpart to the reticent
Lorenzo, leaning on his closed money-box. They represent two comple-
mentary, rather than contrasting, phases of charitable giving. Giuliano is
about to get up and dispense alms, though there is still an element of
circumspection for he does not hold the coins out, and they can only be
discerned with some difficulty from the floor of the chapel; Lorenzo is still
weighing up the options, and this is why he is so pensive.[83]

The front of his money-box is adorned with the head of an animal with a snout and huge ears, which has been variously interpreted as that of a bat and of a lynx. It is probably a composite creature of the kind that was common in medieval art, but the basic meaning seems clear enough. Both animals were credited with great powers of perception, and they underline the shrewdness with which the Medici's money will be distributed. The motif is also slightly ominous, however, like the insignia of a secret police force that pries into the innermost recesses of the citizen's life. The Buonomini di San Martino did indeed carry out thorough investigations into supplicants' finances and morality before deciding whether to give assistance.[84]

The architecture of the New Sacristy, with its mixture of genuine and 'blind' doors and windows, continues the theme of selective admittance. The doorways (like the tabernacles in which the *Capitani* sit) are unusually small and plain, and they appear even smaller because huge, elaborate tabernacle structures squat directly on top of them. This too must be a moralising feature. In the *Handbook of the Militant Christian*, Erasmus insists that the entrance to the 'abode of wisdom is narrow. The doorway is low, and there is danger in not stooping when you enter.'[85] Humility is required here.

Also relevant is the piece of material that Lorenzo holds in his left hand. This is usually interpreted either as a pouch for money, or as a handkerchief. Either would fit the general pattern of the iconography. If a pouch, it is an empty pouch – which means that Lorenzo has just distributed some alms and is thinking of his next move. If it is a handkerchief, then it could allude to Antonino's miraculous handkerchief. He was said to have given a handkerchief to a woman who had appealed to him because her child was seriously ill. He told her to place it on the child's head, whereupon the child made a miraculous recovery.[86] Lorenzo's handkerchief may suggest that he possessed comparable, quasi-saintly powers: here the Medici really are 'medici' – the most powerful of doctors.

The *Capitani* look towards the Madonna and the Medici family saints for guidance, as well as for intercession. They are themselves blind beggars, but ones who beg for advice on what to do with their money and how to save their souls. The Madonna is the most discerning of all alms-givers, for she offered her whole body and soul to Christ. The Medici's active engagement with such mentors demonstrates that their charity has not only been great, but also discriminating. They did of

course give a great deal of money to Antonino and to the Buonomini. *Buonomini vergognosi* who received regular pensions from Pope Leo X included members of the aristocracy who had fallen on hard times, some from the Royal House of Aragon.[87] When Cardinal Giulio was elected Pope Clement, the Buonomini sent their congratulations, and he immediately replied, praising them for their charitable works and promising to give them even more support than in the past.[88] Last but not least, the Medici had paid money to a certain Michelangelo Buonarroti, an exceptionally worthy cause because he was both a great artist and from a fine family that had fallen on hard times. In the face of so many claims to the contrary, Condivi would later stress Michelangelo's own liberality, but with an emphasis on its discernment. Not only was he 'generous with his work', giving away statues and drawings, 'but also with his purse he has often met the needs of some poor, deserving student of letters or of painting'.[89]

The slight irony here is that when Antonino was canonised, Pope Adrian had urged the Florentines to build him a sepulchre worthy of his name, but they failed to do so until 1589, when a chapel designed by Giambologna was built in San Marco, funded by the Salviati family. Yet because of its symbolism, the New Sacristy is a sepulchre at least partially worthy of Antonino.

The New Sacristy, with its emphasis on discrimination and on the personal sacrifice involved in charitable giving, looks back to Michelangelo's 'stony' Madonnas, who are circumspect about being charitable, and looks forward to the imperious figure of Christ of the *Last Judgment*. Even more striking is the way in which the New Sacristy relates to the stone staircase in the vestibule of the library at San Lorenzo, which was only completed, following Michelangelo's instructions, near the end of his life (Plate 17). This 'strange, fascinating, and perilous'[90] structure is freestanding, and its three flights of stairs dominate the room. Only the central flight of stairs has railings; the outer flights are unprotected, and come to an abrupt halt in mid-air, several feet before the library wall. Michelangelo explained his scheme in a letter to Vasari in 1555, saying that he only remembered it 'as it were in a dream'. The central flight, he said, was reserved for the master, and the outer flights for the servants. It certainly does have a dream-like quality: a dream of social exclusion. A railing keeps the lower orders back so they no longer 'block the way' of their betters; the outer flights of stairs are precipices, designed to be disconcerting. One false step and the servants will fall.

The staircase would have felt even more precarious, like the creaking deck of a rolling ship in high seas, if it had been made out of walnut wood as Michelangelo proposed.[91] It is the most sublimely punitive staircase in the history of architecture.

WE HAVE NOW SEEN that the whole ensemble in the New Sacristy revolves around the selective circulation of gazes and of gifts. These gifts are primarily breast milk, 'lifeblood' and money. But the New Sacristy is far more than an intensified version of the Christian *sacra conversazione*. The way in which some of the figures pose and interact recalls the conventions of the pagan feast, and this underpins the atmosphere of exhausted and bloated voluptuousness.

The curved tops of the sarcophagi on which the allegories sprawl recall the way in which the diners at ancient Greek and Roman feasts would recline on couches or on the ground. The first occasion when Michelangelo made a symmetrical arrangement of a pair of reclining figures was in the drawing (*c.* 1505) for the *Tomb of Julius II*, where two male nudes stretch out their arms to eat from a bowl filled with acorns. Thus the theme of the feast had already appeared in a project for a tomb.

There is in fact a direct link between the reclining figures in the New Sacristy and antique diners. The four 'Times of the Day' have often been compared to the men and women who lie on the top of Etruscan sarcophagi. There was much interest in all things Etruscan in Florence. The word 'Tuscany' is derived from Etruria, and these ancestral links were extensively exploited and mythologised by sixteenth-century Tuscans. Etruscan myth loomed large in the ceremonies on the Capitoline Hill in 1513 when Giuliano and Lorenzo de' Medici were made Roman citizens. But what has not been sufficiently emphasised in relation to the iconography of the New Sacristy is that the Etruscan tomb figures are often depicted in the act of eating food. The deceased are shown propped up on cushions, holding dishes or goblets. Husbands and wives are often depicted side by side, and they appear to be having a good time. The actual corpses were beautifully dressed and laid on elaborate couches in the tombs as if alive and attending a banquet. It was a vision of life in Paradise. Michelangelo offers no such vision of Paradise; rather, he depicts a time of post-prandial depression, of physical and psychological hangovers.

Shortly before Michelangelo embarked on the New Sacristy, feasting had become a popular subject in art.[92] A fresco of the *Feast of the Gods*

(*c*. 1518) was the centrepiece of a fresco cycle dedicated to Cupid and Psyche in the entrance loggia of Agostino Chigi's villa in Rome. The series was designed by Michelangelo's arch-rival Raphael, but was largely executed by assistants. The feast in question was the marriage of Cupid and Psyche in Heaven, and their story was often given a Neoplatonic moral fig leaf by being interpreted as an allegory concerning the immortality of the soul. On 1 January 1519 a correspondent informed Michelangelo, who was back in Florence, that the frescos were a 'disgrace for a great artist'.[93] This was probably just as much a criticism of the uneven quality of the execution as of their immorality. The *Feast of the Gods* shows naked gods and goddesses sitting and reclining on cushions supported by fluffy white clouds. The gods chat together, and flirt. The poses of a reclining couple on the far right of the table were probably influenced by figures on Etruscan tombs.

Michelangelo may have seen his own reclining tomb figures as depressed and aloof counterparts to some of the diners who feature in Plato's short dialogue the *Symposium*, the most celebrated non-biblical evocation of a banquet, at which Socrates and other eminent Athenians discuss the nature of love. It has been plausibly argued that in the years after his return to Florence in 1516 Michelangelo moved in Neoplatonic circles,[94] and so he would have fully appreciated the iconography and symbolism of the classical dinner party. In 1533 the poet Francesco Berni wrote a poem in his praise in which he compared him to Plato,[95] while Condivi said he often heard him 'converse and discourse on the subject of love', and he was told by others 'that what he said about love was no different than what we read in the writings of Plato'.[96]

Condivi used Michelangelo's appreciation of Plato to emphasise that his love of the male body is not in the least bit lascivious: 'It is as though Alcibiades, a very beautiful young man, had not been most chastely loved by Socrates, of whom he was wont to say that, when he lay down with him, he arose from his side as from the side of his father.'[97] This is a reference to a passage in Plato's *Symposium* where the young Alcibiades describes an unsuccessful attempt to seduce Socrates. Having invited the philosopher to dinner, Alcibiades forces him to stay the night, and they both have a miserable time:

> So [Socrates] betook himself to rest, using as a bed the couch on which he had reclined at dinner, next to mine, and there was nobody sleeping in the room but ourselves . . . But in spite of all my efforts he

proved completely superior to my charms and triumphed over them and put them to scorn . . . I swear by all the gods in heaven that for anything that had happened between us when I got up after sleeping with Socrates, I might have been sleeping with my father or elder brother.[98]

In the New Sacristy, the lids of the sarcophagi function as couches as well as beds. They are places for resting as well as for conversing. The notional feast seems to have finished, and like Socrates and Alcibiades, the 'blind' reclining figures are both present and absent to each other, and to the viewer. Hospitality is both offered and denied.

6. Movements

> . . . he has often had it in mind to write a treatise . . .
>
> Ascanio Condivi, *The Life of Michelangelo* (1553)[1]

MICHELANGELO'S EXQUISITELY MAGNIFICENT presentation drawings, particularly the series of mythological narratives sent to the young Roman nobleman Tommaso de' Cavalieri in the early 1530s, have almost always been regarded as his most private and intimate works (Plates 18–25). It has recently been said that they represent a new kind of artwork conceived as an end in itself, and that the very intimacy of this new genre allowed for a unique degree of freedom of invention and interpretation.[2] The presentation drawings are thus seen as the harbinger of the modern autonomous artwork, made purely for the sake of art – and in this case, for the sake of love. As such, they were made for 'presentation' to friends, rather than to patrons.

There is much to commend this view. Michelangelo met Cavalieri, who was by all accounts exceptionally handsome, in Rome in 1532.[3] They were to remain lifelong friends, and Cavalieri was present at Michelangelo's deathbed. Cavalieri's birth date is not known, but the stilted immaturity of his early letters to Michelangelo, both in form and content, suggests he may have been as young as twelve or thirteen.[4] Michelangelo, then in his late fifties, seems to have fallen in love with him immediately, and their friendship must have contributed to his leaving Florence for Rome in 1534, abandoning the sculptures for the New Sacristy. The drawings, which have pagan subject-matter and nude figures, were accompanied by extravagantly reverential letters and love poems. In a sonnet (no. 79) Michelangelo thanks Cavalieri for greeting him alone even though he was 'among more noble people', and the assumption is that Michelangelo was 'greeting' Cavalieri exclusively when he sent him the presentation drawings.

167

However, this is to ignore their utilitarian function. According to Vasari, Cavalieri was learning to draw, and so Michelangelo's drawings were in part teaching aids in a correspondence course. They are painstakingly planned and executed, and for the most part fill the whole of the sheet. When Michelangelo sent them to Cavalieri, he invited comment and criticism. There are three drafts of the *Fall of Phaeton* (*c.* 1533), and on one of these Michelangelo wrote: 'Master Tommaso, if this sketch does not please you, tell Urbino [Michelangelo's assistant who had brought the drawing] so that I have time to do another by tomorrow evening, as I promised you. And if you like it and want me to finish it, send it back to me.' Cavalieri may well have made suggestions, for the final drawing has subtle differences. He too seems to have done drawings of the *Fall of Phaeton*, probably copies of Michelangelo's versions, as well as his own compositions, which he sent to Michelangelo.

The pedagogic aspects of these drawings are underscored by the fact that on the back of two of them – the most complete version of the *Fall of Phaeton*, and an 'idealised head' of *Cleopatra* – we find drawings by Michelangelo's assistant Antonio Mini, with corrections supplied by the master.[5] A memorandum appears on the back of the *Archers*, and a couple of lines, rather like musical notes, have been drawn on the back of the *Labours of Hercules*. It is a shocking realisation that these meticulously worked 'confessional' drawings made especially for Cavalieri were not drawn on virgin pieces of paper, but on left-over scraps. He and Michelangelo probably worked together not only on refining the drawings' formal expressiveness, but also on their moral content since they all illustrate various aspects of virtue and vice. This has a pedagogic aspect too, for the exchange would stimulate thoughts and discussions about conduct and morality. Indeed, the drawings are perhaps Michelangelo's most intricate meditation on the morality of the nude form.

At least some of the pagan subject-matter would have been familiar to Cavalieri as his family owned an important collection of antiquities, and it was standard practice to use examples from classical history and mythology as guides to moral conduct. A large part of the novelty of Giovanni della Casa's *Galateo*, a celebrated conduct manual written between 1551 and 1555 for a young man of noble family, and first published in 1558, was its explicit rejection of a classical framework. Della Casa saw the prevailing preoccupation with heroic deeds and virtues as inappropriate to the modern world, and even slightly

ludicrous: 'Men are frightened of wild beasts, but they have no fear of some of the small animals, such as mosquitoes and flies, which, nevertheless, by continual irritation, trouble them more often than others.'[6] Della Casa preferred to be armed with a mosquito net than with the club of Hercules – though this did not prevent him commissioning from Daniele da Volterra a painting of 'Mercury diverting Aeneas from the bed of Dido' that was based on a Michelangelo drawing.[7]

It is unlikely that Cavalieri was the only student Michelangelo had in mind for the presentation drawings. They were made at a time when he seems to have been considering going public as a teacher of art. According to Condivi, he was planning an illustrated treatise on anatomy, 'as a service to those who want to work in sculpture and painting, on all manner of human movements and appearances and on the bone structure'.[8] The presentation drawings are an extraordinary encyclopaedia of 'human movements'. We find nude figures flying and falling, fighting and even fornicating. It is quite possible that Michelangelo drew them with a view to the projected illustrations.

He had already made a number of anatomical studies showing the superficial muscles and bones[9] but these tend to be of straight limbs or backs, with little idea of movement and none at all of gesture. Like the presentation drawings, the most detailed tend to be in red or black chalk. The most complete proportion study shows a standing man, twisting round, with his right arm crossed behind his back, and although he is obviously moving, there is not much indication of meaningful gesture (Plate 13). A third type of drawing – multi-figure narratives – would have been needed to show gestures in a clear and comprehensive way. He had already been exploring such didactic juxtapositions, but only in relation to the human head. On the back of a presentation drawing of three 'ideal heads' sent to a young Florentine, Gherardo Perini, in the early 1520s, Michelangelo drew a bearded profile and, below it, a skull in profile. Both of these were then copied by a pupil.

Like Leonardo's earlier planned treatise on anatomy, Michelangelo's never materialised. Even so, the presentation drawings were widely diffused, for they were among his most copied and engraved works. The projected treatise was not his only publishing project of the period. In the early 1530s, his banker friend Luigi del Riccio circulated fair copies of Michelangelo's poems with the ultimate intention of publishing a collection, but the project foundered after Riccio's death in 1546.[10]

The potential public role for the presentation drawings transforms our understanding of them. Far from being made as an end in themselves, they would have had a larger purpose. By publishing his own ideas about art in an illustrated treatise, Michelangelo may have wanted to dispel his reputation for secretiveness and meanness. Up to this point, he had shown no inclination to make drawings for printmakers, and this reluctance to exploit the medium of print singled him out from many of his great contemporaries.[11] He may also have been impressed by the impact of his cartoon for the *Battle of Cascina*, which he had left behind in Florence in 1505. It was displayed for some years in the Sala del Papa of the Palazzo Vecchio and became a 'school for all the world' (Cellini), being endlessly copied and turned into engravings.[12] His presentation drawings, translated into engravings, would have effectively become public property. As such, the drawings for Cavalieri may be seen as a parallel enterprise to the New Sacristy. For just as in the New Sacristy Michelangelo grappled with ideas about charity, the presentation drawings have a charitable aspect in so far as they were ultimately intended to be of benefit to the aspiring artist – 'as a service to those who want to work in sculpture and painting'.[13] However, his failure to complete his treatise suggests that he eventually opted to maintain at least some of his aura of exclusivity.

MICHELANGELO SEEMS to have made presentation drawings only for friends, and never for payment.[14] The first group were made in the early 1520s and given to Gherardo Perini. Later in the decade he made some more for another young Florentine, Andrea Quaratesi, the son of a wealthy banker, and then in the early 1530s for Cavalieri. All the drawings (except for a couple of portraits) seem to have had pagan subject-matter, with the early ones consisting chiefly of idealised heads and the later ones being complex multi-figure narratives. Earlier artists such as Leonardo appear to have made presentation drawings, but Michelangelo takes them to a new level in terms of ambition and intricacy – and sheer quantity. The most elaborate and numerous were made for Cavalieri.

Andrea Quaratesi wrote that Michelangelo was 'loved by me as a father'. We don't know if Michelangelo's interest in Cavalieri was more than paternal. At the time, the relationship does not seem to have caused comment. It was common knowledge in papal circles, and Cavalieri showed Michelangelo's drawings to the Pope and to many other eminent figures in Rome.

Condivi, writing in more moralistic times, was more circumspect. He does not mention the drawings sent to Cavalieri, and reassures his readers (somewhat defensively) that he has 'never heard any but the most honourable words cross [Michelangelo's] lips, such as have the power to extinguish in the young any unseemly and unbridled desire which might spring up'.[15] He goes on to say, as we learned in the previous chapter, that Michelangelo's love of the male body is as chaste and paternal as Socrates' interest in Alcibiades. Thus it would appear that in his relationship with Cavalieri Michelangelo was in part trying to behave like an ideal father. Michelangelo's own father, with whom he had had a tempestuous relationship, had died in 1531, the year before he met Cavalieri, and he may have been reflecting on the nature of fatherhood.

In Condivi's account, the relationship fits into the humanist pattern of the ideal teacher-pupil relationship. The celebrated humanist teacher Vittorino da Feltre (1373–1446) opened schools for rich and poor boys in Padua and then in Mantua, where he taught the children of the rulers of Mantua, and Federigo da Montefeltro, the future Duke of Urbino.[16] He did not charge his students, and often ran into debt as a result; he was reputedly a virgin who expected his pupils to be chaste, and cared about their well-being 'just as much as parents do with their children'.[17] Vittorino took on painters to give the pupils drawing lessons. A panegyrist said that the teacher had had a crucial and mutually beneficial impact on Federigo da Montefeltro: 'With his care [Vittorino] has educated you, bettered you, made you more handsome, you who by natural disposition were oriented toward the highest dignity. And you [Federigo], through the grandness of your innumerable virtues, have rendered [Vittorino] immortal among those who come after.'[18] Michelangelo had direct experience of the most famous humanist teacher of all – Angelo Poliziano. Poliziano was tutor to the young Piero de' Medici until Piero's mother so complained about Poliziano's predilection for pagan literature that Lorenzo removed him from his post. As we have already seen, Poliziano acted as mentor to Michelangelo on at least one occasion in the Medici sculpture garden, explaining the story behind the battle of the Lapiths and Centaurs.

By the time Michelangelo was giving drawing lessons to Cavalieri, drawing had become a respectable activity (it is quite feasible that Cavalieri's predecessors in Michelangelo's affections, Perini and Quaratesi, were also taking lessons). Castiglione recommends drawing as a useful activity in *The Courtier*, an etiquette book which emerged from the court

of Urbino. He includes a long section explaining why courtiers should be taught how to draw, and why drawing and painting are superior to sculpture – notwithstanding the excellence of Michelangelo. The principal reason given is a very practical one: during wartime it is crucial to be able to draw maps. But he goes on to say that drawing also enables one to depict the whole of the natural world, and to fully appreciate the beauty and proportions of living bodies.[19] Castiglione's favourite artist was Raphael, a close friend who twice painted his portrait. Some of Raphael's finest drawings had been made so that they could be turned into engravings.

Condivi's reference to Socrates and to his young admirer Alcibiades suggests that Michelangelo's relationship with Cavalieri may have gone further than the formal teacher-pupil relationship, and was an example of 'platonic' love between an older man and a boy, with the former acting as mentor. Such relationships were quite common, and the age difference reflected the pattern of heterosexual relationships, for in the Renaissance men usually married much younger women. The most influential account of such a relationship came in Marsilio Ficino's *Commentary on Plato's Symposium on Love* (1474), which had been written for Lorenzo de' Medici and was the first of the Renaissance treatises on love.[20] It was Ficino who coined the term 'platonic love'. He writes:

> Among lovers beauty is exchanged for beauty. A man enjoys the beauty of a beloved youth with his eyes. The youth enjoys the beauty of the man with his Intellect. And he who is beautiful in body only, by this association becomes beautiful also in soul. He who is only beautiful in soul fills the eyes of the body with the beauty of the body. Truly this is a wonderful exchange. Virtuous, useful, and pleasant to both.[21]

Ficino insisted that such relationships should not have a physical component, but Florence was particularly noted for its sodomites. According to a proverb attributed to the Florentines, 'If you want some fun, have sex often with boys.'[22] During sexual intercourse, the elder man played the 'active' role, and the boy was the 'passive' recipient. Sodomy was a capital crime, but the death penalty was rarely handed out, and usually only to repeat offenders or rapists. Fines or public flogging were the most common punishments. Michelangelo was evidently regarded as posing little risk to sexual morality in the years before he met Cavalieri. The last

Florentine Republic (1527–30), inaugurated after an uprising against the Medici, was fiercely anti-sodomite,[23] and yet in 1529 Michelangelo was made one of the nine leaders of the Militia, with responsibility for Florence's fortifications. There is no evidence as to whether Michelangelo ever consummated his relationship with Cavalieri in Rome, with its marginally more liberal mores. But the drawings are certainly fixated on the struggle for male virtue.

In one of Cavalieri's first letters to Michelangelo, dated 1 January 1533, he tries to explain the source of the older man's affection for him, and sees it in terms of a 'platonic' exchange among lovers of virtue. His language is painfully formal:

> I do truly think, rather I am certain, that the cause of the affection you bear for me is this, that since you are full of virtuosity, or better say virtue itself, you are forced to love those who are its followers and who love it, among whom am I – and in this, to the best of my powers, I do not cede to many. I truly promise you that for this you will receive a perhaps greater exchange, since I never bore love for a man more than for you, nor ever did I desire friendship more than yours; and if in nothing else, at least in this I have excellent judgement.[24]

However conventional the language in which their 'exchange' was conducted, there can be little doubt about the intensity of Michelangelo's feelings. In his poems, Michelangelo dreams of a day when he can hold Cavalieri for ever in his 'unworthy and yet ready' arms (no. 72), and he wishes that his own skin could be flayed and made into a gown and shoes that would be worn by the younger man (no. 94). In a draft of a letter of 1533, he claims that Cavalieri is an even more vital source of sustenance for him than food, the mere thought of him 'filling' his body and soul with the most extreme pleasure. This metaphor echoes the eating of Christ's body (in the form of bread and wine) at the Eucharist. A medieval mystic said in relation to the Eucharist that 'love's most intimate union is through eating, tasting, and seeing interiorly'.[25] Perhaps we could see the various works on paper exchanged by Michelangelo and Cavalieri as akin to Eucharistic wafers.

The meticulous execution of the presentation drawings could also be regarded as an expression of love. Ficino saw precision in the execution of artworks as an essential part of the pedagogic process precisely because

it was a manifestation of love: no one can learn an art unless the teacher loves the students, and the students 'thirst very eagerly for that learning'. As a result, 'whoever greatly loves both works of art themselves and the people for whom they are made executes works of art diligently and completes them exactly'.[26] But by the time Michelangelo made his presentation drawings, drawings executed with exactitude were also those which were most likely to be engraved.

IT IS SOMETIMES assumed that the Cavalieri drawings were meant to teach an artistic lesson – to the great Venetian painter, Titian. In 1529 Michelangelo visited Ferrara to study its state-of-the-art fortifications, but while there he also saw Titian's recently completed mythological paintings in Duke Alfonso d'Este's 'camerino' – the *Worship of Venus*, the *Andrians* and *Bacchus and Ariadne*. During Michelangelo's visit, the Duke commissioned a large panel painting of *Leda and the Swan* from him, and by accepting the commission for such a subject, he is often thought to have willingly entered into competition with the Venetian artist, as well as with antiquity. That said, Michelangelo was already exploring mythological subject-matter. The New Sacristy 'Times of the Day' are clearly pagan symbols, and the dukes wear classicising armour. The figure of Leda in his (now lost) painting for Duke Alfonso was closely based on the New Sacristy *Dawn*. In addition, during this decade he worked on a never-realised project for a marble group of *Hercules and Cacus*. He had also made several presentation drawings of ideal heads of pagan figures for Perini. If Titian's paintings had any influence on him at all, they would have encouraged him to try more ambitious, multi-figure mythological narratives.

When we consider the scale and appearance of the presentation drawings, however, it seems far more likely that Michelangelo intended to teach a lesson to painter-engravers – and in the first instance to Dürer, though Titian also designed some of the most ambitious woodcuts of the period. The drawings rival the detail and subtlety of engravings, and are of a similar scale.[27] Michelangelo planned them very carefully, using underdrawing, though *pentimenti* (corrections) do still exist. He did not use underdrawing for the earlier series of 'ideal heads' for Perini. All the drawings are in red or black chalk, and it has recently been discovered after studying some of them under a microscope that the granular shadings are made by applying minute, wedge-shaped strokes of chalk to the paper – a laborious technique.[28] Of Dürer's allegorical engraving

Melancholia, Vasari said it was impossible 'to do more delicate engraving with the burin'. Vasari also admired Dürer's exceptional range of subjects, and especially his animals, declaring that the long-haired dog in *Knight, Death and the Devil* was executed 'with the most subtle delicacy that can be achieved in engraving'.[29] Michelangelo's presentation drawings feature, for him, an unprecedented quantity and variety of animals.

According to Condivi, the idea for Michelangelo's treatise on anatomy and 'human movements' was stimulated by the perceived failings of Dürer's illustrated treatise, *Four Books on Human Proportion* (German edn 1528; Latin edn 1532), the only book of its kind to be published in the sixteenth century:

> I know very well that, when [Michelangelo] reads Albrecht Dürer, he finds his work very weak, seeing in his mind how much more beautiful and useful in the study of this subject his own conception would have been. And, to tell the truth, Albrecht discusses only the measurements and varieties of human bodies, for which no fixed rule can be given, and he forms his figures straight upright like poles; as to what was more important, the movements and gestures of human beings, he says not a word.[30]

In other words, his figures are both stiff and unidealised (Fig. 18). The treatise's illustrations consisted of standing male and female nudes seen from the front and from the side, and sometimes from the back as well. There is no internal modelling; just schematic indications of the principal muscles. Some of the figures are subjected to grotesque proportional distortions, to underline the importance of correct proportions. There are no illustrations of *écorché* figures.

Michelangelo could have seen a copy of Dürer's treatise not long after its posthumous publication in October 1528. It should not have been too hard to find a German-speaker to translate the text for him. He may have been particularly interested in Dürer's insistence in the dedication that he has not gone to all this trouble for personal gain, but for the common good. This partly reflects the belief, common in Protestant circles, that books were not simply commodities, but were privileged objects akin to gifts.[31] Dürer's work was written as a textbook to which artists could refer, and the budding art student Cavalieri may have owned a copy. Michelangelo may have hoped his own treatise would overturn the idea that he only ever did things for personal gain, as well as upstaging Dürer, who had died in April 1528.

Fig. 18: Albrecht Dürer, *Four Books on Human Proportion*, 1528/1532, the 'rustic' figure (engraving, Warburg Institute)

We should also remember that since the completion of the Sistine Ceiling in 1512, very little new work by Michelangelo had been seen. Indeed, it was not until 1541 that another major new work was unveiled, the *Last Judgment*. The New Sacristy was not opened until 1545 (and then in an incomplete state), and most of his other works from this period remained unfinished in his studios in Rome and Florence. The principal exception was a statue of the *Risen Christ* (1519–21), made for the church of Santa Maria sopra Minerva in Rome, but it was rumoured that an assistant had carved the figure of Christ.[32] Around 1534 he had hastily installed the lower storey of the architectural framework for the

Tomb of Julius II in the Roman church of San Pietro in Vincoli, but with only one statue, the entirely forgettable recumbent effigy of the Pope, which was only partially carved by Michelangelo. This gesture was intended to appease the increasingly infuriated Rovere family.[33] In the 1530s, he helped several painter friends by providing them with drawings to be turned into paintings, but an illustrated treatise might have seemed like a more effective way of spreading his influence and shoring up his public image.

It might then be appropriate to say that Michelangelo's presentation drawings aspire to the condition of presentation *engravings*. Indeed, they seem marginally less original if we think of them as surrogate engravings, or as models for engraving. The most highly finished drawings by artists such as Mantegna and Raphael tended to be designs for engraving.[34] The finest engravings were sometimes given away by artists to friends and to patrons. Mantegna gave one to his patron Marquis Francesco Gonzaga, and when he in turn gave it to someone in Milan – possibly Gian Galeazzo Sforza – the artist sent him another impression.[35] Dürer often gave his prints away, and Antonio del Pollaiuolo's *Battle of Nude Men*, the largest surviving Florentine print from the fifteenth century, was probably made to be presented to existing and potential patrons. A further crucial similarity with Michelangelo's presentation drawings is that a far higher proportion of engravings than of paintings or drawings dealt with pagan subject-matter, often of an esoteric and erotic nature.[36]

Marcantonio Raimondi, the greatest Italian engraver of the early sixteenth century, made many prints in collaboration with Raphael, working from his drawings. He also forged Dürer's prints, and made engravings after the *Battle of Cascina*. His so-called *Raphael's Dream* (*c.* 1505; Fig. 19) is the first engraved night scene in Italian art. It shows two naked women reclining on a river bank on which small monsters gambol. In the background, a city blazes. It has never been satisfactorily interpreted, and 'most of the small etchings and engravings this printmaker made in the second decade of the century have their subject matter still unexplained'.[37] Raimondi also collaborated with Giulio Romano on the (in)famous series of erotic prints, *I Modi* (*c.* 1524). He virtually disappeared after being imprisoned in Rome in 1527 by the Imperial army of Charles V, King of Spain and Holy Roman Emperor, which ransacked the city. On being released, Raimondi probably fled to Bologna. Thus the two greatest Italian and German engravers left the scene within a year of each other. Michelangelo, with his beautifully

Fig. 19: Marcantonio Raimondi, *Raphael's Dream, c.* 1505 (engraving, Warburg Institute)

illustrated treatise, could have stepped into the breach. As already suggested, in order to represent gestures, as well as movements, in a meaningful way, he would presumably have needed to create at least some multi-figure narratives. The drawings for Cavalieri could therefore be considered as prototypes: either Michelangelo himself meant to learn how to engrave or (more likely) he planned to give similar kinds of drawing to a professional engraver.[38]

The projected treatise would also explain why the maker of artworks on a superhuman scale should become so interested in small-scale drawings that teem with incident and miniaturist detail. Michelangelo was well aware of the central role played by engravings in the education of the artist. Condivi tells us that he had made a painted version of Martin Schongauer's engraving, the *Temptation of St Anthony*, as a young apprentice, and the mere fact that this is mentioned, and that Schongauer receives the rare accolade of being called 'a very able man for that time', suggests that in his later years Michelangelo was willing to advertise his interest in prints.[39]

Condivi goes on to say that Michelangelo had gone to the fish market so that he could depict one of Schongauer's fishy devils naturalistically, studying the 'shape and colouring of the fins . . . the colour of the eyes

and every other part'. Anatomists sometimes referred to individual human muscles as 'fishes' – Francisco da Holanda describes Michelangelo 'extracting with a knife all the fishes and juices from a corpse'[40] – so perhaps here his interest in print-making and anatomy were getting mixed up in his mind. Also relevant are the moralising medallions on the Sistine Ceiling, placed in between the *ignudi*. These were based on tiny woodcut illustrations in a vernacular Bible. Michelangelo would surely have agreed with a point made by Vasari at the end of his 'Life of Mantegna', that engraving had revealed to the world 'the manners of all the craftsmen who have ever lived'.[41]

What may be the earliest of the more ambitious presentation drawings, the *Labours of Hercules* (*c*. 1530; Plate 18) can be seen as Michelangelo's first response to Dürer. Executed in red chalk, three labours are shown side by side – the killing of the Nemean lion; the battle with Antaeus; and the battle with the Hydra. Exactly the same labours were represented by Pollaiuolo in some large paintings executed for Lorenzo de' Medici.[42] An explanatory inscription over the first group – 'this is the second lion that Hercules killed' – suggests that Michelangelo's drawing was made for a child who had a shaky knowledge of the Labours. They were the perfect subject for such elementary didactic exercises. The drawing was probably made in Florence, perhaps for Andrea Quaratesi.

For variety, each group is shown at a different depth, and the figure of Hercules is shown frontally, in profile and in three-quarter view. The left-hand group of Hercules and the Nemean Lion is the only one to be fully worked up, and one can admire the detail of the lion's wonderfully shaggy mane. The internal modelling of the bodies is remarkably subtle, almost hazy. This, and the red chalk, a medium frequently employed by Michelangelo from the time of the Sistine Ceiling to the early 1530s, suggests rising heat. The right-hand group, showing Hercules and the Hydra, is modelled on the *Laocoön*, but here the group of man and monster is given a flame-like tremulousness that seems to prophesy the eventual cause of the Hydra's, and of Hercules', death. When Hercules cut off the Hydra's heads, he cauterised the wounds with a flaming torch, and this ensured the heads did not grow back again. He then dipped his arrows in the monster's poisoned gall, but was eventually killed by a cloak dipped in the same poison. When he put it on, it burnt him with a mysterious fire, and the dying hero finally consigned himself to a funeral pyre. The dangers of heat – literal and metaphorical – are a recurrent theme in the narrative presentation drawings. The different

levels of finish in the three labours may also have had a didactic function, since they demonstrate the different stages of creating an image. In addition, as we have just seen, Michelangelo sent drawings that were not completely finished to Cavalieri for comment.

Vasari said that if Dürer had had 'Tuscany instead of Flanders for his country, and had been able to study the treasures of Rome, as we ourselves have done, he would have been the best painter of our land'.[43] Moreover, his nudes would have been immeasurably better if he had not had to use Germans, who usually had bad figures, as models.[44] In the presentation drawings, with their nudity and pagan subject-matter, Michelangelo seems to be giving a glimpse of what Dürer might have become if he had been born in Tuscany. The Hercules drawing mimics the three different viewpoints from which standing figures are seen in Dürer's treatise, but places Hercules in far more complex poses.

The *Archers* (*c.* 1530; Plate 19) may well be the first of Michelangelo's great unified narrative scenes. The execution, in red chalk, is even more detailed than in the *Labours of Hercules*. It has been said that the stippling is handled 'with the virtuosity of a professional engraver',[45] though the shadings are not produced by stippling (a profusion of tiny dots), but by a series of minute strokes. We don't know for whom it was made, however. Andrea Quaratesi's name is inscribed on the back in a memorandum dated 1530, but not in Michelangelo's handwriting. It may have been given to Cavalieri, for it was in a Roman collection in the later sixteenth century.

The drawing sets up a contrast between a figure who is 'straight upright' like a pole, and many others who are anything but straight. A group of seven nude archers – five male, and two female – take aim from close range at a herm. Behind the archers a satyr strives to string a bow. The columnar herm stands at the right edge of the composition. A young man with a shield protecting the front of his naked torso, he has an impassive expression. A sleeping Cupid lies on the ground before him, clutching his bow. Some of the archers are airborne; others balance balletically on one leg; another kneels on one leg, and two lie on the ground. The herm and the sleeping Cupid on the far right are only sketched in.

The composition is derived from an antique source – a stucco relief in the Golden House of Nero – but Michelangelo has completely transformed it. Most obviously, he has reversed the image (the herm was on the far left in the original) and made all the archers left-handed. This

is usually taken to be a feature that points to their dubious morality. But one wonders if Michelangelo was experimenting with making an image in reverse with a view to making a print. Printmakers usually reversed the source image.[46] We know that Vittoria Colonna, the Marchesa di Pescara (*c.* 1490–1547), whom Michelangelo met in 1536, and for whom he made three drawings on religious subjects, looked at them using a magnifying glass and a mirror.[47] In the sixteenth century, a mirror's ability to reverse images was regarded as one of its most intriguing qualities. An inventory made in Antwerp in 1552 lists a 'beautiful burnished-mirror, with a square cover' in which 'one can see or look at, people the wrong way round'.[48] The inventory of Michelangelo's possessions recorded at his death in 1564 says that he owned a metal mirror.[49] When Nicholas Beatrizet made an engraving of the *Archers* in the 1540s, he reversed his source. In this respect, we should also note that Hercules holds his club in his *left* hand when battling the Hydra in Michelangelo's *Labours of Hercules*.

In the Roman relief, the archers were extremely stiff and earthbound, weighed down by heavy bows. Michelangelo has not delineated their bows, and so their empty hands stretch forward, as though they are miming the shooting action. The lack of bows was probably due to formal reasons – they would have cluttered up an already crowded composition (an elderly satyr in the background, at top left, does grapple with a bow, possibly trying to string it). But this idiosyncrasy makes the figures appear to be stretching out their arms in yearning, as well as shooting. The composition is almost a parody of God with his outstretched arm amidst his airborne entourage in the *Creation of Adam*. For all their considerable efforts, however, the archers cannot strike at the heart of the herm, or goad him into reacting, for their arrows have hit either his shield or the stone pillar.

No literary source has been found that corresponds with every feature of the drawing, but the basic theme is clear enough.[50] The herm performs a similar function to Terminus, the Roman god of boundaries. When Jupiter wanted to establish his temple on the Capitol, Terminus was the only god to refuse to move. Thus he cemented his previous reputation for obduracy and incorruptibility in territorial disputes. According to Ovid, he could not be bribed, and would not budge even if hit with a plough or a rake.[51] The god's identity and significance had been rediscovered by Poliziano,[52] so Terminus may have been known to the young Michelangelo. By the 1530s, Terminus was famous through-

out educated Europe. Erasmus took Terminus as his symbol in 1509, with the motto *Concedo nulli* – 'I yield to nobody'. The image of Terminus, with a young man's features in left-facing profile, appeared on a widely diffused portrait medal of 1519. Around 1525 Holbein made an emblematic design for Erasmus in which a huge slab is suspended over a herm's head like the blade of a guillotine. The implication is that Erasmus is impervious to even the most brutal attacks of his numerous enemies, who took his motto as a sign of his 'intolerable arrogance'.[53]

Michelangelo's youthful 'Terminus' is assailed by arrows, and this gives the image an erotic twist. He is maintaining personal as much as geographical boundaries – boundaries which the archers cannot infiltrate. As such, he represents the triumph of chastity and of fidelity. He is an immovable 'pillar' of moral strength, pitted against the archers who signify the perpetual motion of the pleasures of the flesh. Cupid is shown sleeping on the ground, with his bow and quiver, and two other 'archers' also lie on the ground, stretching out their arms forlornly towards the herm: they are probably exhausted by their fruitless efforts to break through his defences. Behind the main group of archers, two putti tend a fire in which they are heating arrowheads – a symbol of the heat of passion. A small painting attributed to the Florentine artist Gherardo di Giovanni del Flora, the *Combat of Love and Chastity* (*c.* 1475–1500), is a good guide to the erotic aspects of Michelangelo's drawing. It shows an adolescent Cupid, balancing elegantly on one leg, shooting from close range at the female figure of Chastity, who wears a diaphanous white dress. She fends off Love's arrows with a shield.

The fact that Michelangelo's symbol of chastity is a stone figure, with a pillar for a base, also seems significant. A medal by Matteo de' Pasti (*c.* 1444) has a portrait of his brother Benedetto on one side, and an image of Cupid's arrows breaking against a rock on the other. This symbolises the rock-like stability and exclusivity of brotherly love: it spurns all other loves.[54] Doubtless Michelangelo hoped that Cavalieri would remain faithful to him and to him alone, reciprocating his 'fatherly' love. All the archers are young, so perhaps Michelangelo is concerned that Cavalieri will be tempted by admirers much younger and more energetic than himself. It could appropriately be called the 'Temptations of St Tommaso'.

It is often said that the enigmatic quality of some of the drawings for Cavalieri is due to the fact that they are private expressions of deep-seated thoughts and feelings. The slightly arcane and hermetic quality of

the symbolism would therefore be deliberate. But it is likely that Michelangelo's divided pedagogic loyalties are responsible for at least some of the mysteriousness. The desire to depict 'human movements' can conflict with the requirement to present a straightforward moral.

Thus the herm – the pillar of rectitude – could hardly be more marginalised in the drawing. It is placed near the right edge of the composition (in Erasmus' emblems, Terminus is central), and seems even more marginalised by virtue of being a ghostly, lightly sketched presence. At the centre we find the mêlée of archers. The dead centre of the composition is located at a point between the buttocks and upper thigh of the archer who pirouettes on his right leg. The heaving, yearning crowd of male and female tempters takes centre stage and most completely absorbs the artist's attention. In a poem from the 1520s, Michelangelo appeals to divine Love to strip him of his sinful worldly concerns, and 'with your shield, your rock and your true, sweet weapons, defend me from myself' (no. 33). Here, he needs to be defended against his own fascination with the 'worldly' human figure in action. Thus we are not sure whether to rejoice at the triumph of chastity and fidelity, or to mourn the tragedy of frustrated love.

In Dante's *rime petrose*, it is the lover's fruitless striving to overcome the defences of his stony beloved that gets most of the attention, and with which the poet identifies. Looking at these airborne and running archers, one is also reminded of the entrancing description of the ill-fated lovers in the second circle of Dante's *Inferno* where they cross the sky like flocks of starlings, cranes and doves, borne up by the winds of illicit passion. One of their number is the 'lustful queen' Cleopatra, of whom Michelangelo made another presentation drawing for Cavalieri – an 'ideal head'. The elaborate hairdos of the two female archers (on the far left and at the back) are comparable to that of *Cleopatra*, suggesting that they may be a 'Cleopatra' type. Indeed, it is surely no accident that the women are the only fully airborne figures. It suggests that they get more carried away by passion – are even more 'flighty' – than men.

Michelangelo's divided loyalties are brought into even sharper focus when we consider the similarities between the herm and the stiff 'pole' figures of Dürer's *Four Books on Human Proportion*. The way in which the herm is peppered with arrows recalls Dürer's image of a 'rustic' figure peppered with horizontal proportion markers (see Fig. 18). In addition, the herm's neck has collar-like markings, and this recalls the fourth book of Dürer's treatise, where the images are derived from the jointed

dolls which were frequently used by artists to study movement. The immobile, limbless herm repudiates what Michelangelo prized above all else – 'the movements and gestures of human beings'. A red chalk proportion study of *c.* 1516 by Michelangelo of a standing male nude which is dotted with arrow-like proportion markers is far more dynamic than Dürer's rustic figure (Plate 13).[55]

THE *GANYMEDE* AND THE *TITYUS* (Plates 20 and 21) were probably the first drawings to be given to Cavalieri, in 1533. They seem to have been made as a pair. The former (which no longer survives except in a very worn and compositionally expanded version) shows the beautiful shepherd boy Ganymede, dressed only in a loose cloak, being carried off to heaven by Jupiter in the guise of an eagle. The bird–god is positioned behind a languidly phlegmatic Ganymede, his claws clamped on to the boy's lower legs. The eagle's head and beak bow down and are bent rather awkwardly round the front of Ganymede's torso, as though it is trying to suckle at the boy's breast. It is not a great flying position, but Michelangelo is more concerned to show them fused together inseparably. It also means that Ganymede's head and outstretched arms become the crowning feature of the composition. His curly hair and cloak, billowing backwards and upwards, are like spume on the crest of a giant wave.

This motif clearly has homoerotic connotations, but the story was frequently treated allegorically as a symbol for any kind of divine elevation into a union with God.[56] Eagles were also used as a general symbol of pedagogical nurturing. A thirteenth–century French Cistercian abbot once reprimanded a bishop for not looking after his charges: he should be 'like an eagle provoking her chicks to fly', and he should 'flutter over them and bear upwards in your wings both by word and example those little ones commended to you'.[57] The way in which Ganymede's arms are outstretched along the eagle's wings suggests that he may be learning to fly. It is even conceivable that he is carrying the weight of the huge and rather ungainly eagle rather than vice versa. In a sonnet Michelangelo imagines himself carried up by a winged Cavalieri, thus challenging the convention whereby it is the older (and hairier) man who takes the role of the eagle: 'though lacking feathers I fly with your wings; with your mind I am always carried to heaven' (no. 89). No previous depiction of the subject suggests that Ganymede has been granted the power of unaided flight, or that he might even be in charge.

In the *Tityus* drawing the bird really is on top – for the moment, at any rate. The giant Tityus is shown chained horizontally to a long rocky outcrop in Hades while a vulture cranes its neck over his midriff, its beak hovering suggestively by Tityus' nipple (because of the nature of his sin, one assumes his breast is filled with gall rather than milk). The vulture forms a canopy over him with its outstretched wings which mirrors the shape of Tityus' limbs. Tityus seems to be rolling – or to be rolled – on to his side so that the front of his torso faces us. To the right, the screaming face of another sinner projects wart-like from the trunk of an anthropomorphic tree.

In the Tityus myth, the vulture is supposed to gnaw at his liver (thought to be the seat of lust) as punishment for his rape of Leto, mother of Apollo. Each night, his liver grew back, and was devoured again the next day. Here, however, there appears to be as yet no contact between the vulture and Tityus: at the moment, his punishment might be that of being buried alive, or of being crushed between an avian Scylla and a rocky Charybdis. It is an image of suffocation as much as of vivisection.

It is often said that the *Ganymede* and the *Tityus* represent, respectively, sacred and profane love, but one might equally argue that they suggest the elevated nature of homosexual love, and the base nature of heterosexual love. However, this Tityus isn't entirely beyond redemption. Almost taking his cue from the figure's rolling action, Michelangelo turned over the sheet of paper on which he had drawn the *Tityus*, revolving it ninety degrees. He then – following up his concern with image reversal – traced the outline of the giant and, by making a few subtle changes and editing out the vulture, transformed him into a resurrected Christ, leaping out of the tomb (Plate 22). At the turn of a page, Tityus is free, chaste and holy. Artists frequently flipped over designs to create symmetrical pairs of figures: the front and back views in Dürer's treatise are a single image reversed. But this is the only example in Renaissance art where the orientation of a reversed image has been changed. This sleight of hand – in which pagan becomes Christian; horizontal, vertical – is symptomatic of the semantic gymnastics that occurs in the presentation drawings; and it is an ingenious time-saving trick with which an art teacher dazzles his pupils. It thus shows Michelangelo competing in the production of pedagogic aids. In a letter of 17 July 1533 Sebastiano del Piombo, a painter friend whom Michelangelo sometimes helped out by supplying drawings, suggested that a Ganymede with a halo could be painted in the lantern of the New

Sacristy and called a St John. This is one professional suggesting a shortcut to another.

The *Fall of Phaeton*, made in three different versions, was probably the next drawing. The death of Phaeton, the young son of Apollo, is depicted. When Apollo offered to grant Phaeton a single wish, he insisted on driving the chariot of the Sun, but he soon lost control and to save the earth from incineration, Jupiter struck him with a thunderbolt. As Phaeton's sisters mourned they were transformed into trees and his brother Cygnus into a swan. This is a tale of youthful hubris that ends up destroying an entire family, as well as bringing about ecological disaster. He is a counterpart to those giants in Michelangelo's poem who were blinded when they dared to look into the sun (no. 67). Scholars who regard the presentation drawings as confessional outpourings claim that Phaeton is Michelangelo's *alter ego*, and that through this identification he expresses the recklessness of his daring to love Cavalieri. But it seems more likely that the story of Phaeton is a warning to Cavalieri, and to all young hotheads.

In the most highly finished version (Plate 23, now in the Royal Collection), the composition is read down the page, from top to bottom, and is divided into three slightly disconnected sections. At the apex we find Jupiter astride an eagle, like a toddler astride a rocking horse. In the middle, we see Phaeton and his chariot plummeting to earth. The assemblage is awkwardly triangular, with Phaeton drawn on the same scale as the horses. He falls from his chariot like a snail emerging from a smashed shell, his body writhing bonelessly, the chest and abdomen pushed flat against the picture plane, like a mouth pressed to a window.

Just below, we see a river god (Phaeton crash-landed into the River Po), alongside Phaeton's distraught sisters and his brother, transformed into a swan. In the background, another man carries a water jar towards the river. This is the most compelling part of the composition, with the anguished gestures of the naked sisters contrasting with the river god languidly reclining on the bank of his river. This scene is a female version of the *Battle of Cascina*, for the three sisters (and the swan) are effectively surprised bathers, seemingly about to be crushed by the falling chariot. The flowing river at the base of the composition gives a sense of Nature continuing on its way. It further suggests that this disaster is really only a minor blip, a storm in a wineglass. Rather ironically, three years after Michelangelo did this drawing Alessandro Farnese, the new Pope Paul III, gave him the rights to the revenues from a toll bridge across the Po.

Michelangelo's composition differs from previous versions in its inclusion of Jupiter. An engraving by Antonio Veneziano, possibly derived from a drawing by Raphael, and an antique sarcophagus which was on view outside the church of Santa Maria Aracoeli in Rome, both exclude the god.[58] Previous versions also showed the horses of the chariot of the Sun rearing elegantly upwards, rather than plummeting to earth with legs akimbo. This drawing makes one wonder whether Michelangelo's anatomical treatise would also have included a section on horses and their movements.

On a structural level, this exceptionally complex work, packed with exquisite detail, is analogous to the sonnets that Michelangelo was also sending to Cavalieri. Lorenzo de' Medici had praised the sonnet form because its brevity forced the writer to weigh every word,[59] while another Florentine poet said that the sonnet form was akin to sculpture, as it was not 'coloured' – meaning that it was pared down to the bare minimum.[60] This version of the drawing in the Royal Collection comes closest to being a visual sonnet. Where the sonnet has fourteen lines, the drawing has fourteen principal elements. Reading from the top, we find two elements (Jupiter and his eagle), followed by two groups of six: Phaeton, four horses, and a chariot; three sisters, the swan, and two river gods.

Michelangelo does not only seem to have envisaged the reproduction of his presentation drawings through engraving. The *Fall of Phaeton* was copied in rock crystal, and there are special circumstances which may have made such a translation look compelling, particularly for someone who was thinking of producing an anatomical treatise. Of all these drawings, the subject of the *Fall of Phaeton* was especially associated with painstaking depiction on a small scale. At the end of Galen's anatomical treatise *On the Usefulness of the Parts*, he marvels at the Creator's skill, which is manifested even at the smallest scale:

> . . . any other animal you may care to dissect will show you as well both the wisdom and skill of the Creator, and the smaller the animal the greater the wonder it will excite, just as when craftsmen carve something on small objects. There are such craftsmen even now, one of whom recently carved on a signet ring Phaeton drawn by four horses, each with its bit, mouth and front teeth so small that I did not see them at all except by turning the marvel round under a bright light, and even then, like many others, I did not see all the parts. But when anyone was able to see any of them clearly, he agreed that they

were in perfect proportion. For instance, we had difficulty in even counting the sixteen limbs of the four horses, but to those who could see them the parts of each one appeared marvellously articulated.[61]

Galen still insists that no artwork displays 'more perfect workmanship' than the leg of a flea, and that this proves the supreme greatness of the Creator. This anecdote had been briefly mentioned by Alberti in his treatise *On Painting*,[62] and was repeated in Berengario da Carpi's illustrated anatomical treatise.

When Cavalieri received the final version of the *Fall of Phaeton*, Pope Clement, Cardinal Ippolito de' Medici and 'everyone else' rushed to see it. Cavalieri said he did not know how they were aware of the arrival of the drawing. The twenty-one-year-old Cardinal Ippolito (1511–35), famous for his relationship with a Venetian courtesan and his passion for Giulia Gonzaga, immediately borrowed the *Tityus* so that the design could be cut into rock crystal by the celebrated gem-engraver Giovanni Bernardi da Castelbolognese. He wanted to borrow the *Ganymede* as well, but Cavalieri managed to hold on to it. It can't have been for long, however, because Bernardi also made crystal versions of it and the *Fall of Phaeton* at around the same time. Pier Luigi Farnese acquired the crystals and in the early 1540s commissioned a second set of crystals from Bernardi to be mounted on a precious metal casket.[63]

The most likely candidate for having tipped off the *cognoscenti* is Michelangelo. The Galen passage would surely have been known in these cultivated circles, and Michelangelo may have been out to prove him wrong about the ability of artists to depict miniaturist detail. The presentation drawing – with its three scenes, and its centrepiece of the cartwheeling akimbo legs of Phaeton's horses – is meant to display more perfect workmanship than the leg of a flea. The contracting of Bernardi to make crystals took the intellectual conceit a stage further, though the gem-engraver reverted to tradition by omitting Jupiter astride the eagle. Bernardi based his composition not only on the version in the Royal Collection but also on another in the British Museum. The crystal measures 7.3×6.2cm, and is thus about a third of the size of the British Museum drawing, and a quarter of the size of the Windsor drawing.

The breathless arrival at Cavalieri's *palazzo* of Rome's most eminent culture vultures must also have been intended to impress him with Michelangelo's superstar status; Cavalieri too would have gained kudos. He later sometimes acted as Michelangelo's 'go-between or agent, as

well as functioning as propaganda for the "genius" of the artist'.[64] He is also known to have arranged for Michelangelo to produce designs from which other artists could make paintings.[65]

The *Children's Bacchanal* (*c.* 1533: Plate 24), the most disturbing of all the presentation drawings, was also given to Cavalieri. It contains the largest number and widest range of human and animal protagonists, and is the most painstakingly realised. Each part of the composition, background as well as foreground, is given equal attention, and it is technically astounding: 'It shows to a high degree the consistency and transparent texture of an engraving.'[66] Vasari marvelled at the chiaroscuro, saying that even a drawing that had been breathed into existence could not have achieved greater unity.[67]

The *Children's Bacchanal* shows a gang of thirty naked children preparing a feast, heating up cauldrons and bringing in animal carcasses. They are related to the bacchic winged spirits of wine and feasting found in many Renaissance reliefs, and in Titian's *Worship of Venus*, which Michelangelo saw in Ferrara. But they lack wings; there are girls as well as boys; and they are far more sordid and jaded. At the heart of the composition a group of children struggle with the upended body of a large animal, its legs pointing in the air, creating a jagged zigzag like an apocalyptic stroke of lightning. The animal, though often identified as a red deer, looks more like a hybrid creature – a horse with cloven hooves. This central scene is a parody of an entombment of the dead Christ,[68] and the large sheet hung at the back of the composition recalls a winding sheet. The face of the turbaned child on the right of this 'entombment' group looks prematurely aged, even drugged. Below, in the foreground, a child pulls a sheet over a slumped, reclining figure of a man. To the left, a child suckles on the worn-out breasts of an old centaur woman.

Both these adult figures seem almost irrevocably exhausted. Where the male figure is concerned, this may have a wider environmental implication, for although he resembles a river god, he has no gushing urn and there is no stream running through the foreground. The rocky clearing is here an index of the barrenness which human greed has brought to the earth. The hordes of children suggest the population is exploding, becoming lawless, and putting pressure on food supplies. The sixteenth century did see enormous population growth, as well as migration to the towns, and this caused a sharp increase in food prices, famines, and begging. The population of Rome doubled during the course of the sixteenth century, and that of London quadrupled.[69] Urban

famine was a frequent occurrence, and in 1528 there was famine throughout the whole of Tuscany: Florence closed its gates to starving peasants from surrounding districts.[70]

The Italian writer Mambrino Roseo inserted a description of an ideal commonwealth, Garamantia, into his *Education of a Christian Ruler* (1543), taken directly from Antonio de Guevara's pan-European best-seller, *Mirror of Princes* (1529).[71] The world-conquering Alexander the Great discovers the Garamantians near India, and is given a dressing-down by an elder. Alexander's greed is insatiable: 'the more thou gettest, the more thou desirest'. The Garamantians have only seven laws. The fourth stipulates that once a married woman has three children she should be separated from her husband, 'for the abundance of children causeth men to have covetous harts'; if a woman has more than three children, they should be sacrificed to the gods before her eyes. The final law decrees that no man should be allowed to live for more than fifty years, and no woman for more than forty.[72] Michelangelo's bacchanal is a record of a feeding frenzy that follows shortly after a breeding frenzy, and it seems to invite Garamantian expressions of disgust. It is a demonstration of how adults and children should *not* behave.

The *Children's Bacchanal* is usually assumed to be set in a cave, whose entrance is covered by the sheet stretched across the back of the composition. If this were the case, however, then the light from the fire would cast dramatic shadows. It is more likely to be an outdoor setting in a rocky clearing on an overcast day, or in the early evening. The presence of trees (which seems to have been overlooked) confirms that we are outdoors. Part of a stumpy tree trunk can be glimpsed in the top left-hand corner, but no branches or leaves are visible. A large sheet has been hung from the tree and stretches across the back of the composition to create a curtain. It is attached to another gnarled trunk on the far right that rises at an acute angle above a mêlée of children around a wine vat.[73] Its setting in a cave has led scholars to see it as a delusory world apart, as in Plato's Cave. But the implication of Michelangelo's drawing is that this is an apocalyptic vision of the world at large. Indeed, the *mise-en-scène* recalls the rocky island in the Sistine Ceiling *Deluge*, where the refugees from the flood-waters have created a canopy by stretching a sheet around two trees. The connection with the *Children's Bacchanal* goes further because the naked male figure at the front of the rocky island leans on a treasured wine barrel – a symbol of the gluttony for which they are partly being punished. Michelangelo may have been thinking again about the

Deluge in relation to the *Last Judgment*, which was probably commissioned in the autumn of 1533.[74]

In its twilit and dystopian mood, the *Children's Bacchanal* is rivalled only by the engraving known as *Morbetto* (*c.* 1512–13). Designed by Raphael and engraved by Raimondi, *Morbetto* illustrates an episode from Virgil's *Aeneid* (Bk 3, 130ff.) when Aeneas and his followers are struck by a plague in their new settlement in Crete; it destroys trees, crops and men, so that 'the only yield of that season was death'. Raphael shows dead and dying people and animals piled up in the foreground, and uses a passage from the text as an inscription: 'Men gave up the sweet breath of life or dragged their bodies along.' In the *Children's Bacchanal*, the protagonists are 'plagued' by decadence.

The drawing's most remarkable progeny would appear to be a series of engravings for the most celebrated anatomical treatise ever made. The decorative initials in the first and second editions of Vesalius' *Humani corporis fabrica* (1543/55) depict groups of children putting a skull in a cauldron, playing with bones, sawing an old man's head in half, dissecting a dog, taking a corpse down from a gibbet, and many other insalubrious activities related to the practice of anatomical dissection.[75] Reading back into the *Children's Bacchanal*, one wonders whether it simply represents a feast, or whether it also has an anatomical subtext. Are they boiling the animals only for their meat, or do they also want the bones? Could the adult man and woman in the foreground end up in the cauldron? In this drawing, Michelangelo seems to be exploring the dark, bacchanalian side of his own anatomical project. We are surely supposed to see something monstrous and tragic in the 'entombment' of the horse with cloven feet. Michelangelo revels in the depiction of human and animal anatomy, while seeming to mourn the carnage that facilitates this depiction.

IN A SONNET from around 1533 (no. 79), Michelangelo expresses his gratitude for Cavalieri's affectionate feelings towards him. It begins:

> Felice spirito, che con zelo ardente,
> Vecchio alla morte, in vita il mio cor tieni,
> E fra mill'altri tuo diletti e beni
> Me sol saluti fra più nobil gente . . .

[Happy spirit, who, with eager burning, keeps alive my heart which old age turns towards death, and, among the thousand other delights and

blessings you bring, greet me alone among more noble people.] In the last three lines, Michelangelo elaborately emphasises the sincerity of his own demonstrations of affection towards Cavalieri:

> . . . sconcia e grande usar saria a farla,
> Donandoti turpissime pitture
> Per rïaver belle e vive.

[. . . it would be vile usury on a grand scale were I to give you pictures of the basest kind, and in return receive most beautiful and living people.] The basic conceit must be that by offering Michelangelo his own beautiful self, as well as his fine friends, Cavalieri re-energises an old man, and makes the whole world seem more alive. It would thus be unthinkable for Michelangelo to send him in return pictures that are both immoral and inept. We can probably interpret 'pitture' broadly, as images described in words as well as in the drawings.

Yet the mere mention of 'turpissime pitture' suggests that Michelangelo is asking for reassurance that his drawings are elevated creations. The poem was presumably accompanied by a new drawing, and Michelangelo may have wanted to get his excuses in first. Of course, almost any of Michelangelo's works might be described as 'turpissime', because of their unapologetic nudity. The statue *Bacchus* was still displayed in the Roman garden of the Galli family amidst their antiquities, and its continuing fame is attested to by the fact that it was drawn there by the Flemish painter Maerten van Heemskerck in the early 1530s, minus its right hand, wine goblet and penis. But it is in a presentation drawing from around 1533 that we find Michelangelo's most explicit and detailed depictions of immorality, and it is this drawing that may have accompanied his poem.

Vasari called this black chalk drawing the *Dream*, and it is sometimes known as the *Dream of Human Life* (Plate 25). The focal point is a heroically muscled male nude draped over the edge of a box. He leans back against a large sphere which he grasps: this probably signifies the world. The box is open at the front, and the interior is filled with masks, which must be deceptive and illusory pleasures. His posture and position recall the Sistine Ceiling *ignudi*, but he gazes upwards, rather like Jonah, at a descending winged figure of a boy who aims a trumpet at his forehead. This is a moment of awakening, and the trumpeter is likely to be Fame, summoning him to perform noble deeds.

The drawing probably represents not so much a dream, as the awakening from a nightmare. In the hazily sketched background we see the various components of the youth's 'nightmare'. The haziness does not only come from its being a dream; it is also a smoke-filled battlefield – a battle of nudes and semi-nudes. As Leonardo said of depicting battle scenes: 'The more the combatants are in this turmoil the less will they be seen, and the less contrast will there be in their lights and shadows.'[76] This is a semicircle of interlocking figures, many of them struggling, representing six of the seven deadly sins – Gluttony, Lechery, Avarice, Wrath, Envy and Sloth. Pride is missing because, it is often said, it encompasses all the other sins. But it is more likely that the nude figure grasping the globe signified Pride until he acknowledged Fame's trumpet blast. The angular body and wings of Fame, impossibly stretched out both horizontally and vertically, occupy the top third of the composition, which is otherwise an empty expanse. The way in which Fame hovers above the convulsive cloud-mass of sinners makes one think of the concluding lines of a moralising inscription that accompanied Baccio Bandinelli's enigmatic mythological engraving the *Battle of Reason and Lust*: 'O mortals, learn that the stars are as superior to clouds as Holy Reason is to base desires.' Fame is a kind of star-shaped angel, lording it over the clouds of corruption.

The fact that the six deadly sins are arranged in a semicircular arch makes one wonder if this is supposed to suggest the top half of the dial of an imaginary 'moral' clock. Fame's trumpet penetrates the 'circle' in the middle at the top, and though it is not quite vertical, it is like an hour hand signalling midday or midnight. Michelangelo himself imagined life to be divided into 24 hours.[77] This would further imply that the man is being awoken in the middle of his life. At the beginning of the *Divina Commedia*, Dante wakes up in the middle of the 'journey of life' having been in a dark wood. In the *Convivio*, Dante explains that the thirty-fifth year was the mid-point – and the high point – of the 'arch' (arco) of life (it was also believed that this was the age at which bodies would be resurrected on Judgment Day). Christ was reputed to have died in his thirty-fourth year because he did not want to go into physical decline. Moreover, he died at midday, the 'peak' of the day, and thus the most noble and virtuous hour.[78] What we seem to have here, then, is a moralistic representation of a mid-life crisis, taking place at midday on the man's thirty-fifth birthday.

So what exactly has this man been up to? The sins which have most

caught Michelangelo's imagination are *Gluttony* and *Lust*, and they occupy the whole of the left-hand side of the arch. They are drawn in a more defined manner than the four sins depicted on the right, and more examples are given of each. Gluttony is represented by a man cooking a roast on a spit for an impatient diner seated at a table; behind the diner a man guzzles drink from a flagon. Lust is represented by two heterosexual couples, one nude and copulating, and the other semi-clad and kissing. In the former, the man seems to be the dominant partner; in the latter, the woman. Michelangelo also depicted a huge erect phallus held by a hand emerging from clouds; a schematic outline of an erect phallus; and the erect phallus of the copulating man. But these items were largely erased, presumably by a subsequent owner of the drawing. Their lineaments are just visible, and we know for certain of their existence because they appear in an engraving by Beatrizet and in a design on a majolica plate (Fig. 20).[79] Even the man guzzling from the flagon is borderline erotic because the flagon, with its long neck, is eminently

Fig. 20: Nicolas Beatrizet, *The Dream of Human Life*, *c.*1545 (engraving, Warburg Institute). Detail of erotic sections erased in Michelangelo's drawing

phallic – making this the first allusion in post-classical art to oral sex.[80] Fellatio is rarely mentioned in classical and early modern literature, and was generally considered reprehensible or ridiculous, but in Florence it seems to have been quite widely practised by homosexuals.[81]

Michelangelo clearly wants to contrast these fornicating bodies and erect male members with the body of the dreamer. The drawing is one of the most striking examples of Michelangelo depicting positive and negative nudity in the same image. It is thus in some respects a manifesto. The dreamer may be nude, Michelangelo seems to be saying, but his is an honest nudity. Unlike the lovers, who are turned in on themselves, bound together with a tight knotty hardness, the dreamer's body has an extraordinary looseness and openness. The torso and diminutive flaccid penis are turning towards the viewer; the legs are splayed wide and the body is off balance (the globe may roll off the box at any moment; his right foot may slip off the edge of the box). The dreamer's body is enacting a spontaneous unfurling, a final shedding of all masks, as the sinner readies himself for judgment. It is one of Michelangelo's classic 'confessional' torsos. The globe he leans on and his cantilevered right thigh may suggestively echo the shape of the flask, with its globular base and long neck, but if so, he is only mirroring what he is renouncing.

In order to reveal himself, the dreamer has had to disentangle himself from society. The six deadly sins occur in a crowded and chaotic fug, with one sin promiscuously abutting and overlapping another. Even the sin of sloth, usually represented by a sleeping person, is a group activity, for Michelangelo shows another knotty cluster of three people. It is an orgiastic roller-coaster that is impossible to get off. But the dreamer is foregrounded and treated as a discrete entity, the unbroken contour of his body hermetically sealing him off from the fumy background. It is as though he is now only making himself available for private and monogamous passions. His body is orientated to us alone; his head looks directly upwards. He spreads forwards and laterally, dominating the picture plane.

Yet the contrast is not simply between different types of social bodies; it is also between types of visual art.[82] The fornicating figures in his drawing would immediately have reminded Michelangelo's viewers of porno-graphic prints made in the 1520s by artists in Raphael's circle. In his figure of the dreamer, Michelangelo is trying to present a chaste version of nudity that contrasts with the sordid version popularised by Raphael's associates Giulio Romano, Marcantonio Raimondi and Perino del Vaga.[83]

Raphael was a famous libertine, and Vasari thought his friends were too indulgent of his ceaseless pursuit of 'carnal pleasures' for it had a detrimental effect on his work. When Raphael was commissioned to fresco the entrance loggia of Agostino Chigi's Roman villa with the amorous frolics of *Cupid and Psyche*, he was 'not able to give much attention to his work, on account of the love that he had for his mistress'. Only when Chigi installed her in the villa did the work get done.[84] The frescos are Raphael's sauciest work. As we learned in the previous chapter, shortly after they were completed (1 January 1519) a correspondent wrote to Michelangelo in Florence telling him they were a 'disgrace for a great artist'.[85] He was probably criticising the execution as well as the content, for it was painted by Raphael's assistants – above all, by Giulio Romano. The most flagrant piece of erotica appeared in the decorative borders of the various pictures, which were painted by Giovanni da Udine. Nestling amidst festoons of leaves, flowers and fruit, we find a phallic marrow penetrating a luscious fig which is split open. It is placed just above the open hand of Mercury, who has escorted Cupid and Psyche to heaven to be married: the god must be indicating what will happen after the wedding feast that is the subject of the main picture. By the time he drew the *Dream*, Michelangelo is likely to have been aware of this detail, not least because Giovanni da Udine had come to Florence to make stucco decorations for the cupola of the New Sacristy in 1532.

This juicy detail was the soul of discretion compared with the series of sixteen pornographic prints, *I Modi* (early 1520s), designed by Giulio Romano and engraved by Raimondi.[86] Vasari tells us that the plates showed 'all the various ways, attitudes, and positions in which licentious men have intercourse with women; and, what was worse, for each plate Pietro Aretino wrote a most indecent sonnet, insomuch that I know not which was the greater, the offence to the eye from the drawings of Giulio, or the outrage to the ear from the words of Aretino'.[87] Aretino may have been the inspiration behind Giovanni da Udine's sexualised fruit and vegetable, for he was then attached to Agostino Chigi's household.[88]

Pope Clement banned *I Modi* 'since some of these sheets were found in places where they were least expected', and threw Raimondi into prison (he was released thanks to the intervention of the conspicuously uncelibate Cardinal Ippolito de' Medici). Giulio Romano only escaped punishment because he had already left for Mantua. Today, all that

survives of the original engravings is nine small fragments of heads and upper bodies in the British Museum, though we can get some idea of them from a fragment of a separate print by Raimondi which shows a woman masturbating with a dildo. Only one example is known today of an edition (perhaps of 1527) complete with Aretino's poems. Shortly after the publication and suppression of *I Modi*, another series of erotic prints was published, the *Loves of the Gods*, but these were not banned because they were less explicit. Some of the drawings for this series were made by another Raphael associate, Perino del Vaga.

Michelangelo goes to huge lengths to illustrate – and by illustrating, to denounce – the sexual mores of the age, of which *I Modi* was the most notorious visual document. It seems likely that Michelangelo meant to allude to the prints, and that the allusion was meant to give his denunciation of *Lust* extra weight. Vasari, at the end of his account of *I Modi*, says that 'the gifts of God should not be employed, as they very often are, in things wholly abominable, which are an outrage to the world'.[89] Michelangelo presumably concurred, and he must have been referring to this kind of image when he wrote of 'turpissime pitture'. But Cavalieri must also have seen *I Modi*, and may even have owned a copy (perhaps courtesy of Cardinal Ippolito), for otherwise the risk of shocking him would have been too great – and he would not have understood the allusion. Michelangelo is telling his pupil not to waste his God-given talent as the perpetrators of *I Modi* had done.

Yet it is hard not to think that Michelangelo protests too much. The artifice with which the male genitalia are represented in a variety of images is quite extraordinary. They are represented as a stand-alone diagrammatic outline, aimed skywards at an angle of forty-five degrees; as a naturalistically detailed piece of meat, massive, hairy and horizontal, grasped by a disembodied hand; as a sharp, shadowy dipstick projecting from a predatory man's midriff; and, metaphorically, as the long neck of a flagon. Finally, we have the quiescent, shy penis of the dreamer. The drawing with the diagrammatic outline, which resembles a piece of obscene graffiti, recalls an anecdote told by Vasari about the young Michelangelo. He apparently competed with various painter friends to draw a puppet-figure similar to those scrawled on walls: '. . . in this he availed himself of his memory, for he remembered having seen one of those absurdities on a wall, and drew it exactly as if he had had it before him, and thus surpassed all those painters'.[90] Here, he draws obscene graffiti from memory, and also images like those in *I Modi*.

When Aretino sent a copy of *I Modi* to the surgeon Battista Zatti in 1537 he accompanied it with a letter in which he argued that he composed the sonnets because he was moved by the same spirit that moved Giulio Romano to draw the pictures, and that it was a gesture of defiance against the hypocrisy of those who praise God's creation but forget that it is underpinned by sex. He added that the ancients as well as the moderns depicted lascivious things – citing as an example a sculpture of a satyr raping a boy in the Chigi collection. The letter closed with a celebration of the penis: 'It would seem to me that such a thing, given to us by nature to preserve the species, should be worn around the neck as a pendant and as a brooch on hats, since it is the conduit from which gushes rivers of people, and the ambrosia which the world drinks on feast days.' The penis, he concludes, has created many great people, painters as well as Popes – Michelangelo included.[91] Some of Aretino's proposals seem to be prophesied in Michelangelo's drawing. The 'graffiti' penis does appear to emerge directly from the male lover's turban like a phallic feather, while the man drinking from the flask could be taken as a devotee of the Festival of the Phallus. By the same token, one of Aretino's sonnets offers an explanation for the hand that descends from the clouds to clasp a tumescent penis. A male lover exhorts the female: 'Grab it with your hand . . . I feel such happiness at the feel of my rod in your hand that I will explode if we have sex together.'[92]

It is hard to know, when looking at Michelangelo's Five Stations of the Phallus, whether he came to praise or to bury this particular member. At the very least, he proves he can do pornography as well as anyone. In one of the poems to Cavalieri, he writes that 'my pen does not correspond to my actions, and the paper is made a liar'. Here it is his exhaustive depictions of the erect penis by which the paper is made a liar.

In general, the mythological presentation drawings depict folly and sin so vividly and seductively that they almost seem to revel in it. Their moralism is, one might say, at half-cock.[93] Coming from the poems, which for the most part celebrate Cavalieri's beauty, virtue and wisdom, to the tumultuous presentation drawings is surprising, to say the least. We have the sense that Michelangelo is saying to himself, like St Augustine in the *Confessions*: 'Grant me chastity and continence, Oh Lord, but please, not yet.'[94]

THE HEAVY WORKLOAD of the *Last Judgment* (1536–41; Plate 26) probably made Michelangelo realise he would never have the time to complete his

treatise. In addition, in 1535 he was appointed supreme architect, sculptor and painter to the papal palace, which made him responsible for the completion of the new St Peter's. He also seems to have had difficulty deciding how to organise the treatise, and how to write the text. Condivi says he 'doubted his powers and whether they were adequate to treat the subject properly and in detail, as someone would who was trained in the sciences and in exposition'.[95] As with the Julius tomb, over-ambition may have been the undoing of the project. Having painted the *Last Judgment*, with its 391 figures, he may also have felt that it was tantamount to a treatise on human movements. In some respects the fresco does have the exhaustive inventorising quality of a textbook. In addition to intact bodies, he of course depicts skeletons and bodies in the process of recovering their flesh. Whereas previous painters showed the company of the blessed in neat and relatively calm rows, here there is not a single static body. Although the immediate impact is stunning and overwhelming, such is the fetishisation of human movement and musculature that it ends up seeming rather monotonous and contrived. The *Last Judgment* immediately encountered criticism for the nudity and general lack of decorum.

The fresco was certainly greeted by Michelangelo's contemporaries as an encyclopaedia of movement. Condivi says that in this work Michelangelo 'expressed all that the art of painting can do with the human figure, leaving out no attitude or gesture whatever'. He doesn't discuss it in detail because 'to describe it is lengthy and perhaps not necessary as such a quantity and variety of copies have been printed and sent everywhere'.[96] This is Condivi's only mention of engravings of Michelangelo's work. By implying that the engravings represent many aspects of the fresco, rendering description redundant, he verges on suggesting an equivalence between the original and the copies. An engraving was published by Beatrizet about a year after the fresco was finished, and five other engravers copied it within two decades of its completion. The most impressive, by Giorgio Ghisi, was composed of ten separate sheets which, when mounted together, reproduced the entire fresco.[97] As Condivi was effectively Michelangelo's mouthpiece, he must have been fairly satisfied with at least some of the reproductions, and may even have encouraged the engravers. The *Last Judgment* might be regarded as Michelangelo's most public response to Dürer's treatise: as such, it would be one of the few frescos (apart perhaps from Raphael's) to be partly made with mechanical reproduction in mind. The precision

and refinement of the execution (revealed by the recent cleaning) made Vasari think of another kind of small-scale illustration. He said that Michelangelo gave it a finish 'as was never achieved in any miniature'.[98]

The presentation drawings, particularly those made in the early 1530s, can be seen as part of an unfinished project; or at least, a project that was indirectly sublimated in the *Last Judgment*. Clearly, the claim that Michelangelo lacked public-spiritedness continued to rankle, and Condivi's biography of 1553 is a defensive as well as a celebratory document. It is primarily concerned with justifying Michelangelo's failure to finish the *Tomb of Julius II*.[99] But it also fails to mention most of the major unfinished sculptures, in case these should add to his reputation for unreliability, and defends him against the accusation that he had no pupils (something that had been observed by Vasari in the first, 1550, edition of the *Lives*, and by Paolo Giovio in his brief life from the late 1520s).

Condivi, who was also one of Michelangelo's assistants and a decidedly second-rate painter, makes excuses for his employer's lack of significant followers and his apparent love of secrecy: 'Nor is it true, as many people charge, that he has been unwilling to teach,' Condivi protests, 'on the contrary, he has been glad to do so, and I have known it in my own case as he has disclosed to me every secret pertaining to that art. But, as misfortune would have it, the pupils he has come across either had little aptitude or, if they had aptitude, they did not persevere but considered themselves masters after a few months of study with him. Also, even though he did this readily, he did not care to have it known, preferring good deeds to the appearance thereof.'

Then we come to what is perhaps the nub of the argument: 'It should further be known that he has always sought to instill his art in noble people, as the ancients used to do, and not in plebeians.'[100] A similar sentiment had already been expressed by Michelangelo in a poem of around 1540:

> Amore, perché perdoni
> tuo somma cortesia
> sie di beltà qui tolta
> a chi gusta e desia,
> e data a gente stolta? (no. 146)

[Love, why do you allow your highest favour, beauty, to be taken from him who appreciates and desires it, and be given to stupid people?]

Michelangelo has begun to articulate a problem that was to become central to all subsequent aesthetics: the relationship between art and its public. Was his art to be a 'school for all the world', as Cellini described the cartoon for the *Battle of Cascina*? Or alternatively, if that world was filled with fools, should his art be a private school for a 'deserving' elite? If Michelangelo had once dreamed, while quarrying in Carrara, of carving a colossus which would be 'visible from afar to seafarers', how did that tally with these new drawings that were only fully visible with the help of magnifying glasses? And last but certainly not least, there was the question of God. In a world full of heretics, what justification could there be for preaching only to the converted? For a while, print-making and publication must have held out the possibility of squaring these circles.

7. Humiliations

Non è più bassa o vil cosa terrena
Che quel che, senza te, mi sento e sono
[No earthly thing is more base and vile than I feel myself to be, and am,
without you [my Lord]]

<div align="right">Michelangelo, 'Sonnet' (1555), no. 289</div>

MICHELANGELO'S LAST YEARS were dominated by vast architectural
projects, with sculpture and painting playing a relatively minor role. He
had been appointed Supreme Architect, Painter and Sculptor to the
Vatican Palace in 1535 when he was sixty, and after 1550 his responsi-
bilities were primarily architectural. Most of his time was spent com-
pleting partially constructed buildings – the Farnese Palace and, above
all, St Peter's – or rationalising and extending existing ensembles such as
the Capitoline Hill. The necessity of having to adapt and accommodate
earlier structures made his tasks even more difficult, especially in the case
of St Peter's. These vast building enterprises left less time for painting or
sculpture, though at his advanced age, he would have been less able to
cope with the physical demands of such activities. In theory, architecture
allowed him to take on a primarily executive role. But his habit of
designing each stage of a building as construction proceeded, and his
reluctance to provide measured drawings, meant that his presence was
more frequently required on site.

It was not, however, simply a case of having no time for the figura-
tive arts. In his late architectural projects, sculpture is marginalised. Unlike
his previous architectural work at San Lorenzo, and on the *Tomb of
Julius II*, none of these projects involved the integration of new sculp-
tures into the fabric of the structure. The Capitoline Hill had the most
significant sculptural component, but the sculptures were either antiquities

displayed in front of the buildings or anonymous rows of pedimental statues placed on top of them – so regimented that even Alberti might have approved.

Michelangelo's last completed sculptures were the relatively stream-lined (and therefore easy to carve) figures of *Rachel* and *Leah*, made in around 1542 for the *Tomb of Julius II*, and placed on either side of *Moses* in the drastically reduced final version of the monument in San Pietro in Vincoli, Rome. His last frescos, the *Conversion of Saul* and the *Crucifixion of St Peter*, painted on facing walls in the Pauline Chapel in the Vatican, were executed between 1542 and 1550. They took him a long time not only because he had so many other commitments, but also because, as Vasari said, painting frescos is no job for an old man. Michelangelo was seventy-five in 1550, and he had already been seriously ill in 1544 and 1546. The frescos are deliberately uningratiating. He filled them with ponderous, leathery and lumpy figures, painted in a drably schematic way. The late sixteenth-century artist and theorist Giovanni Paolo Lomazzo correctly observed that Michelangelo painted in three manners – that of the Sistine Ceiling, the *Last Judgment* and the Pauline frescos – with each one being 'less beautiful than the other'.[1]

He did not give up on the visual arts entirely, however. Rather, he narrowed his focus ever more drastically. His surviving work from the last fifteen years of his life, until his death in 1564, is dominated by a series of images featuring the dead Christ. He carved two greater than life size marble sculptures of the *Pietà*, both of which were abandoned, unfinished and mutilated by the artist. The *Pietà* (*c.* 1547–55) which is now in Florence, was made, according to Condivi, to be placed over an altar above his tomb (Plate 28). No one knows the intended purpose of the second marble *Pietà* (*c.* 1550/64), now in Milan, but Michelangelo worked on it almost until the day he died, and he may have eventually envisaged it as a replacement for the one he had mutilated (Plate 31).

He also made some small-scale works on the theme of the dead Christ. We have several drawings of Christ on the Cross flanked by two mourning figures, the Virgin and St John. Of these, six survive in their entirety, and a seventh can be reconstructed from two fragments and from copies (Plates 29 and 30).[2] There are also two crucifixion drawings without mourners, and a couple of preliminary sketches for Christ on the cross. In addition, he carved a small crucifixion in wood that is unfinished and without arms. As the drawings with mourners were made on large pieces of paper of the same size, and there are no drawings on

the back, it is likely that all these small-scale works were made as aids to private devotion.[3]

Because Michelangelo burnt a great many drawings near the end of his life, we have no way of knowing how assiduously he worked on other subjects. But it is clear that he was especially concerned with the subject of the dead Christ. In some of his late poems he appeals to Christ for mercy, and he is even more preoccupied than usual with sin and death. Most of his surviving works after he returned to Rome in 1534 are about religious subjects, and he decorated his house with an unmissable *memento mori*.

The house was located in Macello de' Corvi ('The Slaughterhouse of the Crows'), at the foot of the Capitoline Hill, and was extremely large, with grounds containing a vegetable garden, two cottages, a stable and a forge. It had been given to him, rent free, by the Rovere family, three years after Pope Julius' death, on the understanding that he would work there on the tomb. Because of his dilatoriness, its ownership was in dispute. Halfway up the imposing stairwell he drew the figure of *Death* as a skeleton with a roughly hewn coffin on its shoulder. Underneath were inscribed the somewhat inhospitable lines:

> Io dico a voi, ch'al mondo avete dato
> L'anima e 'l corpo e lo spirito 'nsieme:
> In questa cassa oscura è 'l vostro lato' (no. 110)

[I say to you who have given to the world your whole selves – body, soul and spirit: you will end up in this dark coffin.]

The lugubrious inscription is dated to some time after 1534–5, so it presumably coincided with his work on the *Last Judgment* and his friendship with the extremely devout aristocrat Vittoria Colonna. He is known to have sent her three drawings, probably in the late 1530s/early 1540s, of subjects taken from the life of Christ. Two of these survive – a *Christ on the Cross* (with a human skull placed at the foot of the Cross) and a *Pietà* – while the third, *Christ and the Woman of Samaria*, is lost, though its appearance can be gauged from an engraving.[4]

Michelangelo would have then been already in his sixties, which was extremely old by the standards of the day. It is not altogether surprising if in his old age he became obsessed with death, and with the necessity of forgoing worldly pleasures (Botticelli was around fifty when, in the 1490s, he renounced the elegant style and pagan subjects for which he is

famous, and developed a harsher, deliberately primitive style: and he may eventually have given up painting altogether).

Despite – or perhaps because of – his wealth (he was already well-off by around 1500),[5] Michelangelo always seems to have lived in an ascetic manner. In 1509 he wrote a furious reprimand to his brother Giovan Simone di Lodovico Buonarroti in which he claims: 'for twelve years now I have travelled about all over Italy, leading a miserable life; I have borne every kind of humiliation, suffered every kind of hardship, worn myself to the bone with every kind of labour, risked my very life in a thousand dangers, solely to help my family'.[6] Paolo Giovio, writing in the 1520s, said Michelangelo lived in 'incredible filth'.[7] Condivi tells us that Michelangelo drove himself so hard that he often went without food and sleep, and both he and Vasari claim that he slept in his clothes. 'In his latter years,' Vasari continues, 'he wore buskins of dogskin on the legs, next to the skin, constantly for whole months together, so that afterwards, when he sought to take them off the skin often came away with them. Over the stockings he wore boots of cordwain fastened on the inside, as a protection against damp.'[8]

Michelangelo's habit of sleeping in his clothes, with tightly fastened boots that stick to the skin, was more or less in line with what St Ignatius of Loyola, founder of the Jesuits, recommended in the *Spiritual Exercises* (1548). Ignatius recommends chastisement of the body 'by inflicting actual pain on it. This is done by wearing hairshirts or cords or iron chains, by scourging or beating ourselves and by other kinds of harsh treatment.' However, Ignatius warns against taking chastisement too far: 'The safest and most suitable form of penance seems to be that which causes pain in the flesh but does not penetrate to the bones, that is, which causes suffering but not sickness.'[9] Michelangelo probably saw this self-inflicted flaying, caused by his dogskin boots, as a 'safe' imitation of Christ during his Passion. It was often imagined that Christ's clothes stuck to his back and that when they were torn off, prior to crucifixion, the skin came away, so that he seemed 'like a sheep skinned, neither hide nor hair'.[10] Michelangelo's penitential mood may have been expressed in a more extreme, though imaginary form in the *Last Judgment*. Here, St Bartholomew is depicted with the other saints holding up his own flayed skin, and it has been plausibly argued that the facial features depicted on the grisly relic are Michelangelo's own.[11]

The principal difference between the asceticism of Michelangelo's early and late years seems to be that it was both more conspicuous and

more obviously religious. It was directed towards God as well as towards the aggrandisement of his family. The figure of *Death* in his stairwell is a semi-public statement of intent. In 1545, Michelangelo planned a pilgrimage to Santiago da Compostella in north-western Spain, and though he never went, in 1550 he did make a pilgrimage to seven churches in Rome, and attempted to gain a special Jubilee-year indulgence for his sins from the Pope. In 1556, he made a pilgrimage to the so-called House of Mary at Loreto in central Italy, but was ordered to return to Rome by the Pope when he had only reached Spoleto.[12] His significant charitable gifts date from the late 1540s.[13] Condivi stresses that Michelangelo worked on St Peter's for no salary, and the artist told Vasari in 1557 that he did the work 'for the love of God'. This has recently been shown to be false: he received the huge salary of 100 gold scudi a month, which was at least twelve times more than Titian was being paid for paintings by King Charles V of Spain. Around half his salary came from the revenues from the toll bridge over the River Po.[14] But he was evidently very keen to advertise his piety.

Partly because of these penitential acts and the penitential subjects of many of his late poems, Michelangelo's late images of the dead Christ tend to be seen as personal testaments charged with tragic intensity. The Florentine *Pietà* has been called 'the most subjective and most overtly emotional that has ever been produced'. The Milan *Pietà*, which Michelangelo whittled down until very little was left, has been characterised as 'a symbolic act of suicide'.[15] What I propose to explore here is the precise nature of Michelangelo's engagement with the dead Christ.

IMAGES OF THE DEAD Christ were ubiquitous – more so even than images of the Madonna and Child. This is because of Christ's frequent depiction on crucifixes, worn around the neck, placed on every altar, and kept in the home. At the time when Michelangelo made his drawings and sculptures of the dead Christ, the most influential guide to the meaning of Christ's death was Erasmus' *Handbook of the Militant Christian* (1503). Translated into Italian in 1531, it had a huge influence on the policies of Alessandro Farnese, Pope Paul III (r. 1534–50), the patron of the *Last Judgment* and of the Pauline Chapel frescos.[16] Erasmus insisted that the believer should meditate on Christ's life, and above all on the Passion, rather than simply venerate the saints, a cult which he compared to the polytheism of the ancients.[17] He attacked the cult of saints because the saints embody one or more virtues, whereas Christ is 'the only complete

example of perfect piety'.[18] He particularly disliked the way in which people used the example of the saints, such as David and Mary Magdalene, to condone their own sins.[19]

In order to meditate successfully on the Cross, Erasmus believed it was necessary to match the various parts of the Passion 'with the particular vices you are afflicted with and want to be rid of', for there is 'no temptation or vice for which Christ did not furnish a remedy on the Cross'. The first vice which Erasmus cites is ambition: '. . . when ambition pushes you to want to be great in the eyes of men, think, my suffering brother, of how great Christ is, and to what extent He lowered Himself to atone for your sins'.[20]

The extent of Christ's self-lowering is dramatically manifest in the *Pietà* drawn for Vittoria Colonna, who was one of the most revered and cultured women in Italy (Plate 27). Castiglione hailed her in the introduction to the *Book of the Courtier* as a woman 'whose virtue I have always venerated as something divine'. She was descended from one of the oldest noble houses in Italy. Her ancestor Cardinal Giovanni Colonna was Petrarch's principal patron, and the poet lamented his death in a line of poetry that Michelangelo had jotted down beneath a study for the marble *David*. Michelangelo had met Vittoria Colonna in 1536, shortly after he began painting the *Last Judgment*, and they kept in touch until her death in 1547.[21]

Born in 1490, and thus fifteen years younger than Michelangelo, Colonna had been married at an early age to the soldier Ferrante Francesco d'Avalos, the Marquis of Pescara. The marriage was not happy, and he was frequently away on campaign. She moved in humanist circles and wrote accomplished poetry, but after her husband was killed in 1525 at the Battle of Pavia – victorious, but with his reputation in tatters, because he was suspected of betraying King Charles V of Spain – she went into religious retreat, staying for long periods in various convents. There she wrote her *Canzoniere spirituale*, some of which were religious, while others were retrospective vindications of her husband. Like Erasmus, she was highly sympathetic to some aspects of Protestantism, and was closely involved with religious reformers who hoped for a reconciliation with the Roman Church. Because of Colonna's confinement, she only met Michelangelo occasionally, and for the most part they communicated via letters and poems.

Her faith centred on Christ, and its cornerstone was the doctrine of justification by faith alone. This asserted that grace could not be received

by the worshipper from a priest through the material sacraments of the Mass; rather, it depended solely on man's faith in the justice of Christ. As a result, the performance of good works could not be regarded as intrinsically good and did not automatically win salvation for the performer; good works were only good if the performer already had faith. However, Colonna did not believe that this obviated the need for good works. One of her circle explained her beliefs to the Inquisition in 1566: she had believed that only by faith could she be saved, but at the same time did good works as if her salvation depended on this alone.[22] Her faith was thus a 'third way' between Protestantism and Catholicism.

Colonna's *Pietà*, shows the Virgin Mary seated at the foot of the Cross with Christ's upright torso wedged snugly between her legs. Their bodies are orientated towards the viewer. With her arms outstretched, Mary looks up to the heavens, beseeching. Inscribed on the Cross behind her, emerging from just above her head, is a line from Dante: 'They do not know how much blood it costs' – a line which would continue, if the drawing had not been cut down at the top – '. . . to sow [the Gospel] in the world'. The Virgin is flanked by two wingless angels who hold on to Christ's upper arms, which are laid out over her thighs. But this is not simply a *Pietà*: it is also an entombment. Mary sits on a rocky promontory, which falls sharply away at the front, so that Christ's legs and lower body appear to be sliding vertiginously down into the depths of the earth. In this way, Michelangelo stresses that Christ's death is the ultimate act of self-lowering.[23]

Colonna may have had a say in the subject–matter, but the configuration must be Michelangelo's own: its abstract angular symmetry recalls his extraordinary designs for bastions made ten years earlier when he was in charge of Florence's fortifications during the siege by pro-Medici forces (see Fig. 12). Bastions are projecting platforms level with the city or castle walls which deflect enemy gunfire and provide gun emplacements for defenders. The similarity is not entirely fortuitous, since the figures at the foot of the Cross are 'besieged' by events. Yet they are by no means overwhelmed. Michelangelo's bastions were primarily suited for offensive, rather than defensive, action, and the prickly rigidity and quasi-architectural grandeur of the composition suggests a militant obduracy that emerges at the very moment of Christ's death. The *mise-en-scène* confirms Erasmus' notion that the Cross is 'the one weapon you should use against the Devil'.[24]

We know from a print made before the drawing was cut down that

Michelangelo depicted a Y-shaped Cross, with a horizontal beam near the top, which would have made the composition even more angular. It was, Condivi tells us, 'similar to the one carried in procession by the Bianchi at the time of the plague of 1348, which was then placed in the church of Santa Croce in Florence'. The Bianchi were flagellants who went from town to town crying out 'Peace and Pity'.[25]

In the passage cited earlier, Erasmus contrasted Christ's humility with human pride and ambition. As Michelangelo worked on his vast projects, and as his contemporaries openly called him *divino*, he must have been acutely aware of the dangers of overweening pride and ambition. In the first edition of the *Lives of the Artists* (1550), Vasari hailed the consummate achievement of the *Last Judgment* in astonishing terms:

> This is for our art the exemplar and the grand manner of painting sent down to men on earth by God, to the end that they may see how Destiny works when intellects descend from the heights of Heaven to earth, and have infused in them divine grace and knowledge. This work leads after it bound in chains those who persuade themselves that they have mastered art; and at the sight of the strokes drawn by him in outlines of no matter what figure, every sublime spirit, however mighty in design, trembles and is afraid.[26]

The image of the dead Christ brought him down to earth, and prevented him turning into a new Nimrod, the arrogant giant who built the Tower of Babel. The catalyst for the Reformation had been an indulgence sold in Germany to finance the rebuilding of St Peter's, so Michelangelo may have been even more concerned to justify his own ways to men.

In his late poems, however, it is the figurative arts rather than architecture that constitute the greatest temptation for the artist:

> Con tanta servitù, con tanto tedio
> E con falsi concetti e gran periglio
> Dell'alma, a sculpir qui cose divine (*c.* 1552; no. 282)

[To sculpt divine things here can be done only with great slavery and great tedium, with false ideas and with grave danger to the soul.] Here, the huge physical and intellectual demands of the art of sculpture ensnare the sculptor, rather than liberate him. It is possible that for Michelangelo the Florentine *Pietà* came to epitomise the sin of over-ambition, and that

this is one of the main reasons why he failed to finish it and ended up mutilating it. Sculpture, too, was the pagan art form *par excellence*.

The Florentine *Pietà* (Plate 28) was almost certainly intended for a niche over the altar in Michelangelo's funerary chapel. Christ's crumpled body is barely supported by the Virgin Mary and Mary Magdalene, but looming over them in the background is the cowled figure of Nicodemus, the Pharisee who came secretly by night to receive teaching from Christ, and who assisted at his burial. According to legend, Nicodemus was a sculptor who portrayed Christ, reputedly carving the celebrated relic the *Volto Santo* (Sacred Face) in Lucca. Vasari claims, in a letter of 1565, that Nicodemus is a self-portrait of Michelangelo.

Equally relevant to the elderly Michelangelo is a question that Nicodemus asked Christ. When Christ told him that a man could only see the Kingdom of God if he is born again spiritually, Nicodemus asked how a man can be born again when he is old, whereupon Christ insists that he must believe this is possible (John 3). The idea of spiritual rebirth was extremely topical. Its feasibility had recently been asserted by the Council of Trent, a series of conferences attended by leading figures in the Catholic Church whose purpose was to draw up new doctrinal guidelines in response to the Protestant schism. In a *Decree on Original Sin* promulgated in June 1546, Christ's words to Nicodemus are cited: 'For, *unless one is born again of water and of the holy Spirit, he cannot enter the kingdom of God*' (John 3: 5). The Council went on to affirm that 'God hates nothing in the reborn, because there is no condemnation for those who are truly buried with Christ by baptism into death, *who do not walk according to the flesh* but, putting off the old person, and putting on the new person created according to God, become innocent, stainless, pure, blameless and beloved children of God, *heirs indeed of God and fellow heirs of Christ*, so that nothing at all impedes their entrance into heaven'.[27] John 3: 5 was cited again in a *Decree on Justification* published in January 1547.[28] It has been argued that Michelangelo began the sculpture in 1547 due to his 'despair' at the death of Vittoria Colonna,[29] but the publication of these decrees is a more likely catalyst. This sculpture is very much about Michelangelo's status and fate; women are both startlingly subordinate and peripheral.

Michelangelo had frequently depicted the dead Christ being supported from behind by a mourner, but the head of the mourner is never much higher than that of Christ.[30] Here Nicodemus towers over Christ and the two diminutive Marys, forming the pinnacle of a pyramidal composition (his hood is akin to a cupola). Traditionally, only

God the Father is allowed to tower over the dead Christ, as in depictions of the Holy Trinity. The twist of Nicodemus' shoulders and the tilt of his head recall the Madonna in the New Sacristy, but he is much more decisive in his movements and is stooping from a great height. The point must be to show the moment when the 'great' sculptor is brought down to earth by the spectacle of Christ's death, and renounces his colossal ambitions, recognising the extent to which Christ has 'lowered' himself for the benefit of his fellow men.

Nonetheless, Michelangelo's sculpture still shows huge 'worldly' ambition. No modern sculptor had carved a four-figure, more than life-size group from a single block. At almost seven and a half feet high, Niocodemus is an astonishingly prominent and powerful figure, 'erect and firm on his legs', as Condivi put it, supporting Christ 'with a display of vigorous strength'.[31] Vasari informs us that Michelangelo partly made the work because 'the exercise of the hammer kept him healthy in body',[32] while Condivi says that being 'full of ideas and energy', he needed to be working on something. The claim that Michelangelo was still full of energy is probably an exaggeration, as his productivity levels in painting and sculpture declined markedly in his latter years, but Condivi is representing an idealised image of the artist, and this ideal is realised in Nicodemus. With his immensely broad shoulders and large stature, he is the epitome of the strong, all-conquering, quasi-divine sculptor. His support of Christ seems surprisingly effortless: the only visible support he offers is to place his right hand under Christ's arm.

But Michelangelo appears to be so concerned with emphasising the dignity and power of Nicodemus that he misjudges the emotional tone. There is a nagging feeling that Nicodemus is *condescending* to Christ's level. The sculpture as a whole has much of the expressionless artificiality of an early studio photograph, taken with a long exposure. Nicodemus is the benignly aloof patriarch of the family. His stoop is rather like that of Ivan the Terrible in Sergei Eisenstein's film of that title. Christ's body is a crumpled zigzag that cuts through the group like a bolt of lightning, but its spasmodic energy barely reverberates through Nicodemus or the two Marys. There is something very matter-of-fact about the whole composition, as though the mourners were merely going through the motions and emotions.

Mary Magdalene might almost be a pillar of salt. She is expressionless, and her arms make a wholly unconvincing attempt at supporting Christ well away from her own body, almost as though she were anticipating the

'Noli me Tangere' incident. The rawness of the Virgin Mary's emotions and actions is compromised by the way that she is comfortably squatting on a block of stone. Condivi marvelled at how 'all the figures are perceived distinctly and the draperies of any one figure are not to be confused with those of the others'.[33] This seems a polite or inadvertent way of saying that the group lacks unity and the figures are like strangers to each other. Their separation is exacerbated by some extraordinary disparities in scale. The Magdalene, for example, is about half the size of Nicodemus.

Michelangelo's ambition surpassed his ability to execute the group. He had problems with the carving, and broke off various limbs – Christ's left leg and both his arms; the right arm of the Magdalene; and the left arm of the Virgin where it is attached to Christ's arm. His assistant Tiberio Calcagni later restored the group, replacing some parts and remaking others, as well as finishing most of the Magdalene.[34] He did not replace the left leg – quite sensibly, as it turns out, because we scarcely miss it and its absence increases our sense of Christ's downward collapse. But judging by Michelangelo's subsequent depictions of the dead Christ, one suspects he regarded the sculpture as a spiritual as well as an artistic failure.

MICHELANGELO'S LATE crucifixion drawings are no less concerned with the nature and the limits of art (Plates 29 and 30). At first sight, the crucified Christ is a subject that offers little scope for the artist, particularly for one who is interested in human movement and gestures. It offers a naked body, of course, but if one wanted to be original it would be far easier to find new ways of depicting the bystanders than the man whose hands and feet are nailed to the Cross (and Michelangelo does indeed make subtle variations in the gestures and expressions of the Virgin and St John). At the same time, however, these limitations can make the subject an exciting challenge, just as they did when he was writing a sonnet. Michelangelo, in the dialogue recorded by Holanda, dismisses Flemish painters because they try to do everything well, whereas 'a man may be an excellent painter who has never painted more than a single figure'.[35] Vittoria Colonna was present at these discussions, and the 'single figure' Michelangelo had in mind may well at this stage have been the crucified Christ, which he drew for her. No other artist, before or since, has been more resourceful in finding new ways of representing a crucified body.

Michelangelo's principal pre-1550 representations of the crucified Christ stress Christ's athleticism and beauty – as indeed do the drawings

for Colonna and the Florentine *Pietà*. In the *Three Crosses*, a chalk study of 1523 for an unexecuted relief, a heroically muscled Christ is crucified on a Y-shaped Cross, and his arms are raised majestically like wings. In the *Christ on the Cross* (c. 1540) drawn for Colonna, Christ's body twists in a powerful convulsion, and looks upwards towards the heavens like a tormented pole-vaulter.[36] The shape of Christ's body is strangely reminiscent of the *Ganymede*. When Colonna wrote to thank Michelangelo for the drawing, she singled out its high finish and detail: 'Unique Master Michelangelo and my most singular friend. I have received your letter and seen the Crucifixion which has certainly crucified in my memory every other picture I have ever seen. Nor could one see another better made, more lifelike or more finished; and for sure I could never explain how subtly and wonderfully it is made . . . I have looked at it closely in [a strong] light and through a magnifying glass and in a mirror and I never saw anything so well finished.'[37]

There were sound theological reasons for depicting Christ *in extremis* as a beautiful athlete. Not only was Christ believed by theologians such as St Antonino and Savonarola to be the most beautiful man who ever lived, but when he was crucified it was important to show the viewer that he would soon be gloriously resurrected. Thus his agonies should not impair his beauty – and his divinity – too much. In Michelangelo's St Peter's *Pietà* (1498–9), the beautiful and very much alive 'corpse' seems to be a lithe living body slumbering in a deep sleep.

There was another important reason why Christ's sufferings should not be depicted too realistically. Since the various stages of Christ's Passion were a model for worshippers who wanted to 'imitate' Christ (the banners of lay confraternities usually depicted Christ's flagellation), this imitation should only go so far. Thus St Ignatius said that the best way to scourge oneself was 'with thin cords which hurt superficially, rather than to use some other means which might produce serious internal injury'.[38] Michelangelo's early depictions of Christ's Passion may be seen as a guide to the infliction of superficial wounds, rather than simply an 'aestheticisation' of violence. Christ's wounds in the St Peter's *Pietà* are barely more than surface scratches. In 1516, Michelangelo provided Sebastiano del Piombo with some drawings of the flagellation of Christ, on which Sebastiano later based a fresco in the Roman church of San Pietro Montorio. This painting was criticised by Giovanni Andrea Gilio in his *Due Dialoghi* (1664) for making it look as though Christ was being struck for a joke with whips normally used on a child, rather than

with great knotted ropes.[39] But this was to miss the utilitarian function of such images. No penitent imitating such an image was likely to end up in hospital, and it could also be argued that they were less likely to be seduced by the Devil. St Bernard believed that the Devil was more likely to attack those weakened by excessive penance, for such activities 'sapped their spiritual stamina'.[40] Michelangelo's own father, writing to him in Rome in 1500, warned him that 'misery is bad, because it is a vice that is displeasing to God and to the peoples of the world, and furthermore it will hurt your soul and your body'.[41]

The most prophetic of Michelangelo's early crucifixion images – precisely because it is the least dynamic and athletic – is the 'good' thief in the *Three Crosses* drawing. His arms are stretched upwards, almost vertically, and bent back over the horizontal bar of the Cross; his legs hang free, his head hangs down, and his whole body is completely motionless. The near-vertical arms and legs, the straight torso and the lack of movement make the 'good' thief closely resemble a celebrated classical sculpture of Marsyas – the so-called 'hanging' Marsyas, two versions of which flanked the entrance to the Medici sculpture garden when the young Michelangelo worked there. It is the only celebrated antique figure sculpture (apart from Herm and Caryatids), that does not depict or imply movement (Fig. 21).

In the 1550s Michelangelo became obsessed with perfecting the 'Marsyas' crucifixion.[42] In several drawings, the arms of Christ are brought closer than ever to the vertical, but are devoid of wing-like power; his body becomes increasingly inert (Plate 29). The numerous *pentimenti* and redrawn lines make it look as though Christ is disintegrating, if not actually being flayed. As we saw in an earlier chapter, Marsyas was a symbol of an art rooted in anatomy. At the end of Michelangelo's career he is preoccupied with a mythological figure who had presided over its beginning. The importance of Marsyas was recognised in the decorations made for Michelangelo's funeral in 1564. The entrance to the Medici gardens, with the two Marsyases, was depicted on the catafalque erected in San Lorenzo, Florence.[43]

The idea that the flaying of Marsyas might be analogous to the death of Christ is in some respects surprising. In the Renaissance, the flute-playing Marsyas was usually regarded as someone who got his just deserts. He was flayed after challenging the lute-playing Apollo to a musical contest, with the winner being able to impose any penalty on the loser. The story was generally interpreted as showing the just punish-

Fig. 21: 'Hanging' Marsyas, from P. A. Maffei, *Raccolta di Statue Antiche e Moderne*, 1704.

ment for arrogance or even heresy, and the triumph of harmony.[44] In this guise, it was adopted as a symbol by several Popes. The entry in a guidebook to antiquities in Rome published in 1556 is typical. Having described a white marble 'hanging' Marsyas in the Palazzo della Valle-Capranica, shown with his wrists tied up above his head and his legs hanging free, we are told that he had 'the temerity to dare to compete with Apollo in the art of Music'.[45] Woodcut illustrations of the myth were included in the anatomical treatises of Vesalius and of Michelangelo's friend Realdo Colombo, and part of the myth's appeal was that Marsyas was considered a criminal, and the corpses used by

anatomists were also usually those of criminals. Anatomists identified themselves with the 'enlightened' Apollo, flaying criminals while harmoniously revealing the deeper truths about the human condition.

It was possible, however, to make an association between Christ and Marsyas, especially as Christ was often compared to a sheep or lamb that had been flayed or sheared. Indeed Giovanni Andrea Gilio, one of the most fervent critics of Michelangelo, insisted that Christ in his Passion should not be depicted as beautiful and elegant, but as bloody, deformed and flayed.[46] More esoterically, Alcibiades in Plato's *Symposium* compares Socrates simultaneously to both Silenus and Marsyas. Silenus was a fat old man who was supposed to conceal divine wisdom under his ugly exterior, and hollow statuettes of Silenus were sold which could be dismantled to reveal a statuette of a god inside. The point of this comparison was that Socrates was famously ugly, yet with a 'beautiful' mind. Alcibiades compares Socrates to Marsyas because both could charm men with 'the power which proceeded out of his mouth' – Socrates with his words, and Marsyas with his flute.[47] In the Renaissance, Erasmus compared Christ with Silenus – human on the outside, divine inside – and it is not hard to see how the Marsyas myth might be again conflated with that of Silenus.

That this formal similarity between Marsyas and the Christ in Michelangelo's crucifixion drawings was not accidental finds indirect confirmation in a drawing made by a protégé of Michelangelo's. In the early 1550s the sculptor Guglielmo della Porta designed a bronze relief of the flaying of Marsyas in which he is front-on and bolt upright, isolated in space, yet surrounded by a crowd, as in a crucifixion scene. Earlier Renaissance artists had always shown Marsyas obliquely or in profile.[48] The drawing is in ink over chalk, and is executed swiftly with nervous, spasmodically flowing strokes. Michelangelo fell out with his protégé at around this time because della Porta insisted on locating Pope Paul III's tomb in the centre of St Peter's. Nonetheless, one suspects that in his treatment of Marsyas, della Porta had been influenced by Michelangelo.

There is a further reason why Michelangelo, in his seventies and eighties, may have been drawn to the Marsyas myth, and this would make these works no less autobiographical than the Florentine *Pietà*. Dante, at the beginning of the *Paradiso*, composed during the last two or three years of his life, describes it as his 'final/ultimate work' (*ultimo lavoro*), and in order to complete it appeals to Apollo to enter his breast, and breathe into him 'just as when you drew Marsyas from the sheath of

his limbs'. Here, the flaying is a rather improbable metaphor for the poet being divinely inspired, and so Dante's Marsyas ultimately becomes the creator rather than the destroyer of harmony. The basic idea must be that the poet has to shed his humanity in order to gain access to divine truths. We should imagine Michelangelo identifying with the sufferings of the Marsyas–Christ (and of the elderly Dante) as he drew these late crucifixions, and at the same time wishing to be metaphorically 'flayed' in order to depict them adequately. In a madrigal, probably written for Vittoria Colonna, Michelangelo imagined God as an Apolline enabler who could strip him of his carnal sheath. Hoping to shed his bad old skin so that his soul may return to Heaven, he implores God to stretch out his merciful arms and take him from himself (no. 161).[49]

The late crucifixion drawings are remarkable for the way in which numerous *pentimenti* and redrawn contours make the images tremble, almost as though they were a mirage, or glimpsed through running water, or at sunset. The bystanding mourners, the Virgin Mary and St John, are depicted in a similar way. They are drawn with black chalk, and in some white lead body colour has been used both to model forms and to cancel out mistakes.

In 1537, while working on the *Last Judgment*, it was reported that Michelangelo could no longer carry out detailed work at close range because of long-sightedness, so failing sight may account for at least some of this tremulousness.[50] At the same time, however, Michelangelo seems to have made the most of his disability. In the Middle Ages it was believed that excessive grief could impair vision by blocking the optic nerve,[51] and these tremulous images of the crucifixion may be meant to indicate the grief with which the artist drew them, as well as the grief with which we are intended to view them. Near the end of his life, Michelangelo actually fantasised about being blind. In 1560, the Milanese sculptor Leone Leoni made a portrait medal of Michelangelo, with his co-operation, the reverse of which depicted the great artist as a blind pilgrim led by a dog. The medal bears an inscription from the Psalms, and it is surely penitential grief that has blinded the artist.

In the late drawings, the blobs of white body colour could perhaps suggest tears that have fallen onto the paper. It is possible that Michelangelo exacerbated the 'corrections' for expressive effect, because even the ruled lines indicating the Cross are redrawn several times, and at a variety of angles. Ruled lines are usually drawn more neatly, and usually only once, in his late architectural drawings.[52] So whereas the

Cross in a fragmentary drawing dated 1557 is made from clusters of ruled lines that cause it to bend and vibrate, a far more complex ruled drawing of a vault for St Peter's on the verso, made after builders had carried out his instructions incorrectly, is almost entirely error-free.[53] Vasari said that Fra Angelico wept every time he painted a crucifixion, and Michelangelo may be demonstrating, through innovative technical means, that he did indeed weep. In the dialogues with Holanda, of around 1540, he had praised the intellectual qualities of Italian art that will never cause the viewer 'to shed a tear', in contrast to the emotive naturalism of 'Flemish' art.[54] At the last, he seems to have created an 'intellectual' art that does invite the viewer to weep.

Michelangelo's technique may also be responding to something in the Marsyas myth. A distinction was made between the kind of music played by Marsyas on his wind instrument and that played by Apollo on his stringed instrument: strings were thought to be spiritually uplifting while pipes stirred the more basic passions.[55] Some Renaissance artists, including Parmigianino and Titian, emphasised the 'earthy' nature of Marsyas by showing him being flayed upside down. In Ludovico Dolce's *Trasformationi* (Venice, 1553), based on Ovid's *Metamorphoses* where the Marsyas myth is related, Apollo's music is 'that true exalted harmony'.[56] Michelangelo clearly cared about music for he wrote madrigals, and some of his poems were set to music. In addition, while working on St Peter's and on designs for other churches, he must have given some thought to acoustics. It was also a commonplace of classical and Renaissance aesthetics to compare proportions in architecture and the human body to musical intervals.[57] In the dialogues with Holanda, Michelangelo says that painting is a 'music and melody which only intellect can understand, and that with great difficulty'.[58] Even so, the only instruments he ever depicted are wind instruments. Fame 'awakes' the dissolute youth in the presentation drawing the *Dream of Human Life* by blowing a trumpet at point-blank range, and the angels wake the dead in the *Last Judgment* by blowing trumpets.

In the late crucifixion drawings, the 'vibrating' lines may have a musical quality, but they do not suggest the triumph of spiritual harmony over the passions. Far from it. The columnar Christ, and the equally columnar bystanders, are human instruments who reverberate with shock and pain. They are perhaps human counterparts to the pipe organs which often accompanied singing in church, but which were disapproved of and destroyed by the Reformed Churches of northern

Europe.[59] Leonardo, in his *Notebooks*, said that music can justly be called the younger sister of painting, and he compared music's harmonious rhythms to the contour line that 'bounds the members from which human beauty is born'.[60] Leonardo was an accomplished performer on the lyre, an elegant string instrument, and he thought the painter could and should work with music playing in the background. He would surely have regarded the mass of revised contours in Michelangelo's crucifixion drawings as painfully cacophonous – akin to the hammering noises which he complained accompanied the sculptor's less sophisticated work, and which he contrasted with the harmonious music that could inspire the painter. For Leonardo, painting is nonetheless superior to 'unhappy' music, 'because it does not fade away as soon as it is born'.[61] Michelangelo's 'musical' drawing style, with its sonorous indistinctness, underscores the 'unhappy' fragility of human life.

It is often said of these late drawings that Christ's body seems to be dematerialised by the flurry of lines from which he is composed, giving it a transcendent quality. While it is certainly true that it is hard to make out much anatomical detail or the precise position and expression on Christ's face, there is little sense that this represents the triumph of spirit over flesh. There is nothing uplifting about Christ's arms. He is more like Icarus than Ganymede. We are conscious of the dead weight of his body plunging and disintegrating downwards, like water cascading from a broken gutter. There is little sense of his impending resurrection, only of his entombment.

Christ's body also seems orientated towards the earth because the Cross is extremely low (in most cases his feet would be only about two feet above the ground), and because the bystanders act as bulky ballast that fixes him in place. In one drawing, the Virgin Mary and St John actually embrace Christ while he is still on the Cross, with the Virgin placing her cheek and hand against his thigh, thus anticipating the *Pietà* (Plate 30). This is an unprecedented motif. But their close adhesion to him counteracts the fact that in this drawing his arms are outstretched horizontally: he is not yet being allowed to take flight.

We might easily assume that the crucifixion drawings were a response to mounting criticisms of the *Last Judgment*, of which critics complained that art had got the better of piety, and that there was excessive nudity and gratuitous contortions. In 1545 the Venetian scandalmonger Aretino, after seeing an engraving of the fresco, wrote to Michelangelo. Having castigated the 'royal spectacle [of] martyrs and virgins in improper attitudes', he urged Michelangelo to salvage his reputation by

'turning the indecent parts of the damned to flames, and those of the blessed to sunbeams; or imitate the modesty of Florence, who hides your David's shame beneath some gilded leaves'.[62] Aretino was trying to blackmail Michelangelo, and implied that the letter would remain private only if he sent him some drawings. He also referred ominously to Michelangelo's 'thieving' in relation to the *Tomb of Julius II*, and to the fact that he only gave drawings to 'Gerards and Thomases' – a reference to the presentation drawings given to Gherardo Perini and Tommaso de' Cavalieri. Michelangelo failed to rise to the bait, and so Aretino published a revised version of the letter in 1550.

The crucifixion drawings could not be accused of making a royal spectacle of genitals and gymnastics. The body of Christ is stark, stiff and meagre. The meagreness is exacerbated by the near total absence of genitalia, which sometimes makes the body almost girlish. Yet Michelangelo goes much further than Aretino – or anyone else at the time – could have conceived. The indistinctness of the drawings cannot be seen as merely a matter of decorum. The dark blotches – now signifying shadows, now damaged flesh – and the frantic flurry of lines – now wispy, now harsh as though he were drawing a knife across a plaster wall – are not stylistic fig leaves. They are not simply a sketchy *sfumato* designed to airbrush genitalia. One imagines that Aretino – a good friend of Titian, and one who had famously extolled his sunsets – would have been dumbfounded by them.

The sonorous indistinctness of these drawings recalls aspects of Luther's 'Theology of the Cross', which was formulated in sermons and a series of 'theses' from around 1518–21.[63] Luther believed that God did not reveal himself through the world that he had created, so it was pointless to speculate on the created world if one wanted to be a theologian. Instead, God had revealed himself through the Passion and above all through the Cross of Christ. Yet this revelation was indirect, for the crucified Christ is not immediately recognised as God. The key biblical passage used by Luther to support this contention is Exodus 33: 23. God appears before Moses as a 'cloudy pillar', and when he asks God to show his 'glory', God says that no man will see his face and live. As he passes Moses by, he will cover Moses with his hand: 'And I will take away mine hand, and thou shalt see my back parts: but my face shall not be seen'. According to Luther, only the faithful, the 'friends of the Cross' who have already humbled themselves before God, are able to discern beneath the humility and shame of the Cross the power and glory of God. However, for those rationalists who were committed to

'speculating' about the created world, Christ's death on the Cross is always going to be a grotesque embarrassment, the inglorious antithesis of divinity.

Even though there was much less interest among Italians in Luther's theological innovations than in his criticisms of a corrupt Church,[64] Michelangelo did move in advanced religious circles where such things would have been discussed – not least, by Vittoria Colonna. Still, the basic idea that God is 'hidden' was hardly an unfamiliar one. When Christ informs Nicodemus that he must be born again, he also tells him not to analyse this revelation too assiduously: 'The wind bloweth where it listeth, and thou hearest the sound thereof, but canst not tell whence it cometh, and whither it goeth' (John 3:8). In addition, as we discovered with the *Madonna of the Stairs*, Michelangelo also knew the significance of the Christ Child turning his back to the viewer in order to conceal his 'shining face'.

In the drawings of the dead Christ made for Colonna, it only took a magnifying glass to perceive details that were invisible to the naked eye. But no technology will help us to see Christ in the late crucifixion drawings any more clearly. Some anatomical details are registered, but they seem on the brink of disappearing. The face is almost unreadable. Christ's amorphous carcass is virtually unrecognisable as either man or God. There is nothing shining or shiny here. He is akin to a 'cloudy pillar' – made of storm clouds. Only the faithful will discern who he is. In order to keep our eyes fixed on the momentous event, there are no 'worldly' background details to distract us. In all the drawings, the bystanders stand either just behind Christ, or appear to be moving forward from a starting position that was behind Christ. Thus they start off only seeing Christ's 'back parts', but their faith enables them to move forward to see him from the front. This too was new.

That Michelangelo wanted there to be a struggle to *see* Christ is in fact a repudiation of a central tenet of the Marsyas myth. For Marsyas' punishment was assumed to have made his body more rather than less visible. Ovid says it was 'possible to count his throbbing organs, and the chambers of the lungs, clearly visible within his breast'.[65] The antique sculptures of the 'hanging' Marsyas type, so enthusiastically and vividly described by Vasari, conformed to this idea. They were *tours de force* of anatomical detail. The death of Marsyas not only revealed the genius of the Creator who had made his body in the first place, it also gave the artist the opportunity to demonstrate his mastery of the innermost secrets of the human body. For anatomists, and for all those committed to

understanding the created world, this unspeakably cruel death seemed a small price to pay for the information – and validation – that it provided. This is as true of the hyper-real images of the human body by northern artists such as Grünewald, as it is of more classically inspired versions made by Italian artists.

By depicting the crucified Christ with an unfathomable body, Michelangelo turns his back on such rationalisations of the myth. His Marsyas-Christ offers few conventional anatomical rewards. Certainly, we see a body that has been mangled to death. It is obviously – to borrow the melodramatic terms that Michelangelo used to describe his own ageing body – a 'human wreck' that is 'worn out, ruptured, crushed and broken' by its sufferings (no. 267). But it tries to avoid making a *spectacle* of suffering. When looking at these crucifixions, we also contemplate our own inability to see.

The drawings are equally a repudiation of the meditative techniques advocated by mystical writers. The worshipper was urged to picture the crucifixion scene in the mind's eye very clearly: 'Let me picture Christ our Lord hanging on the Cross before me . . .' says St Ignatius in the *Spiritual Exercises*.[66] Clarity was paramount, for it was standard practice to meditate on sequences of wounds and body parts. In Thomas à Kempis' *The Imitation of Christ* (1441), the worshipper is expected to 'take refuge' in Christ's Passion and to 'dwell' within his wounds.[67] St Catherine of Siena, in a letter to the Abbess and nuns of an Augustinian monastery near Florence, written in the late fourteenth century, said that in order to enable the worshipper's soul to attain perfection, 'Christ has made his body into a staircase, with great steps'. The last step is Christ's mouth, in which the soul 'reposes in peace and quiet'.[68] Christ's mouth is all but invisible in Michelangelo's drawings, and the body's structure is nebulous. We cannot easily 'climb' on it, or 'dwell' in it. Even the Cross seems unstable. This too has a Lutheran component. Traditionally, revelation was regarded as the result of a painstaking ascent, step by step, of the ladder of the spiritual life; but Luther insisted it was a sudden and purely gratuitous illumination of the soul.[69]

When the crucifixion drawings are discussed, they are often compared with the last lines of a sonnet written in the early 1550s, in which Michelangelo laments how his imagination made of art an idol:

> Né pinger né scolpir fie più che quieti
> L'anima, volta a quell'amor divino
> C'aperse, a prender noi, 'n croce le braccia (no. 285)

[Neither painting nor sculpting can any longer quieten my soul, turned now to that divine love which on the Cross, to embrace us, opened wide its arms.] In the crucifixion drawings, Michelangelo turns to a new kind of art, but its novelty lies precisely in its reluctance to 'embrace' the viewer. This is not simply a matter of technique. One of the crucial features of the Marsyas-Christ motif is that with arms raised above the head, Christ can no longer be imagined 'embracing' the viewer. As a gesture, it only suggests a vertical downwards sliding. Even when Michelangelo does depict Christ with arms 'opened wide', he is visually dragged downwards by the bystanding Virgin and St John, who embrace him, into a *Pietà* position.[70]

The Milan *Pietà* (Plate 31) is Michelangelo's most elaborate meditation on the Marsyas-Christ. The body of Christ is upright, and supported only by his mother, who holds him from behind, her cheek placed against the top of his head. Christ's body started out as a more conventional, ample figure – the right arm of the original figure, which was begun before the Florentine *Pietà*, remains as a freestanding fragment. But shortly before his death when he was partly disabled, probably by a stroke, Michelangelo reworked the sculpture. He whittled Christ's body down to that of a tubular waif, with a disconsolate Mary almost piggybacked on his shoulders. The pair have often been said to look back to the attenuated figures that adorn Gothic cathedrals, but they equally look forward to the attenuated, huddled misfits of Picasso's Blue Period.[71]

Yet the *mise-en-scène* equally evokes Renaissance depictions of the flaying of Marsyas, with Mary taking the place of the tree to which Marsyas is tied. Even if the carving had been finished, the body would still have appeared severely shrivelled. We don't know why Michelangelo left the beautiful, anatomically eloquent arm from the original *Pietà* hanging in mid-air. But it may well be because it highlights the Marsyas association, for it now seems to be reaching out to Christ's leg in the same way that Apollo's knife-wielding arm reached out to Marsyas in order to flay him in Renaissance depictions of the scene. If this is so, there is little sense here that Apollo might be restoring harmony. Rather, he is creating something whose form teeters on the edge of formlessness.

8. Legacies

Of all this sentiment [predilection for death] Michelangelo is the achievement; and, first of all, of pity. *Pietà*, pity, the pity of the Virgin Mother over the dead body of Christ, expanded into the pity of all mothers over all dead sons, the entombment, with its cruel 'hard stones': this is the subject of his predilection.

<div align="right">Walter Pater, The Poetry of Michelangelo (1871)[1]</div>

MICHELANGELO DIED IN his house in Rome in the late afternoon of 18 February 1564. He was nearly eighty-nine. He was attended by, among others, his pupil and friend Daniele da Volterra, his servant Antonio Mini, and Tommaso de' Cavalieri, now married with two grown sons. Vasari informs us that 'with perfect consciousness he made his will in three sentences, leaving his soul in the hands of God, his body to the earth, and his substance to his nearest relatives, and enjoining on his friends that, at his passing from this life, they should recall to him the agony of Jesus Christ'.[2]

Around three weeks later, Michelangelo's coffin arrived at the customs house in Florence. The consignment was addressed to Vasari, who immediately had it placed in the vault of the Confraternity of the Assumption. From there, it was taken in a torchlit procession by the members of the newly founded artists' academy, the Accademia del Disegno, to the church of Santa Croce, where the Buonarroti were traditionally buried. The coffin was opened before being buried and it was widely reported that the body showed no signs of decay – proof of the artist's saintly status.

Four months later, on 14 July, an elaborate memorial service was held in the Medici family church of San Lorenzo, organised by the Academicians. The church was draped in black cloth and decorated with

paintings depicting episodes from the artist's life. A huge catafalque filled the nave, adorned with allegorical sculptures. Duke Cosimo I de' Medici, the ruler of Florence, had sanctioned the ceremonies but did not attend. It was the first time an artist had been accorded such an elaborate memorial service. Indeed, since the fifteenth century only five high dignitaries of Church and state had been accorded the same honour at San Lorenzo.[3] Vasari and the members of the Accademia del Disegno subsequently constructed an elaborate wall tomb in Santa Croce, which was completed in 1575.

Michelangelo's unique levels of achievement across a range of disciplines – sculpture, painting, architecture, drawing and poetry – and the consequent demand for his services, had already helped ro raise the status and earning power of the most successful artists. But Vasari also wanted these funeral ceremonies to remind current patrons and artists of their own duties in relation to the visual arts. The paintings which had been displayed in San Lorenzo showing episodes from Michelangelo's life stressed that he would have achieved far less without munificent patrons, and that he would have been a far lesser artist without his devotion to the study of anatomy and, above all, of drawing – *disegno*.

Yet in many respects Michelangelo was an unsuitable model for an aspiring artist (and, as the heirs of Pope Julius would have attested, a tough proposition for an aspiring patron). Vasari admitted as much in the second, 1568 edition, of the *Lives*. The purpose of this great book was to demonstrate the cultural and intellectual importance of the visual arts in general, and of Florentine art in particular. Vasari placed the 'divine' Michelangelo at the summit of the whole history of art, but despite his impassioned advocacy, he knew that Michelangelo's limitations made him an awkward choice as the model artist.

This issue comes to the fore in the 'Life of Raphael', where Vasari imagines the younger artist's response to Michelangelo's work after his arrival in Florence from Urbino in 1504. Vasari suggests that Michelangelo's focus on the male nude is due to the fact that he was by training and temperament a sculptor, a profession which, as in antiquity, regarded the creation of large-scale, freestanding figures as the pinnacle of achievement. However, painters have a different and more wide-ranging job to do – something which Raphael understood instantly.

Vasari tells us that having realised that in the depiction of nudes 'he could never attain to the perfection of Michelangelo, [Raphael] reflected, like a man of supreme judgment, that painting does not consist

only in representing the nude human form, but has a wider field'. Vasari then went on to describe an 'endless number' of things that painters can do and sculptors can't. The inordinately long list – so exhaustive as to be worthy of Flaubert – includes landscape and architectural backgrounds, atmospheric and perspectival effects, men and women of all ages, draperies, armour, animals, lifelike portraits and even hair.[4] Here, Michelangelo ends up seeming like the exception to prove the rule – the rule being that while sculptors can surpass painters in the making of idealised but hairless male nudes, the rest of the world is the painters' oyster. From being the central figure in European art, Michelangelo here teeters on the edge of becoming a magnificent cul-de-sac.

Vasari's tactful but firm reminder of the potential for art to be universal in its motifs coincided, in 1568, with the simultaneous publication in Florence and Venice of an Italian translation of the Latin text of Alberti's *On Painting*. The same translation had already been published in 1547 and 1565, so there was clearly an upsurge of interest in this treatise.[5] Alberti had insisted that the artist should 'take care to know how to paint not only a man but also horses, dogs and all other animals and things worthy of being seen'. He then compiled a list of ancient artists who were good at only one thing, and this included Dionysios who 'was unable to paint anything but men'. He concluded that artists should neglect no aspect of their profession that can bring praise.[6] This comprehensive, unidiosyncratic approach to art is borne out by Vasari himself, a highly efficient all-rounder. Although Vasari borrowed poses and gestures from Michelangelo, his art as a whole owes more to Raphael.[7]

Michelangelo's contemporaries were thrilled by his work's grandeur and vitality. But the many artists who plundered his work almost invariably tended to increase its fluidity and equipoise in order to bring it more into line with conventional ideas of harmony. Michelangelo may himself have encouraged such 'mannerist' misunderstandings of his work, for at one point he is said to have recommended 'serpentine' figures. According to Lomazzo's *Treatise on the Art of Painting* (1584), Michelangelo advised the Sienese painter Marco Pino to 'always make the figure pyramidal, serpentine, and multiplied by one, two or three'. This meant, according to Lomazzo, that a figure could have several curves in it, 'like a live snake in motion' or a 'waving flame', or the letter 'S'.[8] It is essentially a proposal for a quasi-balletic figure that is perfectly balanced and counterbalanced. The comparison with snakes and flames

also suggests a figure that is virtually weightless. It applies far more to the mannerist nudes of Giambologna or Bronzino than to those of Michelangelo, and ultimately looks back to the fifteenth century – to the battling nudes of Pollaiuolo, identical flame-like flayed figures engaged in their carefully choreographed dance of death.

Michelangelo's own bodies never look as though their movements are rehearsed, let alone choreographed.[9] You could never imagine them being able to pirouette, or even to repeat a movement. Condivi said that because Michelangelo had a superb memory, he 'never made two [figures] alike or in the same pose'.[10] The same would apply to the figures' own movements. Their extremities often have a dancer's grace – *Bacchus'* right foot and left hand; the Libyan Sibyl's feet; the hands of the *ignudo* above Jeremiah; the extended arm of Adam; the hands of Giuliano de' Medici – but this grace does not pervade or even dominate the whole figure. The flying figures in the *Archers* are the nearest Michelangelo comes to creating a dance troupe, but they jostle each other and fall to the ground. Rather like the Keystone Cops, they are heading towards a metaphorical brick wall, in the form of the herm statue of Terminus. When Peter Paul Rubens – one of the greatest students of Michelangelo's work – subsequently adapted some of these flying figures for an oil painting, he diminished the feeling of blockage and pile-up by transforming it into a 'successful' rape scene, the *Rape of Hippodamia* (1630s). The erstwhile frustrated archer now cleanly embraces his prey.

In Michelangelo's work, grace is denied even in its demonstration; it is held in check by a stubborn and sometimes sullen weightiness in other parts. Michelangelo's figures are almost as resistant to the idea of dancing as he was: 'Oh you make me laugh because you can think of dancing! The only thing to do in this world is to weep!'[11] Their resistance to dancing is also a resistance to socialisation, for dance in the Renaissance was a great communal activity.

By eschewing rehearsed movement, Michelangelo introduces the idea of the unconscious and involuntary movement into art. Earlier, in relation to the marble *David*, I cited St Augustine's remark that one consequence of the Fall was that man lost control of his penis, so that it was liable to be aroused of its own accord: the flesh gave 'proof of man's disobedience by a disobedience of its own'. Michelangelo finds sites of potential truancy lurking throughout the body and, by extension, the mind. The brooding intensity of his figures is caused by psychological

feelings and bodily pressures of which they are not completely in control. All these energies, which threaten to dislocate and even dismember these giant bodies, are miraculously held in check by the rigid framework of the marble block. But we, the viewers, are intuitively aware of the potential for sudden, lurching movement. This is why we can never fully relax in their presence.

FOR MUCH OF THE seventeenth and eighteenth centuries, Michelangelo was disapproved of by the neo-classical art establishment, and was regularly castigated for his coarseness, and for the recklessness that left so many sculptures unfinished. From the outset, the *Last Judgment* was attacked for indecency. Pope Paul IV (r. 1555–9) threatened to destroy the whole fresco and finally ordered Daniele da Volterra to furnish some of the figures with strategically placed drapery, which earned him the nickname *Il Brachettone* (Big Breeches). The prominently placed St Catherine of Alexandria, holding her spiked wheel, was substantially repainted and supplied with clothes. Sculptors, more mindful perhaps of the lesson of antiquity than painters (no major antique paintings survived), were particularly intolerant. Practitioners as different as Bernini and Canova were united in their criticism of – and even revulsion at – Michelangelo's treatment of anatomy. It was in the eighteenth century that the story went around about Michelangelo 'crucifying' a live model so that he could study the death agonies.

By contrast, the Romantics would come to venerate Michelangelo as a supreme being who represented the triumph of the visual imagination. A major turning point was marked by the last of Sir Joshua Reynolds' *Discourses*, delivered to the Royal Academy in London in 1790 shortly before his retirement. It was an impassioned celebration of Michelangelo's 'most poetical and sublime imagination' which Reynolds regarded as the 'language of the Gods'.[12] He focused entirely on Michelangelo's painting, however, and the only sculpture he singled out was *Moses*. His lecture series ended in momentous fashion: 'I reflect, not without vanity, that these Discourses bear testimony of my admiration of that truly divine man; and I should desire that the last words which I should pronounce in this Academy, and from this place, might be the name of – MICHAEL ANGELO.'[13] He died about fourteen months later.

In the nineteenth century, Michelangelo became a modern Prometheus, and the acme of the tortured and misunderstood genius.

Eventually, he would become a Nietzschean superman and, for psychoanalytic critics, a neurotic who both suffered from and exploited his 'inverted' sexuality. In Eugène Delacroix' *Michelangelo in his Studio* (1849–50), the great man sits brooding on a bench, his tools laid aside, with the *Moses* and the New Sacristy *Madonna and Child* looming up spectrally behind him. The picture was understood straight away as a surrogate self-portrait of Delacroix, and the painter expressed his admiration for Michelangelo on numerous occasions: 'Let those minds detached from vulgar prejudice mock, if they will, this sublime genius frightened by the judgment of God, wondering before the gates of the tomb if he has used his life well . . . I see him at an advanced hour of the night, struck with fear at the spectacle of his creations, rejoicing in the secret terror that he wanted to awake in men's souls.'[14]

Auguste Rodin is the first and only great sculptor to try to emulate Michelangelo.[15] He was routinely described by critics as a reincarnation of Michelangelo – something that eventually came to irritate him. He first visited Florence in 1876 to join in the aesthetic feeding frenzy prompted by the 400th anniversary of Michelangelo's birth. Italy had only recently unified, and Michelangelo was acclaimed as a representative figure of Italian civilisation. From very early on in his career Rodin seems to have associated Michelangelo with broken bodies and shattered dreams. His first great success was a bronze *Mask of a Man with the Broken Nose* (1863–4). It powerfully evoked Daniele da Volterra's bronze *Portrait of Michelangelo*, which gave a frank rendition of the artist's famous nose, broken in a youthful brawl with the sculptor Pietro Torrigiano.

Although Michelangelo's example helped imbue Rodin's male nudes with greater anatomical vigour and bulk, the French sculptor mutilates and lacerates the human body almost at will. Rodin's great freestanding figure, *Walking Man* (1877–8; Fig. 22), a bronze cast of which was installed in the courtyard of the Michelangelo-designed Palazzo Farnese in Rome in 1911, lacks a head and arms, and the rest of his naked body is expressively gashed and cratered. Only five years earlier, in 1872, John Ruskin had denounced Michelangelo's privileging of the body over the head: 'Physical instead of mental interest. The body, and its anatomy, made the entire subject of interest: the face, shadowed . . . unfinished . . . or entirely foreshortened, backshortened, and despised . . .'[16] *Walking Man* is almost an attempt to take this 'defacement' to a logical conclusion.

In 1903, the poet Rainer Maria Rilke, who worked for a while as

Fig. 22: Auguste Rodin, *Walking Man*, 1877–8, photographed in the courtyard of Palazzo Farnese, Rome, *c.* 1911 (Paris, Musée Rodin)

Rodin's secretary, tried to justify his former employer's exaltation of the body at the expense of the head: 'Life showing in the face . . . as easily read as on a dial, was, when seen in the body, less concentrated, greater, more mysterious and eternal. There it wore no disguise.'[17] We have already seen how in Michelangelo's day the torso – the home of the heart – was sometimes believed to be the most open and honest section of the body. Rilke believed that Rodin's interest extended far further down the body, to the point where the body touched the ground, so that even the feet of his statues were expressive.[18] This wholesale privileging of the body is facilitated by the fact that Rodin's figure, like so many modern sculptures, is fully 'in the round', and can thus be circumnavigated. Michelangelo is more controlling and discriminating. With the exception of the *Bacchus*, almost all his statues are made in relation to an architectural backdrop, which helps him to frame and section the body, continually opening and closing windows on its various parts.

Far from being slowed down by these assaults, Rodin's *Walking Man* is speeded up, like an Olympic-standard headless chicken. The

mutilations are in fact refinements. He is now a state-of-the-art walking machine, sustained by pure leg and torso power. He destroys the static idea inherent in the word 'statue', and becomes the embodiment of a figure who is permanently in transit, whether through cities or landscapes. *Walking Man* is a new kind of Hydra. Immeasurably stronger for its mutilation, it feels as though his two all-powerful legs only came into being after the arms and head were hacked off.

In Rodin's work, the act of dismemberment and mutilation often appears to be a *fait accompli* – his amputees seem completely rehabilitated and healed. With Michelangelo, however, mutilation and laceration tend to be imminent and future dangers. His male nudes are never so single-minded or instrumental as Rodin's, never able to shed the unnecessary bits of their bodies and *specialise* in a single action; they might with more justice be said to specialise in a single passion – suffering.

Walking Man reminds us that this is the age of mechanisation – the age of speed, steam and photography. In Rodin's work, the Michelangelesque motif becomes faster and more evanescent; less pressing and pressurised. Rodin 'emulates' the Florentine titan not in hard blocks of marble, but in the malleable liquid media of clay, plaster and bronze. There is no sense that the skin of Rodin's figure might ever be a membrane whose rupture would be fatal: the face of the *Man with the Broken Nose* appears to have been kneaded willy-nilly like yeasty dough.

But we can also turn such assertions on their head. In an age of evanescence and speed, artists looked to Michelangelo to bolster and intensify art that might otherwise be spread perilously thin.

THE FRENCH WRITER Anatole France once accused Rodin of 'collaborating too much with catastrophe', because he regarded the vigour with which he refashioned the human body as sadistic and exploitative.[19] This criticism may also be made of Michelangelo, and he is undoubtedly the first great artist to whom it can be applied. Paradoxically, this is one of the reasons why he has been so revered in the modern era.

One of the most important vehicles in Michelangelo's art for the expression of suffering – actual and potential – is the proximity of raw stone and (male) skin. Almost everywhere in his work, naked male bodies inhabit a world of sharp and rough stones. Rocks are used as weapons in the *Battle of the Centaurs*; the bathers clamber over the rocky river bank in the *Battle of Cascina*; the New Sacristy 'Times of the Day'

stretch out on rocky ledges. Then there is the contrast between his 'stony' Madonnas and the naked Christ – most strikingly, perhaps, in the St Peter's *Pietà*. Everywhere, we can feel the friction and the potential for friction. This is what Walter Pater means, in the passage quoted at the start of this chapter, when he refers to 'the entombment, with its cruel "hard stones".'

This predilection may help explain the astonishing number of unfinished sculptures – around three-fifths of Michelangelo's total output. Many explanations have been put forward for this extraordinary state of affairs.[20] Vasari claimed that Michelangelo's incomparably high standards meant that he was rarely satisfied with his sculptures, and so the unfinished statues are in fact magnificent failures. His account was accepted by many critics in the seventeenth and eighteenth centuries. Some critics followed Condivi in believing that 'the rough surfaces do not interfere with the beauty of the work'.[21] Modern critics have ranged from those who argue he would have finished all his sculptures were it not for force of circumstance – unreliable and bullying patrons, etc. – to those who believe his sculptures were essentially *unfinishable*.

The sculptor Henry Moore subscribed to the second view. Of the second set of *Slaves*, made for Pope Julius' tomb, he said: 'I don't think they're unfinished, because though Michelangelo might have gone on a bit more, I can't conceive that he would ever have wanted to finish them in the high way he finished other works. Here again it's the same contrast – a contrast between two opposites, like the rough and the smooth, the old and the new, the spiritual and the anatomical.'[22] Moore preferred the unfinished to the finished sculptures. This is typical of the modern era with its cult of ruins and fragments. Thus Delacroix did not depict Michelangelo presenting a polished wax model for approval by a patron, or offering a finished work to the public in triumph. Rather, he depicted him on his own in his studio tormented by sculptor's block. Behind him is the unfinished New Sacristy *Madonna and Child*, shown from the side to accentuate its incomplete state. Only the bottom corner of the *Moses* is shown, and it is thus transformed into a fragment. Delacroix' 'sketchy' painting technique is meant to be a counterpart to the incompleteness of the sculptures.

The taste for the unfinished initially arose because of the premium placed on spontaneity. A market for drawings and (to a much lesser extent) sculptors' clay and wax sketch models first emerged during Michelangelo's day. But unfinished work – above all, his own – was also

increasingly valued because of the way in which it bore witness to human conflict in general, and to artistic struggle in particular. These ideas have not simply been imposed on Michelangelo's art anachronistically by Romantic artists such as Delacroix. Indeed, in many ways, Michelangelo can be considered their originator.

Force of circumstance may explain Michelangelo's inability to finish some of his sculptures, but aesthetic and psychological reasons must surely also play some part. In his poetry, he is clearly fascinated by the rough, stony husk that 'contains' the beautiful statue, and by the contrast between them.[23] The 'husk' is not always extrinsic to the figure sculpture, a coarse covering that must be hacked off. He also talks of wanting to scrape and slough off his own 'rough' skin, so here the rough bits are intrinsic – if undesirable – parts of the body. The unfinished sections of his sculptures vividly reminded Michelangelo of the endless cycle of birth and rebirth. Psychoanalytic critics have suggested that the surrounding stone is the 'maternal source' of the sculpted figures, but it is more a question of spiritual than physical rebirth.[24]

There is another, even more basic explanation of these works. The unfinished sections of a statue like *St Matthew* (Plate 10) may be said to envelop his body like a flinty hair shirt. They are punitive as well as protective. Indeed, the aggression inherent in these unfinished sections is reinforced by the fact that the principal place in Florence where you could see 'massive stones bearing the gashes and punctures of pick and point', set in counterpoint with smoother stone, was in the 'rusticated' masonry of traditional Tuscan fortified palaces.[25] The famous 'kneeling' windows, made from blocks of smooth but angular stone, which Michelangelo inserted into the Medici Palace at street level in the 1520s, are completely surrounded by rusticated stone. No wonder Matthew is so jumpy, hemmed in by all this 'rusticated' stone: you can feel the skin tingle and burn – and even bleed.

And just as Michelangelo's feet were so tightly and continuously bound in his boots that the skin came away when he took them off, so Matthew's feet stand 'as though in thick mire'.[26] They have been swallowed up by the unfinished background and you suspect they will not be extracted without pain. So too the unfinished left foot of the ailing Madonna in the New Sacristy. Her foot is underpinned by a platform sole of unfinished stone that is so high it would even bring supermodels to grief. The philosopher Wittgenstein wondered whether we could not speak of a stone that causes pain as having 'pain patches' on

it, so bound up does it become with the idea of pain.[27] Michelangelo's unfinished sections may be the first ever depiction of such 'pain patches'.

In the case of *St Matthew*, a double humiliation is being enacted. The 'pain patches' are not only a punishment for Matthew's human failure; they also signal Michelangelo's artistic failure. He had recently signed the St Peter's *Pietà*, 'MICHELANGELUS BUONAROTUS FLORENT FACIEBA'. The incomplete 'facieba(t)' was a revival of an ancient method of signing artworks. By saying that the artist 'was making', rather than 'made' the artwork, it suggested he had stopped before the work was finished. This demonstrated the humility of the artist ('my work is imperfect and so it cannot be regarded as finished') as well as the enormity of the task.[28] The work is in fact painstakingly polished, and the signature suggests an element of guilt at such perfection. The making of artworks is here envisaged – and even idealised – as unending struggle, unending (partial) failure. The unfinished sections in some of his sculptures may be regarded as another, more radical and profound form of 'FACIEBA'.

TO A DEGREE, 'collaborating with catastrophe' is central to being a Christian artist, for the culminating moment in the life of Christ – the moment that gives his life its meaning – is his death on the Cross. The Christian welcomes and revels in Christ's Passion as much as he pities and condemns it. Thus it makes doctrinal sense for his mother, the Virgin Mary, who knows her son's fate in advance, to try to be emotionally detached. From day one, she must act in the knowledge that he has to die a horrifying death. Michelangelo's Madonnas might be seen as consummate professionals, performing their allotted task to perfection. It is only after Christ has been crucified that the emotional floodgates are prised open, and the paramount importance of this moment for Michelangelo is confirmed by the fact that it is the only time that we witness an intense outpouring of *sympathetic* emotion. Walter Pater was quite right to see the 'pity of the Virgin Mother over the dead body of Christ' as the key to his art: in his work, we are regularly encouraged to both desire and pity the intense suffering of godlike men. For in suffering and ultimately in death lies the only prospect of supreme truth and beauty.

But was Pater also right to see the pity of the Virgin Mother as a universal image which could be 'expanded into the pity of all mothers over all dead sons'? We can only do so if we close our eyes to the rest of Michelangelo's work. For 'real' mothers, even in an age of high child mortality, would

presumably hope to predecease their sons (as Michelangelo's own mother did), and are hardly likely to deem a son's early death both desirable and necessary. They are more likely to behave like the Madonnas of Leonardo and Raphael who, to a greater extent, participate in their son's childhood and humanity. The future fate of the Christ Child is usually indicated by various allegorical props (birds, pomegranates, crosses, etc.), but for the most part, these mothers act as if they are holding their full meaning in abeyance. Their joy may well be intensified precisely because they know such idyllic moments will be short-lived.

And can Christ's Passion be 'expanded' to become a model for all men? The difficulty with universalising the emotional content of Michelangelo's art is that, if we examine his whole *oeuvre*, there is little evidence of sympathetic engagement prior to a moment of crisis. Unlike his contemporaries, he avoided images of tenderness and conviviality, and not just in his Madonna and Child images. He gave away artworks as tokens of friendship, but the idea of friendship scarcely features in these works. The presentation drawings have traumatic moralising subjects. Michelangelo's only surviving portrait is a drawing of the head and shoulders of his beautiful young friend, *Andrea Quaratesi* (1532), in which the boy looks at us with wonderfully doleful eyes, his beret drooping in sympathy with his eyelids. It is as though the mere fact of being looked at, let alone drawn, saps the soul. There is little sense of pleasure in being drawn by an admirer who was already being hailed as the greatest artist in history. Michelangelo looks similarly doleful in the handful of portraits for which he consented to sit.

In Michelangelo's art, there is a tendency for human beings to come together, and to show overt affection and love, only when there is a crisis. His most intimate and even erotic images are his Pietàs, Lamentations and Entombments in which Christ, the love object, is dead – if temporarily. There are few expressions of tenderness, either impassioned or even just friendly, between living people. Intimacy does feature in some of his drawings of the Madonna, but is suppressed in the finished works. The male nudes in *Doni Tondo* do seem relatively relaxed and chummy, but they are background figures, and their naked flesh is pressed ominously against a corrugated wall of sharp rocks. The only representations of erotic love *à deux* occur in his lost painting of *Leda and the Swan* (*c.* 1530), and in his presentation drawings the *Rape of Ganymede* and the *Dream of Human Life*. The first two involve violence and bestiality, albeit of a very choice sort, while the last is about sin.

By channelling so much of the spectator's emotion into single cata-strophic moments, and making every day seem like Judgment Day, Michelangelo runs the risk of turning the viewer into someone who is 'good at a funeral'. Precisely this kind of deathbed outpouring was criticised in relation to family life by Petrarch in his *Remedies for Fortune Fair and Foul*. He castigated those who only showed their 'affection' just before or after the death of a close relation. There are two dialogues, conducted by personifications, in which a son laments the loss of his father, and another in which the death of a brother is mourned.

When 'Sorrow' says 'I have lost the best of brothers', 'Reason' replies: 'You should have been with him often. If you failed to do so, it is not his death that hurt you, but your own carelessness. Death, alas, has exercised his privilege. You have neglected yours.' 'Reason' urges a son with an elderly father who 'hopes to die before you and who dreads to live after your death', to show him 'the greatest affection while you can, because you will regret forever what you failed to do now'. Another 'bereaved' son is told that it is only just that 'you should have to sigh in vain for the authority you so loathed'.[29]

This same issue found comic expression in Michelangelo's own day in a play by the German poet and playwright Hans Sachs. In *The Old Game* (1554), a farm labourer complains about his wife: 'She's mighty proud of her love for me, and I believe that if I did die, she'd show her grief right enough. But what's the good of that? How will her tears and groans help a man when he's gone? I'd sooner have 'em when I'm alive, I might get a better time of it!'[30] The posthumous outpouring of sympathy has very recently been described as 'unctuous pseudo-compassion'. It is now caused not by the suffering of gods and heroes, but by celebrity con-fessions, deaths and disasters reported in the media: 'Real sympathy is continuous and all-embracing – nothing like the counterfeit compassion we exhibit in mourning for the famous.'[31] The demand from all these writers is for cradle-to-grave expressions of devotion, not just theatrical outbursts at moments of crisis whose intensity may well be the product of a double grief – grief for the dead, and grief for one's own prior negligent indifference.

The ebb and flow of life and relationships, the growth of the child or of the plant, is of scant interest to Michelangelo. To use Giovanni della Casa's terminology, Michelangelo's imagination is haunted and inspired by battles with wild beasts, rather than with mosquitoes or flies. His art specialises in the grandly catastrophic. It is steeped in the plangent poetry

of Christ's Passion, and for the most part transforms it into a beautiful, seductive, and sometimes narcissistic dream: the dying slave, to take just one example, seems like a willing victim, colluding in its own catastrophe.

This faith in the spiritual benefits of immersion in the apocalyptic has been shared by many modern artists, and Michelangelo has been a key influence. The Viennese expressionist Oskar Kokoschka had recourse to Michelangelo when he made a poster for his own play *Murderer, Hope of Women* (1909). The play is now recognised as the earliest German Expressionist drama, and it stars a man and a woman whose sado-masochistic love ends up destroying them. In the poster, a traumatised woman cradles a dead naked man in her arms, a motif which is derived in large part from Michelangelo's Milan *Pietà*.[32] Kokoschka claimed that the love of this ill-fated pair was spiritual rather than physical, and that it echoed Christ's Passion: 'The Passion is the eternal story of man. Even the miracle of the resurrection can be understood in human terms, if it is grasped as a truth of the inner life: one does not become human once and for all just by being born. One must be resurrected as a human being every day.'[33] Here, spiritual rebirth does not require a deeper engagement with the world at large. It requires a private, solipsistic regime of sado-masochistic violence.

Francis Bacon is the most prominent recent artist to be influenced by Michelangelo, and the Passion powerfully informed his iconography of isolated, tormented individuals. Bacon painted many images of crucifixions, explaining that he hadn't found 'another subject so far that has been as helpful for covering certain areas of human feeling and behaviour'.[34] Many of Bacon's traumatised male nudes strike Michelangelesque poses, but whereas the movements of Michelangelo's figures are determined by the shape of the marble block, Bacon's figures easily overflow the limits of the internal frames which are such a characteristic feature of his work. In *Study for Nude* (1951), a crouching figure gingerly steps over the edge of the box-like 'spaceframe' which he seems to inhabit, much as a dog might slink out of a kennel (Fig. 23). In subsequent work, such as *Three Studies of Figures on Beds* (1972), Bacon superimposes a circle on each pair of writhing male bodies, but the circle can only partially contain them. As here, Bacon's reclining nudes often recall the New Sacristy 'Times of the Day'.

In Bacon's imagination, Michelangelo was twinned with Edward Muybridge, the purveyor of sequential photographs illustrating human

Fig. 23: Francis Bacon, *Study for Nude*, 1951 (oil on canvas, private collection)

motion: 'Michelangelo and Muybridge are mixed up in my mind together, and so I perhaps could learn about positions from Muybridge and learn about the ampleness, the grandeur of form from Michelangelo.'[35] *Study for Nude* even features rows of tiny numbers based on those that appear as measuring devices in sequential photographs. The picture itself is a shimmering grisaille, a fluvial symphony in silvers and greys. Like Rodin, Bacon speeds Michelangelo up, and melts him down. But so fluid are Bacon's figures that he seems to be fast-forwarding through their personal Passions, as though faintly bored by it. Indeed, since Michelangelo broke the ice and universalised it, the Passion has

become a little bit banal. In Bacon's work, naked bodies writhe on a daily basis in bedrooms and bed-sits around the world. Tragedy has turned into mundane secular melodrama.

The modern apocalyptic sensibility has been most cogently expressed by the messianic German sculptor Joseph Beuys. He first came across Michelangelo in the 1930s, when he saw a film on the artist at school. Recalling the experience much later, in the 1970s, he said that the primitive projector made the film flicker, and he remembered it as 'a great whirling sausage-machine of cloud shapes and chaos'. It made a huge impression.[36] What Beuys has done is to mythologise the experience retrospectively, and tailor it to an era that regards the *Last Judgment* as the greatest artwork ever made. For it is only really in the twentieth century that this painting has been universally regarded as a supreme achievement. Vasari said that at the mere sight of it, every artist 'trembles and is afraid'.[37] In the twentieth century, even a film projector in a small town in north-western Germany shuddered with terror.

Beuys' sculpture – assemblages and installations made from materials such as fat and felt – shows no formal connection to Michelangelo's, but his traumatic idea of consciousness, explained in 1986, is not altogether dissimilar: 'it is clear consciousness is impossible without death. It is only when I hit a sharp corner, so to speak, I wake up. In other words, death keeps me awake.'[38] This is a secular version of the world of 'cruel "hard stones".'

MICHELANGELO'S ART IS magnificent, awe-inspiring, enthralling. It makes almost everything else seem 'small and tame and worldly'.[39] But we can still wonder why the most meaningful body has to be a solitary body under strain and in pain.

A Note on Literary Sources

MICHELANGELO WAS THE most literate artist of his age. Not only did he write poetry, but in later life he was regarded as an authority on the works of Dante. Throughout this book, I make connections between Michelangelo's artworks and ideas and images in the religious and secular literature of the period. However, Michelangelo did not read Latin, the language of Europe's educated elite, and some of the texts I cite – by writers such as St Augustine, Petrarch and Boccaccio – were only available in that language. The publication of printed editions of many of these Latin texts meant that they were far from rare – indeed, in many cases they were 'popular classics' – but the question still arises as to how Michelangelo could have known about their contents. It is a question that needs to be answered, not least because some modern scholars have doubted the relevance of any text which an artist could not have read for themselves.

What we need to remember is that despite the invention of printing in the middle of the fifteenth century, this was still primarily an oral culture: Jacob Burckhardt, in *The Civilisation of the Renaissance in Italy* (1860/68), observed that '"listening" was among the chief pleasures of life'. When Michelangelo was working in Bologna in the mid-1490s, he read great Tuscan literature to his patron after work in the evening until he fell asleep. Painting was called 'silent poetry' because poetry was usually read out loud, recited or sung. One of the favourite literary formats of the period was the dialogue (Castiglione's *The Book of the Courtier* is the most celebrated example), and Michelangelo was a 'speaker' in two dialogues compiled by friends during his own lifetime.

The importance of the spoken word and of eloquence meant that methods for improving one's memory were constantly being devised. Educated people in Michelangelo's day were expected to be able to

recall literary texts (and sermons) in great detail, and were proud of their feats of memory (Michelangelo was reputed to know the whole of Dante off by heart). If these texts were in Latin, then the 'speaker' often had to translate them for the benefit of non-latinist listeners. The great latinist Angelo Poliziano is said to have proposed the subject of 'the Rape of Deianira and the Battle of the Centaurs' to the young Michelangelo, 'telling the whole story one part at a time'. The story is told by Ovid, so Poliziano was carefully translating from Latin for the benefit of his protegé.

Thus you did not need to have read a text to have a detailed knowledge of it, especially if you had trained your memory. The biggest tribute that Michelangelo's biographer Condivi pays to his master's intellect is that he 'delighted in the *conversation* of learned men' [my italics]. His love of reading is mentioned almost as an afterthought.

Bibliography and Abbreviations

Many of the English-language essays cited here have been reprinted in *Michelangelo: Selected Scholarship in English*, ed. William E. Wallace, New York, 1996, 5 vols. A useful general bibliography, compiled by Anthony Hughes and Caroline Elam, can be found after the entries for Michelangelo in *The Dictionary of Art*, London, 1996, vol. 21, pp. 431–61.

AB *Art Bulletin*

Ackermann James Ackermann, *The Architecture of Michelangelo*, Harmondsworth, 1970

Aikema Bernard Aikema, 'Lorenzo Lotto: la Pala di Sant'Antonino e l'Osservanza Domenicana a Venezia', in *Mitteilungen des Kunsthistorisches Institut in Florenz*, 33, 1989, pp. 127–40

Aldrovandi Ulisse Aldrovandi, 'Delle Statue Antiche, che per tutta Roma, in diversi luoghi, & case si veggono', in Lucio Mauro, *Le Antichità della Città di Roma*, Venice, 1556

Alberti (1966) Leon Battista Alberti, *On Painting*, trans. John R. Spencer, New Haven, 1966

Alberti (1972) Leon Battista Alberti, *On Painting and Sculpture*, ed. and trans. Cecil Grayson, London, 1972

Alberti (1986) Leon Battista Alberti, *Momo o del Principe*, ed. Rino Consolo, Genoa, 1986

Alberti (1987) Leon Battista Alberti, *Dinner Pieces*, trans. David Marsh, Binghampton, New York, 1987

Alberti (1997) Leon Battista Alberti, *On the Art of Building in Ten Books*, trans. Joseph Rykwert, Neil Leach and Robert Tavernor, Cambridge, Mass., 1997

Ancona Mirella Levi d'Ancona, 'The Doni Madonna by Michelangelo: An Iconographic Study', in *AB*, 50, 1968, pp. 43–50

Anglo Sydney Anglo, *The Martial Arts of Renaissance Europe*, New Haven, 2001

Antonino (1740) Antonino, *Summa Theologica*, Verona, 1740

Antonino (1858) Santo Antonino, *Opere a Ben Vivere*, ed. Francesco Palermo, Florence, 1858

Appleyard Bryan Appleyard, 'How cold our hearts have grown', *New Statesman*, 14 Jan. 2003, pp. 8–9.

Aretino *Lettere sull'arte di Pietro Aretino*, ed. Fidenzio Pertile and Carlo Cordiè, Milan, 1957–60, 2 vols

Ariosto Ariosto, *Orlando Furioso*, trans. Guido Waldman, Oxford, 1983

Arrizabalaga, Henderson and French Jon Arrizabalaga, John Henderson and Roger French, *The Great Pox: The French Disease in Renaissance Europe*, New Haven, 1997

Astell Ann W. Astell, *Job, Boethius, and Epic Truth*, Ithaca, 1994

Augustine (1984) Augustine, *City of God*, trans. Henry Bettenson, Harmondsworth, 1984

Augustine (2001) Augustine, *The Confessions*, trans. Philip Burton, London, 2001

Bambach Carmen C. Bambach, 'Review of Michael Hirst, *Michelangelo and his Drawings*', *AB*, 72, 1990, pp. 493–8

Barelli Emma Spina Barelli, 'Note Iconografiche in Margine al Davide in Bronzo di Donatello', in *Italian Studies*, 39, 1974, pp. 28–44

Barolsky Paul Barolsky, *Michelangelo's Nose: A Myth and its Maker*, University Park, 1990

Bartsch *The Illustrated Bartsch*, ed. W. Strauss, New York, 1978

Battisti Eugenio Battisti, 'Le Origini Religiose del Paesaggio Veneto', in *Venezia Cinquecento*, 2, 1991, pp. 9–25.

Baxandall Michael Baxandall, *Painting and Experience in Fifteenth Century Italy*, Oxford, 1972

Bayley C. C. Bayley, *War and Society in Renaissance Florence*, Toronto, 1961

Beck James H. Beck, *Three Worlds of Michelangelo*, New York, 1999

Benker Gertrud Benker, *Christophorus: Patron der Schiffer, Fuhrleute und Kraftfahrer – Legende, Verehung, Symbol*, Munich, 1975

Bennett Jill Bennett, 'Stigmata and sense memory: St Francis and the affective image', in *Art History*, vol. 24, no. 1, Feb 2001, pp. 1–16

Berengario Jacopo Berengario da Carpi, *A Short Introduction to Anatomy*, trans. L. R. Lind, Chicago, 1959

Berenson Bernard Berenson, *The Drawings of the Florentine Painters*, Chicago, 1938 (1970 reprint), 3 vols.

Berger John Berger, *The Shape of a Pocket*, London, 2001

Berliner Rudolf Berliner, 'God is Love', in *Essays in Honour of Hans Tietze*, ed. Ernst Gombrich et al., Paris, 1958, pp. 143–60

Beuys *Energy Plan for Western Man: Joseph Beuys in America*, ed. Caron Kuoni, New York, 1990

BM *Burlington Magazine*

Boas George Boas, *Essays in Primitivism and Related Ideas in the Middle Ages*, Baltimore, 1948

Bober and Rubinstein Phyllis Pray Bober and Ruth Rubinstein, *Renaissance Artists and Antique Sculpture*, Oxford, 1986

Boccaccio Giovanni Boccaccio, *Opere*, ed. Cesare Segre, Milan, nd

Boccaccio (1998) *Tutte le Opere di Giovanni Boccaccio*, ed. Vittore Branca, Milan, 1964–

Boiardo Matteo Maria Boiardo, *Orlando Innamorato*, trans. Charles Stanley Ross, Oxford, 1995

Bouwsma (1980) William J. Bouwsma, *John Calvin: A Sixteenth Century Portrait*, Oxford, 1980

Bouwsma (2000) William J. Bouwsma, *The Waning of the Renaissance: 1550–1640*, New Haven, 2000

Brandt (1987) Kathleen Weil-Garris Brandt, 'Michelangelo's *Pietà* for the Cappella del Re di Francia', in *Il se Rendit en Italie: Etudes Offertes à André Chastel*, Paris, 1987, pp. 77–119

Brandt (1992) Kathleen Weil-Garris Brandt, 'Michelangelo's Early Projects for the Sistine Ceiling: their Pictorial and Artistic Consequences', in *Michelangelo Drawings*, ed. Craig Hugh Smyth, Hanover, 1992, pp. 56–87

Brandt (1999–2000) Kathleen Weil-Garris Brandt et al., *Giovinezza di Michelangelo*, exh. cat., Florence, Palazzo Vecchio and Casa Buonarroti, 1999–2000

Braudel Fernand Braudel, *The Mediterranean and the Mediterranean World in the Age of Philip II*, trans. Sian Reynolds, London, 1972, 2 vols

Brockhaus Heinrich Brockhaus, *Michelangelo und die Medici-Kapelle*, Leipzig, 1909

Brucker (1969) Gene Brucker, *Renaissance Florence*, Berkeley, 1969

Burckhardt Jacob Burckhardt, *Cicerone*, Stuttgart, 1964

Bush Virginia Bush, *The Colossal Sculpture of the Cinquecento*, New York, 1976

Butterfield Andrew Butterfield, *The Sculptures of Andrea del Verrocchio*, New Haven, 1997

BV Giorgio Vasari, *La Vita di Michelangelo nelle Redazioni del 1550 e del 1568*, ed. Paola Barocchi, Milan, 1962

Bynum (1982) Caroline Walker Bynum, *Jesus as Mother*, Berkeley, 1982

Bynum (1987) Caroline Walker Bynum, *Holy Feast and Holy Fast*, Berkeley, 1987

Cadogan Jean K. Cadogan, *Domenico Ghirlandaio: Artist and Artisan*, New Haven, 2000

Cahn Walter Cahn, *Masterpieces: Chapters on the History of an Idea*, Princeton, 1979

Calvesi Maurizio Calvesi, *Il sogno di Polifilo Prenestino*, Rome, 1980.

Calvin *Calvin's New Testament Commentaries*, trans. T. A. Smail, ed. David W. Torrance and Thomas F. Torrance, Grand Rapids, 1964–

Cardini Robert Cardini, *La Critica del Landino*, Florence, 1973

Carlino Andrea Carlino, *Books of the Body: Anatomical Ritual and Renaissance Learning*, Chicago, 1999

Carteggio *Il Carteggio di Michelangelo. Edizione postuma a cura di Giovanni Poggi*, ed. Paola Barocchi and Renzo Ristori, Florence, 1965–83, 5 vols

Casa Giovanni della Casa, *Galateo or the Book of Manners*, trans. R. S. Pine-Coffin, Harmondsworth, 1958

Castiglione Baldassare Castiglione, *Il Cortegiano*, ed. Silvano del Missier, Novara, 1968

Catherine *I, Catherine: Selected Writings of Catherine of Siena*, ed. and trans. Kenelm Foster and Mary John Ronayre, London, 1980

Cellini Benvenuto Cellini, *The Autobiography of Benvenuto Cellini*, trans. George Bull, Harmondsworth, 1956

Centi Tito Centi, 'S. Antonino Pierozzi', in *La Chiesa e il Convento di San Marco*, Florence, 1989, vol. 1, pp. 61–78

Chambers D. S. Chambers, *Patrons and Artists in the Renaissance*, London, 1971

Chantelou Paul Freart de Chantelou, *Diary of Cavaliere Bernini's Visit to France*, ed. Anthony Blunt, trans. Margery Corbett, Princeton, 1985

Chapman Hugo Chapman, 'Michelangelo Drawings', in *BM*, June 2003, pp. 468–70

Clark (1958) Kenneth Clark, *Leonardo Da Vinci*, Harmondsworth, 1958

Clark (1960) Kenneth Clark, *The Nude*, Harmondsworth, 1960

Clark (1961) Kenneth Clark, 'The Young Michelangelo', in *Renaissance Profiles*, ed. J. H. Plumb, London, 1961, pp. 37–51

Colish Marcia L. Colish, *Medieval Foundations of the Western Intellectual Tradition: 400–1400*, New Haven, 1997

Colonna (1980) Francesco Colonna, *Hypnerotomachia Poliphili*, ed. Giovanni Pozzi and Lucia A. Ciapponi, Padua, 1980

Colonna (1981) Francesco Colonna, *Hypnerotomachia Poliphili*, with introduction by Peter Dronke, Zaragoza, 1981

Colonna (1999) Francesco Colonna, *Hypnerotomachia Poliphili*, trans. Joscelyn Godwin, London, 1999

Colonna: Dichterin *Vittoria Colonna: Dichterin und Muse Michelangelos*, exh. cat., Kunsthistorisches Museum, Vienna, 1997

Condivi (1998) Ascanio Condivi, *Vita di Michelangelo Buonarotti*, ed. Giovanni Nencioni, Florence, 1998

Condivi (1999) Ascanio Condivi, *The Life of Michelangelo*, trans. A. S. Wohl, University Park, 1999

Coroleu Alejandro Coroleu, 'Mens Fenestrata: The Survival of a Lucianic Motif in Seventeenth-Century Spanish Literature', *Res Publica Litterarum*, 1996, pp. 217–26

Corpus Charles de Tolnay, *Corpus dei Disegni di Michelangelo*, Novara, 1975–80, 4 vols

Cox-Rearich Janet Cox-Rearich, *The Collection of Francis I: Royal Treasures*, New York, 1996, pp. 302–13.

Culture and Belief *Culture and Belief in Europe 1450–1600*, ed. David Englander et al., Oxford, 1990

Cunningham Andrew Cunningham, *The Anatomical Renaissance: The Resurrection of the Anatomical Projects of the Ancients*, Aldershot, 1997

Dante (1967) *Dante's Lyric Poetry*, ed. and trans. Kenelm Foster and Patrick Boyde, Oxford, 1967

Dante (1973) Dante, *Rime*, ed. Gianfranco Contini, Turin, 1973

Dante (1990) *Dante's 'Il Convivio'*, trans. R. Lansing, New York, 1990

David E. David, *Harvest of the Cold Months: The Social History of Ice and Ices*, ed. Jill Norman, London, 1994

David Myth *The David Myth in Western Literature*, ed. Raymond-Jean Frontain and Jan Wojcik, Indiana, 1980

Davie Mark Davie, 'Luigi Pulci and the Generation of '94', in *Italy in Crisis 1494*, ed. Jane Everson and Diego Zancani, Oxford, 2000, pp. 63–79

Davis Natalie Zemon Davis, 'Beyond the Market: Books as Gifts in Sixteenth-Century France', *Transactions of the Royal Historical Society*, 5th series, 33, 1983, pp. 69–88

Decrees *Decrees of the Ecumenical Councils*, ed. Norman P. Tanner, London, 1990, 2 vols

Dempsey Charles Dempsey, *Inventing the Renaissance Putto*, Chapel Hill, 2001

Dictionary *Dictionary of the Bible*, ed. James Hastings, London, 1909

Disputa delle Arti *La Disputa delle Arti nel Quattrocento*, ed. Eugenio Garin, Florence, 1947

Doni Anton Francesco Doni, *I Marmi*, ed. Ezio Chiòrboli, Bari, 1928

DuBruck Edelgard E. DuBruck, 'The Death of Christ on the Late-Medieval

Stage', in *Death and Dying in the Middle Ages*, ed. Edelgard E. DuBruck and Barbara I. Gusick, New York, 1999, pp. 355–76

Dunkerton Jill Dunkerton, 'Michelangelo as a Painter on Panel', in *The Young Michelangelo*, exh. cat., National Gallery, London, 1994, pp. 85–127

Ebreo Leone Ebreo, *Dialoghi d'Amore*, Bari, 1929

Echinger-Maurach Claudia Echinger-Maurach, 'Michelangelo's monument for Julius in 1534', *BM*, May 2003, pp. 336–44

Einem Herbert von Einem, *Michelangelo*, London, 1973

Eisler Colin Eisler, 'The Madonna of the Steps: Problems of Date and Style', in *Stil und Überlieferung in der Kunst des Abendlandes*, Berlin, 1967, vol. 2, pp. 38–9, 115–21

Eliav-Feldon Miriam Eliav-Feldon, *Realistic Utopias: The Ideal Imaginary Societies of the Renaissance 1516–1630*, Oxford, 1982

Elam Caroline Elam, 'Che Ultima Mano?: Tiberio Calcagni's Postille to Condivi's Life of Michelangelo', in Condivi (1998)

Elkins James Elkins, 'Michelangelo and the Human Form: His Knowledge and Use of Anatomy', *Art History*, 7, 1984, pp. 176–86

Epictetus *Epitteto Manuale: Con la versione Latina di Angelo Poliziano*, ed. Enrico V. Maltese, Milan, 1990

Erasmus (1964) *The Essential Erasmus*, trans. John P. Dolan, New York, 1964

Erasmus (1965) *The Colloquies of Erasmus*, trans. and ed. Craig R. Thompson, Chicago, 1965

Ettlinger (1965) L. D. Ettlinger, *The Sistine Chapel before Michelangelo*, Oxford, 1965

Ettlinger (1972) L. D. Ettlinger, 'Hercules Florentinus', in *Mitteilungen des Kunsthistorischen Institutes in Florenz*, 16, 1972, pp. 119–42

Ettlinger (1978) L. D. Ettlinger, 'The Liturgical Function of Michelangelo's Medici Chapel', *Mitteilungen des Kunsthistorischen Institutes in Florenz*, 22, 1978, pp. 287–304

Fernándes-Santamaría J. A. Fernándes-Santamaría, *The Theatre of Man: J. L. Vives on Society*, Philadelphia, 1998

Ficino (1980) Marsilio Ficino, *The Book of Life*, trans. C. Boer, Irving, 1980

Ficino (1985) Marsilio Ficino, *Commentary on Plato's Symposium on Love*, trans. Sears Jayne, Dallas, 1985

Filarete Antonio Filarete, *Treatise on Architecture*, trans. John Spencer, New Haven, 1965

Frank Isabelle Frank, 'Cardinal Giuliano della Rovere and Melozzo da Forlì at SS Apostoli', in *Zeitschrift für Kunstgeschichte*, 159, 1996, pp. 97–122

Franklin David Franklin, *Painting in Renaissance Florence 1500–1550*, New Haven, 2001

D. Freedberg David Freedberg, *The Power of Images*, Chicago, 1989

S. J. Freedberg Sydney J. Freedberg, *Painting of the High Renaissance in Florence and Rome*, 2 vols, New York, 1972

Freyhan R. Freyhan, 'The Evolution of the Caritas Figure in the Thirteenth and Fourteenth Centuries', *JWCI*, 11, 1948, pp. 68–86

Frommel Christoph L. Frommel, *Michelangelo und Tommaso dei Cavalieri*, Amsterdam, 1979

Galen Galen, *On the Usefulness of the Parts of the Body*, trans. Margaret Tallmadge May, Ithaca, New York, 1968, 2 vols

Garin (1963) Eugenio Garin, *Portraits from the Quattrocento*, New York, 1963

Garin (1965) Eugenio Garin, *Italian Humanism*, trans. Peter Munz, New York, 1965

Gaston Robert W. Gaston, 'Attention and Inattention in Religious Painting of the Renaissance: Some Preliminary Observations', in *Renaissance Studies in Honour of Craig Hugh Smyth*, Florence, 1985, ed. Andrew Morrogh et al., vol. II, pp. 253–68

Gauricus Pomponius Gauricus, *De Sculptura*, ed. and trans. André Chastel and Robert Klein, Geneva, 1969

Giannotti *Dialogi di Donato Giannotti*, ed. Deoclecio Redig de Campos, Florence, 1939

C. Gilbert (1959) Creighton Gilbert, 'The Archbishop on the Painters of Florence, 1450', *AB*, 41, 1959, pp. 75–87

C. Gilbert (1971) Creighton Gilbert, 'Texts and Contexts of the Medici Chapel', *Art Quarterly*, 34, 1971, pp. 391–409

C. Gilbert (1994) Creighton Gilbert, *Michelangelo: On and Off the Sistine Ceiling*, New York, 1994

F. Gilbert Felix Gilbert, *Machiavelli and Guicciardini: Politics and History in Sixteenth Century Florence*, Princeton, 1965

Gleason Elisabeth Gregorich Gleason, 'Sixteenth Century Italian Interpretations of Luther', in *Archive for Reformation History*, 60, 1969, pp. 160–73

Goffen Rona Goffen, *Renaissance Rivals: Michelangelo, Leonardo, Raphael, Titian*, New Haven, 2002

Gordon (1981) Donald E. Gordon, 'Oskar Kokoschka and the Visionary Tradition', in *The Turn of the Century: German Literature and Art, 1890–1915*, ed. C. G. Chapple and H. Schulte, Bonn, 1981, pp. 23–52

Gordon (1987) Donald E. Gordon, *Expressionism: Art and Idea*, New Haven, 1987

Gould Cecil Gould, 'Michelangelo: Battle of Cascina', *Charlton Lectures on Art*, University of Newcastle, 1966

Grayson Cecil Grayson, 'Dante and the Renaissance', in *Italian Studies Presented to E. R. Vincent*, ed. C. P. Brand et al., Cambridge, 1962, pp. 57–66

Grazia Sebastian de Grazia, *Machiavelli in Hell*, London, 1989

Guevara Antonio de Guevara, *The Diall of Princes*, Amsterdam, 1968

Hale (1983) John Hale, *Renaissance War Studies*, London, 1983

Hale (1985) John Hale, *War and Society in Renaissance Europe 1450–1620*, Leicester, 1985

Hale (1993) John Hale, *The Civilisation of Europe in the Renaissance*, London, 1993

J. Hall James Hall, *The World as Sculpture: The Changing Status of Sculpture from the Renaissance to the Present Day*, London, 1999

M. B. Hall Marcia B. Hall, 'Savonarola's Preaching and the Patronage of Art', in *Christianity and the Renaissance: Image and Religious Imagination in the Quattrocento*, ed. Timothy Vernon and John Henderson, Syracuse, New York, 1990, pp. 483–522

Hamburgh Harvey E. Hamburgh, 'The Problem of Lo Spasimo of the Virgin in Cinquecento Paintings of the Descent from the Cross', *Sixteenth Century Journal*, 12, 1981, pp. 45–75

Hartt (1950) Frederick Hartt, 'Lignum Vitae in Medio Paradiso: the Stanza d'Eliodoro and the Sistine Ceiling', in *AB*, 32, 1950, pp. 115–45

Hartt (1951) Frederick Hartt, 'The Meaning of Michelangelo's Medici Chapel' in *Essays in Honour of George Swarzenski*, Berlin, 1951, pp. 145–55

Hatfield Rab Hatfield, *The Wealth of Michelangelo*, Rome, 2002

Henderson (1994) John Henderson, *Piety and Charity in Late Medieval Florence*, Oxford, 1994

Henderson (1999) John Henderson, 'Charity and Welfare in Early Modern Tuscany', in *Health Care and Poor Relief in Counter-Reformation Europe*, ed. A. Cunningham and O. Grell, London, 1999, pp. 56–86

Henry and Kanter Tom Henry and Laurence B. Kanter, *Luca Signorelli: The Complete Paintings*, London, 2002

Hesiod Hesiod and Theognis, trans. Dorothea Wender, Harmondsworth, 1973

Hibbard Howard Hibbard, *Michelangelo*, London, 1974

Hilloowala and Oremland Rumy Hilloowala and Jerome Oremland, 'The St Peter's Pieta: A Madonna and Child? – An Anatomical and Psychological Reevaluation', *Leonardo*, 20, 1987, pp. 87–92.

Hirst (1976) Michael Hirst, 'A Project of Michelangelo's for the Tomb of Julius II', *Master Drawings*, XIV, 1976, pp. 375–82

22. *Risen Christ, c.*1532

23. *Fall of Phaeton, c.*1533

*24. Children's Bacchanal, c.*1533

25. *Dream of Human Life*, c.1533

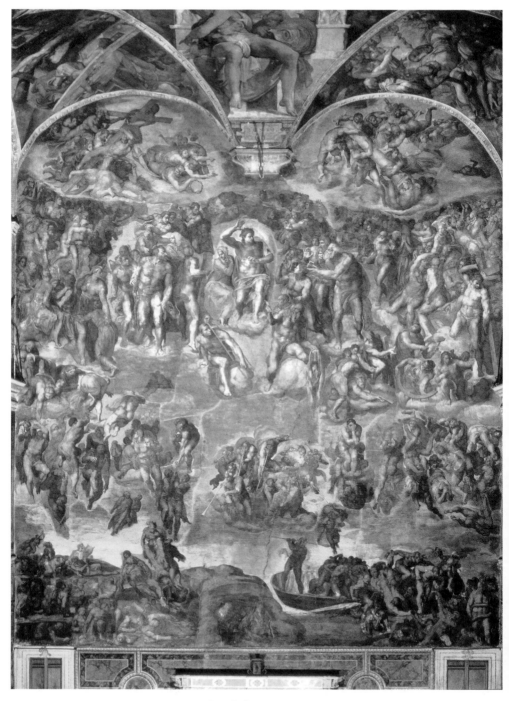

26. *Last Judgment*, 1536–41

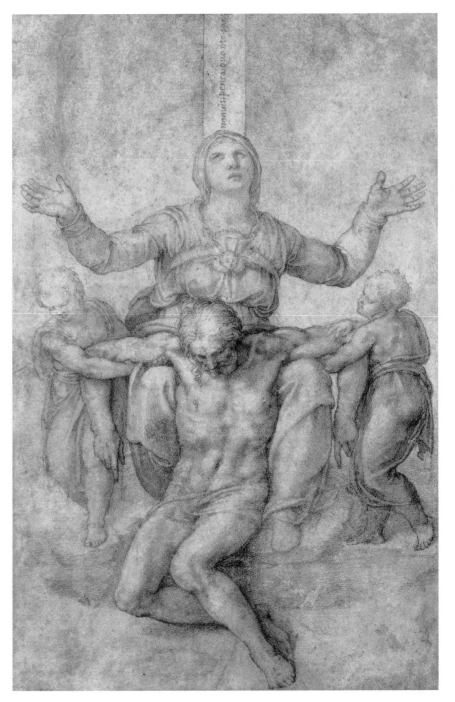

27. *Pietà, c.*1538–40

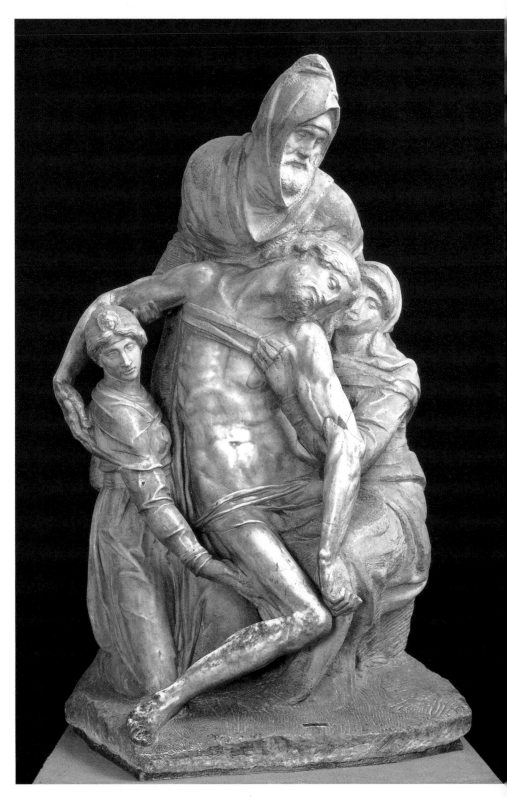

28. *Pietà, c.*1547–55

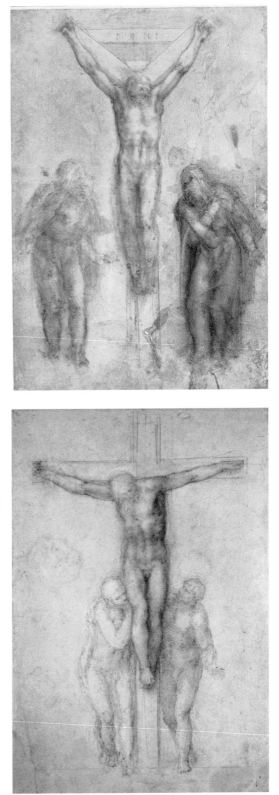

29. *Christ on the Cross with the Virgin
and St John the Baptist, c.1550–5*

30. *Christ on the Cross with the Virgin
and St John the Baptist, c.1550–5*

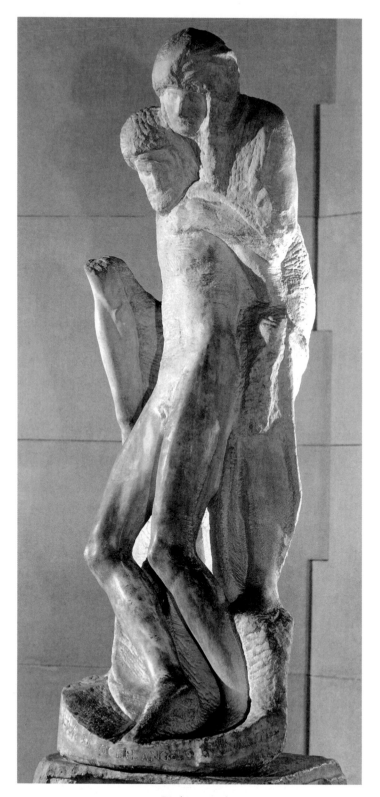

31. *Pietà, c.*1550/64

Hirst (1988) Michael Hirst, *Michelangelo and his Drawings*, New Haven, 1988

Hirst (1992) Michael Hirst, 'Madonna della Scala', in *Il Giardino di San Marco: Maestri e Compagni del Giovane Michelangelo*, exh. cat., Florence, 1992, pp. 86–9

Hirst (1994) Michael Hirst, 'The Artist in Rome 1496–1501', in *The Young Michelangelo*, exh. cat., National Gallery, London, 1994, pp. 13–82

Hirst (1996) Michael Hirst, 'Michelangelo and his First Biographers', *Proceedings of the British Academy*, 1997, pp. 63–84

Hirst (1998) Michael Hirst, 'Introduction' to Condivi (1998)

Hirst (1999) Michael Hirst, 'Observations on drawings for the Sistine Ceiling', in *The Sistine Chapel: A Glorious Restoration*, ed. Pierluigi de Vecchi, New York, 1999, pp. 8–25

Hirst (2000) Michael Hirst, 'Michelangelo in Florence: David in 1503 and Hercules in 1506', *BM*, August 2000, pp. 487–96

Holanda (1921) Francisco da Holanda, *De la Pintura Antigua*, ed. Elias Tormo, Madrid, 1921

Holanda (1928) Francisco da Holanda, *Four Dialogues on Painting*, trans. Aubrey F. G. Bell, London, 1928

Holmes Megan Holmes, 'Disrobing the Virgin: The *Madonna Lactans* in Fifteenth-Century Florentine Art', in *Picturing Women in Renaissance and Baroque Italy*, ed. Geraldine A. Johnson and Sara F. Matthews Greco, Cambridge, 1997, pp. 167–95

Hope (1981) Charles Hope, 'Artists, Patrons and Advisers in the Italian Renaissance', in *Patronage in the Renaissance*, ed. Guy Fitch Lytle and Stephen Orgel, Princeton, 1981, pp. 293–343

Hope (1987) Charles Hope, 'The Medallions on the Sistine Ceiling', in *JWCI*, 50, 1987, pp. 200–4

Hope (1990) Charles Hope, 'Altarpieces and the Requirements of Patrons', in *Christianity and the Renaissance: Image and Religious Imagination in the Quattrocento*, ed. Timothy Vernon and John Henderson, Syracuse, New York, 1990, pp. 535–71

Hope (2000) Charles Hope, 'Composition from Cennini and Alberti to Vasari', in *Pictorial Composition from Medieval to Modern Art*, ed. Paul Taylor and François Quiviger, London, 2000, pp. 27–44

Hope and McGrath Charles Hope and Elizabeth McGrath, 'Artists and Humanists', in *The Cambridge Companion to Humanism*, ed. Jill Kraye, Cambridge, 1996, pp. 161–88.

Hughes Anthony Hughes, *Michelangelo*, London, 1997

Humfrey (1993) Peter Humfrey, *The Altarpiece in Renaissance Venice*, New Haven, 1993

Humfrey (1997) Peter Humfrey, *Lorenzo Lotto*, New Haven, 1997

Italian Art 1400–1500 *Italian Art 1400–1500: Sources and Documents*, ed. Creighton Gilbert, Englewood Cliffs, 1980

Italian Art 1500–1600 *Italian Art 1500–1600: Sources and Documents*, ed. Robert Klein and Henri Zerner, Evanston, 1989

Italy in Crisis *Italy in Crisis 1494*, ed. Jane Everson and Diego Zancani, Oxford, 2000

Jacobs Fredrika Jacobs, '(Dis)assembling Marsyas, Michelangelo and the Accademia del Disegno', in *AB*, 84, Sept. 2002, pp. 426–48

Janelle Pierre Janelle, *The Catholic Reformation*, New York, 1971

Janson (1963) H. W. Janson, *The Sculpture of Donatello*, Princeton, 1963

Janson (1973) H. W. Janson, 'Titian's Laöcoon Caricature and the Vesalian-Galenist Controversy', in *Thirteen Studies*, New York, 1973, pp. 39–52

Joannides (1992) Paul Joannides, 'Primitivism in the Late Drawings of Michelangelo: The Master's Construction of an Old-Age Style', in *Michelangelo Drawings*, ed. Craig Hugh Smyth, National Gallery of Art, Washington, 1992, pp. 245–61

Joannides (1996) Paul Joannides, *Michelangelo and his Influence: Drawings from Windsor Castle*, exh. cat., National Gallery of Art, Washington, 1996

Joannides (1997) Paul Joannides, 'Michelangelo bronzista: Reflections on his Mettle', *Apollo*, 145, June 1997, p. 11–20

Joannides (2000) Paul Joannides, *Inventaire Général des Dessins Italiens VI: Michel-Ange Élèves et Copistes*, Paris, 2003

Jobert Barthelemy Jobert, *Delacroix*, Princeton, 1998

Johnson Geraldine A. Johnson, 'Beautiful Brides and Model Mothers: the Devotional and Talismanic Functions of Early Modern Marian Reliefs', in *The Material Culture of Sex, Procreation, and Marriage in Premodern Europe*, ed. Anne L. McClanan and Karen Rosoff Encarnacion, New York, 2001, pp. 135–61

Jones and Penny Roger Jones and Nicholas Penny, *Raphael*, New Haven, 1983

Justi Carl Justi, *Michelangelo: Neue Beiträge zur Erklärung seiner Werke*, Berlin, 1909

Juvenal Juvenal, *The Satires*, trans. Niall Rudd, Oxford, 1991

Kecks Ronald G. Kecks, *Madonna und Kind*, Berlin, 1988

Keegan John Keegan, *A History of Warfare*, London, 1993

Kemp (1981) Martin Kemp, *Leonardo da Vinci: The Marvellous Works of Nature and Man*, London, 1981

Kemp (1989) Martin Kemp, 'The Super-Artist as Genius: The Sixteenth Century View', in *Genius: The History of an Idea*, ed. Penelope Murray, Oxford, 1989, pp. 32–53

Kempis Thomas à Kempis, *The Imitation of Christ*, trans. Leo Sherley-Price, Harmondsworth, 1952

Kenseth Joy Kenseth, 'Bernini's Borghese Sculptures: Another View', *AB*, 63, 1981, pp. 191–210

Kent Dale Kent, 'The Buonomini di San Martino: Charity for "the glory of God, the honour of the city, and the commemoration of myself",' in *Cosimo 'il Vecchio' de' Medici, 1389–1464*, ed. Francis Ames-Lewis, Oxford, 1992, pp. 49–68

Klapisch-Huber Christiane Klapisch-Huber, *Women, Family, and Ritual in Renaissance Italy*, trans. Lydia Cochrane, Chicago, 1985

Koldeweij Jos Koldeweij et al., *Hieronymus Bosch*, Rotterdam, 2001

Korman Sally Korman, 'Dante Alighieri Poeta Fiorentina: cultural values in the 1481 Divine Comedy', in *Revaluing Renaissance Art*, ed. Gabriele Neher and Rupert Shepherd, Aldershot, 2000, pp. 57–67

Kornell (1992) Monique Nicole Kornell, *Artists and the Study of Anatomy in Sixteenth Century Italy*, PhD thesis, University of London, Warburg Institute, 1992

Kornell (1989) Monique Kornell, 'Rosso Fiorentino and the Anatomical Text', *BM*, 131, Dec. 1989, pp. 842–7

Kreytenberg Gert Kreytenberg, 'Tino di Camainos Statuengruppen von den drei Portalen des florentiner Baptisteriums', *Pantheon*, 55, 1997, 4–12

Kristeller P. O. Kristeller, *Studies in Renaissance Thought and Letters*, Rome, 1956

Lambert Samuel W. Lambert, 'The Initial Letters of the Anatomical Treatise De Humani Corporis Fabrica of Vesalius', in *Three Vesalian Essays*, New York, 1952, pp. 1–24

L'Anatomie *L'Anatomie chez Michel-Ange*, ed. Chiara Rabbi-Bernard, Paris, 2003

Landau and Parshall David Landau and Peter Parshall, *The Renaissance Print: 1470–1550*, New Haven, 1994

Landi Carlo Landi, *Demogorgone*, Palermo, 1930

Landino *Commento di Cristoforo Landino fiorentino sopra la Comedia di Dante Alighieri poeta firentino*, Florence, 1481

Landucci Luca Landucci, *A Florentine Diary*, trans. Alice de Rosen Jervis, London, 1927

I. Lavin Irving Lavin, 'David's Sling and Michelangelo's Bow: A Sign of Freedom', in *Past-Present: Essays on Historicism in Art from Donatello to Picasso*, Berkeley, 1993, pp. 29–61, 268–74

M. A. Lavin Marilyn Aronberg Lavin, *Piero della Francesca*, London, 2002

Lawner Lynne Lawner, *I Modi*, Evanston, 1988

Leonardo (1970) *The Literary Works of Leonardo da Vinci*, ed. Jean Paul Richter, 2 vols, London, 1970

Leonardo (1989) *Leonardo on Painting*, ed. Martin Kemp, New Haven, 1989

Leonardo (2002) Leonardo da Vinci, *Prophecies and other Literary Writings*, trans. J. G. Nichols, London, 2002

Levey Michael Levey, *High Renaissance*, Harmondsworth, 1975

Levin Harry Levin, *The Myth of the Golden Age in the Renaissance*, New York, 1969

Liebert Robert S. Liebert, *Michelangelo: A Psychoanalytic Study of his Life and Images*, New Haven, 1983

Lomazzo (1584) Giovanni Paolo Lomazzo, *Trattato dell'arte de la pittura*, Milan, 1584

Lomazzo (1974) Giovanni Paolo Lomazzo, *Idea del Tempio della Pittura*, ed. and trans. Robert Klein, Florence, 1974, 2 vols

Loyola St Ignatius of Loyola, *The Spiritual Exercises*, trans. Thomas Corbishley S.J., Wheathampstead, 1973

Lucretius Lucretius, *On the Nature of the Universe*, trans. R. E. Latham, Harmondsworth, 1951

Lucian *The Works of Lucian of Samosata*, trans. H. W. and F. G. Fowler, Oxford, 1905

Machiavelli (1961) Niccolò Machiavelli, *The Prince*, trans. George Bull, Harmondsworth, 1961

Machiavelli (1998) Niccolò Machiavelli, *The Discourses*, ed. Bernard Crick, trans. Leslie Walker, London, 1998

MacCulloch Diarmaid MacCulloch, *Reformation: Europe's House Divided 1490–1700*, London, 2003

Mancinelli Fabrizio Mancinelli, 'The Problem of Michelangelo's Assistants', in *The Sistine Chapel: A Glorious Restoration*, ed. Pierluigi de Vecchi, New York, 1994, pp. 46–57

Marongiu Marcella Marongiu, *Il Mito di Ganimede prima e dopo Michelangelo*, exh. cat., Florence, Casa Buonarotti, 2002

Marsh D. Marsh, *Lucian and the Latins: Humour and Humanism in the Early Renaissance*, Ann Arbor, 1998

Martines (2002) Lauro Martines, *Power and Imagination: City-States in Renaissance Italy*, London, 2002

Martines (2003) Lauro Martines, *April Blood: Florence and the Plot Against the Medici*, London, 2003

Massing John Michael Massing, 'The Madonna of the Stairs', in *Circa 1492:*

Art in the Age of Exploration, exh. cat., National Gallery of Art, Washington, 1992, pp. 268–9

Mathews Thomas F. Mathews, *The Clash of Gods: A Reinterpretation of Early Christian Art*, Princeton, 1999

McClure George W. McClure, *Sorrow and Consolation in Italian Humanism*, Princeton, 1991

McGrath Alister E. McGrath, *Luther's Theology of the Cross*, Oxford, 1985

Meiss Millard Meiss, *Painting in Florence and Siena after the Black Death*, New York, 1964

Michelangelo (1996) Michelangelo, *The Poems*, trans. Christopher Ryan, London, 1996

Michelangelo (2003) *Michelangelo poesia e scultura*, ed. Jonathan Katz Nelson, Milan, 2003

Moltedo Alida Moltedo, *La Sistina Riprodutta*, exh. cat., Rome, 1991

Montaigne Michel de Montaigne, *The Complete Essays*, trans. M. A. Screech, London, 1991

Monumenta Ignatiana *Monumenta Ignatiana: Exercita Spirituali*, Rome, 1969, 2 vols

Moore *Henry Moore on Sculpture*, ed. Philip James, New York, 1971

Morçay Raoul Morçay, *Saint Antoine*, Tours-Paris, 1914

More Thomas More, *Utopia*, trans. Paul Turner, Harmondsworth, 1965

Morrogh Andrew Morrogh, 'The Medici Chapel: the Designs for the Central Tomb', in *Michelangelo Drawings*, ed. Hugh Craig Smyth, National Gallery of Art, Washington, 1992, pp. 143–62

Mozza Angelo Mozza, 'La pala dell'Elemosina di Sant'Antonio nel dibattito cinquecentesco sul pauperismo', in *Lorenzo Lotto*, ed. Pietro Zampetti and Vittorio Sgarbi, Venice, 1981, pp. 347–64

Musacchio Jacqueline Marie Musacchio, 'The Madonna and Child, a Host of Saints, and Domestic Devotion in Renaissance Florence', in *Revaluing Renaissance Art*, ed. Gabriele Neher and Rupert Shepherd, Aldershot, 2000, pp. 147–59

Nagel Alexander Nagel, *Michelangelo and the Reform of Art*, Cambridge, 2000

J. C. Nelson John Charles Nelson, *Renaissance Theory of Love*, New York, 1958

J. K. Nelson Jonathan Katz Nelson, 'The Florentine Venus and Cupid: a Heroic Female Nude and the Power of Love', in *Venus and Love: Michelangelo and the New Ideal of Beauty*, exh. cat. Galleria dell'Accademia, Florence, 2002, pp. 26–63

Nelson and Stark Jonathan Katz Nelson and James J. Stark, 'The Breasts of Night: Michelangelo as Oncologist', *New England Journal of Medicine*, 23 November 2000, letters page

255

Nuland Sherwin B. Nuland, *Leonardo da Vinci*, London, 2000

Old Master Drawings *Old Master Drawings*, Sotheby's Sale Catalogue, London, 11 July, 2001

O'Malley (1979) John W. O'Malley, *Praise and Blame in Renaissance Rome*, Durham, 1979

O'Malley (1993) John W. O'Malley, *The First Jesuits*, Cambridge, Mass., 1993

Østermark-Johansen Lene Østermark-Johansen, *Sweetness and Strength: The Reception of Michelangelo in Late Victorian England*, Aldershot, 1998

Ovid (1955) Ovid, *Metamorphoses*, trans. Mary M. Innes, Harmondsworth, 1955

Ovid (2000) Ovid, *Fasti*, trans. A. J. Boyle and R. D. Woodard, London, 2000

Panofsky (1930) Erwin Panofsky, *Hercules am Scheidewege*, Leipzig, 1930

Panofsky (1964) Erwin Panofsky, 'The Mouse that Michelangelo Failed to Carve', in *Essays in Memory of Karl Lehmann*, ed. Lucy Freeman Sandler, New York, 1964, pp. 242–51

Panofsky (1969) Erwin Panofsky, 'Erasmus and the Visual Arts', in *JWCI*, 1969, pp. 200–27

Panofsky (1972) Erwin Panofsky, *Studies in Iconology*, New York, 1972

Panofsky (1992) Erwin Panofsky, *Tomb Sculpture*, London, 1992

Panofsky-Soergel G. Panofsky-Soergel, 'Post-scriptum to Tommaso Cavalieri', in *Scritti di storia dell'arte in onore di Roberto Salvini*, Florence, 1984, pp. 399–405

Park Katharine Park, *Doctors and Medicine in Early Renaissance Florence*, Princeton, 1985

Partridge Loren Partridge, 'Michelangelo's Last Judgment: An Interpretation', in *Michelangelo: The Last Judgment, A Glorious Restoration*, New York, 1997, pp. 8–154

Paschini Pio Paschini, *Tre Ricerche sulla Storia della Chiesa nel Cinquecento*, Rome, 1945

Pastor Ludwig von Pastor, *History of the Popes*, London, 1894–1953, 40 vols

Pater Walter Pater, *The Renaissance*, ed. Kenneth Clark, London, 1961

Pecchiai Pio Pecchiai, 'David con la Fromba e . . . Cupido con l'Arco?', in *Il Vasari*, III, 1930, pp. 211–15

Pedretti Carlo Pedretti, *The Literary Works of Leonardo da Vinci: Commentary*, Oxford, 1977, 2 vols

Penny Nicholas Penny, *The Materials of Sculpture*, New Haven, 1993

Pensiero Pedagogico *Il Pensiero Pedagogico dello Umanesimo*, ed. Eugenio Garin, Florence, 1958

Perosa Alessandro Perosa, 'Codici di Galeno postillati dal Poliziano', in *Umanesimo e Rinascimento: Studi offerti a Paul Oskar Kristeller*, Florence, 1980, pp. 75–109

Perrig Alexander Perrig, *Michelangelo's Drawings: The Science of Attribution*, New Haven, 1991

Petrarch (1975) Petrarch, *Opere Latine*, ed. A. Bufano, Turin, 1975, 2 vols

Petrarch (1976) *Petrarch's Lyric Poems*, trans. and ed. Robert M. Durling, Cambridge, Mass., 1976

Petrarch (1991) *Petrarch's Remedies for Fortune Fair and Foul*, trans. and ed. Conrad H. Rawski, Bloomington, 1991, 5 vols

Plato Plato, *Symposium*, trans. Walter Hamilton, Harmondsworth, 1951

Pliny Pliny, *Natural History*, Cambridge, Mass., 1952 (vol. 9), 1962 (vol. 10)

Plotinus Plotinus, *The Enneads*, trans. Stephen MacKenna, London, 1991

Poliziano Angelus Politianus, *Opera Omnia* (1553), ed. Ida Maier, Turin, 1970–1, 3 vols

Polizzotto Lorenzo Polizzotto, 'The making of a saint: the canonisation of St Antonino, 1516–1523', in *Journal of Medieval and Renaissance Studies*, 22, 1992, pp. 353–81

Pon Lisa Pon, *Raphael, Dürer, and Marcantonio Raimondi: Copying and the Italian Renaissance Print*, New Haven, 2004

Pope-Hennessy John Pope-Hennessy, *An Introduction to Italian Sculpture*, London, 1996, 3 vols

Popham A. E. Popham, *Catalogue of the Drawings of Parmigianino*, New Haven, 1971, 3 vols

Popham and Wilde A. E. Popham and J. Wilde, *The Italian Drawings of the 15th and 16th Centuries in the Collection of His Majesty the King at Windsor Castle*, London, 1949

Prosatori Volgari *Prosatori Volgari del Quattrocento*, ed. Claudio Varese, Milan, 1957

Pulci (1955) Luigi Pulci, *Morgante*, ed. Franco Ageno, Milan, 1955

Pulci (1986) Luigi Pulci, *Opere Minori*, ed. Paolo Orvieto, Milan, 1986

Pulci (1998) Luigi Pulci, *Morgante*, trans. Joseph Tusiani, Bloomington, 1998

Puttfarken Thomas Puttfarken, *The Discovery of Pictorial Composition: Theories of Visual Order in Painting 1400–1800*, New Haven, 2000

Ramsden *The Letters of Michelangelo*, ed. E. H. Ramsden, London, 1963, 2 vols

Reactions to the Master *Reactions to the Master: Michelangelo's Effect on Art and Artists in the Sixteenth Century*, ed. Frances Ames-Lewis and Paul Joannides, Aldershot, 2003

Renaissance Latin Verse *Renaissance Latin Verse: An Anthology*, ed. Alessandro Perosa and John Sparrow, London, 1979

Renaudet Augustin Renaudet, *Erasme et L'Italie*, Geneva, 1954

Reynolds Sir Joshua Reynolds, *Discourses*, ed. Pat Rogers, Harmondsworth, 1992

Rigoni M. A. Rigoni, 'Una Finestra Aperta sul Cuore', *Lettere Italiane*, 1974, pp. 434–58

Rilke Rainer Maria Rilke, *Rodin and Other Prose Pieces*, trans. G. Craig Houston, London, 1986

Roberts and Tomlinson K. B. Roberts and J. D. W. Tomlinson, *The Fabric of the Body: European Traditions of Anatomical Illustration*, Oxford, 1992

Robertson Charles Robertson, 'Bramante, Michelangelo and the Sistine Ceiling', in *JWCI*, 49, 1986, pp. 91–105

Rocke Michael Rocke, *Forbidden Friendships: Homosexuality and Male Culture in Renaissance Florence*, New York, 1996

Rodin *Rodin and Michelangelo: A Study in Artistic Inspiration*, exh. cat., Philadelphia Museum of Art, 1997

Roland Ingrid D. Roland, *The Culture of the High Renaissance: Ancients and Moderns in Sixteenth Century Rome*, Cambridge, 1998

Roo Peter de Roo, *Material for a History of Pope Alexander VI*, Bruges, 1924, 3 vols

Rosand David Rosand, *Drawing Acts: Studies in Graphic Expression and Representation*, Cambridge, 2002

Rubin Patricia Lee Rubin, *Giorgio Vasari: Art and History*, New Haven, 1995

Rubin and Wright Patricia Lee Rubin and Alison Wright, *Renaissance Florence: the Art of the 1470s*, exh. cat., National Gallery, London, 1999

Ruskin John Ruskin, *The Relation Between Michael Angelo and Tintoret*, 1872, London, 1872

Ruvoldt Maria Ruvoldt, 'Michelangelo's Dream', *AB*, March 2003, pp. 86–113

Saalman Howard Saalman, 'Concerning Michelangelo's Early Projects for the Tomb of Julius II', in *Michelangelo Drawings*, ed. Craig Hugh Smyth, National Gallery of Art, Washington, 1992, pp. 89–129

Sancta Caterina *La Festa et Storia di Sancta Caterina: A Medieval Italian Religious Drama*, ed. and trans. Anne Wilson Tordi, New York, 1997

Saxl Fritz Saxl, *Lectures*, London, 1957, 2 vols

Savonarola (1955) Girolamo Savonarola, *Prediche sopra Ezechiele*, ed. Roberto Ridolfi, Rome, 1955, 2 vols

Savonarola (1969) Girolamo Savonarola, *Prediche Sopra I Salmi*, ed. Vincenzo Romano, Rome, 1969, 2 vols

Savonarola (1996) Girolamo Savonarola, *Compendio di rivelazioni / Trattato sul Governo della Città di Firenze*, ed. Fausto Sbaffoni, Casale Monferrato, 1996

Scarry Elaine Scarry, *The Body in Pain*, New York, 1985

Schmidt Victor M. Schmidt, 'Painting and Individual Devotion in Late Medieval Italy: the Case of Saint Catherine of Alexandria', in *Visions of Holiness: Art and Devotion in Renaissance Italy*, ed. Andrew Ladis and Shelley E. Zwaw, Athens, Georgia, 2001, pp. 21–36

J. Schulz Juergen Schulz, 'Michelangelo's Unfinished Works', *AB*, 57, 1975, pp. 366–73

B. Schulz Bernard Schulz, *Art and Anatomy in Renaissance Italy*, Ann Arbor, 1982

Scritti d'arte *Scritti d'arte del Cinquecento*, ed. Paola Barocchi, Milan, 1971, 2 vols

Seymour Charles Seymour, *Michelangelo's David: A Search for Identity*, Pittsburgh, 1967

Seznec Jean Seznec, *The Survival of the Pagan Gods*, Princeton, 1953

Shaw Christine Shaw, *Julius II: The Warrior Pope*, Oxford, 1993

Shearman (1967) John Shearman, *Mannerism*, Harmondsworth, 1967

Shearman (1972) John Shearman, *Raphael's Cartoons in the Royal Collection*, London, 1972

Shearman (1992) John Shearman, *Only Connect: Art and the Spectator in the Italian Renaissance*, Princeton, 1992

Siraisi Nancy G. Siraisi, *Medieval and Early Renaissance Medicine*, Chicago, 1990

Smith Graham Smith, 'A Medici Source for Michelangelo's Doni Tondo', in *Zeitschrift für Kunstgeschichte*, 38, 1975, pp. 84–5

Society *The Society of Renaissance Florence*, ed. Gene Brucker, New York, 1971

Songs I *On the Song of Songs I*, trans. Kilian Walsh, Shannon, 1971

Songs II *On the Song of Songs II*, trans. Kilian Walsh, London, 1976

Stahl Ernst Konrad Stahl, *Die Legende vom Heil. Riesen Christophorus in der Graphik des 15 und 16 Jahrhunderts*, Munich, 1920.

Steinberg Leo Steinberg, 'The Metaphors of Love and Birth in Michelangelo's Pietà', in *Studies in Erotic Art*, ed. Th. Bowie, New York, 1970, pp. 231–85

Stokes Adrian Stokes, *Michelangelo: A Study in the Nature of Art*, London, 1955

Storia della Letteratura *Storia della Letteratura Italiana: Il Quattrocento e l'Ariosto*, ed. Emilio Cecchi and Natalino Sapegno, Milan, 1988

Summers David Summers, *Michelangelo and the Language of Art*, Princeton, 1981

Sylvester David Sylvester, *Interviews with Francis Bacon*, London, 1980

Symonds John Addington Symonds, *The Life of Michelangelo Buonarotti*, London, 1893, 2 vols

Syson and Thornton Luke Syson and Dora Thornton, *Objects of Virtue: Art in Renaissance Italy*, London, 2001

Talvacchia Bette Talvacchia, *Taking Positions: On the Erotic in Renaissance Culture*, Princeton, 1999

Thorndike Lynn Thorndike, *Science and Thought in the Fifteenth Century*, New York, 1963

Thornton Dora Thornton, *The Scholar in his Study*, New Haven, 1997

Tisdall Caroline Tisdall, *Joseph Beuys*, London, 1979

Tolnay (1947–60) Charles de Tolnay, *Michelangelo*, New York, 1947–60, 5 vols

Tolnay (1968) Charles de Tolnay, 'Donatello e Michelangelo', in *Donatello e il suo Tempo*, Florence, 1968

Tolnay (1975) Charles de Tolnay, *I Disegni di Michelangelo nelle Collezioni Italiani*, Florence, 1975

Trattati d'Arte *Trattati d'Arte del Cinquecento fra Manierisimo e Controriforma*, ed. Paola Barocchi, Bari, 1960, 2 vols

Trexler (1971) Richard C. Trexler, 'Florentine Religious Experience: The Sacred Image', in *Studies in the Renaissance*, 19, 1971–2, pp. 7–41

Trexler (1980) Richard C. Trexler, *Public Life in Renaissance Florence*, New York, 1980

Trexler (1994) Richard C. Trexler, *Dependence in Context in Renaissance Florence*, Binghamton, 1994

Varnhagen Hermann Varnhagen, *Zur Geschichte der Legende der Katharina von Alexandrien*, Erlangen, 1891

Vasari Giorgio Vasari, *Lives of the Most Eminent Painters, Sculptors and Architects*, trans. Gaston du C. de Vere, London, 1996, 2 vols

Verellen T. Verellen, 'Cosmas and Damian in the New Sacristy', in *JWCI*, 43, 1979, pp. 375–82

Vitruvius Vitruvius, *The Ten Books on Architecture*, trans. M. H. Morgan, New York, 1960

Voragine Jacobus de Voragine, *The Golden Legend*, trans. William Granger Ryan, Princeton, 1993

Wallace (1987) William E. Wallace, 'Michelangelo's Assistants in the Sistine Chapel', *Gazette des Beaux Arts*, 129, December 1987, pp. 203–16

Wallace (1992) William E. Wallace, 'Michelangelo's Roman *Pietà*: Altarpiece or Grave memorial?', in *Verrocchio and Late Quattrocento Italian Sculpture*, ed. Steven Bule et al., Florence, 1992, pp. 243–55.

Wallace (1994) William E. Wallace, *Michelangelo at San Lorenzo: The Genius as Entrepreneur*, Cambridge, 1994

Wallace (1995) William E. Wallace, 'Instruction and Originality in Michelangelo's Drawings', in *The Craft of Art: Originality and Industry in the Italian Renaissance and Baroque Workshop*, ed. Andrew Ladis and Carolyn Ward, Athens, Georgia, 1995, pp. 113–33

Wallace (2000) William E. Wallace, 'Michael Angelus Bonarotus Patritius Florentinus', in *Innovation and Tradition: Essays on Renaissance Art and Culture*, ed. Dag T. Andersson and Roy Eriksen, Rome, 2000, pp. 60–74

Wand Jeryldene M. Wand, 'Vittoria Colonna's Mary Magdalen', in *Visions of Holiness: Art and Devotion in Renaissance Italy*, ed. Andrew Ladis and Shelley E. Zwaw, Athens, Georgia, 2001, pp. 195–212

Warburg Aby Warburg, *The Renewal of Pagan Antiquity*, trans. David Britt, Los Angeles, 1999

Wasserman Jack Wasserman, *Michelangelo's Florentine Pietà*, Princeton, 2003

Weinberg Bernard Weinberg, *A History of Literary Criticism in the Italian Renaissance*, Chicago, 1961, 2 vols

Weinstein Donald Weinstein, *Savonarola and Florence: Prophecy and Patriotism in the Renaissance*, Princeton, 1970

Wilde (1932) Johannes Wilde, 'Eine Studie Michelangelos nach der Antike', in *Mitteilungen des Kunsthistorisches Institutes in Florenz*, 4, 1932, pp. 41–64

Wilde (1958) Johannes Wilde, 'The Decoration of the Sistine Chapel', in *Proceedings of the British Academy*, 1958, pp. 61–81

Wilde (1978) Johannes Wilde, *Michelangelo*, Oxford, 1978

Wind (1937) Edgar Wind, 'Aenigma Termini', in *JWCI*, 1, 1937–8, pp. 66–9

Wind (1967) Edgar Wind, *Pagan Mysteries in the Renaissance*, London, 1967

Wind (1985) Edgar Wind, *Art and Anarchy*, London, 1985

Wind (2000) Edgar Wind, *The Religious Symbolism of Michelangelo*, Oxford, 2000

Winternitz Emanuel Winternitz, *Musical Instruments and their Symbolism in Western Art*, New Haven, 1979

Wittgenstein Ludwig Wittgenstein, *Philosophical Investigations*, trans. G. E. M. Anscombe, New York, 1953

Wittkower (1973) Rudolf Wittkower, *Architectural Principles in the Age of Humanism*, London, 1973

Wittkower (1977) Rudolf Wittkower, *Sculpture: Processes and Principles*, London, 1977

R. and M. Wittkower (1963) Rudolf and Margot Wittkower, *Born under Saturn*, New York, 1963

R. and M. Wittkower (1964) Rudolf and Margot Wittkower, *The Divine Michelangelo: The Florentine Academy's Homage on his Death in 1564*, London, 1964

Wölfflin Heinrich Wölfflin, *Classic Art*, trans. Peter and Linda Murray, London, 1994

Woman Defamed *Woman Defamed and Woman Defended: An Anthology of Medieval Texts*, ed. Alcuin Blamires, Oxford, 1992

Woodhead W. H. Woodhead, *Vittorino da Feltre and Other Humanist Educators*, Columbia, Missouri, 1963

Woods-Marsden Joanna Woods-Marsden, *Renaissance Self-Portraiture*, New Haven, 1998

Wright Alison Wright, 'The Myth of Hercules', in *Lorenzo il Magnifico e il suo Mondo*, ed. Gian Carlo Garfagnini, Florence, 1994, pp. 323–9.

Wyss Edith Wyss, *The Myth of Apollo and Marsyas in the Art of the Italian Renaissance*, Newark, 1996

Notes

Introduction

1. Carteggio, vol. 4, CMLXVIII.
2. Clark (1961), pp. 37, 39.
3. R. and M. Wittkower (1964), p. 77.
4. Kemp (1989), pp. 47–9. See also the introduction to J. Hall.
5. Condivi (1999), pp. 9–10, 99–101, 58. Hirst (1998), pp. xvii–viii.
6. Wallace (1994).
7. Giannotti, pp. 68–9. Michelangelo did not invariably avoid dinner parties. In 1525, he wrote to Sebastiano del Piombo in Rome about a dinner hosted by the Florentine dignitary Cuio Dini. The dinner and the conversation 'gave me the greatest pleasure, as I escaped a little from my depression, or rather from my obsession'. Ramsden, no. 170; *Carteggio*, vol. 3, no. 124. Vasari, vol. 1, pp. 607–8, says that Michelangelo often caroused with the painter Jacopo l'Indaco, but after growing weary of his jokes, locked his door to him.
8. Østermark-Johansen, p. 248.
9. *Reactions to the Master,* p. 1.
10. Pope-Hennessy, vol. 3, p. 444.

1. Mothers

1. BV, vol 2, p. 245.
2. Wölfflin, p. 44.
3. For an interesting discussion of his women, see Symonds, vol. 1, pp. 266–74.
4. Gabrielle D'Annunzio: 'Who said that Buonarotti only knew breasts that were made of stone? Aurora is a mass of sensuality that is both tragic and insatiable.' Quoted in BV, vol 3, p. 1029.
5. For the variations in Michelangelo's depictions of women, see J. K. Nelson, p. 33ff.

6. The *Doni Tondo* has been dated as late as 1506.

7. Crucifixes (with or without an image of the crucified Christ) were ubiquitous, but they were usually on a smaller scale.

8. Warner, p. 182 and *passim*.

9. *Italian Art 1400–1500*, pp. 145–6; Musacchio, p. 147ff.; Johnson.

10. Alberti (1966), p. 80.

11. *Leonardo* (1989), p. 196.

12. M.B. Hall, pp. 499–500; *Italian Art 1400–1500*, pp. 157–8.

13. Savonarola (1996), p. 199ff. Some of his contemporaries criticised his arrogance in claiming that he had made a visionary 'journey to Paradise' during which he had learned the exact nature and amenities of the place; Wind (2000), pp. 26–7.

14. Chambers, p. 144.

15. Eisler, pp. 115–21; Massing, pp. 268–9; Hirst (1992), pp. 86–9; Goffen, p. 79ff.

16. Alberti (1966), pp. 72–3.

17. Holmes, p. 178.

18. Schmidt; Varnhagen, p. 21ff.; Meiss, p. 107. For disquiet at not seeing the Virgin Mary's eyes, Trexler (1980), pp. 68–9.

19. The Christ Child has his back towards St Catherine in Titian's *Virgin and Child and St Catherine with St Dominic and Donor* (*c.* 1512–13).

20. *Sancta Caterina*; p. 96, ll. 361–8. In the Getty panel, the Madonna seems to be trying to intercede with her son on Catherine's behalf.

21. In 1492, the Borgia Pope, Alexander VI (1431–1503), commissioned Bernardino Pinturicchio to decorate his private apartments, and the centrepiece of the finest room is a mural of *St Catherine of Alexandria Disputing with Pagan Philosophers before the Emperor Maximilian.*

22. Tolnay (1947–60), vol. 1, pp. 75–6.

23. Vasari, vol. 2, p. 648; Tolnay (1968), pp. 259–75.

24. Pope-Hennessy, vol. 2, p. 355.

25. Giammario Filelfo, quoted and translated by Baxandall, p. 138.

26. Freyhan, pp. 68–86. The sepulchre of Cardinal Piero Corsini (1422) in Florence Cathedral shows Charity suckling a child at her right breast while looking at her heart which she holds up to God; ditto a late fifteenth-century intarsia panel in the Museo dell'Opera del Duomo, Pisa, except that the child suckles from the left breast, and the heart is flaming.

27. The novelty of Michelangelo's solution is particularly apparent if we compare it with the more amiable *Madonna lactans* in Domenico

Ghirlandaio's contemporary altarpiece for a chapel in Santa Maria Novella (1490–4). Michelangelo's relief could be seen as a pointed response to it. Cadogan, pp. 183 and 264–8. For similarities in paint media between this altarpiece and Michelangelo's *Entombment*, see Dunkerton, p. 111ff.

28. The attribution of this panel is disputed but I can see no very good reason to doubt it.

29. Carl Justi, quoted by Einem, pp. 35–6.

30. Smith, pp. 84–5; Tolnay (1947–6), vol. 1, p. 110.

31. Levey, pp. 53–5. Levey's insight has apparently gone unnoticed, perhaps because it is made in passing.

32. Voragine, vol. 2, pp. 10–14. It was often used to teach reading in schools. Artists would have probably used the Italian translation by Nicolò Malermi first published in Venice in 1475.

33. Stahl.

34. See especially Mantegna's fresco in the church of the Eremitani in Padua.

35. Ancona, pp. 45–7. The nudes are always compared to those in the background of Luca Signorelli's *Virgin and Child with Male Nudes, Saint John the Baptist and Two Prophets* (c. 1489–90); but Signorelli also placed nudes behind a statue of St Christopher in the contemporaneous Bichi altarpiece. See Henry and Kanter, nos 12–16, 19.

36. In altarpieces, the Madonna and Child are sometimes flanked by St Christopher, necessitating a double depiction of Christ. Vasari felt this was 'monstrous', and proposed to a patron that the Virgin should be shown seated in clouds, passing the child down to Christopher. Hope (1990), p. 544.

37. Benker, p. 127. The Guild of Dyers, the Arte della Lana, had commissioned the *Apostles* for the cathedral, and gave Michelangelo a room in the Hospital of the Dyers at S. Onofrio in which to work on the Cascina cartoon, which features the River Arno.

38. Trexler (1971); D. Freedberg, ch. 6 and *passim*.

39. *Italian Art 1400–1500*, p. 43.

40. Goffen, p. 86, makes this point about the *Madonna of the Stairs*, without elaborating.

41. Warner, pp. 236–43.

42. Clark (1958), p. 104.

43. Catherine, pp. 133 and 128.

44. Nagel, p. 36ff.; pp. 45–6.

45. Epictetus. For Coluccio Salutati's Stoicism, McClure, p. 83.

46. Two versions are reproduced by Franklin, p. 12.

47. Syson and Thornton, p. 151ff. For rivalry between painters and sculptors, J. Hall.

48. Battisti, pp. 9–25.

49. Pulci (1998), p. 138; Pulci (1986), p. 228. In a similar vein, Florence is described in an allegorical poem from the mid-fourteenth century as the daughter of Rome and the 'pillar' (*colonna*) of the Church. Weinstein, p. 47.

50. Trexler (1971), pp. 21–2.

51. Parmigianino's *Madonna with the Long Neck*, which features a tall, elegant column in the background, is a later example.

52. Vasari, vol. 1, pp. 559–60.

53. Dante (1973), p. 284ff.

54. Tolnay (1947–60), vol. 3, p. 16.

55. Warner, p. 134ff.

56. Dante (1967), p. 171. The relevant poems are nos 77–80 Dante (1973). All translations are taken from Dante (1967).

57. *Petrarch* (1976), nos 69, 130.

58. Prosatori Volgari, pp. 985–90; Grayson, p. 68. Some critics argue that Lorenzo wrote the introduction.

59. Cardini, pp. 227–9.

60. Ibid.; Baxandall, p. 114ff.; Korman, pp. 57–67.

61. Landino, *Inferno*, Canto XXXII: 'poi che lui ha atractare delle chose horrende et terribili et aspre che sono in questo ultimo cerchio conosce che si richiede rime cioe versi aspri et chiocci: cioe rochi pe quali si dimostra merore et tristitia; che chosi si conviene al tristo buco'.

62. Garin (1963), p. 228.

63. For the archaism of the early drawings, Nagel, pp. 1–22. The sculptors Giovanni Pisano and Jacopo della Quercia are other important precursors.

64. *Old Master Drawings*.

65. Alberti (1966), p. 78.

66. Vasari, vol. 2, p. 645.

67. Condivi (1999), p. 6–7.

68. Vasari, vol. 2, p. 643. F.T. Marinetti, founder of Futurism, would boast he had been suckled by a Sudanese wet-nurse.

69. Klapisch-Huber, p. 132ff.

70. Vasari, vol. 1, p. 711. Rubin, p. 380.

71. Hale (1985), p. 102.

72. Marsh.

73. Lucian, pp. 1–7.

74. Condivi (1999), p. 15.

75. Hirst (1994), p. 72, n. 10.
76. Vasari, vol. 2, p. 649.
77. *Renaissance Latin Verse*, p. 124, no. 79.
78. For ice sculptures, David.
79. Brandt (1987); Wallace (1992), pp. 243–55.
80. Warner, p. 209.
81. Pope-Hennessy, vol. 2, pp. 23–6, 419.
82. For the eroticism, Steinberg, pp. 231–85. For the Papal Jubilee, Roo, vol. 3, p. 367.
83. *Leonardo* (1989), p. 152.
84. Nagel, pp. 99–101; Hilloowala and Oremland.
85. Condivi (1999), pp. 24–7.
86. *Culture and Belief*, pp. 208–9.
87. For dating, Colonna (1980), vol. 2, p. 3ff.; Colonna (1981), p. 17.
88. Colonna (1980), vol. 2, p. 19.
89. Colonna (1999), p. 386.
90. Ibid., pp. 446, 454.
91. Ibid., pp. 396–7.
92. Ibid., p. 399.
93. Ibid., p. 420.
94. Ibid., pp. 421–2.
95. Ibid., p. 423.
96. Her hair is very long in the other woodcuts so it must be the short-haired Poliphilo who is being embraced.
97. Ibid., p. 455.
98. It has also been claimed (by Calvesi) that Colonna was a Roman prince rather than a Venetian, though most scholars doubt this.
99. Roland, p. 60ff.
100. Shearman (1992), pp. 236–7.
101. Pope-Hennessy, vol. 2, p. 26.
102. BV, vol. 1, p. 173.
103. Gilbert (1994), p. 27.
104. Alberti (1987), p. 20.
105. Kent, p. 53; Trexler (1980), p. 70; Brucker (1969), p. 176.
106. Pulci (1955), canto 9.
107. Pulci (1986), pp. 219–29.
108. *Leonardo* (1970), vol. 2, p. 293, no. 1293.
109. *Erasmus* (1965), pp. 287–91.
110. BV, vol. 1, p. 184.

2. Giants

1. *Petrarch* (1991), vol. 1, no. 5, 'Strength'.
2. Castiglione, Bk 1, no. 20.
3. Holanda (1928), p. 68.
4. The emphasis is on 'great' artist – I exclude Arno Breker and Tom of Finland.
5. Bush, p. xxviii.
6. Condivi (1999), p. 39.
7. Wind (2000), p. 164, does however note that the three small sculptures he made in Bologna in 1494–5 for the Shrine of St Dominic 'suggest that marble work on an intimate scale must have been among the skills he acquired in Florence'. Small-scale work was highly prized in the circle of Lorenzo de' Medici. Joannides (1997), pp. 11–20, claims he made some small bronzes.
8. Cahn, p. 28ff.
9. Condivi (1999), p. 29–30. Michelangelo was in Carrara from April to December 1505.
10. Ibid., p. 130, n. 42. Marginal comments recorded by Tiberio Calcagni, for which see Elam (1998).
11. Augustine (1984), Bk 15, p. 9. See also Boas, p. 52.
12. Alberti (1966), p. 39.
13. The earliest of the inspired prophetesses was reputed to be the Erythraean Sybil, who is depicted alongside the sacrifice of Noah.
14. Wölfflin, p. 47.
15. Puttfarken, p. 123ff.; Mathews, ch. 4, 'Larger than Life'.
16. Alberti (1966), says 'painter', but this was his generic term for artists.
17. Alberti (1966), p. 72. Hope and McGrath, p. 166, believe his enthusiasm for narratives 'may well have been a commonplace among artists'.
18. Puttfarken, p. 123ff.; Hope (2000), p. 33.
19. Alberti (1966), p. 75.
20. Ibid., p. 91.
21. Ibid., p. 76.
22. Alberti (1997), pp. 162 and 241.
23. Alberti (1966), p. 125. Pomponius Gauricus mentions a similar gadget which allows a statue to be made by twenty-five sculptors. Gauricus, pp. 100–1.
24. Alberti (1997), p. 310.
25. Ibid., p. 257; Martines (2002), p. 33.

26. 'Sito, forma e misura dello 'nferno e statura de' giganti e di Lucifero', in Landino, pp. 12–13.

27. Pulci (1998), Canto XXV, verse 169. See Davie, p. 64. During the course of the poem, Pulci thanks Angelo Poliziano for offering editorial advice.

28. Pulci (1998), Canto VII, verse 28.

29. Augustine (1984), Bk 15, p. 23.

30. These are the formulaic terms used by Pulci.

31. Martines (2003), p. 233.

32. *Leonardo* (1970), vol. 2, no. 1188; I have used Carlo Pedretti's translation.

33. November 1545. *Carteggio*, vol. 4, no. MXLV.

34. Augustine (1984), pp. 572, 573.

35. See also the blind giants in no. 67, ll. 81–8.

36. In the late 1480s Leonardo sent a letter to a Florentine friend, the author Benedetto Dei, about a giant 'who comes from the Libyan desert'. The giant slips over on muddy ground, falls flat on his face, and hordes of people swarm over his fallen body, attacking it with puny weapons. Kemp (1981), pp. 159–60.

37. Bush, p. 72.

38. Gauricus, p. 102.

39. For a good summary of the Hercules' history, Cox-Rearich, pp. 302–13.

40. Ettlinger (1972), pp. 120–1; Wright.

41. In 1413 Donatello and Brunelleschi planned to make a colossal statue of *Hercules* from gilded metal plates over a core of building-stone to provide ballast. But the *Hercules* never saw the light of day, and the whole project was abandoned until Agostino di Duccio, probably in the early 1460s, made a multi-part terracotta statue of *Hercules*, though it is not clear whether this was ever set up on the cathedral. Seymour, p. 37.

42. Wind (1967), pp. 177–90; Nagel, p. 90ff.

43. Condivi (1999), p. 24.

44. Hirst (1994), p. 31.

45. Castiglione, Bk 4, section 8. The analogy was first made by Plutarch.

46. Vasari, vol. 2, p. 651.

47. Seymour, p. 26ff. Alberti's *De Statua* was probably written with the cathedral sculptures in mind.

48. Vasari, vol. 2, p. 653.

49. Trexler (1980), pp. 49–50, 337, 356.

50. Seymour, p. 7. See also, Lavin, p. 367. For his use of the drill, Wittkower (1977), pp. 102–13. For the drawing, Joannides (2004), no. 4.

51. Hirst (2000), p. 490 and n. 30.

52. *David Myth.*
53. Astell, p. 165.
54. For a useful survey of Florentine Davids, Butterfield, p. 27ff. Even in Michelangelo's sketch for the bronze David, he is scarcely a boy: see Brandt (1999–2000), pp. 414–5.
55. Augustine, (1984), Bk 22, p. 1074.
56. Burckhardt, p. 633. S. Freedberg, vol. 1, p. 41. Wölfflin, p. 62, says something similar about sixteenth-century art in general, but in my view, this phenomenon is almost exclusively confined to Michelangelo: 'The fifteenth century thought it necessary to animate every part equally; the sixteenth found it more effective to accentuate a few isolated points only.'
57. Christ was usually dead or dying when he was shown nude. Adam is perhaps the closest analogy.
58. Saxl, vol. 1, p. 69.
59. Augustine (1984), Bk 16, p. 710.
60. *Culture and Belief*, pp. 208–9.
61. These vivid words come from the first Italian translation of the Bible, *Bibbia Vulgare Istoriata*, trans. Nicolò Malermi, Venice, 1490. Re II, 6/7.
62. *Petrarch* (1991), vol. 1, Bk 1, p. 74; Bouwsma (1980), pp. 121, 225. Savonarola (1969) is much more sanguine, vol. 1, Sermon 18, pp. 291–303.
63. 'The Handbook of the Militant Christian', in *Erasmus* (1964), p. 75.
64. *Trionfo della morte*, p. 34; Michelangelo (1996), pp. 244–5, F1 & F2. See also Boccaccio, Rime, 2, no. 38, ll. 68–9.
65. Voragine, vol. 2, p. 187; and Erasmus, 'Concerning the Immense Mercy of God' (1524), in *Erasmus* (1964), pp. 233–4.
66. Grazia, p. 356.
67. For this and other interpretations, see *Woman Defamed*, pp. 8, 75, 95–6, 101, 105–6, 116, 267.
68. Antonino (1858), part 2, ch. 1, p. 97.
69. Condivi (1999), p. 105.
70. Brockhaus, p. 103. Brockhaus prints the entire sermon, but only applies 'strong of hand and beautiful of appearance' to *David*. For unconvincing attempts to moralise the right and left sides of *David*, see Wilde (1932), p. 57; Tolnay (1947–60), vol. 1, pp. 95, 155.
71. Savonarola (1969), vol. 1, pp. 43–4. Michelangelo was in Bologna at the time, but he may have heard about it.
72. Pecchiai, pp. 211–15, made this suggestion, but his only explanation was

that Michelangelo had just made the famous statue of Cupid in the V&A, which is no longer attributed to him.

73. Barelli, pp. 28–44; Janson (1963), pp. 85–6. Erotic readings have been rejected by, among others, Shearman (1992), pp. 17–27.

74. Berger, p. 98.

75. Plotinus, I.1, p. 13.

76. Panofsky (1930). Antonio Filarete, in his *Treatise on Architecture* (*c.* 1460), rejected the myth of Hercules at the Crossroads, because it did not satisfy him intellectually. He expressed the idea of being torn between Virtue and Vice in a single figure fashioned from allegorical symbols. *Filarete*, p. 246.

77. Pliny, Bk 34, section 77.

78. Alberti (1966), p. 77.

79. Gauricus, p. 54, suggests that these different characteristics should be indicated by symbolic attributes, and this was standard practice in medieval and early Renaissance art. But there is no indication that Pliny and Alberti think in this way.

80. Condivi (1999), p. 17; Wind (2000), pp. 23–33.

81. Augustine (1984), p. 578; Bk 14, chs 16 and 17.

82. Montaigne, p. 115.

83. Bouwsma (1980), p. 179. Michelangelo's late, penitential poetry has often been associated with David's Psalms, and a portrait medal of Michelangelo made by Leone Leoni is inscribed with a passage from Psalm 51, which begins with David pleading for forgiveness. See Barolsky, p. 47.

84. Voragine, vol. 2, p. 186.

85. Ibid.

86. Baxandall, p. 51.

87. Ibid., p. 56.

88. Friedrich Kriegbaum, quoted by Einem, p. 47.

89. Voragine, vol. 2, p. 184.

90. BV, vol. 2, p. 131.

3. Bodies

1. Vasari, vol. 2, p. 649.

2. Chantelou, p. 137.

3. BV, vol. 2, pp. 120–32.

4. Ibid., p. 126.

5. Hale (1985), p. 195.

6. BV, vol. 2, p. 130, where Jonathan Richardson (1728) cites the story.

7. Corpus 250r. Roberts and Tomlinson, p. 73. Thomas Banks crucified a corpse in London in 1800, under the auspices of the Royal Academy.
8. Barolsky, p. 153ff.
9. Siraisi, p. 86; Cunningham, ch. 2.
10. Siraisi, p. 89.
11. Machiavelli (1998), Preface to Bk 1, p. 98.
12. Siraisi, p. 127.
13. Ibid., pp. 154–7.
14. Ramsden, vol. 2, no. 329 (April 1549); *Carteggio*, vol. 4, no. MCXXIX.
15. Hale (1985), p. 121. See also Hale (1983), pp. 359–420.
16. Cunningham, p. 37ff.
17. Galen, vol. 2, p. 731. This was translated into Latin early in the fourteenth century.
18. More, pp. 100–1.
19. Hughes, p. 30.
20. Leonardo (2002), p. 87.
21. *Leonardo* (1970), vol. 2, p. 338, no. 1353.
22. *Scritti d'arte*, vol. 1, p. 7.
23. Vasari, vol. 1, p 775.
24. See Petrarch, 'Invective contra Medicum – Invettive contro un Medico', in Petrarch (1975), vol. 2, pp. 828–9, 888–9; Garin (1965), p. 24ff.
25. *La disputa delle arti*.
26. Thorndike, p. 52.
27. Park, p. 170.
28. Thorndike, p. 55.
29. Perosa, pp. 75–109; Ficino (1980).
30. Park, p. 226ff.
31. *La disputa delle arti*, p. 41.
32. Clark (1960), p. 181.
33. *Leonardo* (1989), p. 130, says that anatomical study is necessary because the live model could lack 'fine muscles in that action which you wish him to adopt'. But this excuse seems very implausible because it is still far easier to find a live model with the right body than a dissectable corpse.
34. Elkins.
35. Kornell (1992), p. 123.
36. Nuland, p. 147.
37. Joannides (1996), nos 26, 27, 41, 42.
38. Elkins, pp. 178–9.
39. Holanda (1921), ch. 18.

40. Summers, p. 399, suggests this procedure explains the 'pronounced anatomy and apparently hard surfaces' of some of the figures in the *Last Judgment*. Kornell (1992), pp. 187–8, disagrees with Summers and assumes the passage is garbled.

41. Cf. Corpus 299r, a briskly executed study of the bent legs of a reclining figure, which was probably made in the early 1520s when he was planning the reclining statues of the 'Times of the Day' for the New Sacristy. His other *écorchés* of bent knees, such as Corpus 107r, are probably also imaginative reconstructions.

42. Alberti (1972), p. 75. I prefer Grayson's translation of this passage to Spencer's.

43. Ibid, p. 97.

44. Carlino, p. 127.

45. Kornell (1992), pp. 32–3.

46. Galen, vol. 2, pp. 726–7.

47. *Trattati d'Arte*, vol. 1, p. 128–9.

48. Ghiberti urged artists to study anatomy; Antonio Pollaiuolo is credited by Vasari with being the first artist to perform dissections; he was followed by Leonardo da Vinci.

49. Clark (1960), p. 191.

50. Jacobs, pp. 427–9.

51. Vasari, vol. 1, p. 553. See Wyss.

52. Condivi (1999), p. 12.

53. Vasari, vol. 1, p. 533.

54. Rubin and Wright, p. 257ff.

55. *Leonardo* (1989), p. 130.

56. Condivi, p. 17.

57. Summers, p. 397–405.

58. Condivi (1999), p. 99.

59. For Colombo, see Cunningham, p. 143ff.

60. But see chapter 6, entitled 'Movements'.

61. Wallace (1994), p. 24ff.

62. *Petrarch* (1991), vol. 1, no. 30, 'Spectacles'.

63. Condivi (1999), p. 15 and p. 126, n. 19.

64. Ibid., p. 15.

65. Alberti (1966), p. 75. (The passage, found in some of the manuscripts, is not included in Grayson's translation.)

66. Even the woman is being pulled by the head/hair.

67. Kornell (1989), p. 846. The most common contemporary image of

violence involving a naked – or near-naked – man and a rock was that of the penitent St Jerome, who beat his breast with a rock. This subject was especially popular because the saint's sun-dried and undernourished body gave the artist the opportunity to reveal the underlying anatomy.

68. Cunningham, p. xiii. Etienne Dolet, *Carmen libri quatuor*, Lyons, 1539, Bk 4, no. 18. Dolet published some of Rabelais' works.

69. The only real precedent for this investment in the area of the torso is in Tuscan Romanesque crucifixes, where Christ's torso is flanked by an apron showing scenes of the Passion.

70. There is also a motif of another person's arm crossing the neck – *Venus and Cupid* and *Milan Pietà* – or a wing – the *Rape of Ganymede*.

71. Only one portrait from life survives, a soulful drawing from 1532 of a beautiful young man, Andrea Quaratesi.

72. Ruskin, p. 17.

73. Rainer Maria Rilke said that in Rodin's sculpture expression had shifted from the face, and that he had thereby imbued every pore of the human body with an eye-like and mouth-like expressivity: Rilke, pp. 10–11. Michelangelo focused primarily on making the torso expressive.

74. The *Palestrina Pietà*, a sculpture which is not accepted as autograph by most scholars, has dramatic transverse thongs. One might also mention the so-called 'kneeling' windows for the Medici palace, where the windows would be the equivalent of the torso, and the 'kneeling' brackets, the legs.

75. In his poem on the eye (no. 35), Michelangelo is particularly interested in the intensely mobile relationship between the eyelids and the eye.

76. Vitruvius, p. 69. The first Italian translation appeared in 1521, but the Latin text was enormously influential before then and would have been discussed in Michelangelo's circle.

77. Marsh, p. 117

78. Rigoni; Coroleu.

79. Bouwsma (2000), p. 21.

80. Augustine (2001), section 4.2.3 [Psalm 72.26].

81. O'Malley (1993), p. 48; *Monumenta ignatiana*, vol. 2, pp. 170, 98. Berengario, p. 93.

82. Bouwsma (1980), p. 132.

83. II Corinthians 7: 15, 'And his inward affection is more abundant toward you.' Calvin, vol. 10.

84. Clark (1960), p. 63.

85. Weinstein, p. 143. Savonarola (1996), p. 43, who also claimed the Virgin's crown of heart-shaped stones had been made by Florentines.

86. Colonna (1999), pp. 35–6.

87. Poliphilo's ailing giant recalls Mantegna's *Dead Christ*, which is depicted with powerful foreshortening lying horizontal on a table. The wounded soles of the feet confront the viewer in the foreground, and in the distant background, Christ rests his head on a pillow.

88. Quoted by Bennett, p. 11.

89. Stokes, p. 60.

90. Augustine (2001), section 1.5.6.

91. Alberti (1986), Bk 1, p. 35.

92. Dempsey, p. 122.

93. Vasari, vol. 2, p. 657.

94. Clark (1960), p. 191; see also Goffen, p. 154.

95. Above all, it recalls Signorelli's *Resurrection of the Flesh* (1501) in Orvieto. Vasari, vol. 2, p. 654, talks about Michelangelo's salvaging of the ruined block of marble from which he carved the *David* in terms of a resurrection of the dead.

96. Gould, p. 514.

97. Clark (1960), p. 195.

98. Corpus 14r.

99. Seznec, p. 66.

100. Vasari, vol. 2, p. 735. The emphasis on anatomy appears in the second edition, when Vasari wanted anatomy to be a central plank of his Academy of Art.

101. Siraisi, p. 87.

102. Carlino, p. 108.

103. Berengario, p. 24.

104. *Leonardo* (1970), vol. 2, p 85, no. 796; *c.* 1508.

105. R. and M. Wittkower (1963), p. 56. The passage is from Baldinucci.

106. Condivi, p. 97.

107. Enea Vico's famous print of the sculptor *Baccio Bandinelli's Florentine Academy* (early 1540s) shows skeletons lined up in the foreground together with a live dog: the dog is unlikely to be in such a strategic position simply to emphasise the domesticity of the scene.

108. *Leonardo* (1970), vol. 2, p. 306, no. 1303. There is another similar prophecy (no. 1305) about crucifixes being sold.

109. Vasari, vol. 2, pp. 28–9.

110. Woods-Marsden, p. 89ff.

111. Janson (1973), pp. 39–52.

112. Nuland, p. 150.

113. Schulz, p. 90.
114. Soderini had been a close friend of Marsilio Ficino, and the philosopher had addressed his arguments about Christ's medical practice directly to him. Ficino (1980), p. 185.
115. Barolsky, pp. 30–1, gives examples but does not contextualise the phenomenon. The portraits that Michelangelo allowed to be made of himself late in his life, however, depict him as a melancholy patrician.
116. Panofsky (1992), p. 74.
117. The only vaguely similar precursor to this is a famous Florentine etching from *c.* 1460, *The Planet Mercury and his 'Children'*, which shows the various artforms: the sculptor kneels before a bust of a woman with his chisel placed in her eye and his mallet level with his shoulder. For some later examples of this trope, see J. Hall, p. 360, n. 30.
118. Summers, pp. 304–7; Panofsky (1972), pp. 225–8. The *Worship of the Brazen Serpent* on the Sistine Ceiling is a positive image of the worship of a bronze effigy of an animal, but it is not a statue.
119. Keegan, p. 324.
120. Hale (1985), p. 325.
121. Holanda (1928), pp. 50–3. Holanda had come to Italy to study military architecture, and this must be why he gained admittance to Michelangelo's inner circle. Benvenuto Cellini revered Michelangelo, and he made a similar comparison between skill at art and skill at war: 'I can use a sword to get what's owing to me . . . every bit as well as I've used tools for the work you've seen me do.' Cellini, p. 34.
122. This is misleading in so far as the best mercenaries during the Renaissance were Swiss – hence the Pope's Swiss Guard.
123. 'Lezzione della maggioranza dell'arti'. Weinberg, vol. 1, pp. 6–7.
124. See Castiglione, Bk 1, section 42ff.
125. Pliny, Bk 34, section 138
126. Hale (1985), p. 179.
127. Arrizabalaga, Henderson and French.
128. Bayley, pp. 227–8.
129. 'On the Armour of the Parthians', in Montaigne, p. 453–4.
130. See *Petrarch* (1991), vol. 1, pp. 269–71.
131. Boiardo, pp. 326–7. Bk 2, Canto 12. The most famous lament for the end of chivalry occurs in Ariosto's *Orlando Furioso*, Canto XI, Stanza 25–6: Ariosto, p. 109.
132. Gilbert, pp. 258–9. See also *Italy in Crisis*.
133. The most famous artistic acknowledgement of the disaster is Botticelli's

Mystic Nativity (1500), which is surmounted by a Greek inscription that begins: 'I Sandro made this picture at the conclusion of the year 1500 in the troubles of Italy . . .' Botticelli hoped that the troubles would herald the Second Coming of Christ, as promised in Revelation.

134. Hale (1985), p. 15.
135. Machiavelli (1961), p. 136.
136. Anglo, pp. 4, 318, n. 5.
137. Castiglione, Bk 2, ch. 8.
138. Holanda (1928), p. 15.
139. Wallace (2000), pp. 60–74.
140. Holanda (1928), p. 51.
141. Vasari, vol. 2, p. 735. See, for example, the presentation drawing, the *Fall of Phaeton* (c. 1533), with its horses crashing to earth; the *Children's Bacchanal* (c. 1533), with a dead 'horse' being carried in, its feet in the air; the fresco *Crucifixion of St Peter* (1545–50, in the Vatican), with its marginalised horsemen; the *Conversion of Saul* (1542–6), on the opposite wall, with Saul thrown from a horse. In 1537, Michelangelo was commissioned to make a small bronze horse (nothing more is heard about it) and in 1559 he was asked by Catherine de' Medici to make an equestrian monument of her dead husband, the French King Henry II, but only seems to have produced a drawing of the horse. He delegated the rest of the work to Daniele da Volterra.

4. Crowds

1. Ramsden, vol. 1, no. 51, November 1509; *Carteggio*, vol. 1, no. LXXX.
2. Condivi (1999), p. 102.
3. Wölfflin, p. 50.
4. Wilde (1958), p. 64.
5. Shearman (1972), p. 7.
6. Ettlinger (1965), p. 12.
7. Ibid., p. 32ff.
8. O'Malley (1979), p. 168–9.
9. Wilde (1958), p. 123.
10. Holanda (1928), p. 15–16; 69 and 71.
11. Shearman (1992), pp. 149–91 (on domes); see also Tolnay (1947–60), vol. 2, pp. 15–16.
12. Frank.
13. *Carteggio*, vol. 1, no. 10.
14. Raphael had only painted a few square feet of fresco before embarking on the Stanza della Segnatura.

15. Ramsden, vol. 1, no. 157, December 1523; *Carteggio*, vol. 3, no. DXCIV: 594.

16. Ghiberti seems to have rejected a scheme proposed by Leonardo Bruni.

17. Robertson, pp. 91–105.

18. The ten circular images are adapted from woodcut illustrations in the vernacular Malermi Bible, Venice 1493. Hope (1987), pp. 200–4.

19. Wallace (1987), pp. 203–16; Mancinelli (1994), pp. 46–57. Hatfield, p. 24ff, says that Michelangelo's bank accounts prove he could not have afforded assistants, but surely not every transaction had to go through his account: when he died, a chest full of gold coins was found in his house.

20. Condivi, p. 57.

21. Mancinelli, p. 56.

22. C. Gilbert (1994), p. 118.

23. S. Freedberg, vol. 1, p. 97.

24. *Dante* (1990), part 2, section 15 [16], 10. See Dempsey, p. 88–9.

25. Dempsey, p 90. In Michelangelo's *Manchester Madonna* (*c.* 1495), there are two pairs of angels who stand in the background on either side of the Virgin, but they do not interact with the main protagonists.

26. Gaston, p. 256.

27. This is true of the four allegorical figures (*c.* 1508–9) on the ceiling of Raphael's Stanza della Segnatura, and the Sybils painted by Filippino Lippi in Santa Maria Sopra Minerva, Rome.

28. The *spiritello* behind Isaiah stretches out his arm, but it is not clear whether he is pointing at anything.

29. *The Idler*, 79, 20 October 1759. Reynolds, p. 353.

30. Jones and Penny, p. 57ff.

31. The Libyan Sybil holds up the pages of the left side of the book so that they make a curve which echoes that of the curved architectural member at the end of the ceiling.

32. Michelangelo had only recently started writing poetry, jotting down lines of verse, his own and that of others, next to his drawings. Of this phase Bernard Berenson has suggestively written: 'I suspect, too, that Michelangelo had his moments of listlessness, long months, perhaps, of pottering about, when he could not easily concentrate attention upon anything, so that we find . . . alongside of hasty drawings, aimless phrases from the Prayer Book, snatches from Petrarch, and attempts at original verse-making, which, perhaps begun in this fashion out of mere listlessness, finally settled into habits of deliberate composition.' Berenson, vol. 1, p. 211.

33. Carl Justi, quoted by Einem, p. 64.

34. This is probably a plea for justice, as allegorical representations of Justice often depicted her with compasses or set-square.

35. Condivi (1999), p. 48.

36. As well as being depicted in the wall frescos, a standing figure of Christ appeared between the first 'Popes', St Peter and St Paul, on the altar wall, until it was replaced by the Christ of Michelangelo's *Last Judgment*.

37. W. Taylor Smith, 'Jonah', in *Dictionary*, p. 492. It was sometimes believed that venting anger on venerated images jolted the depicted saint or god into action: Trexler (1980), p. 118ff.

38. Augustine (1984), Bk 18, ch. 30, p. 798.

39. Condivi (1999), p. 38.

40. Hirst (1999), p. 12.

41. Vasari, vol. 2, p. 670. Hartt (1950), p. 129ff., asserts the centrality of the *ignudi* and their acorns, but for different reasons.

42. Levin, p. 20ff.

43. Hirst (1976), Hirst (1988), pp. 91–2. Saalman, p. 96, n. 4, dates it around 1516. The disputed dating does not seriously affect my argument.

44. Lucretius, p. 200; Juvenal, no. 6, l.10.

45. Levin, p. 26.

46. *Petrarch* (1976), no. 50, ll. 21–4.

47. The motif derives from Hesiod, whose works were first printed in Latin in 1471. Michelangelo's poem (no. 67) is his longest.

48. Hartt (1950), p. 93.

49. So do the male nudes who lounge around in the background of the *Doni Tondo*.

50. 'Works and Days', in *Hesiod,* p. 62.

51. Levin, p. 26.

52. Jones and Penny, p. 50; Shaw, p. 269, gives a less literal translation.

53. Shaw, p. 187.

54. Brandt (1992), p. 77.

55. Scarry, p. 185ff.

56. Stokes, p. 89.

57. Pater, p. 90.

58. For example, Leonardo's *Annunciation* (*c.* 1473) and Botticelli's altarpiece of 1489–90, painted for the church of Cestello. It also recalls Taddeo Gaddi's *Annunciation to the Shepherds* in Santa Croce, Florence.

59. The 'reaching out' only occurs in paintings, however.

60. Landi; Seznec, p. 220ff.

61. *Boccaccio* (1998), vols 7–8, pp. 72–5. The Demogorgon features in Boiardo's *Orlando Innamorata*, where he is the omnipotent ruler of fairies and demons, and in the unfinished sequel to Ariosto's *Orlando Furioso*, where he decrees the total destruction of France. In a sonnet written in around 1512 (no. 10), Michelangelo compared the Pope ('He who wears the mantle') to the Gorgon Medusa.

62. Wind (2000), p. 77.

63. Ibid., pp. 81–7. There was some dispute over whether this first child was male or female. One Latin name, Litigium, is masculine, but Boccaccio says that the most commonly used term, 'Discordia', has a feminine stem.

64. Leone Ebreo, whose correspondents included Giovanni Pico della Mirandola, thought that Discordia's mother, Chaos, was analogous to Eve. In his influential *Dialoghi d'amore*, published in 1535, but substantially written in Genoa in around 1495–1500, Ebreo proposed that Demogorgon had created Chaos to be his companion just as Eve had been created from Adam: Ebreo, p. 110.

65. It had previously been explored by Alberti (1987), p. 61, and by Leonardo (1970), vol. 2, p. 280.

66. A similarly outstretched leg is found in the presentation drawing the *Punishment of Tityus*, and it explicitly rhymes with the wing of the vulture that pecks at his liver.

67. Ackermann, p. 128.

68. A tiny crab appears on the far right of the presentation drawing of *Tityus*.

69. Wind (2000), p. 60.

70. A comparable figure can be found just left of centre in the drawing for Pope Julius' tomb, reaching up towards the papal oak tree.

71. Panofsky (1972), p. 44. One is reminded, too, of the hieroglyphic frieze which Bramante proposed to Pope Julius II, and which was rejected. Taking its cue from part of the Pope's Latin name (PONT II), it was a bridge with two arches.

72. Raphael's engraving the *Massacre of the Innocents* (*c.* 1511) may have been influenced by Michelangelo's *Fall* and *Expulsion*: not only are some of the figures comparable, but a double-arched bridge (see previous note) spans the back of the entire composition, enclosing the figures and suggesting the inevitability of their fate.

73. Tolnay (1947–60), vol. 2, p. 29.

74. *Erasmus* (1964), p. 69.

5. Benefactions

1. *Songs I*, p. 58. Sermon 9.
2. Ramsden, vol. 1, no. 161. January 1524; *Carteggio*, vol. 3, no. DCVII.
3. For a discussion of the term *sacra conversazione*, Humfrey (1993), pp. 12–13.
4. See Hope (1981), pp. 320–3.
5. Hibbard, p. 188.
6. M. Hall, pp. 511–12. She cites only two wall tombs, both constructed in the first decade of the century.
7. Wilde (1978), p. 114ff.; Morrogh. For the organisational aspects of the project, Wallace (1994).
8. Pope-Hennessy, vol. 1, p. 401.
9. BV, vol. 3, p. 1005.
10. Verellen, pp. 375–82.
11. Wilde (1978), p. 125.
12. Ettlinger (1978), p. 295.
13. MacCulloch, p. 14.
14. The statue's size and prominence may also owe something to the recent erection of an imposing stone statue on a pillar outside the new chapel of the *Schöne Maria* (beautiful Mary) in Regensburg. It immediately became a site of pilgrimage, and on 1 June 1519, Pope Leo X issued a bull granting indulgences to pilgrims, 50,000 of whom came in the first month alone. Freedberg, pp. 100–3.
15. Kreytenberg. See also Mino da Fiesole's *Tomb of Count Hugo of Tuscany* (1481), in which a large relief of Charity surmounts the sarcophagus of the deceased.
16. *Italian Art 1500–1600*, p. 46. The influence of Tino da Camaino has been discerned in Michelangelo's late sculptures by Joannides (1992), p. 249.
17. Corpus 22v; 23v.
18. Bernini's statue of *David* was initially seen from the back: see Kenseth. There are interesting similarities between the New Sacristy Madonna and Child and Titian's *Virgin and Child and St Catherine with St Dominic and a Donor* (*c.* 1512–13) in the Fondazione Maganani-Rocca, Parma. Christ presents his back to St Catherine who crouches on the far left of the composition.
19. Pope-Hennessy, vol. 3, p. 79, who argues it was made for the Julius tomb.
20. Berengario, p. 87; Bynum (1982), p. 132; Klapisch-Zuber, p. 161.
21. The twisting children in Tino da Camaino's sculpture of Charity have been

compared to the snakes that hang from the breasts of allegorical representations of Lust: Freyhan, p. 83.

22. Hart (1951), p. 294.
23. *Erasmus* (1964), p. 35.
24. Duke Federigo da Montefeltro was depicted by an unknown artist wearing armour while reading a book in *c.* 1477. This showed that arms and letters were complementary activities. Piero della Francesca also depicted him kneeling in full armour before the Virgin: for this motif see M. A. Lavin, p. 277ff. For Santissima Annunziata, Warburg, p. 204ff.; Trexler (1980), p. 123.
25. Clark (1960), p. 35 and note on p. 365. The leather body armour of the sleeping soldier in Piero della Francesca's *Resurrection of Christ* hugs the asymmetrical body more closely, but is still quite schematic.
26. Pope-Hennessy, vol. 2, p. 401.
27. The four *Slaves*, probably begun in around 1519 and intended for the revised version of the Julius tomb, have exceptionally bloated bodies with large breasts. This is particularly apparent in the *Young Slave* and the *Awakening Slave*.
28. Bynum (1982), p. 110ff.; Berliner, who says that the earliest known representation of this theme appeared in a Latin codex of 1424 in the Vatican, and is by a German artist.
29. Bynum (1982), p. 117.
30. *Catherine*, pp. 83, 99, 105, 159.
31. Bynum (1987), p 272. The painting is the *Saviour* by Quirizio da Murano (*fl.* 1460–78). It is in the Accademia, Venice. Berengario, p. 87.
32. *Songs II*, p. 27. See also pp. 220–3; and *Songs I*, pp. 58–63, 78–9, 86. An Italian translation was published in Milan in 1494.
33. Doni, Part 3, pp. 20–1.
34. Hartt (1951). One survives in a fragmentary state in Casa Buonarroti.
35. *Songs I*, p. 87.
36. Corpus 248, *The Holy Family with the Infant St John*.
37. Giovanni Anton Montorsoli transformed him into a tomb statue of *Judith* (*c.* 1536) with her ample breasts exposed like an Amazon. This statue appears on the tomb of Jacopo Sannazaro in Naples. Vasari's portrait of *Alessandro de' Medici* is based on the statue of Giuliano; but Vasari remasculinises him by equipping him with a complete suit of shiny armour.
38. Tolnay (1947–60), vol. 3, p. 67; Hartt (1951), pp. 149–50, n. 23; Hughes, p. 200.
39. Nelson and Stark.

40. Condivi (1999), p. 67. See also Panofsky (1964).
41. *Leonardo* (1970), vol. 2, p. 281, no. 1275.
42. In Raphael's portrait of 1518, Lorenzo holds a circular enamelled box, which possibly contains a wax portrait of the Frenchwoman to whom he was betrothed, close to his midriff.
43. Pope-Hennessy, vol. 2, p. 442.
44. Gilbert, pp. 135–6.
45. Vasari, vol. 2, p. 681.
46. Niccolò Martelli in a letter of 1544. Pope-Hennessy, vol. 3, p. 444.
47. Hatfield, p. 87ff.
48. Wallace (2000), p. 64.
49. Ramsden (June 1523), vol. 1, no. 154; *Carteggio*, vol. 2, no. DLXXVII.
50. *Scritti d'Arte*, vol. 1, p. 12.
51. Hatfield, p. 126ff.
52. Polizzotto; Morçay; Centi; Gilbert (1959).
53. Vasari, vol. 1, p. 408; Centi, p. 68.
54. Savonarola also raised alms for Antonino's beloved *poveri vergognosi*. See Landucci: diary entries for 6 December 1494 and 16 February 1495.
55. Polizzotto, pp. 363–4; Morçay, p. 499.
56. Pastor, vol. 9, pp. 142–3.
57. In the evidence that was presented, attention was drawn to the fruitfulness of the relationship between Cosimo de' Medici and Antonino, and even greater benefits were prophesied if the Medici's patronage was again allowed to flow. Antonino's celebrated acts of charity were particularly stressed. But the papal consistory twice rejected the proposal, at the end of 1516 and the beginning of 1517, due to opposition to Medici self-aggrandisement, and also because of the relatively few miracles credited to Antonino. (Though the patron saint of Florence, John the Baptist, hadn't performed any miracles.) Cardinal Giulio initiated and financed a third attempt, and after much arm-twisting, the cardinals agreed in December 1520. Parallels were also drawn between Antonino and his successor as Archbishop of Florence, Cardinal Giulio. Polizzotto, p. 367.
58. The closest visual parallel I have found to the upper body of Michelangelo's Giuliano de' Medici is Andrea Riccio's bronze relief *St Martin and the Beggar* (*c.* 1510; Venice, Ca' d'Oro).
59. Kent, p. 51.
60. Ibid., p. 57.
61. Paschini, p. 5.
62. Antonino (1740) III, section 20, ch. 3.

63. Secular authorities were less tolerant. As a result, the poor were better served if they were tried by ecclesiastical courts. Colish, pp. 326–30.

64. Henderson (1994), pp. 356–8. This climate of opinion may well have contributed to the disappearance of the *Madonna lactans* from Florentine art in the mid-1440s, and when the subject is readdressed in a work like Michelangelo's *Madonna of the Stairs* (*c.* 1489–92), the 'charitableness' of the Madonna is severely muted.

65. Koldeweij, p. 112ff.

66. Arrizabalaga, Henderson and French, p. 155; Henderson (1999), p. 58.

67. Arrizabalaga, Henderson and French, p. 161.

68. *Erasmus* (1965), p. 70.

69. See Fernándes-Santamaría, p. 145ff.

70. Machiavelli (1961), pp. 94–5.

71. Ramsden, vol. 1, no. 157, December 1523; *Carteggio*, vol. 3, no. DXCIV.

72. Ramsden, vol. 1, no. 161, January 1524; *Carteggio*, vol. 3, no. DCVIII.

73. Vasari, vol. 2, p. 740.

74. Ramsden, vol. 2, no. 368, February 1552; *Carteggio*, vol. 4, no. 1,169; 'poor nobles' is my translation, following *Carteggio*, vol. 4, p. 373, no. 1.

75. Ramsden, vol. 2, no. 370, April 1552; *Carteggio*, vol. 4, no. 1,171.

76. Mozza,; Aikema; Humfrey (1997), pp. 87–9, 137–9.

77. Ibid. (1997), p. 139.

78. Humfrey (1993), p. 78.

79. Panofsky (1972), p. 211.

80. Ibid.; see also Panofsky (1992), p. 92.

81. Justi, p. 231.

82. I am grateful to Tom Nichols for this point.

83. Something similar occurs in the frescos subsequently painted by Michelangelo on opposite walls of the Pauline chapel. According to Tolnay (1947–60), vol. 5, p. 71, the *Conversion of St Paul* and the *Martyrdom of St Peter* 'offer two successive stages of an existence dedicated to God'.

84. Panofsky (1992), p. 92, n. 1. The state had always intruded into 'private' life: *Society*, pp. 179–212.

85. *Erasmus* (1964), p. 37. See also the Gospel according to St Matthew, Book 7, v. 13–14.

86. Morçay, p. 419, who cites an anonymous sixteenth-century painting of the subject owned by the woman's descendant.

87. Pastor, vol. 8, pp. 81–3.

88. Ibid.

89. Condivi (1999), p. 106.
90. Hibbard, p. 218.
91. It would have matched the desks in the library, which were made from walnut.
92. In 1514, Giovanni Bellini had painted a large mythological painting for Alfonso d'Este of Ferrara, *The Feast of the Gods.*
93. Leonardo Sellaio. *Carteggio*, vol. 2, no. CCCLXXXIX; Jones and Penny, p. 183, for letter and dating.
94. Kristeller, pp. 324–6.
95. Berni said that whereas Plato uses words, Michelangelo 'says things'. Michelangelo replied with his own comic verse (no. 85).
96. Condivi (1999), p. 105.
97. Ibid.
98. Plato, pp. 104,107.

6. Movements

1. Condivi, p. 97.
2. Ruvoldt, p. 87.
3. Frommel says he may have met him through the Rome-based Florentine sculptor Pierantonio Cecchini. BV, vol. 4, p. 1882ff.; Perrig, p. 75ff.
4. Panofsky-Soergel.
5. See Wallace (1995); Joannides (1996), p. 56, attributes the bust of a woman on the back of the *Fall of Phaeton* to Mini; Bambach, p. 495, thinks the sketch on the back of *Cleopatra* is a preparatory draft by Michelangelo.
6. Casa, ch. 1.
7. Hirst (1988), p 39. There are two versions of this painting.
8. Condivi (1999), pp. 97–9.
9. Hirst (1988), p. 14, dates the surviving studies to around 1520. But there are likely to have been many more which haven't survived.
10. The poems for publication are featured in *Michelangelo poesia.*
11. Hirst (1999), p. 13.
12. I am grateful to Luke Syson for this point.
13. Hatfield, p. 192ff., says his gifts date from after 1530, and his charitable donations from 1547.
14. Ibid, pp. 105–18; Joannides (1996), p. 54ff.; Panofsky (1972), p. 212ff.; Rosand, p. 182ff.; Syson and Thornton, p. 174ff.
15. Condivi (1999), p. 105.
16. Woodhead; Trexler (1994), pp. 298–305; *Pensiero pedagogico*, pp. 553–667.

17. Trexler (1994), p. 299.
18. Ibid., p. 304.
19. Castiglione, Bk 1, sections 49–53.
20. J. C. Nelson.
21. Ficino (1985), p. 58.
22. Rocke, p. 87.
23. Ibid, p. 231.
24. *Carteggio*, vol. 3, no. DCCCXCVIII
25. *Carteggio*, vol. 4, no. CMXVI; Bynum (1987), p. 4.
26. Ficino (1985), p. 66.
27. David Landau has suggested to me the prints of Giulio Campagnola as a useful technical comparison to Michelangelo's drawings; Rosand, pp. 203–4, contrasts Michelangelo's technique with that of Campagnola – but surely the similarities are more telling than the differences.
28. Hirst (1988), p. 113, who examined them under a microscope.
29. Vasari, vol. 2, pp. 77, 79.
30. Condivi (1999), p. 99. The last sentence was inserted into the second printing, almost undoubtedly by Michelangelo himself; Hirst (1998), p. xvi, n. 38.
31. Davis, p. 72.
32. Wilde (1978), p. 147.
33. Echinger–Maurach, pp. 336–44.
34. Joannides (1996), p. 54.
35. Landau and Parshall, p. 101.
36. Ibid., p. 89.
37. Ibid., p. 297.
38. Agostino Veneziano (1490–1536) is a possible candidate. He worked in Rome after 1531, and produced many mythological prints as well as copies of other prints.
39. Condivi (1999), p. 9. For Michelangelo's interest in northern prints, see Joannides (1992).
40. Kornell (1992), p. 187; Holanda (1921), ch. 18.
41. Vasari, vol. 1, p 564.
42. Hirst (1988), p. 110.
43. Vasari, vol. 2, p. 77.
44. Ibid., p. 76.
45. Popham and Wilde, p. 248.
46. A counterproof was sometimes made of chalk drawings (all the presentation drawings are in black or red chalk), which might – or might

not – obviate the need to print the source image in reverse. For counterproofs of a red chalk drawing by Raphael, see Pon, pp. 110–13.

47. The two surviving drawings would work well enough in reverse, with only minor modifications (the writing in the *Pietà*; the angel pointing to Christ's side in *Christ on the Cross*); the third, *Christ and the Woman of Samaria*, survives only in a print.

48. *Culture and Belief*, p. 138. See also Thornton, pp. 167–74.

49. Beck, p. 223.

50. Panofsky's claim that the archers' failure is their inability to hit the centre of the shield seems forced: the arrows are quite evenly distributed all over the shield, and over the rest of the herm.

51. Ovid (2000), no. 2, pp. 639–78.

52. Poliziano, vol. 1, p. 256. See Wind (1937); Panofsky (1969), p. 215.

53. Wind (1937), p. 66.

54. In the 1540s Paolo Giovio devised an impresa for Vittoria Colonna – Conantia Frangere Frangunt – which implied that 'the cliffs of her most steadfast virtue strike back the fury of the sea, breaking and dissolving it into foam'. Wand, p. 206.

55. Corpus 61.

56. Marongiu.

57. Bynum (1982), p. 125. In Psalm 91, the Lord is compared to a bird: 'Surely he shall deliver thee from the snare of the fowler . . . He shall cover thee with his feathers, and under his wings shalt thou trust.'

58. *Bartsch*, vol. 26, no. 298; Bober and Rubinstein, no. 27.

59. Summers, p. 180.

60. Bernardo Bellincioni (1452–92), who moved to Milan where he became the ducal poet. He corresponded in verse with Lorenzo de' Medici and Landino. *Storia della letteratura*, p. 640.

61. Galen, vol. 2, p. 731.

62. Alberti (1966), p. 94.

63. See Syson and Thornton, p. 174ff.

64. Ibid., p. 175; BV, vol. 4, pp. 1890–1.

65. Vasari, vol. 2, p. 737.

66. Popham and Wilde, p. 254.

67. BV, vol. 4, 1550 edn, p. 1898.

68. Nagel, pp. 158–62.

69. Hale (1993), p. 456.

70. Braudel, vol. 1, p. 328.

71. Ibid., p. 415.

72. Guevara, ch. 34. For birth and population controls in Renaissance utopias, Eliav-Feldon, p. 35ff.

73. The boar's head at top left is probably intended to hang from a branch of the tree.

74. A similar kind of curtain is pulled by a satyr to reveal a nymph in an illustration to Francesco Colonna's *Hypnerotomachia Poliphili*, Colonna (1999), p. 73.

75. Lambert, pp. 1–24.

76. *Leonardo* (1970), no. 602.

77. Ramsden, vol. 2, no. 402; *Carteggio*, vol. 5, no. MCCIX. Michelangelo says he is 'alle venti 4 ore' – at the eleventh hour.

78. Dante (1990), IV, xxiii, 88–110 and 146–7. C. Gilbert (1971) uses the 'arco' image to explain the New Sacristy 'Times of the Day' placed on their curved bases. This section of the *Convivio* has a wider relevance to Michelangelo and Cavalieri, because Dante goes on to describe the qualities of each age, beginning with Adolescence, a phase which lasts from the age of eight months until the twenty-fifth year. It is then followed by Youth. The adolescent who 'enters into the wrongful wood of this life' needs adults to point him in the right direction – and he must obey their instructions. Ibid., IV, xxiv, 123–7.

79. Ruvoldt, p. 106.

80. Partridge, p. 107, says that Minos is being fellated by a snake.

81. Rocke, pp. 92–4. For a Parmigianino drawing of *c.* 1535–40 of a man masturbating another, see Popham, no. 496.

82. Panofsky (1972), p. 224, calls the *Dream* a 'counterblast' to Dürer's engraving the *Dream of the Doctor*, in which a sleeping man is seduced by the Devil and by a full-length naked Venus.

83. Tolnay (1975), 'Introduction', n.p., claimed that Michelangelo destroyed some erotic drawings, but without giving evidence. See Perrig, p. 3.

84. Vasari, vol. 1, pp. 737–8.

85. Jones and Penny, *Raphael*, p. 183.

86. Lawner; Talvacchia.

87. Vasari, vol. 2, p. 86.

88. Jones and Penny, p. 185.

89. Ibid., p. 87.

90. Vasari, vol. 2, p. 741

91. *Aretino*, vol. 1, pp. 110–11.

92. Sonnet 7. Talvacchia, p. 207.

93. They can be usefully compared with the moralising medallions on the

Sistine Ceiling (*Fall of Phaeton* with, for example, Antiochus falling from his chariot as punishment for his threat to kill the Jews). But the presentation drawings offer fewer examples of virtue.
94. Augustine (2001), p. 174; 8.7.17.
95. Condivi (1999), p. 99.
96. Condivi (1999), p. 83.
97. Moltedo, pp. 68–72, n. 17.
98. Vasari, vol. 2, p. 694.
99. Hirst (1996), p. 73.
100. Condivi (1999), pp. 106–7.

7. Humiliations

1. Lomazzo (1974), vol. 1, ch. 16, p. 139.
2. Chapman, p. 469, doubts that these fragments are from the same composition because of discrepancies in scale and style.
3. Hirst (1988), p. 57.
4. Many engravings were made of Colonna's drawings. During the Reformation, prints gained a certain spiritual kudos, particularly in northern Europe. Not only were they less subject to iconoclastic attacks than sculpture or painting, it was also said that because prints were only black and white, their austerity and simplicity made them an appropriate vehicle for the expression of Protestant ideas. Landau and Parshall, p. 364.
5. Hatfield, p. 188ff.
6. Ramsden, vol. 1, no. 49. July–August 1509; *Carteggio*, vol. 1, no. LXVII.
7. *Scritti d'Arte*, vol. 1, p. 12.
8. Vasari, vol. 2, p. 746. Condivi (1999), p. 106, says he slept in his boots because he suffered from cramp, though one would imagine that wearing tight boots would exacerbate the problem.
9. Loyola (1973), nos 85 and 86.
10. From a fifteenth-century French mystery play. DuBruck, p. 364.
11. This is a lugubrious equivalent of Phidias carving his own portrait on the shield of his statue of Minerva (just as Minerva carries a spear, a militant St Bartholomew carries a knife). See *Petrarch* (1991), vol. 3, p. 284.
12. Wasserman, p. 31.
13. Hatfield, p. 193.
14. Ibid., p. 160ff.
15. Pope-Hennessy, vol. 3, pp. 108–9.
16. Renaudet, p. 238ff.
17. *Erasmus* (1964), p. 60 (4th rule).

18. Ibid., p. 66 (5th rule).
19. Ibid., p. 75.
20. Ibid., p. 81 (17th rule).
21. *Colonna: Dichterin.*
22. Nagel, p. 171.
23. The image complements the *Bruges Madonna*, where the Christ Child, wedged between his mother's legs, descends from the rocky promontory on which she sits.
24. *Erasmus* (1964), p. 80 (17th rule).
25. Condivi (1999), p. 103.
26. Vasari, vol. 2, p. 695.
27. *Decrees*, vol. 3, pp. 666–7.
28. Ibid., p. 672.
29. Wasserman, p. 29.
30. The single exception is the *Pietà* drawing made for Vittoria Colonna, but here the Virgin looks up in despair.
31. Condivi (1999), p. 87.
32. Vasari, vol. 2, p. 697.
33. Condivi (1999), p. 90.
34. Wasserman, ch. 3.
35. Holanda (1928), p. 71.
36. A comparable athleticism is found in two other 'crucifixions' by Michelangelo: the Sistine Ceiling Haman, crucified to a gnarled tree stump with Y-shaped branches, and St Peter in the Pauline Chapel, crucified upside down.
37. *Carteggio*, vol. 4, no. CMLXVIII.
38. Loyola, no. 86.
39. Giovanni Andrea Gilio, *Due Dialoghi* (1564), in *Trattati d'arte*, vol. 2, p. 40.
40. *Songs II*, sermon 33, p. 153.
41. *Carteggio*, vol. 1, no. VI, December 1500. Erasmus attacks the practice of fasting: *Erasmus* (1964), p. 59 (4th rule).
42. Berenson, vol. 1, p. 234. See especially Clark (1960), pp. 217, 244–5.
43. Jacobs, pp. 426–48.
44. Wyss.
45. Aldrovandi, p. 217.
46. *Trattati d'arte*, vol. 2, p. 40.
47. Plato, p. 100ff.
48. Wyss, pp. 128–9. The Marsyas was part of a never completed series of

sixteen reliefs of mythological subjects, probably commissioned by Cardinal Alessandro Farnese.

49. See also nos 33 and 94. Barolsky, pp. 30–1.
50. Hirst (1988), p. 8.
51. McClure, p. 16.
52. The famous study for Porta Pia (*c.* 1561) is perhaps the principal exception, but it is still not nearly as wobbly as the crucifixion drawings.
53. Corpus 422.
54. Holanda, p. 15.
55. Winternitz, pp. 150–65.
56. Wyss, p. 120.
57. Wittkower (1973), p. 117ff.
58. Holanda (1928), pp. 16–17.
59. MacCulloch, p. 590. Savonarola also disapproved of organs and polyphony.
60. *Leonardo* (1970), vol. 1, no. 32, p. 76.
61. Ibid.
62. *Carteggio*, vol. 4, no. MXLV; p. 123.
63. McGrath, p. 148ff.
64. Gleason, p. 169.
65. Ovid (1955), p. 145; Bk 6, ll. 382–400.
66. Loyola, no. 53.
67. Kempis, p. 68, Bk 2, ch. 1.
68. *Catherine*, p. 105.
69. Janelle, p. 187.
70. The only exception is Corpus 422, in the Louvre, a fragmentary crucifixion where Christ looks directly out towards the viewer. However, from what remains, it looks as though he barely delineated the arms.
71. I am thinking above all of the nude standing lovers in *La Vie* (1903).

8. Legacies

1. Pater, p. 100.
2. Vasari, vol. 2, p. 735.
3. R. and M. Wittkower (1964), p. 14.
4. Vasari, vol. 1, p. 742.
5. This was Lodovico Domenichi's translation from the Latin text. It was published in Venice in 1547, and in Monte Regale in 1565. Alberti (1966), p. 35.
6. Ibid., pp. 95–6.

7. See Rubin, p. 396ff.; *Reactions to the Master*, pp. 6–7.

8. Lomazzo (1584), pp. 22–4.

9. For Michelangelo the 'mannerist', see Shearman (1967).

10. Condivi (1999), p. 107.

11. *Giannotti*, pp. 68–9.

12. Reynolds, pp. 327, 332.

13. Ibid., p. 337.

14. Jobert, pp. 45–6. See also Chabanne.

15. *Rodin*.

16. Ruskin, p. 17.

17. Rilke, p. 10.

18. Ibid., p. 11. Rodin knew 'there could be weeping feet, that there is a weeping of the whole body'.

19. Wind (1985), p. 42. Wind believes this to be a wholly modern tendency.

20. J. Schulz, pp. 366–73. Some of the 'unfinished' sections are probably the result of preparatory blocking out by assistants.

21. Condivi (1999), p. 67. He said this about the statues of the New Sacristy.

22. *Moore*, p. 191.

23. See also C. Gilbert (1994), pp. 40–4.

24. Liebert, p. 235.

25. Penny, pp. 88–90.

26. Friedrich Kriegbaum, quoted by Einem, p. 47.

27. Wittgenstein, p. 312; quoted by Scarry, p. 16.

28. Goffen, p. 113ff. His 'unfinished' sculptures are a variation on this theme.

29. *Petrarch* (1991), vol. 3, nos 46 and 51; vol. 1, no. 82.

30. *Culture and Belief*, p. 173.

31. Appleyard.

32. Gordon (1981), p. 23–52.

33. Gordon (1987), p. 34–6.

34. Sylvester, p. 44.

35. Ibid., p. 114.

36. Tisdall, p. 17.

37. Vasari, vol. 2, p. 695.

38. *Beuys*, p. 179.

39. Clark (1961), p. 37.

Chronology

1475	Birth of Michelangelo Buonarroti in Caprese, youngest son of Lodovico di Leonardo Buonarroti Simoni (1444–1531) and of Francesca di Neri Miniato del Sera (d. 1481).	
1478		Publication of Luigi Pulci's *Morgante*.
1481		Publication of Landino's edition of Dante.
1487	Presence recorded in the studio of the painters Domenico and Davide Ghirlandaio.	Publication of *The Legend of St Catherine*.
1488	Apprenticed to Domenico and Davide Ghirlandaio.	
1489–92	Probably frequents Lorenzo de' Medici's sculpture garden in San Marco, and is attached to the Medici household. *Madonna of the Stairs* and *Battle of the Centaurs*.	
1491		Savonarola becomes prior of San Marco
1492		Death of Lorenzo de' Medici, who is succeeded by his son Piero.
1493	Works for Piero de' Medici. *Hercules*; *Crucifix* for Santo Spirito, where he performs first anatomical dissections.	
1494	Shortly before King Charles VIII enters Florence, Michelangelo flees for Venice, before travelling on to Bologna.	King Charles VIII of France invades Italy; Piero de' Medici flees Florence. The city becomes a Republic.
1495–6	Returns to Florence, moves to Rome. Commission for *Bacchus*.	
1498	Contract for St Peter's *Pietà*.	Savonarola excommunicated and burnt at the stake. Death of Antonio del Pollaiuolo.
1501	Leaves Rome for Florence. Contract for marble *David*.	Leonardo returns to Florence.
1502	Contract for bronze *David*.	

1503	Contract to carve twelve *Apostles* for the Cathedral in Florence. First payment for *Bruges Madonna*.	Election of Giuliano della Rovere as Pope Julius II. Leonardo commissioned to paint *Battle of Anghiari*. Publication of Erasmus' *Handbook of the Militant Christian*.
1504	Marble *David* inaugurated in Piazza della Signoria, Florence. Commissioned to paint the *Battle of Cascina*. Probably begins work on *Doni Tondo*.	
1505	Summoned to Rome to work on the tomb of Pope Julius II. Spends eight months in the marble quarries of Carrara.	Bramante commissioned to rebuild St Peter's.
1506	Returns to Florence in exasperation after work is suspended on the tomb. Having gone to Bologna to make up with Pope Julius, is commissioned to make a bronze effigy of the Pope.	Discovery of Laocoön.
1508	Starts work on Sistine Chapel Ceiling, which he completes in 1512.	Raphael begins the frescos in the Vatican *Stanze della Segnatura*.
1513	New contract for Julius tomb. Begins *Slaves* and *Moses*.	Death of Pope Julius. Giovanni de' Medici elected as Pope Leo X. The Medici are reinstated as rulers of Florence.
1516	Third contract for Julius tomb. Secures commission for façade of San Lorenzo.	
1517		Martin Luther, objecting in part to the sale of indulgences to finance the new St Peter's, nails 95 theses to a church door in Wittenberg.
1517–18	Long visits to marble quarries to find marble for San Lorenzo and Julius tomb.	
1519	Façade commission cancelled. Commissions for a new sacristy and library at San Lorenzo.	Leonardo da Vinci dies in France.
1520		Pope Leo excommunicates Luther. Death of Raphael.
1521		Death of Pope Leo. Election of Adrian of Utrecht as Adrian VI.
1523		Canonisation of St Antonino. Death of Pope Adrian. Election of Cardinal Giulio de' Medici as Clement VIII.
1524	Work begins on Laurentian Library.	Giulio Romano and Marcantonio Raimondi's book of pornographic prints, *I Modi*, probably published.

1527	Work at San Lorenzo interrupted after expulsion of Medici from Florence and the declaration of a republic.	Rome is sacked by Imperial troops. Pope Clement is imprisoned and then flees.
1528		Castiglione's *Book of the Courtier* and Dürer's *Four Books on Human Proportion* published.
1529	Made responsible for Florence's fortifications.	
1529–30	Goes into hiding after fall of the city, but is pardoned by Pope Clement. Work resumes at San Lorenzo. Probably makes first of mythological presentation drawings.	Florence besieged by pro-Medicean troops.
1531	Death of father, Lodovico.	Henry VIII becomes head of Church in England.
1532	Meets Tommaso de' Cavalieri	
1534	Leaves Florence for Rome.	Death of Pope Clement. Alessandro Farnese elected Pope Paul III.
1536	Starts painting *Last Judgment*. Meets Vittoria Colonna.	
1537		Cosimo de' Medici becomes first Duke of Florence.
1538	Commissioned to remodel buildings on the Capitoline Hill.	
1541	Completes *Last Judgment*.	
1542	Final contract for Julius tomb. Begins work on frescos in Pauline Chapel.	
1543		Publication of Andreas Vesalius' *De Humani Corporis Fabrica*.
1545	Installation of Julius tomb in San Pietro in Vincoli.	First session of Council of Trent.
1546	Appointed architect of St Peter's.	The Council of Trent decree on Original Sin.
1547	Death of Vittoria Colonna.	
1548		Publication of Loyola's *Spiritual Exercises*.
1550	First mention of Florentine *Pietà*. Completes frescos in Pauline Chapel. Vasari publishes first edition of the *Lives*. Aretino publishes letter criticising the *Last Judgment*.	
1553	Condivi's *Life of Michelangelo* published.	
1556	Pilgrimage to Loreto.	
1558	Makes a model of the staircase for the Laurentian Library.	
1558–9	Nudities in *Last Judgment* painted over by order of Pope Paul IV.	
1564	Death of Michelangelo.	
1568	Vasari publishes second edition of the *Lives*.	

Index